"In *Our Secret Society*, Tanisha Ford expertly uses the extravagant life of Mollie Moon to tell the hidden history of the Civil Rights Movement: a complicated tale of how the movement was funded. Captivating. Gripping. Smart."

—Ibram X. Kendi, National Book Award–winning
author of *Stamped from the Beginning*

"A vivid behind-the-scenes snapshot of a dazzling era."

—*Publishers Weekly* (starred review)

"In *Our Secret Society*, Tanisha Ford chronicles the exhilarating life of Mollie Moon. With cinematic sweep and methodological innovation, Ford brilliantly challenges received narratives of Black politics and imaginatively forges new ways of knowing and understanding social movements and the little known but indispensable roles Black women like Moon have played in them. This book is beautifully written, with the passion, wit, and style of its subject. A stunning accomplishment."

—Farah Jasmine Griffin, author of the
award-winning *Read Until You Understand*

"In *Our Secret Society*, Tanisha Ford follows the money and reveals an astonishing, untold story of Black women who drove the Civil Rights Movement by commanding the Black freedom financial grid. Following the escapades of the captivatingly brilliant Mollie Lewis

Moon . . . this dazzlingly told rise and fall of the movement's 'bag women'—savvy, sensational, but also burned by sexism—is a tale for our own times about the hazards of mixing politics and philanthropy in the interest of Black liberation."

—Martha S. Jones, author of *Vanguard*

"In *Our Secret Society*, Mollie Moon finally gets long-overdue credit for the critical role she played in the history of the Civil Rights Movement. Writing with care and passion, Tanisha Ford shows how Moon combined her commitment to activism with her love of the social whirl and emerged as a fundraising genius. . . . This is an essential read that broadens our understanding of the centrality of Black women in the movement. Ford's work is as brilliant, as lively, and as gorgeous as Mollie Moon herself."

—Jill Watts, author of *The Black Cabinet*

"This riveting, beautifully crafted investigation of the money moves of the Civil Rights Movement's 'bag women' shows Tanisha Ford, one of our nation's top historians, at her absolute finest. Here is the rare text that celebrates the working class—small-dollar donors that made a movement possible—while reminding us of the intellectual prowess and political savvy of the Black women power brokers who put their community's money to its highest uses: the pursuit of Black freedom."

—Brittney Cooper, *New York Times* bestselling author of *Eloquent Rage*

"This is a story I will treasure for a lifetime."

—Kia Goosby, *Vanity Fair*

"The brilliant Tanisha C. Ford has recovered the sparkling story of Mollie Moon, whose fundraising helped support the work of the Civil Rights Movement. With rigorous research and signature finesse, Ford illustrates the oft-forgotten centrality of women in the movement."

—*Ms.* magazine

"You shouldn't miss *Our Secret Society*. You need to know about this almost-hidden slice of history. You'll like this book one hundred percent."

—*The Philadelphia Tribune*

"*Our Secret Society: Mollie Moon and the Glamour, Money, and Power Behind the Civil Rights Movement* rescues from an undeserved obscurity one of the truly significant women who made the Civil Rights Movement the success that it was (and continues to be) as a much-needed national tool to continue to establish racial equality in our still racially turbulent American politics and culture."

—Midwest Book Review

"*Our Secret Society* is a fascinating book that brings readers into the personal side of politics and movement building—through the life of a Black woman. All the tea. All the politics. The parties. It's a behind-the-scenes look at everything Black. I love this book."

—Michael Harriot, *New York Times* bestselling author of *Black AF History*

"*Our Secret Society* is a gem and a MUST HAVE in every Black woman's personal library!"

—Candice Marie Benbow, author of *Red Lip Theology*

OUR SECRET
➤ SOCIETY ⬅

MOLLIE MOON AND THE GLAMOUR, MONEY, AND
POWER BEHIND THE CIVIL RIGHTS MOVEMENT

TANISHA C. FORD

AMISTAD

An Imprint of HarperCollins*Publishers*

First photography insert: Pages 1 (top left) (bottom right), 4 (bottom), and 5 by Henry Lee Moon Family Photographs, Western Reserve Historical Society, Cleveland, Ohio. Used with permission. Page 1 (middle right) by Langston Hughes Papers, James Weldon Johnson Collection/Yale Collection of American Literature, Beinecke Rare Book and Manuscript Library. Used with permission. Pages 2 and 3 by University of Southern California Digital Library, Library Exhibits Collection. Used with permission. Page 4 (top) by Gwendolyn Bennett Photograph Collection, Schomburg Center for Research in Black Culture, Photographs and Prints Division, New York, New York. Used with permission. Pages 6 and 7 by Yale Joel/The LIFE Picture Collection via Shutterstock. Used with permission. Page 8 by *Ebony* (February 1950 issue). Used with permission. *Second photography insert:* Pages 1, 2 (bottom), and 8 by Henry Lee Moon Family Photographs, Western Reserve Historical Society, Cleveland, Ohio. Used with permission. Page 2 (top) by John W. Mosley Photograph Collection, Charles L. Blockson Afro-American Collection, Temple University Libraries. Used with permission. Page 3 by Rare Books, Special Collections, and Preservation, River Campus Libraries, University of Rochester. © Van Vechten Trust. Used with permission. Page 4 by Carl Van Vechten Papers Relating to African American Arts and Letters. James Weldon Johnson Collection/Yale Collection of American Literature, Beinecke Rare Book and Manuscript Library. © Van Vechten Trust. Used with permission. Page 5 by E. Azalia Hackley Collection of African Americans in the Performing Arts, Detroit Public Library. Used with permission. Page 6 (top) by Louise E. Jefferson papers, Amistad Research Center, New Orleans, LA. Used with permission. Page 6 (bottom) by Charles L. Blockson Afro-American Collection, Temple University Libraries. Used with permission. Page 7 (top) by *Jet* (October 27, 1966 issue). Page 7 (bottom) by Ron Galella/Ron Galella Collection via Getty Images. Used with permission.

HarperCollins books may be purchased for educational, business, or sales promotional use. For information, please email the Special Markets Department at SPsales@harpercollins.com.

FIRST HARPERCOLLINS PAPERBACK PUBLISHED IN 2024

Library of Congress Cataloging-in-Publication Data is available upon request.

ISBN 978-0-06-311572-9

24 25 26 27 28 LBC 5 4 3 2 1

AUTHOR'S NOTE

———

All monetary figures have been adjusted for inflation. Please see the notes section for citations, which include the original figures.

For Zi Bailey

At an early age I became aware of my obligation to participate in organized efforts to level the onerous barriers which locked me and my people in a ghastly cultural, political, and economic ghetto. . . . Neither I nor my family had sufficient income to make significant financial contributions to this cause. We did, however, have commitment, energy, and time to contribute.

—MOLLIE MOON

CONTENTS

———

INTRODUCTION

———

Westchester County, New York, 1964

National Urban League Guild fundraiser Mollie Moon surveyed the grand room of the Rockefeller family's Pocantico Hills estate, sizing up the classic floral centerpieces that sat atop tables covered in crisp white linen. The classic gold Chiavari ballroom chairs added an opulent touch. Rodman Rockefeller, son of Governor Nelson Rockefeller and a trustee of the Urban League of Westchester, had spared no expense for this luncheon. However, the food was never quite as sumptuous as the décor, Mollie thought as she watched the guest next to her slice into a roasted chicken breast and medley of winter vegetables. She could hear a roomful of sterling silver forks pinging lightly as they struck the fine porcelain plates. The sound crescendoed into an orchestra with the melodic humming of voices as people merrily ate and drank champagne.

It was February 26, 1964, and Rodman had invited an interracial group of ninety celebrities, politicians, and civic leaders to his family's sprawling Westchester County estate to raise $500,000 to support the local Urban League's economic empowerment initiatives.

Mollie hadn't planned this event, but over the past twenty-five

years of her illustrious career as a premier fundraiser for the National Urban League, she had planned and attended many affairs just like it. Mollie had built a career by bringing the *right* people—politicians, artists, European aristocrats, and philanthropists—together in the *right* rooms. In fact, her reputation as the doyenne of Harlem society was solidified once she'd proven, time and again, that she hosted Black New York's most extravagant galas. The savvy Mrs. Moon had a knack for getting potential donors just lubricated enough on expensive imported champagne that they would open their family coffers to give generously to the National Urban League. The parties Mollie staged were the stuff of legends. Every Black newspaper from New York to Los Angeles—and even some mainstream papers in the 1960s—spilled tons of ink covering Mollie's annual costumed affair: the Beaux Arts Ball. Ever since the inaugural ball in 1941, it had been a major winter social event. Tickets were sold by vendors across the city and were priced on a sliding scale so everyone from weary Black subway workers to the rising stars of stage and screen could attend. The Guild's far more exclusive summer party was an invitation-only fundraiser, designed to fete the Urban League's most loyal A-list donors—including the men of the Rockefeller family, who were Mollie's personal friends.

Mollie was pulled out of her reminiscences by the sound of a butter knife tapping a champagne glass. The event's toastmaster, Wall Street investment banker Carl Pforzheimer Jr., was politely gesturing for the room to quiet down so he could bring the featured speaker to the dais.

Dr. Martin Luther King Jr., dressed in a conservative dark suit and tie, made his way to the podium, commanding the audience's attention from the moment he stood up. The reverend had recently ascended from relative obscurity to become the most

prominent civil rights leader. The soaring rhetoric of his "I Have a Dream" speech at the 1963 March on Washington had brought him instant fame—and notoriety. Outside liberal circles, most white Americans deemed King a dangerous man. He participated in direct nonviolent protests, which often resulted in arrests, and penned fiery political essays from his jail cell. He was an agitator who demanded an end to racial segregation. Immediately.

Mollie glued her eyes on King as the first sounds of his rich tenor voice resounded through the utter quiet of the rapt crowd. King slowly and methodically discussed the impending civil rights bill, which movement leaders had been demanding the US Congress enact. The landmark bill had just been voted on by the House of Representatives and was now being considered by the Senate. Barry Goldwater, one of the bill's major opponents, was advocating for states' rights to set the terms of civil legislation. King told the Pocantico crowd, in no uncertain terms: "The states should have rights, but no state should have the right to do wrong." If the Senate stripped the bill of its public accommodations and fair employment provisions, "it would be better to have no bill at all."

Any guests who had paid their hefty luncheon donations thinking they'd get to hear King's signature Baptist church preacher bellow were mistaken. Instead, he lowered his voice, drawing the audience to him, and implored those do-gooder white and Negro leaders to use whatever political influence they might have to make 1964 the year the nation brought Negroes into mainstream America, lest they face the wrath of the Black militants who were organizing to take freedom by any means necessary. With that, King thanked the Rockefeller family for its support of "human rights and human dignity." The crowd jumped to its feet in applause as King left the lectern. As he returned to his seat, he stopped to

"hobnob chattily" with members of the Westchester elite who rushed to shake his hand and steal a moment of his attention.

Mollie knew King hated speaking at events like this, even though his easy charisma never betrayed the fact. But supplicating wealthy white folks had become a major feature of his role as president of the Southern Christian Leadership Conference, one of the country's major civil rights organizations. King often gave a talk like this in Westchester and then traveled into New York City for some face time with the philanthropic foundation managers who had funded a voter registration drive and now wanted to pick his brain about the direction of the movement and the organizations they should be supporting. Mollie understood because she, too, was regularly called into backroom meetings to explain racism to white liberals and listen to their guilty stories about how they didn't realize until now how bad things had been for African Americans. She considered it a cost of supporting those activists who had committed their lives to the fight for racial equality.

Dr. King had been conscripted into doing this Westchester fundraiser by the other "Big Six" civil rights leaders. King, Whitney Young (who was also at Pocantico) of the National Urban League, Roy Wilkins of the NAACP, Dorothy Height of the National Council of Negro Women, and others had organized under the name Council for United Civil Rights Leadership to consolidate their fundraising efforts. They'd taken $1.5 million from the Taconic Foundation to help finance the March on Washington. Now King, the biggest draw among the Big Six, had to give this talk as a show of gratitude for the white elite's financial generosity to the movement.

Mollie couldn't help but look at the much younger Dr. King and wonder how either of them had ended up in this room. She

had been born into a working-class family with Hattiesburg, Mississippi, roots. White Southerners' degradation of Black Americans—upheld by the horrors of Jim Crow segregation—had set Mollie's mother, Beulah Rodgers Lewis, into flight from the Deep South to the industrial Midwest. Childhood memories of Mollie's encounters with the savagery of white supremacy had etched themselves into her psyche. Mollie's undergraduate training at Meharry Medical College in Nashville had prepared her for a professional life "behind the veil." W. E. B. Du Bois's notion of double consciousness was less a theory and more a strategy for survival. And in her short career as a practicing pharmacist in a male-dominated industry, she had learned how deeply the veil excluded and injured people of her race *and* gender.

Mollie had joined the progressive Left in the early 1930s, when the African American community was in financial turmoil due to the Great Depression. Mollie's peer, brilliant legal theorist Pauli Murray, referred to their cohort as the "Depression Generation." These were people born in the first decade of the twentieth century, who had followed the mandate that a college education was the clearest way to Negro advancement—only to graduate just as the deepest depression in history decimated Black wealth and stranded Black communities already in economic flux. These architects of change had to find ways to rebuild America in their own radical democratic vision. And doing so would require a strong, national fundraising plan that could push money across the United States. The racial justice philanthropists of the Depression Generation melded the world-building vision of foundation philanthropy with African-derived notions of mutual aid, volunteerism, and mass giving.

Back then, Mollie had strong critiques of capitalism and disavowed

the hoarding of resources by global financial elites, who represented less than one percent of the population. She left her career in pharmacy to become a social worker, where she felt she could best aid the Harlem community. She formed networks with other Left-leaning Black women institution builders—from Augusta Savage and Louise Thompson Patterson to Eslanda Goode Robeson and Bessye Bearden—to establish and fund community-based programs that could train up the next generation of Black artists and activists.

Martin Luther King Jr. had recently begun to disavow capitalism and the bourgeois lifestyle he and his wife, activist Coretta Scott King, had been associated with—whether accurately or not. He was pressing toward a Black-led but interracial poor people's campaign that would give the masses of Black and white workers a platform on which they could fight together for a fair minimum wage and universal unemployment insurance. King wanted to shed the "Dr. King" persona that had gotten so outsize that even he could see how it hampered his ability to organize effectively at the grassroots level.

Yet here they both were. Sitting in a room full of Rockefellers and other business professionals, while people who looked like them, dressed in uniforms and white gloves, served them food and poured them tea.

*　*　*

Private events like this one at the Rockefellers' Pocantico Hills estate received scant coverage in the national newspapers. Most of the people involved—the millionaires, the activists, and the power brokers like Mollie—did not want the general public to know just

how money flowed to the movement, from whom, or who had brokered the deal. Theirs was a secret society of money movers and influencers.

Tensions often flared over the monies the National Urban League raised. Should Black organizations accept financial contributions from high-net-worth white families, who had likely made their millions through capitalist exploitation? When the answer was yes, power brokers such as Mollie Moon were tasked with translating Black grassroots causes into passion projects legible to monied white folks. They and their donations were greeted with lavish praise by the leaders of African American organizations across the country. When other organizations rejected whites' money, these women were skewered in the Black press for their "accommodationist" politics.

The racial and economic landscape was extremely fraught in the 1960s. Grassroots activists were understandably concerned that the Black elite would not only steer the movement toward middle-class issues but also sell out to white donors. High-net-worth donors and philanthropic foundations only gave money to movement initiatives they deemed worthy. And because of their own financial stakes in the capitalist system and the need to appease the politicians who kept things working in their favor, these philanthropists were most likely to support safe initiatives, such as Negro youth programs and education.

Black militants believed this type of support killed the fervor of the movement, steering it toward more moderate approaches. Back then they called this form of political coaxing "co-optation"; today we call it "movement capture." And everybody, across the race and class spectrum, was trying to insulate themselves from economic reprisals at the hands of white segregationists, who were

often elected officials, bank presidents, and power players in their respective cities. They targeted anyone who supported the Civil Rights Movement. Working-class African Americans were typically hardest hit, but wealthy Black Americans also chose to give donations under the veil of anonymity to protect themselves from retaliation.

Despite deep mistrust and threats of violent reprisals, those committed to the movement had to figure out a way to move money quickly across the country, to get it to cities and communities that needed it most. This is where Mollie Moon and Black American women fundraisers like her became indispensable to the movement. They were the glue that connected Black social clubs, church groups, sororities, fraternities, and professional organizations into a national network of contributors who gave of their time and money to keep the movement afloat.

These networks formed the basis of what we can think of as a Black Freedom financial grid across which they moved money, often secretly. The grid connected a variety of local and national African American civic and social organizations, community trusts and mutual aid societies, churches and charities. Despite factional struggles, vigilante violence, and institutional racism, the Black Freedom financial grid established the economic base that supported the frontline activism of Martin Luther King Jr., Fannie Lou Hamer, and John Lewis. This hidden history of how the Civil Rights Movement was funded is an essential part of understanding the business of movement building and the real cost of pursuing social justice.

Our Secret Society lifts the veil from this sometimes opulent, sometimes grimy world of fundraising. By piecing together Mollie Moon's coveted Rolodex, we can chart her rise from leftist social

worker to famed African American fundraiser—as the Harlem Renaissance folded into the Civil Rights Movement. We can see the strategies, odd alliances with the white philanthropic upper crust, and networks of African American grassroots organizations, celebrities, and millionaire businesspeople who have been relegated to the margins of US history. Political intrigue, compromise and confrontation, beautiful gowns and luxury hotels, protests and violent uprisings—it's all part of the story behind the Civil Rights Movement.

New Negroes in Moscow

Moscow, 1932

"Comrades, we've been screwed!" Mollie Virgil Lewis's head whipped around to hear the angry voice of journalist Henry Lee Moon. He had stormed into the room, declaring to his fellow *Black and White* castmates that their movie in the making had been officially terminated by the Soviet government. Mollie had never seen the usually calm Henry in such an emotional state. Her jaw tensed as she listened to him launch into a tirade about how their hosts had betrayed them and how they needed to leave Moscow immediately, lest they be stranded in the USSR. The thought of being deserted thousands of miles away from home, as a bitter cold Russian winter loomed, was terrifying. Could

Henry be right? Had they been screwed over by their Russian sponsors?

Just two months earlier, Mollie, Henry, and twenty other cast members of *Black and White* had arrived in Moscow to begin shooting what was to be a propaganda film about the horrors of Jim Crow segregation and labor exploitation in the United States. The movie was being produced by Mezhrabpomfilm, a progressive company that specialized in films about the global plight of workers, with headquarters in Berlin and studios in Moscow. Mezhrabpom had used its ties to the Communist Party USA (CPUSA) to garner support for *Black and White* in the States. The CPUSA had appointed African American activist Louise Thompson, a party affiliate, to select the ensemble and coordinate their travel. Louise had struggled to entice professional actors to join the cast; they dare not be blacklisted for frolicking with gun-toting Bolsheviks. Her attempts at fundraising the cost of the cast's overseas trip were also a bust. Fundraising was an art form that required a great pitch and access to monied progressives. Louise had neither. Left with few options, she had been forced to recruit an eclectic cast of twenty- and thirty-somethings from among her social network who could afford the two-hundred-dollar third-class ticket on the SS *Europa*.

Among the cast was Mollie's best friend, Dorothy "Dot" West, a wunderkind writer of the Harlem Renaissance. The two had met when Mollie moved into Dot's San Juan Hill apartment building at 43 West 66th Street a couple years earlier. Just out of college, they were a striking pair. Mollie's round face, thick and curvy body, and toffee-colored skin complemented West's rich mahogany complexion, wide smile, and thin frame. Mollie was taking a graduate class here and there and hosting parties at her tiny apartment.

She had an effervescent personality and a brilliant sense of humor. Dot was highly cerebral; she penned short stories that explored themes of race and class. She was the youngest of her writer peers and was happy to finally have a friend her own age. Mollie and Dot joined the James Weldon Johnson Literary Guild, took in plays and movies together, and were partying their way through Harlem's restaurant and bar scene. In befriending Dot, Mollie acquired a star-studded group of friends who were leaders of the New Negro Movement, including Langston Hughes, Zora Neale Hurston, Countee Cullen, and Claude McKay. Mollie fell into the heady swirl of art, politics, and drinking that characterized life within this tribe of friends.

Dot and Mollie were friendly with both Louise and Henry, who'd invited them to join the *Black and White* project. Louise was also good friends with Langston, whom she'd persuaded to help write the script and act in the film. Langston had recruited his best friend, attorney Loren Miller, who lived in Los Angeles and wrote for the *California Eagle*. Louise likely knew Mildred "Mil" Jones, a bobbed-haired, peachy-skinned bohemian, from her days as a professor at Hampton Institute. Mil had recently earned a degree in art history from Hampton. An erudite Howard University student named Frank Montero—a mentee of Ralph Bunche—was the youngest among the group. A smattering of social workers and minor stage and theater performers rounded out the cast. Louise had consciously selected an ensemble that ranged in complexion and hair texture, and it was a bonus that everyone had impeccable style. They looked more like models ripped from the pages of a Negro lifestyle magazine than the Broadway stage. Still, they were eager to portray Southern sharecroppers in *Black and White*.

Only a few were affiliated with the Communist Party, but their

minds had all been molded by the New Negro Movement. They recognized themselves as a collective of race, women and men who demanded an end to anti-Black violence and poverty, which had been worsened by the Great Depression. Nearly half of African Americans nationally were unemployed in 1932, which was double and, in some states, triple the rate of white unemployment. President Franklin Delano Roosevelt's New Deal programs were doing little to rectify the issue. Cast members saw a direct link between these economic disparities and dominant cultural representations that reinforced the idea that people of African descent were racially inferior to whites. Many New Negroes rejected the race's color hierarchy and the idea that proximity to whiteness, even through arts patronage, equaled power. The Depression transformed women like Mollie and Dot from individuals seeking personal fulfillment into problem solvers looking for solutions to a world of ills. For them, the USSR was an important case study of how to liberate workers and dissolve the class system, which had allowed the wealthiest one percent to hoard money and resources. There was no way they'd pass up an opportunity to visit Moscow.

The cast had arrived in June and had planned to stay in Moscow for four months, as their contract required. Once on Russian soil, Mezhrabpom covered the cost of their lodging and provided a daily stipend for food. And while the Kremlin wasn't involved in their day-to-day activities, the cast understood that they were esteemed guests of the state. How good it felt to move through a world where their melanin-rich skin did not instantly mark them as second-class citizens, to move about a city without feeling the sting of the color line. And they were quite a sight on the streets of Moscow. Most Russians had only seen Negroes in films. So when they encountered the cast on the

streets, crowds would gather around to shake hands with their darker comrades.

The women's major challenge was contending with the near constant rain and wind that wreaked havoc on their hair. Dot and others wrote home asking family members to send care packages with Hinds' Honey and Almond Cream, Vaseline, and hot combs. But even these hair mishaps were part of the adventure.

Filming on *Black and White* didn't start immediately once the cast arrived because the script was still in development. This gave them time to explore the city. Tales of caviar-eating royals and seductive vodka-sipping spies had swirled through Western popular culture. But 1930s Moscow was the vanguard of radical art and politics. Paris had long been upheld as a creative hub for Negro expats who had been loosed from ol' Jim Crow's grip and were seeking creative inspiration and maybe even illicit, interracial sex. But now post-tsarist Moscow was the alluring destination. Black artists and intellectuals who could conjure a legitimate reason to sojourn to the USSR excitedly followed in Paul and Eslanda Robeson's footsteps to experience the real, revolutionary Russia.

By August, Mollie and the cast's days were leisure-filled. They strolled the city's broad and bustling streets, in awe of the ornate architecture—an artifact of a previous era. Heterosexual and same-sex romances bloomed between cast members and even with their white hosts. Intimacy took on new shapes in an environment where Negro Americans could express the fullness of their humanity. The cast delighted in their luxurious days at the Moscow Art Theatre and the opera, soaking up as much artistic energy as they could, followed by evenings listening to jazz and feasting on haute cuisine at the majestic Hotel Metropol.

Other cast members joined a theatrical club and a writers' guild

where they immersed themselves in the writings of Fyodor Dostoevsky. They studied the avant-garde art of Wassily Kandinsky and Natalia Goncharova. Mil Jones became the pupil of socialist realist painter Aleksandr Deyneka, whose 1928 work *The Defense of Petrograd* made him a central figure in the European art world. Such intermingling with white artistic giants would have been unheard of in most parts of the United States. In capitalist America, the fine arts were considered the province of the wealthy. People with talent and inspiration had to pay for private tutelage and art or drama school. But in the USSR, they could see what a socialist vision for artistic education looked like. The Soviet model turned the Western European model on its head; fine art was for the people, by the people.

Louise wrote to her mother: "We are just living like royalty." For Mollie, the trip felt like the closest she was ever going to come to the European finishing school experience that the daughters of the white elite received. When some felt guilty about the fact that the trip had become a boondoggle, others declared that rest and relaxation was its own radical act. It was a monumental, life-changing trip. The cast believed that, despite any of the petty personal feuds that naturally emerge when a group lives and works together for an extended period, they would be forever bonded.

Henry's pronouncement that *Black and White* was over before it even really got started and that the Kremlin was involved in the film's demise instantly fractured their bond in ways none of them could have predicted. Henry had always been skeptical of Stalin and the Communist International (Comintern)—a Soviet-controlled organization that agitated for global communism. He was an anticapitalist but did not believe Russian communism was a panacea for US race relations. Henry, an investigative journalist, had been

probing deeper to see what life was truly like under Stalin's regime, beneath the veneer of class solidarity and *sovietsky* rhetoric fed to them by the Kremlin. And what he had learned disturbed him: reports of widespread famine, executions, and deportations. He believed Stalin had forced Mezhrabpom to kill *Black and White* for his own political gains, and now the filmmakers were selling them a bill of goods about why filming had been delayed. Louise quickly stepped in to passionately defend the filmmakers. She believed the Mezhrabpom spokesman who'd clarified that the film had been postponed, not cancelled. Louise reasoned that the postponement resulted from the filmmakers' conflict with Langston over the script, which he had harshly criticized, rather than some geopolitical fight between the US and the Kremlin. Half of the cast, including Mollie, agreed with Louise that something far less Machiavellian had happened to delay the film.

The major problem, which no one fully recognized at the time, was that Soviet officials had two competing agendas. On the one hand, Stalin believed that the most effective way to spread socialism was to convert the darker peoples of the world, who were most likely to have experienced unmitigated exploitation. He wanted to shine a light on the United States' race problem and show that socialism offered a solution to all forms of inequality. *Black and White* would embarrass the US government and undermine newly elected Franklin Roosevelt, whose New Deal was becoming the cornerstone of modern liberalism and state-regulated capitalism. The Comintern's support of Southern Black laborers was a strategic move, even though Black Americans made communism their own. On the other hand, the nascent Soviet state sought full diplomatic recognition from the United States so it could conduct business and trade in the international arena.

The price of securing that prize was promising not to interfere in US internal affairs by attempting to stir up dissent. If the USSR couldn't contract with American companies to build bridges and dams and mechanize agriculture, how would it become a more industrialized nation? Caught between these two competing goals were the progressive Mezhrabpomfilm company and the cast of Black American radicals.

Henry and Louise's argument about *Black and White* quickly devolved into a debate about who was the biggest sellout to the race. Henry and his crew—which included his two best friends, fellow journalist Ted Poston and Thurston Lewis, and two others—accused Louise and Loren Miller of trying to curry favor with the senior leadership of the CPUSA. To improve her standing in the party and with the Comintern, they asserted, Louise was willing to compromise the bond of the very group she had assembled. Louise fired back that their claims were "ridiculous" and "pathetic." It was especially hurtful that Henry, whom she'd considered a brother, was making such allegations. She argued that Ted and Thurston's lewd behavior—swimming nude and sleeping with prostitutes—was the real betrayal of the race. Langston and Loren intervened, defending Louise and themselves while trying to ease tensions. A member of Henry's crew called Langston a "Communist Uncle Tom."

Mollie watched in disbelief as her new circle of comrades engaged in a verbal knockdown that broke the pledge they'd made to uphold the honor of the race at all costs. If someone did something that was only mildly embarrassing, as a form of friendly teasing they would hear, you "disgraced the race!" Behind these closed doors, however, any pretense of respectability had been lost. Vicious words had been hurled; they could not be unsaid. Everyone

was emotionally spent. It was unclear if friendships could ever be restored.

Henry, Ted, Thurston, and a handful of others immediately began packing their bags and making arrangements to sail home. Mezhrabpom promised to reimburse all cast members' transportation costs and provide a small relocation stipend that would help them get settled in the US or elsewhere in Europe.

Mollie decided to remain in the Soviet Union for the time being. She'd had a political awakening about labor issues and class politics that she wanted to continue exploring. Mollie hadn't had a formal education in socialism or the liberal arts. She had undertaken a rigorous course of science and mathematics, majoring in pharmacy at Meharry Medical College in Nashville. Louise, conversely, had been a professor of business administration at Hampton, and when she had moved to New York, she began attending workshops organized by the left wing where she studied Marx and Lenin. Louise placed a high value on social theory and anti-capitalist philosophies. Mollie had observed Louise's condescending attitude toward her and other younger women in the cast whom she deemed politically uninformed. It was no secret that Louise considered Mollie "glamorous and flighty." Dot would also sometimes criticize Mollie behind her back for not being a serious enough companion for the artistic and intellectually curious Dot. She considered Mil "a more suitable companion" than Mollie because Mil was "more serious-minded" and "intelligent."

In Moscow, Mollie had started filling in these gaps in her education. Mollie, perhaps even more than Louise and certainly more than Dot—who was born into the Black Boston elite—had been aware of the exploitation of the Black poor since she was a young girl. She was born in Hattiesburg, Mississippi, in 1907 and

had been named Mollie after her maternal grandmother. Mollie's mother, Beulah Rodgers Lewis, had fled her tattered marriage and the Deep South for Cleveland when Mollie was just an infant. They lived with Beulah's sister and her family in a house they had been renting in Cleveland's segregated Eleventh Ward. Their new home functioned as a boarding house for Southern migrants hoping to make a new start in the industrial Midwest. The men found menial work in the steel, railroad, and automotive industries; the women often took in laundry or hired themselves out as domestics.

Mollie learned principles of hard work and mutual aid. The only way for poor Negroes to survive was to do so in community. They helped raise one another's children, attended church together, pooled their money to support racial causes, and perhaps organized informal savings clubs. When Mollie's mother remarried and moved to Gary, Indiana, with her new husband, a mill worker, Mollie witnessed how mill shutdowns created economic instability in the household. Workers organized strikes and labor unions to fight for better rights. Though Beulah had always tried to shield Mollie from the harsh realities of their economic situation, poverty's hard knocks were incessant.

As a young adult, Mollie often hid her working-class roots, allowing people to assume she had grown up privileged. Beulah decided to return to Mississippi and enroll Mollie at the Rust College secondary school—the same school Beulah had attended until she got married and gave birth to Mollie at age fourteen. It was a sacrifice that set Mollie's life on a different trajectory. She was accepted to Meharry after graduating from Rust in 1925. Mollie adapted to life among the Negro middle class and those with bourgeois aspirations who attended Meharry and the nearby Fisk University. She pledged Pi Chapter of Alpha Kappa Alpha Sorority, Incorporated,

and later became the social chair of her 1928 graduating class. At Meharry, she learned to speak and dress the part of an elite Negro woman. As she assimilated into a life of affluence, her own past became a blurred image in her rearview mirror.

The Great Depression jolted Mollie out of her middle-class haze. She was working at a pharmacy in Gary while assisting her mother and stepfather, who were in dire financial straits, when she realized that respectability alone wouldn't save anyone. The problem wasn't one of morals and hard work, but structural. The system was rigged against Negroes. And, if she were honest with herself, it had been fear of poverty more than a desire for high attainment that had led her into pharmacy. She knew struggle intimately and didn't want to return to it. Becoming a pharmacist, one of the most prestigious careers a Negro of any gender could have in the 1920s, guaranteed economic stability. But Mollie knew she was called to do more than work at a pharmacy—in Gary of all places. She stayed long enough to help Beulah regroup and save some money. Then she took a bold step to change her life. Mollie moved to New York City in 1930, when she was around twenty-three years old. New York, the Mecca of the New Negro Renaissance, was a place where she could find her life's mission. She wanted to help the most marginalized African Americans. Shifting careers to become a teacher, or maybe a social worker, would allow her to make a deep social impact.

Though she could not have known it at the time, every step she'd made since moving to New York had drawn her toward the revelation that awaited her in Moscow. Mollie's route to radicalism was not one that a scholar like Louise valued, but it was a political education nonetheless. The USSR was one place where Southern-born Negroes of humble origins like Mollie were

praised and heralded. She felt safe shedding some of the bourgeois pretentions she'd adopted and leaned into her working-class identity. In socialism, Mollie saw a model for how workers such as her stepfather could secure economic justice for themselves and their households. She saw a way to help Negro children discover pride in themselves and their African roots. Her commitment to the movement for racial equality had become more resolute.

Despite her new outlook on class, Mollie still had a penchant for opulence. The tension between her hunger for luxury and her burgeoning radical politics wouldn't be easily resolved. The woman who grew up working class would always be enamored with shiny things: designer wares and expensive nights out on the town. She couldn't shake her investment in consumer capitalism. Dot could not relate to this attitude. Dot's father had been born enslaved and rose to become one of the most successful Black entrepreneurs in Boston, moving his family into the exclusive Brookline enclave. She'd grown up in a mansion and summered at her family's home on Oak Bluffs, Martha's Vineyard. Dot always downplayed her family's affluence, analyzing their wealth and class position like it was more an intellectual project than a privileged lived experience, which always perplexed Mollie.

Mollie's most fervent enemies would always criticize her willingness to go broke to give off the airs of wealth. It seemed to be an exact opposite of the kind of economic justice she was calling for, worsened by the fact that she often courted men who could buy her fancy things. Some labeled her a shameless flirt, a gold digger, or worse. In her former life as a pharmacist, Mollie had earned enough money to treat herself to a life of luxury. Perhaps because she had practically been abandoned by her birth father, she loved having men shower her with gifts and attention. She typically

chose older men of stature, whose money could shield her from experiencing the "struggle love" that had characterized her mother's romantic life. It was a wound that wouldn't be easily healed.

Still, Mollie thrived in the perceived contradiction in her personality. It gave her an air of mystery; she watched people struggle to figure her out, especially wealthy gentleman suitors. There was power in being an educated woman who transgressed gender norms and demanded to be loved on her own terms. And she was learning she could be both a glamorous social butterfly and a New Negro radical. She wouldn't wait for others to realize that there was enough space in the left wing for the Mollies and the Louises of the world to coexist.

After the fallout of *Black and White*, Mollie and Louise got to know each other better. They'd been assigned as roommates during their stay in Moscow but mostly socialized with different cliques. Now that the cast had thinned, they could move beyond their superficial assessments. Mollie toured Uzbekistan with Louise, Langston, and a handful of other castmates as guests of the Theatrical Trade Union. They visited Tashkent, Bukhara, and Samarkand, where they met with workers and peasants. Mollie even rode a camel. Each stop involved long speeches by local officials about how Bolshevik ideas had improved the lives of Soviet ethnic minorities. The group soon realized that this exhausting, state-sponsored tour through underdeveloped Uzbekistan was little more than a publicity machine for the USSR. They'd been encouraged to publish favorable stories in the Negro press about their tour and the success of socialism throughout the USSR.

They bailed on the tour early, refusing to spend another night in the desert, and returned to Moscow. Mollie and a couple women in the cast made plans to settle in Berlin, a city with a thriving

entertainment scene and renowned institutions of higher learning. Dot and Mil, who had begun an intimate domestic partnership, decided to brave the winter and remain in Moscow long term. Dot got hired as a screenwriter for Mezhrabpom, and Mil found work with the *Moscow News*. Mollie hugged her good friends, promising they'd meet up in Paris at some point to take in the City of Lights before sailing back to New York. Then they parted ways.

Berlin

Berlin, September 1932

Mollie had received a two-thousand-dollar severance stipend from Mezhrabpom. It felt like a lot of money at the time. But now she realized it wouldn't go far. She and the few women from the *Black and White* cast who had also relocated to Berlin found accommodations at a shabby hotel and sought out jobs that could supplement their quickly dwindling pot of money. Later, they'd move to more suitable digs. Mollie had told everyone before she left Moscow that she was going to Berlin to study German at the University of Berlin and take a few education classes that might count toward a degree. However, rumor had it that Mollie had begun a sordid affair in Moscow with a German diplomat who had invited

her to Berlin, the nation's capital. If this was true, the romance was short-lived, because she was single by the time she arrived, and the failed romance hadn't spoiled her outlook on the city.

Berlin's atmosphere was different from Moscow's. It had been a major global city in the Roaring Twenties, a hub for culture, science, and technology. But, like most of the world, it had been wrecked by the Great Depression. Poverty and unemployment had worsened in the last decade, which only fed seismic political unrest. When Mollie arrived, the gay spirit of the '20s had dimmed, though Berlin still had a lively nightlife and fine arts scene, with educational institutions that could rival any around the globe. Adolf Hitler's National Socialist German Workers' Party, or Nazi Party, was consolidating power. They shunned communism—especially of the Russian variety—in favor of an extreme form of German nationalism that emphasized the superiority of the Aryan race. Nazis demanded that workers align with them as they led the nation out of economic tumult. Shortly into Mollie's stay in Berlin, Hitler was elected head of the German government and began to implement a series of anti-Semitic, anti-gay, and anti-Black policies, which codified Nazism in German law.

While Mollie adamantly rejected the racist politics of the Third Reich, she told American reporters at the time that "German people, including members of the Nazi organizations, accorded me a full measure of courtesy and consideration." She had not heard of any Negro being mistreated on account of their race while she was in Berlin. However, African Americans were hardly treated with the same comradeship in Berlin as the *Black and White* cast had reported receiving in Moscow. Black people were not part of Hitler's plan for global domination. At best, Negro Americans were tolerated by agents of the state, but not celebrated. Years later, Mol-

lie would change her account, saying her time in Berlin showed her "the horrendous things human beings can do to other human beings."

Despite Germany's shifting political landscape, Mollie was already delighting in her independence in Berlin. In Moscow, she had been one of several Black people in her ensemble. They moved as a unit, with a shared identity as "the Negroes." In Berlin, Mollie was mostly on her own; she was able to define her own identity, explore her own secret passions. Plus, she was now a seasoned traveler, and her cosmopolitanism showed. Berlin would be a safe place, where she could reinvent herself, again. She had fed the radical side of her personality in Moscow. In Berlin, she explored the glamorous side.

Finding employment in Berlin's thriving entertainment scene was a way for a foreigner to make some quick cash. Mollie secured a job as a hostess at a cabaret, working under the stage name "Mona, the Indian Girl." She wore a skimpy outfit that hugged her curves and toyed with sexual fantasies about the swarthy *other* in exchange for a 10 percent commission on the drinks she sold. Being a hostess was glamorous in its own way. Her nights were long, but she could use her keen social skills to entertain her progressive German customers. One night, after a seemingly endless shift, Mollie returned to her flat, took off her heels, and massaged her throbbing feet. She chuckled, remembering the time when the steward on their cruise liner to Europe had offered her champagne. "No wine for me, thank you," she had told him. One of her castmates looked at her in disbelief: "Mollie, are you turning down champagne?" She naïvely replied: "Was that *champagne*?" She tried the bubbly and instantly loved it. And now here she was, serving bottles of champagne for a living.

Working in a nightclub—nearly nude, no less—was far from the type of job Beulah would have wanted for her daughter, and in some ways Mollie was ashamed of it as well. It was less about the nature of the work and more that she wasn't living up to her full potential; she had not even investigated enrolling at the university. On the other hand, she reasoned, she was a young, vivacious twenty-five-year-old who had the world at her fingertips. Maybe she could use the hostess job to launch into a career on the stage and screen, become someone far grander and more visible than a do-gooder civil servant. The Josephine Baker of Berlin, perhaps. Or she could snag a rich beau who would pay her bills and finance the utterly opulent lifestyle she sometimes dreamed of, traveling first class and dining with celebrities and aristocrats. "A poor gal has to earn a living so I'm still looking for a real 'sugar daddy,'" she playfully quipped in letters to Dot. This dream of a gentleman benefactor was short-lived once she realized the cabaret was actually a lesbian establishment that straight men rarely wandered into. Berlin's gay culture blossomed between the world wars, despite the stranglehold of Hitler's repressive and deadly Nazi regime. Same-sex desire, as intoxicating as the cocktails Mollie served, was alive and unleashed in the city's smoky after-hours spots.

On her nights off, Mollie and her friend Connie partied their way through Berlin, drinking and dancing until sunrise. Mollie had purchased a new wardrobe, including a stylish overcoat, cocktail dresses, and a high black silk hat that she described as "the kind you see in the movies." Buying the new garments had set her back so much financially that her funds wouldn't rebound again for the foreseeable future. Perhaps the clothes made Mollie feel a sense of security at a time when everything else felt uncertain. They frequented gay and straight bars and made many friends along the

way. She met and had brief trysts with several men, who often told her she looked like a "black Marlene Dietrich." These dates usually involved being showered with candy and flowers, but with the Depression raging, none of these potential suitors was rich enough to be a sugar daddy.

While Mollie figured out the pace of her new life and planned her next big career move, she swore her roommates to secrecy about her cabaret job. If anyone from the *Black and White* cast asked, they were to say Mollie was studying at the university. For a while, Mollie's student ruse worked, but then rumblings of her real work in Berlin started to trickle out. Journalist Chatwood Hall (whose real name was Homer Smith Jr.), a member of the *Black and White* cast, reported in the *Afro-American* that Mollie was in Berlin "doing operatic work." This was shade throwing at its finest. Anyone who knew Mollie would instantly recognize this as a dubious cover for some real gossip. One of her Berlin roommates let it slip to Louise Thompson that Mollie was "passing for Indian," which infuriated Mollie because she had repeatedly told the Berlin friend to "let me manage my own affairs and not tell anyone in the States what I am doing."

Louise was the worst person for this tawdry news to reach. Everyone knew how Louise abhorred the act of racial passing. A decade earlier, Louise had engaged in what some might call "survival passing," or "9 to 5 passing," when she lived in California, identifying as a Mexican American woman for potential employers to secure a menial job. But once her politics evolved, she vowed to never pass again, because it was psychologically wrenching and hinged on a perceived color privilege that separated her from other Negroes.

Mollie had heard all her life that she looked like she had Indian in her family. At the time, this general language could allude to

Native American or South Asian ancestry. But she was not light enough to pass for white. Perhaps she'd initially created this Mona character to defy Jim Crow when she'd briefly lived in segregated New Orleans. A reporter quoted her, saying: "I just put on a sari, painted a red dot on my forehead, and said I was an Indian." Mollie later denied ever stating she intentionally dressed this way when traveling through the South. But, if she had, she might've done so to find safe passage on trains or to enter public establishments that did not serve Negroes. Stylish turbans became a fixture of Mollie's wardrobe, even when she wasn't passing, feeding the notion that she was "exotic," or racially ambiguous, from a tropical land where race mixing was common. Fetishizing people from the Far East was common among Westerners in the 1930s; it is not surprising that cabaret patrons would have wholly bought into her Mona guise—not really caring if "Mona" was South Asian, Polynesian, or Native American. On another occasion, while in Berlin, Mollie and a friend dressed as Hawaiians to attend a gala and "nearly stopped the ball with our brown bodies." Among New Negroes, this sort of racial cosplay was heavily frowned upon; it was another form of surrendering to a white-centered color hierarchy.

It's unclear how Mollie felt about racial passing or colorism more broadly. Her mother, Beulah, was a brown-skinned woman, and she had not raised Mollie to believe that light was right. Still, young Negro women were inundated with material on beauty and desirability that celebrated light skin, straight hair, and thinness as ideals to which every woman should aspire. Mollie might have leaned into the privileges of her color and hair texture. But her full-figured body placed Mollie lower on the beauty hierarchy than thin women with similar features. She would have been keenly aware of how some Black and white folks viewed her body and perhaps

passed judgment about what they perceived as her lack of physical discipline and low self-esteem. Today we call this fatphobia.

Still, racial passing was rarely done simply for the thrill, because the cost of being exposed was so high. Thus, Mollie's Mona character and her Hawaiian costume might not have been racial passing but more like racial playing—a sleight of hand used to confuse white folks. She played with and into their racial stereotypes before revealing she was something other than what they'd anticipated. It was trickery that exposed the fallacies of race as a social construct. Mollie might have argued that she wasn't living as Indian, she was entertaining as Indian. Moreover, it seems her employers knew her real racial identity. Her racial transgressions through performance reveal the complexities of the global color line in the 1930s.

* * *

By Christmas, Mollie had hit rock bottom. She was running through money faster than she could make it. Her financial situation had become so dire that Mollie, who identified as heterosexual, joked about coupling with one of the wealthy society lesbians who frequented the cabaret just to make ends meet. Her rather far-fetched desire to parlay her limited work on *Black and White* into a film career was not looking as promising as she'd hoped. Mollie confided to Dot that she would be returning to the States "broke and naked." At one point, Mollie and a roommate named Sylvia had contemplated suicide. "Neither of us will ever amount to a dam[n]," she later told Dot about her suicidal ideation. They were going to "take some poison and end it all." Sylvia had already attempted to poison herself with formaldehyde while in Moscow, before being discovered by cast members, so she knew how to mix

a concoction with red wine to help it go down smoother. But Mollie was worried about how news of her suicide would affect her mom. She was Beulah's only baby, and no parent should have to bury their child. And while she ultimately decided not to commit suicide, living abroad for an extended period, in the dreariness of a Berlin winter, had clearly started to weigh heavily on her psyche.

University classes seemed a bitter consolation prize for deciding to keep living. Mollie's long-term plan of becoming a teacher had been earnest. Taking classes just wasn't the sexiest thing to do during a once-in-a-lifetime trip to Europe. But she had exhausted all other possibilities and found herself stagnating, drowning in alcohol and excessive partying. Perhaps worse—according to her own moral and political compass—she wasn't doing anything that benefitted anyone other than herself. The selfishness seemed to be feeding her depression. "I didn't want to remain in Berlin idle so that is why I took this [course]work at the university—not for any particular job," she shared with Dot. Learning would be her lifeline, a road map back to a life of purpose. And once she made that decision, everything else about her life in Berlin seemed to fall into place. She continued to work at the cabaret because it paid for her classes, but it became a means to an end, not the center of her world.

She first enrolled in a course in the German language, in January 1933, that comprised international students from Russia, Japan, China, Greece, and a few from the US. It's likely that she formed friendships with some of these students, extending her network beyond her Black and White roommates and her coworkers at the cabaret. Aided by formal training, Mollie's language facility improved rapidly. She was better able to communicate, and it opened new possibilities for political engagement with progressive Germans.

One day, as she was nearing a public square by campus, she

witnessed something that burst the erudite bubble she had been living within at the university. Nazi foot soldiers had ignited a massive bonfire and were tossing classic texts by Jewish, Negro, and communist intellectuals into the blaze. Albert Einstein, Sigmund Freud, Karl Marx, Vladimir Lenin, Walter White, James Weldon Johnson, Upton Sinclair, Friedrich Engels. Some of these thinkers Mollie had only recently discovered; others she knew personally. The uniformed men began "shrieking and leaping in the air like madmen," which aroused the barbaric mob. "I have never seen a lynching. I had never visualized one in my mind," Mollie would later write, "but in this moment, I know to the minutest detail, what one is like."

Mollie could see the relationship between the violence Hitler's party was enacting and the anti-Black violence her community endured at home. Even before the onset of World War II, Mollie likely recognized that Nazism, like US white supremacy, was a global issue.

She began hosting teas at her flat for guests like writer and New Negro Movement leader Alain Locke and his mentee Arthur Fauset, the brother of novelist Jessie Redmon Fauset, who was a teacher in Philadelphia. The teas turned into political salons where, inevitably, the topic of the global liberation of all African-descended people became the subject of earnest debate. When Locke returned to New York, he sent Mollie newspapers from home so she could sharpen her intellect and keep a finger on the movement for racial equality in the US.

Berlin, August 1933

After a year in Berlin, Mollie was nearly fluent in German. She had been introduced to esteemed American educator Richard Thomas

Alexander, a professor at Columbia University's Teachers College. Alexander had recently launched New College, an experimental pedagogy lab housed within Teachers College. It was an incubator for teachers who espoused progressive and radical ideologies to work together to create cutting-edge teaching methods. He and several of his students were in Germany for field experience. Alexander believed the Great Depression had created the need for a new type of educator, and thus a new approach to teacher training. Educators needed to prepare their students to solve the world's most pressing social issues. He believed teachers should have experience in social work and spend at least one summer studying abroad.

In Alexander, Mollie saw a style of teaching that blended method with praxis. This was exactly the kind of educator she wanted to be for Negro students. She decided she wanted to become a high school biology teacher. It made sense given her Meharry background. She could train student activists in what today we call STEM and meld the sciences with New Negro intellectualism and Marxist-Leninist theories of social transformation. Impressed by Mollie's time in Moscow, Alexander invited her to join the New College students on an extensive field study at German schools across the country. As one of the few people in the group who spoke German, she could be a translator. For this work, she'd receive 8 credits at Teachers College, which she could apply toward a master's degree program. It was perhaps the most thrilling opportunity she had experienced during her stint in Berlin.

New York City, December 1933

Just before Christmas, Mollie made the journey back to New York from Berlin. In one of her final letters to Dot before leaving, Mollie

wrote: "I really hate the thought of leaving Berlin. In my opinion it's the grandest place in the world." It was a pleasant sign of the ways her life had changed from the previous winter. She planned to tell Dot more about her experiences when they reunited in Paris for a big New Year's celebration, but Dot had to cancel their plans. Her father had died unexpectedly, and she needed to rush home to be at her mother's side. It was such a bittersweet end to a trip that had transformed them so deeply.

Dot and Mollie were never again as close as they'd been before the trip. It wasn't that they'd had a falling out. Their ships were just moving in different directions now. Dot moved back to Massachusetts for a spell and focused on caring for her widowed mother. Occasionally, she came back to New York to see friends and imbibe the energy. She published a magazine, *Challenge*, in which she sharpened her theories about class stratification and its intersections with race and gender. She eventually moved to Oak Bluffs full time, where she penned her first novel, *The Living Is Easy*. Mil moved into Dot's apartment at 43 West 66th Street. And it was she and Mollie who became good friends and confidantes as they struggled to weather the Depression.

In perhaps the strangest twist, it was Henry Lee Moon whom Mollie had telegrammed to share details of her return. The two hadn't been particularly close before, but they seem to have started corresponding after Henry returned to the States from Moscow. It's likely that he was waiting at the ship terminal in Hell's Kitchen to welcome Mollie home with a warm embrace. How good it must have felt to see a familiar face, who smelled like home, after living away for so long. She likely wanted to bury her face in his thick overcoat, to inhale in one deep breath everything she'd missed in the past year and a half. Besides, their correspondence, even if only

occasional, had created a new intimacy between the acquaintances, a language that was shared between them and not with the rest of their circle.

It seems that the nearly two years since the ugly split among the *Black and White* cast had healed some old wounds. They were finding their ways back into one another's lives. Henry had made amends with Louise and Langston. He, Ted, and Thurston were still as thick as thieves. Loren was back in Los Angeles and was now married, but when he came to visit Langston in the city, he'd meet up with Henry and the guys. Henry had never gotten over his anger with Stalin and the Comintern, but those who belonged to their group of comrades were learning how to love one another within and despite of their diverging politics. Their bond had been forged in the fires of international geopolitical struggle. From it emerged the roots of what would later be called Black internationalism—an approach to building political and cultural solidarities across national borders between people of African descent. Theirs wasn't a perfect community, but as the Depression was reaching its nadir, they realized petty squabbles would have to take a back seat. Their brilliant political minds were needed to aid the struggle for racial equality.

CHAPTER 3

Power Couple

Harlem, Spring 1937

Mollie Lewis had been living in New York City again for only a few months when she and Henry Moon decided to go out for a special dinner—by themselves. Since her return to the Big Apple, she'd been frequenting the movies and the theater, followed by late nights of lindy hopping and guzzling whiskey sodas at the Mimo Club, Eddie's, or the Monterey. Oh, how Mollie had missed the New York nightlife. Gary, Indiana—where she had resided after her return from Europe—was a dull town full of steel mills. Occasional trips to nearby Chicago had been no substitute for the jolt of excitement she could only experience on Manhattan streets after dark. Mollie's cocktail dresses and heels were finally being put to good use again.

She and her New York friends were regulars on the Harlem scene. Her inner circle still included members of the *Black and White* cast—Henry, Dorothy "Dot" West, Mildred "Mil" Jones, Ted Poston, and Thurston Lewis; as well as Alta and Aaron Douglas, Countee Cullen, Claude McKay, and Augusta Savage (the widow of Ted's older brother). Mollie's ebullient spirit won her legions of acquaintances who were delighted to see her out and about. She ran into everyone from boxer Joe Louis to Walter White of the NAACP, who'd be dressed to the nines and holding court, drinks in hand, at one of the Mimo Club's corner tables. Mollie loved to dance, but Henry had two left feet. According to Mollie, Henry, who was six years Mollie's senior, "can't tell a waltz from a rhumba." Still, he was Mollie's favorite escort on these nights out, and she had spent more time with him than anyone else since she'd returned to Harlem.

The two friends had mostly lived in different cities since Henry had stormed out of Moscow in 1932. After Mollie returned to the United States from Berlin late the following year, she enrolled in the master's program at Columbia University's Teachers College, to jump-start her new career as a high school biology teacher. She then went to Gary to visit with her mother, Beulah, and her stepfather for the holidays. What was only supposed to be a three-month stay had turned into three years. Illness befell Mollie's stepfather, which made it impossible for him to work at the steel mill. He lost his insurance, and they owed five hundred dollars in back rent in addition to other bills. Beulah's relief check from the government was the only thing keeping them afloat. Then Beulah's husband left altogether, abandoning her and their marriage, leaving her steeped in debt.

The family's protracted financial crisis in Gary had made it im-

possible for Mollie to continue her studies in New York. Instead, she resumed her job at the local pharmacy to help Beulah get her finances together. "It's just like the bottom has dropped out of my little world of beautiful dreams," Mollie had written to Henry. Every dollar she'd saved to cover her courses now went toward helping Beulah pay her expenses, which left Mollie with a tuition bill at Teachers College that she couldn't afford to pay off. She had no idea if she'd ever be able to return to New York. She would later tell the story, saying she lost interest in being a teacher while in Berlin and had come back to the States excited to devote her life to the movement for racial justice. Perhaps she chose to remember it this way to hide her shame over having to drop out of the program. In 1937, Mollie was finally able to convince Beulah to sell her belongings and move in, once again, with her sister in Cleveland.

Mollie's regular correspondence with Henry through all her family struggles had fortified a deep bond between the two. She had come to trust Henry implicitly; he was one of the few whom she'd invited into the interior of her world. Mollie had hung on to her San Juan Hill apartment, concealing the harsh reality of her financial situation from their mutual friends. She kept up the ruse that she was off gallivanting across the country, taking in sights such as Niagara Falls. Henry had keys to Mollie's place and was responsible for forwarding her mail and coordinating with the cleaning lady. Mollie would zip into New York to attend important events and leave just as quickly, returning to the humdrum of Gary. New York friends came to accept that she was fiercely private, considering her elaborate attempts at discretion part of the Mollie mystique. Henry held her confidence while seeming to never pass judgment.

In the eyes of most who knew him, Henry was a steadfast

friend who came from good stock. He was born in Cleveland to a middle-class, activist family. His father, Roddy Moon, had established the Cleveland chapter of the NAACP when Henry was an adolescent. From an early age, when Henry was introduced to *The Crisis* and other African American publications, he understood that writing was a medium through which the Negro community could exchange ideas and fortify political solidarities. The Moons believed in the importance of education as a route to Negro empowerment, and young Henry was all but mandated to attend college. He chose Howard University in Washington, DC, where he edited the prestigious *University Journal*, which published the political thoughts of undergrads, and joined Omega Psi Phi fraternity. He later earned a master's in journalism from Ohio State University. After working in public relations at Tuskegee Institute, where he networked with movers and shakers from across the country, Henry moved to New York City. And he was among the smartest men Mollie had ever met.

Through their frequent letter writing, Mollie and Henry had struck up a mild flirtation. It seemed fine at the time since they were separated by hundreds of miles. But now that they were face-to-face again, after having built such a deep rapport, the chemistry between them was hard to deny. Mollie started to wonder what the rules were for dating someone whom her friend Dot West had dated casually years earlier. Perhaps out of loyalty to Dot, she tried to push any nonplatonic emotions for Henry to the recesses of her heart. However, having frequent dinners together wasn't the best way to smother one's feelings. Initially, people in their circle didn't think much of their social frolicking. Henry was trustworthy, and their friends believed he loved Mollie like a little sister and comrade. Mere months away from her thirtieth birthday, Mollie was

technically old enough to venture out without a chaperone; Henry had still volunteered to serve in this capacity, providing protection from other men. Mollie found herself increasingly unable to suppress her attraction to Henry.

This night, Henry had suggested they go to a restaurant much quieter than their typical haunts. Mollie could sense a different energy between them as they slid into seats on opposite sides of the table. Henry stared into Mollie's almond-shaped brown eyes and professed: "I love you and always will and I intend to have you for my own, my very own." He saw in Mollie a lover and a life partner. His declaration sent a charge of excitement through Mollie's body. Henry wasn't a classic heartthrob; he was bookish, shorter than the average man, with a portly build and a receding hairline. But he was handsome and brilliant.

She knew of his reputation as a serial monogamist. He was prone to quickly falling in and out of love with women, which led many to conclude that he wasn't much different from his best friends Ted and Thurston, who people thought were playboys. Any fears she might have harbored about Henry leaving her brokenhearted were assuaged as Mollie studied his ebony-hued face and saw he truly was serious about her. She had to be honest with herself; she loved him too. Deeply. It wasn't some hot and passionate love, nor was it the transactional love that she'd shared with past suitors who had showered her with gifts. It felt steady and more stable than anything she'd ever experienced. But where could this relationship go?

Mollie had deeply conflicted feelings about marriage. She'd been married twice, and neither had worked. Her first marriage was to a man named Cleolus "Cle" Leonidas Blanchet, whom she'd met while a pharmacy student at Meharry Medical College in Nashville. Cle

had earned a doctorate in pharmacy from Meharry and was hired as an instructor in the program. He was born into an elite, home-owning Creole family in New Orleans and had all the markings of the Negro bourgeoisie: he was a charter member of the Theta Beta Literary Society, a 32nd degree Mason, and a member of Alpha Phi Alpha fraternity. The two married when Mollie was only nineteen. They kept the marriage a secret because Mollie was still a student. After her graduation in 1928, the Blanchets moved to Cle's home-town, where he worked as the head pharmacist and owner of a local drugstore, and Mollie worked alongside him. They were the ulti-mate upper-class Black society couple. Mollie joined several social clubs for women, in addition to Alpha Kappa Alpha sorority, which she'd pledged while an undergrad, and hosted dinners at their home.

Despite having all the trappings of success, Mollie was deeply unhappy. She had followed Cle's professional aspirations and was suffocating under the weight of the interlocking class and gender expectations of elite Negroes. Mollie and Cle had been married for four years when a salacious story, published in the *Chicago Defender*, accused her of having an affair with a married physician. Cle filed for divorce, and Mollie didn't contest. She was depicted in the press as a jezebel who had brought shame on her husband's good name, despite her insistence that the story was a strategic character assassination that had been exaggerated and fed to the press by Cle's influential family. After the divorce, she ran into Cle's brothers and their wives—all high-society folk in Chicago—at the Palm Tavern. She told Henry it "certainly did revive unpleas-ant memories." "[I could still] see those damned headlines in the *Defender* when I saw those Blanchets." "[I had no reason to feel ashamed] but I did." The saving grace was that she was "really looking good" in a print dress and carrying a fur stole, which she

affectionately called Susie Q. The Blanchet union had soured her on bourgeois Negroes and their politics of respectability. She perhaps leaned into her "loose woman" reputation as a form of rebellion, finding solace in dating around and partying her way through heartbreak.

When Mollie returned to Gary from Berlin in 1933, she took up with a man named Eugene, who became her second husband. It was likely more a marriage of convenience than a romance. Mollie's career dreams had just been dashed by the Depression, and she was trying to make peace with the fact that Gary might be her home for the foreseeable future. Her fear of a life of poverty often led Mollie to make desperate and rash decisions. Eugene was one such bad choice. He offered Mollie and Beulah a modicum of financial security, but he wasn't a life partner. By this point, Mollie had traveled through the USSR and Europe and was fluent in German. She was out of Eugene's league, and he knew it. He was troubled by the adoration Mollie received, especially when they were in Chicago with Russian-born intellectuals and white American progressives who saw her as an enchanting conversation partner. He was possessive of Mollie, even though he himself had a roaming eye. Less than two years into the marriage, he was "all tied up" with a young schoolteacher, driving her car, introducing her to his mother—who'd never liked Mollie. The marriage was all but over by 1937, when she returned to New York for good.

The bitter sting of two failed marriages remained with Mollie. It seemed nearly impossible for a modern Negro woman with big career aspirations and leftist politics to find a suitable life partner. However, if it were possible with anyone, it would be Henry Lee Moon. Henry, who had never been married, was aware of Mollie's past marriages. He had progressive gender politics and, on

principle, wasn't invested in respectability or traditional gender norms. And most important, Henry wasn't threatened by Mollie's ambitions.

Mollie and Henry could become a New Negro power couple. The women in power unions were on equal footing with their husbands—just as visible and accomplished, if not more so. Although no one called them power couples then, such partnerships had been featured in the Negro press since Mollie was a child: Booker T. and Margaret Murray Washington, Mary Church and Robert Terrell, and Ida B. Wells and Ferdinand Barnett. Henry and Mollie's could be a union built upon a shared commitment to racial justice and a deep love of all things intellectual. They'd both already traded memberships in social clubs for the NAACP and the Urban League, they attended forums on race relations, and they read together voraciously. They regularly gave money to mutual aid societies, the Negro branch of the Red Cross, and other mass philanthropic endeavors, not as an act of charity but as an extension of their politics. Henry, as a leading New Negro intellectual, would help shape the public discourse around racial equality, while Mollie, who was becoming a patron of the Negro arts, would continue to champion African American artists and their freedom dreams. Instead of the inane dinner parties she'd hosted for those saditty New Orleans Negroes, she'd use her event planning skills to further the movement—supporting political candidates who were sympathetic to the Negro cause, hosting fundraisers for labor organizers.

Many young professionals were getting married later in life than had their parents, but marriage was still the norm. Women in particular were expected to marry and bear children in their twenties, and doing so often increased their social cachet. Educated women

often found it was easier to navigate a career if they had "Mrs." in front of their name. Yet, Mollie was once again single as she headed into what society deemed the spinster years. Because stories from her casual dating days still lingered on the tongues of conservative New York society, she might have reasoned that marriage would shield her from being labeled a jezebel or an old maid. Had it not been for this social pressure, she likely would not have married again. Men weren't looked upon as disparagingly for being unmarried in their early thirties, but at thirty-six, Henry had exhausted the alluring bachelor schtick. People would start to wonder what was wrong with him. Most of their friends were married. Even Ted and Thurston had taken wives. Their queer friends couldn't marry legally, but some were in committed partnerships—even if covertly.

Marriage could be a refuge for Mollie and Henry, a way to protect their reputations while building social currency. But Mollie was getting ahead of herself. It was best to simply bask in this moment of elation over Henry's professed love than to contemplate every possibility for her future as Mrs. Henry Lee Moon. So much about her life and Henry's was still uncertain due to the scarcity of employment opportunities for Negroes, particularly during the Depression. So instead of committing to marriage, Mollie said yes to being Henry's girlfriend.

Mollie had only recently stumbled into a social worker position with the NYC Department of Welfare's Civil Services division. It wasn't a teaching job, but social work, too, was a noble career that would allow Mollie to do the racial justice work she'd committed herself to in Moscow. The professionalization of social workers coincided with the Great Migration. Local governments needed educated African Americans to venture into

migrant communities, assess their needs, and offer aid. Early Black social workers became experts on social theory and wealth distribution. They published their findings in journals and held their own conferences. By the time Mollie entered the profession, a Negro social worker was considered a hybrid of an activist, a public intellectual, and a caregiver, at the vanguard of social change. It also helped that government positions offered a fair wage, a benefits package, time off, and opportunities for promotion and transfers to other agencies. If Mollie passed a few proficiency tests and survived a probationary period, she could have permanent employment by her thirtieth birthday. And perhaps she could save up enough money to pay her bill at Teachers College and re-enroll in grad school.

Henry's life was a shambles. He and Ted had recently been fired from the *Amsterdam News* for encouraging staffers to unionize, under the auspices of the Newspaper Guild of New York, after part-time staffers were surreptitiously let go to cut costs. Henry had rebounded, finding freelance assignments with the *New York Times*, where he wrote hard-hitting stories about lynching, the housing crisis, and economic justice. He hoped the *Times* would see that he was worthy of a full-time staff position—even though the prestigious paper hadn't ever hired a Negro. He eventually gave up this dream. Assistance from the Works Progress Administration (WPA), which gave relief work to unemployed writers, helped Henry a bit. But it was not enough to cover the rent on his Sugar Hill apartment. He was forced to move out of this illustrious section of Harlem and into the 135th Street YMCA, which had a housing facility for Harlem's two thousand homeless men. Henry had worked with the New York Mutual Aid Association on this project (which had relied heavily upon funding from John D.

Rockefeller Jr. and Julius Rosenwald), not realizing at the time that he'd soon be dwelling in the facility.

His life just was not where he'd imagined it would be at this stage. Esteemed activist and writer Bessye Bearden had lauded him in her *Chicago Defender* column New York Society as "one of the leading political theorists of the Left Wing." His commentary on race relations and the possibilities and limitations of interracialism was published in prominent race magazines and journals along-side E. Franklin Frazier, Lester Granger, and Martha Gruening. Would he ever fulfill the promise he had shown? Deep inside, he was scared that he might not.

Washington, DC, Spring 1938

Finally, Henry caught a break. Through the WPA, he was hired by the publicity department of the United States Housing Authority (USHA), a newly established agency within the US Department of the Interior, where he worked with the Office of Race Relations. Henry had been writing about and active in addressing the Negro housing crisis for years. In this position, he could engage in policy debates and hopefully do something to aid his people's fight for fair and quality housing. Accepting the job meant leaving New York City, a place he'd called home for over a decade, and relocating to Washington. He hated leaving Mollie, his dearest friends, and his political community.

A man who'd always dreamed of a career as a writer could never be fully satisfied with a desk job in Washington. But during the Depression, you had to go wherever there was a sound opportunity. And this was a critical time to be in the nation's capital. The federal government was expanding under President Franklin Delano Roosevelt's leadership, at a rate of several hundred new hires per

month. Meanwhile, tens of thousands of Negroes from the Deep South and elsewhere were moving to the District for new opportunities, often only finding housing in cramped alley dwellings and employment in backbreaking, menial jobs. Henry, who had been a college student at Howard at the end of the Great War, intimately understood the tensions between the government and the city's Black poor. Yet returning to Washington as one of the few Negroes who had received a coveted federal government job—from janitors and charwomen to clerks and advisers—would ensure that he received a warm welcome.

He moved into a three-room apartment at 1206 Kenyon Street Northwest, in a remodeled town house owned by his USHA supervisor Robert Weaver, who lived downstairs with his wife, Ella Haith Weaver. Bob, as his friends called him, was a Harvard-educated economist who had quickly ascended the ranks of the New Deal administration. The Weavers' town house was in a prestigious, predominantly Negro residential neighborhood called Columbia Heights. Streets like Kenyon were tree-lined, with massive Victorian-style homes whose ornate architectural designs matched the ambitions and the bourgeois tastes of their residents. The area had flourished in the early decades of the twentieth century, becoming a desirable enclave for white, high-level federal officials. Now Negro professors, school administrators and teachers, and clergymen were among the Weavers' neighbors. Black-owned eateries and beauty salons such as the Cardozo Sisters Hairstylists flourished, with the help of small business loans that were made available by New Deal agencies.

Originally, Henry hadn't planned on committing to an apartment so soon, hoping that an opportunity would appear in New York and his time in DC would be short. But when the previous

tenant announced that he was leaving, everyone told Henry he wouldn't find a better place. By better, they weren't just referring to the neighborhood and the digs themselves. Living in the same building as his supervisor meant that Henry would have a direct pipeline to power. Weaver, director of the Office of Race Relations, was the special assistant to USHA administrator Nathan Straus Jr., whose influential and philanthropic Jewish New York family co-owned the Macy's department store empire and whose wife belonged to the Goldman-Sachs family. Straus reported to Harold Ickes, secretary of the interior, who also coordinated the Public Works Administration, which (in contrast to the WPA) contracted with private firms to construct public buildings and infrastructure. Moving into the Weavers' house would instantly elevate Henry's status and bode well for his own promotion should he decide to build a government career.

Henry and Mollie's relationship was still going strong, despite the distance. Mollie had secured permanent employment with the Department of Welfare. She was a caseworker charged with visiting the tenement flats and boarding houses of unemployed Negro Americans who were seeking economic relief and other government aid. Mollie saw up close the Depression's devastating impact on Black and brown Harlemites. Their dwellings were practically uninhabitable, often without running water or proper ventilation. Her job was rewarding but emotionally taxing. It was gut wrenching to stare abject poverty in its face and not be able to offer an immediate remedy. This vantage point likely made Mollie further detest the US system of inequality, which indiscriminately heaped resources upon the white and wealthy, while poor people of color had to prove they were honest and worthy of government assistance.

Mollie found that working with the Negro poor gave her more social power and influence among New York elites. The closer she worked with the poor, the more white do-gooders wanted to hear her thoughts on how to solve the race problem. It was an uncomfortable paradox. She was invited into alliances with Lester Granger and other leading African American social workers, many of whom were active in the Urban League, who sought to transform New York's social services programs. Working-class Negroes believed she was a gatekeeper to a government job, or that having her as their caseworker meant she might approve their application for benefits. People beyond her circle wanted to know and befriend her. The position brought with it a level of prestige and visibility that Mollie suddenly found herself ill-equipped to handle.

Her romance with Henry was a welcomed respite from the demands of her job and burgeoning career as a race woman, though she still harbored uncertainties about marriage and their future. The true nature of their relationship was still a closely held secret that only a handful of their friends knew. She delighted in their clandestine weekend visits and the deep sexual connection they were forging. Now that Henry had steady employment, he was ready to marry. Mollie agreed to become his fiancée, but she was hesitant to give up her purposeful new life in New York to live among the stuffy suits of Washington. She believed that DC, which was just below the Mason-Dixon Line, was socially conservative and bound to many of the same conventions as other parts of the South where she had lived—Tennessee, Mississippi, and Louisiana. On days when she was more enthusiastic about the proposition of marriage, she'd say: "I have thrashed everything out within myself. If it means giving up the job, I shall do it and come to you. If I can't get a job, I'm going to be contented playing the role

of a real wife. I'm sure it will be fun because it will be something new." On days when she was more doubtful: "Have been trying to convince myself to give up this place. It still hangs in the balance."

Perhaps the biggest obstacle was that Mollie was still legally married to Eugene. Before the 1960s, it was customary for the estranged husband to file for divorce, so Mollie had to rely on Eugene to act first. They'd been separated for nearly two years without any initiative on his part. One day, in June 1938, Mollie received a letter from Eugene announcing that their divorce would soon be final. Henry was thrilled about the news. "Once the divorce matter is cleared, we must proceed immediately to the marriage," he said. Still, few of their friends and family even knew they were dating, much less engaged. Now that Mollie would be a legally single woman, Henry advised they hire an attorney, which he'd pay for, to ensure the divorce paperwork was in order.

He suggested now was the perfect time for Mollie to tell her mother about the divorce. He didn't want Beulah to be surprised when she received a wire announcing Mollie and Henry's impending nuptials. He informed his parents, who were delighted that their son was finally settling down. At that point, though, Henry hadn't even purchased a ring. It seems that Mollie, too, was now eagerly anticipating their union. "I'm so happy. It's really the first time that I've actually looked forward to getting married. I'm even planning on what I'm going to wear," she told Henry. "If this third and last one is not a success, it will be through no fault of mine."

Washington, DC, August 1938

Finally, on August 13, 1938, the two got hitched in DC. Theirs was far from the society wedding spectacle often staged by the Negro upper crust. The ceremony was simple and "delightfully informal." Only a

few guests, old and dear friends, were in attendance. They married in the living room of Margaret and Alphaeus Hunton. Mollie and Margaret, a librarian and Chicago native, had gotten close during Mollie's time living in Gary. Henry and Alphaeus had ties that went back to their college days at Howard. Alphaeus now was a radical activist and Howard English literature professor. The two couples had become like family. A pastor who had also been one of Henry's Howard classmates officiated. At the last minute, the daughter of the Hunton's upstairs neighbor was appointed flower girl. It was the only element of wedding tradition they followed.

"Exotic Mollie Lewis Marries Henry Moon: Marriage Is Complete Surprise to Couple's Numerous Acquaintances," ran the headline in the *Amsterdam News*. The story, written by Marvel Cooke, a left-wing journalist who was part of the couple's social circle, was a gossipy exposé. In Cooke's rendering, Mollie, "the ravishing beauty" who had "stood continental society on its ear" during her travels in Europe, took Henry, the "confirmed bachelor," off the market. It mentioned Mollie's first marriage to Cleolus. And it revealed that Mollie and Henry's closest friends were "completely flabbergasted" when news of the marriage leaked. Henry wasn't amused by Marvel's tell-all announcement. Mollie took it in stride. Most friends were supportive, despite their surprise. However, Roy Wilkins, an NAACP leader, told Mollie the marriage would never last with Henry living in Washington and her in New York. And a woman friend of Mollie's named Rae Olley expressed her skepticism of long-distance marriages. Mollie was hurt and disheartened by Wilkins's sentiments, so much so that she picked a terrible fight with Henry. Henry wrote to her, attempting to allay any doubts she might have about his commitment to their marriage. Mollie eventually apologized for her behavior.

Truth was, the Moons hadn't resolved how they would main-
tain a commuter marriage as working professionals. The one ma-
jor decision they'd agreed upon was that Henry's apartment in
Washington would be their marital home. Mollie would keep her
New York apartment as a second home of sorts. She and Henry
would commute back and forth between residences a couple times
a month, utilizing the reliable train services that connected NYC
to DC in a coastal corridor. However, most of the time they would
live apart. It was only a temporary solution to a major issue that
would have to be resolved, sooner rather than later.

Civic Leaders

Washington, DC, Fall 1938

Henry's job placed him among Washington's self-proclaimed but widely recognized Negro civic leaders. Like their New York circle, Henry and Mollie's Washington colleagues were heavily influenced by the New Negro Movement. But most were more moderate in their politics than the left-wing New Yorkers the Moons knew. Civic leaders tended to have federal or municipal jobs that came with a commitment to serving the public good. Most of the DC civic leaders espoused a form of racial liberalism, which acknowledged that race was a social construct and that Jim Crow segregation needed to be swiftly abolished. But they believed change should be achieved by working within the sys-

tem, alongside progressive white Americans, to pass new legislation that would level the racial playing field. Radicals, by contrast, believed the system was irreparably broken because it had been built upon a foundation of white supremacy. The US capitalist infrastructure was reinforced by the legislative and judicial arms of the government. And this co-constitutive relationship, they argued, kept Negroes perpetually disenfranchised, underemployed, and hypercriminalized.

Mollie and Henry fell somewhere in between the radicals and the racial liberals. In principle, the Moons were left wing. Both were anti-capitalist, though Mollie was more a student of Marxist-Leninist revolution than Henry. Neither felt their role in the movement was on the front line, agitating for armed resistance, though they believed fixing the system required more than reform. They were friends with Margaret and Alphaeus Hunton and others within the relatively small community of radical Black DC elites who organized around the National Negro Congress, instead of the NAACP. But the Moons' government jobs were slowly moving them closer to center than they would've admitted. They were becoming civic leaders who were deeply invested in electoral politics and voted for Democratic Party candidates (even though Mollie's mother, and many African Americans of her generation, was a staunch Republican). Writ large, the lines between political factions were being blurred and redefined in the wake of the Great Depression.

Most Washington civic leaders were in power couples. The group revolved around Henry's boss, Bob Weaver; Weaver's best friend, Judge William "Bill" Hastie; and their wives. Bob's wife, Ella, was a major fundraiser for the influential DC chapter of the NAACP. An educator and playwright, Ella had graduated from

Carnegie Tech in 1932. She had been working at Howard when she met and married Bob in 1935. Later she had earned a PhD in speech pathology from Northwestern University. Henry described Ella as "most cordial," "a Washington wife to be sure." Ella's powerful network of DC friends included members of the old-money Black elite, such as the Syphax family and society "it" girl Mercedes Rector. Hastie's first wife, Alma Scurlock Hastie, was active in the NAACP as well and had played a pivotal role in the boycott against the Safeway grocery store chain for its refusal to hire Negro employees.

Frank and Frankye Horne were also major players in that circle. Frank was a native New Yorker who had earned a PhD in ophthalmology. He worked under Mary McLeod Bethune in the National Youth Administration before becoming the assistant adviser on race relations in Weaver's USHA office. Frankye had to forgo her ambitions once she fell ill from tuberculosis. Rounding out the circle were the Johnsons and the Lovetts. Clarence Johnson was a midlevel administrator at USHA whose wife, Cora, was one of the few homemakers. Attorney Edward Lovett was on USHA's legal staff. His wife, Louise Lovett, was a teacher at the prestigious Negro school Cardozo High.

They were all members of FDR's Black Cabinet. While sounding official, it was never sanctioned by FDR and, by most accounts, was a body whose existence he never publicly acknowledged. It was a collective of Negro New Deal employees who had organized themselves, under Bethune's leadership, to address systemic issues that affected the African American community in DC and in the home states they represented. This power network looked within its own ranks to help other high-profile, educated Negroes with similar politics secure government jobs. Most came from civil

rights families and had long been fighting for social and economic justice, full enfranchisement, and quality education on the local level. These folks believed their mid- to high-ranking appointments offered a possibility to reimagine US democracy from the inside.

The Moons quickly found their place among Henry's new circle of Washington peers. Henry's sharp intellect and easy demeanor made him both stimulating and agreeable. He was the type of thinker they wanted in the room when matters of race and labor justice were on the table. As he was probably the strongest writer among them, they leaned on Henry's pen for their shared projects. He became a regular face at meetings of the "so-called Black Cabinet," as he described them to Mollie. After one meeting he told her: "As usual in such gatherings there was a lot of talking, a lot of blowing off and sharp, bitter, cross currents. Little was accomplished." He found a greater sense of political direction and camaraderie afterward, when he, Frank Horne, and another male civic leader had drinks at the Capital Pleasure Club. He continued to attend the meetings but felt it was clear that the entire enterprise was futile. Many in the Black community and the press concurred, writing the Black Cabinet off as mere "political window-dressing."

Meanwhile, Mollie was learning to speak the language of Washington politics and policy. She avidly followed First Lady Eleanor Roosevelt's views on the New Deal, which were more racially liberal than the president's. Mollie found that it was good to have a few talking points at the ready when she was in DC with Henry and having meals with the Weavers and their friends. She also learned that even these government shirts loved the theater and used her juice to procure tickets to New York City plays and pre-

mieres. Frank was the uncle of emerging star Lena Horne. Mollie made plans to see Lena in her starring role in *Blackbirds* on opening night. She had Henry invite Frank to go with them. Mollie struck up a correspondence with Ella in the same way. It was important that Ella, as a playwright, stay connected to the New York theater world. She occasionally sent Mollie a few hundred dollars to buy tickets to events in the city. When Bob Weaver was there for work, he would hang out at Mollie's apartment. One night, Mollie and Bob, along with Mil Jones and some other friends, cracked open a bottle of scotch; Bob ended up staying and chatting with the group until 1 a.m.

There was a certain bourgeois lifestyle that went along with being a prominent Washington civic leader. Louis Lautier, an *Afro-American* journalist who penned the Capital Spotlight column and was an ancillary member of the Black Cabinet, considered Weaver's friends "big shots" with big salaries. Weaver and Bethune both earned approximately $120,000 a year. Frank Horne earned over $80,000 and Clarence Johnson nearly $65,000. Weaver and Bethune were part of the roughly one percent of Negroes in the country with six-figure salaries. By contrast, their earnings would have been only an average salary for similarly ranked white government employees and below average for similarly educated and credentialed white American professionals more broadly. But within the Negro world, these folks were the crème de la crème.

Their residences reflected their status as members of the monied elite. Washington's social life revolved around domestic spaces where people hosted elaborate dinner parties. For civic leaders, the dining room table was akin to the golf course, a place where strategies could be hatched and alliances formed. This "snooty set," as they were often called in the society pages, invested a great deal of money and

effort into home décor. Undoubtedly, Bob Weaver's impressive salary helped him and Ella buy their luxury town house in Columbia Heights, which Ella had decorated in a classy, understated manner.

According to society writer Leighla Whipper Lewis, who penned the Capital Caviare column in the *Afro-American*, Marie Brown Frazier, wife of Howard sociology professor E. Franklin Frazier, had created one of the most beautifully and uniquely decorated residences in the District. Marie, who was prominent in the arts and education circles of DC, Chicago, and Atlanta, was known for hosting congenial parties of women as well as couples. Their home at 220 Rhode Island Avenue NW was furnished with hand-carved vases, oriental prints, and porcelain. Aaron Douglas originals hung on the walls of the dining room. Despite E. Franklin's vexed relationship with the Negro bourgeoisie and its social mores, the Fraziers set a high standard of living.

Mollie and Henry peered around the homes of their new friends, drawing design inspiration. They loved the home of Hilyard and Helena Robinson, who lived upstairs from Alphaeus and Margaret Hunton and had attended their wedding. Hilyard was a DC native and architect who taught at Howard. He was famous for his design of the Langston Terrace Dwellings housing project. The Robinsons' home was decked out with expensive furnishings that reflected the couple's internationalist sensibilities.

The challenge was that the Moons made nowhere near the salaries of the Weavers and others in DC society. Henry brought home $40,000 annually and Mollie only half that much. Compared to the rest of Negro America, they were relatively well off. But there was real social pressure to keep up the lifestyle: buying designer clothing and housewares, taking regular trips overseas, and procuring modern artwork. Mollie was tasked with trans-

forming Henry's DC bachelor pad into a home suitable for a couple aspiring to join the circle of civic leaders. Henry told her: "Wait until we get our place just as we want it. You have the taste, and somehow I'll have to dig up the money, to make it perfect."

These social expectations likely created in her profound feelings of anxiety. On one hand, Mollie knew this world well. Between the Nashville and New Orleans Black elites she had lived among, she understood the tastes of the Negro nouveau riche. There was a time when she was willing to go broke to keep up with the Joneses, to refashion herself as a woman of status, not one born near the poverty line. On the other hand, she had fled that bourgeois way of life when she divorced her first husband and moved to New York. She didn't mind the materialism, but she hated the classism and social propriety that came with it. In Mollie and Henry's bohemian New York set, there was no pressure to have a stellar home; their social events were all about the food, drink, and amazing company. You could host a party in a broom closet if the ambiance was right.

Now her past seemed to be staring her in the face as she maxed out her credit lines to get their Washington residence up to snuff. If Mollie Moon was going to play the game, she was going to play to win. She shopped at Macy's, Bloomingdale's, and Sach's, a smaller Jewish-owned discount department store that was friendly to Negro clientele. She bought two big chairs, like those she had seen in Ella Weaver's den, as well as a huge coffee table and a copper lamp. Thanks to a clearance sale, she was able to buy a beautiful rug for the living room—the same one as in Helena and Hilyard Robinson's home—for $800 instead of $2,000. Perhaps her favorite purchase was an expensive down comforter for their marital bed, which was so costly she didn't even tell Henry how much she'd paid for it. Her purchases came to more than $4,000. Everything bought on credit

would have to be paid off at $215 per month. It was a substantial chunk of their monthly income—especially after paying rent and utilities on two apartments, plus paying down Mollie's old tuition bill, and they were still sending Beulah money nearly every month. "My God!" Mollie exclaimed once she did the math. "But then I guess it's worth it," she rationalized. Henry wasn't enthused about spending all that money on home décor. But when the remodeling project was done, he appreciated the clout Mollie and her good taste won them. "Mollie puts life into this town," one DC friend told them after attending a party at the Moons' place. "Everyone who comes into our apartment seems to like it and the way you have furnished it," Henry boasted to Mollie.

The tension of straddling two cities with different social worlds was beginning to manifest itself on Mollie's body. She became obsessed with perfection, with looking like the powerful wife of a Washington big shot, an image that the younger Ella Weaver seemed to effortlessly embody. Mollie had her gold front tooth and the one next to it replaced with pearly white veneers, which she proudly flashed whenever possible. She implemented a rigorous diet and exercise plan and started undergoing reducing massages when she "tipped the scale" at 163 pounds. The goal was to at least get down to the mid-150s—though the women who were considered the most glamorous weighed closer to 125 pounds, which allowed them to fit European couture sizes. And having an *en vogue* wardrobe was essential for socialites and fashion-conscious civic leaders.

Weight loss was always something of a yo-yo because Mollie loved delicious food: "I ate up the kitchen sink last night, but I'm starting back today on my strict diet." Although she wanted to be thinner, the truth was that Mollie was quite comfortable in her skin, feeling just as confident as a size 18 as she did as a 14.

But there were new class pressures to be thin. Upper-class Black women, like their white counterparts, were expected to discipline their bodies. But Black women had to battle against the interlocking forces of sexism, anti-blackness, and fatphobia, which defined their perceived fat bodies as bestial and savage. The desire to combat these stereotypes was so intense that many within the Negro community, especially those of the upper classes, began to police the bodies of other Black women. Many even believed that thinness was a way to demonstrate fitness for full citizenship.

Mollie's heightened visibility meant that society journalists, particularly the men, had started hounding her in their columns about every pound she gained or lost. Henry was not scrutinized in the same ways, even though he'd gained weight since their wedding. It was the unfair social cost of being a Black woman civic leader.

Mollie was preparing for the start of the social season—or social swirl, as it was called. The society calendar began in late fall and ran through spring. The Washington and New York swirls were considered the big leagues of Negro society, with endless galas, cocktail parties, private dinners, shows, and exhibitions. She bought a new black velvet evening gown with a long train and a blue lamé cocktail dress on credit from Bloomingdale's, even though she was three months behind on her telephone bill. Participating in one of these cities' swirls required tons of luxe garments and incredible stamina. Attempting to do both cities—and do them well—was nearly impossible. But Mollie was determined to do her part to establish the Moons' social and political stature.

Harlem, January 1939

Perhaps because Mollie and Henry lived in a commuter marriage, they were also able to establish individual activist identities. Mol-

lie's activism was an extension of her career in social work. Addressing economic injustice was one of the Negro community's biggest concerns. By day, Mollie connected Negroes with government resources. In the evenings, she attended mass meetings on labor and race relations. She was particularly excited about a forum held at the Harlem Library just after the new year. Her friend, writer Claude McKay, was one of the featured speakers. "I wouldn't have missed it for anything," Mollie told Henry. Like most political events in Harlem, all factions were represented and wanted to speak their piece about the state of the Negro. The crowd was rowdy, either booing or applauding raucously after each speaker made a point. McKay became angry at the crowd's response to his arguments and left before the meeting was over. Mollie joined him later for drinks at the Monterey, and he was still fuming.

She concluded that most folks in the audience, which included members of Marcus Garvey's Universal Negro Improvement Association, seemed to have felt that Negroes should forget about begging white folks for their support and unite among themselves to deal with their own problems. Even some folks who did not espouse Black nationalism eschewed interracial organizing. Mollie agreed that interracialism was not a viable path for Black Americans to achieve racial justice: "I'm so sick of reading about interracial groups forming between Negroes and Whites for better understanding." She believed most white people would always look out for their own interests and could not or would not understand the plight of impoverished Negro Americans.

Mollie had developed her own political stance, which could best be described as Black socialism. She had been introduced to communist ideas in Moscow, but there Marxism was shaped by a non-Black, Eurocentric perspective. Since her return, especially

during her years in Gary, she had learned more about how African American workers were adapting communism's core tenets to Black experiences, blending them with Black nationalist ideologies and Pan-Africanism. Their grassroots organizing strategy exposed the limitations of interracial activism and stressed the need for Black Americans to have their own strong political base.

Her Black socialism was also women centered. She was keenly aware of the ways that economic insecurity particularly affected Negro women. Many of these ideas were forged during her regular attendance at meetings held by *The Crisis* magazine, affiliated with the NAACP and founded by W. E. B. Du Bois. In New York, a wide range of leading Black intellectuals were invited to speak on contemporary issues at *Crisis* gatherings. For example, in his lecture, Carter G. Woodson argued that Negroes should cast aside their anti-Japanese racism and recognize the ways that Japan's fight against European imperialism was part of the same battle African Americans were fighting domestically. The meetings reflected Black internationalism, encouraging a global lens on the oppression of Negroes throughout the African diaspora and the larger structures of capitalism and imperialism that united all non-white peoples in struggle for self-determination.

In a piece she wrote for *The Crisis*, Mollie described the plight of women in steel towns such as Gary "living dreary lives under the domination of powerful and impersonal corporations" who bore the brunt of "the uncertainty of employment for their men folk" that made "life a hard and uneven road for them." Mollie had watched as the marriage of her mother, Beulah, and her stepfather had been rocked by the collapse of the industry. Beulah's life was left in a shambles once he abandoned her. She wrote about the necessity of the work spearheaded by the women's auxiliary

of the Steel Workers Organizing Committee, an offshoot of what became the progressive, racially inclusive Congress of Industrial Organizations (CIO). "In the matter of race relations, Gary and the adjacent steel towns are by no means utopian. . . . Bitter racial animosities have flared, not only between Negroes and whites, but also between native citizens and the foreign born," many of whom brought with them "nationalistic enmities rooted in old world conflicts." Mollie emphasized that the women's auxiliary aimed to "induce the women of such diverse groups" to understand that "when it comes to exploitation, the mill owners draw no color line."

Communism remained a point of disagreement for Henry and Mollie, and the issue resurfaced at the onset of World War II. Mollie was invited to an intimate dinner party at the home of Vivian "Buster" Burey Marshall and Thurgood Marshall at 409 Edgecombe Avenue in Harlem. Other guests included Mollie's friend and colleague Sara Dunston, who worked closely with Roy Wilkins and the NAACP; Daisy Lampkin; and New York tax commissioner Hubert Delany. With all of these powerhouse thinkers in one room, the dinner soon devolved into "the usual argument" about communism. "There were four of them against Delany and me," Mollie reported to Henry. The "ultra conservatives branded us as 'Reds'" because "we found some good points about Russia and were condemning Great Britain." Daisy became "so frustrated" with Delany's pro-communist stance; she didn't think that the tax commissioner should be "so outspoken" about his radical political beliefs.

Henry wondered why Mollie hadn't abandoned any lingering commitment she had to Russia. "I suppose you're ready to admit that Stalin is no whit better than Hitler," Henry responded. "This is what Stalin has brought the revolution to. He has completely

repudiated Lenin as well as Trotsky, has desecrated man's noblest dream, and has set the real revolution back a generation or more." Henry criticized the *Daily Worker*'s continued support of Stalin despite his crimes against humanity. He added an ironic after-thought: "Maybe the Soviets would be willing to produce 'Black and White' now that they no longer seem to give a damn about what anyone thinks about them."

Government employees were being targeted for even perceived ties to communism. Henry watched as friends got caught up in the net of suspicion. He knew that he and Mollie could also be inves-tigated, especially because they'd traveled to the USSR a few years earlier. And, eventually, the FBI did investigate Henry because of his ties to a radical DC bookstore cooperative. Publicly, he stepped further away from the radical Left. Over time, Henry's position in the federal government had made him appear as more of a political conformist who toed the Democratic Party line. New Deal offi-cials and their congressional supporters were engaged in a fierce struggle on two fronts: against the Dixiecrats in their own party, who defended racial exclusion, segregation, and discrimination in federal programs in the South, and the conservative Republicans, who opposed federal regulation of business and public expendi-tures for social welfare. He remained active in the National Negro Congress, the National Urban League, and the League for Mutual Aid. He joined the DC chapter of the United Federal Workers, which was fighting for equal employment for Negroes in the fed-eral government.

The Moons did, however, find some shared political causes on which they could join forces. Mollie and Henry hosted events to-gether at their DC home, which established their power-couple identity as fighters for social justice. They had dinner parties,

informational meetings, and rallies for the National Negro Congress, the CIO, and FDR's reelection campaign in 1940. Louise Thompson, their friend from the *Black and White* days, told Henry that Mollie should have Haitian poet and Marxist theorist Jacques Roumain over for a private dinner. Henry believed that, since Roumain was exiled after being imprisoned for opposition to the US–supported Sténio Vincent regime, he might be short on funds. Acts of generosity formed the crux of Mollie and Henry's early philanthropy. They established a tradition of hosting events at their home that reached even greater magnitude in the 1950s, when the Moon name was synonymous with gatherings that brought the smartest progressive Blacks and whites into the same room to discuss politics and celebrate the arts over one of Mollie's stellar home-cooked meals.

Harlem, Spring 1940

After two years of long-distance living, a different kind of ache threatened to rip the Moons' marriage apart. Their relationship was suffering under the weight of the geographical distance between them and their uncertainty about when, if ever, they would live in the same city. Binge drinking became a coping mechanism for Mollie's high-stress job and her loneliness. One Saturday night she stopped over at a girlfriend's house and "drank so much beer that I'm going to go to bed and sleep 'til Monday." The next month she tearfully lamented that there's "nobody to take me to the party and nobody to come home and sleep with me." Henry had been her favorite nightlife companion, but they weren't able to party together like they had before. Yet she never made any serious attempt to change the situation. It was Henry who demanded some resolution. "Our primary and most urgent need" is "to get together

permanently," he declared. "If we're going to have a home, and we must, we must share it together, not occasionally, but always."

Henry also wanted children. He sent Mollie a newspaper clipping, headed "Do You Want a Baby?" It was a fertility treatment advertisement targeted at women suffering from "functional weakness," which the ad said made it difficult for married couples to experience the full joy that comes from parenthood. Henry wrote in the margin: "Does this interest?" It is unclear whether Henry was referring to having a baby, seeking help from a fertility specialist, or both. In the 1940s, birthing children was considered natural for married women. Those who had difficulty getting pregnant were thought to be scarred by venereal disease or sexually frigid. The blame fell squarely on the woman's shoulders, not on her male partner's, even if his low libido or low sperm count was a factor. With Mollie approaching middle age and having been married to Henry for two years without showing any signs of pregnancy, people would have been wondering. And perhaps Henry himself had doubts and concerns.

It is likely that Henry saw the question of having a baby and the issue of their commuter marriage as two sides of the same situation. Appealing to Mollie's presumed maternal instinct could induce her to be more proactive about living together full time. Mollie never discussed anything related to fertility in her letters. If she worried that she might be infertile, the issue would have been so deeply personal and perhaps shameful that she would never expose her feelings on paper. It is also possible that she was not ready to be a mother and secretly took measures to ensure that she did not become pregnant before she was ready.

Perhaps to save her marriage, Mollie relented and agreed to start planning for a baby. They set up a special savings account

and committed to seeing each other more often, hoping more lovemaking would lead to a pregnancy. Henry continued to look for employment in and around New York City. Mollie, conversely, seemed to become more resolute about maintaining her career in New York. If they were to start a family, it would not be in Washington.

At the same time, Mollie's activism was reaching new heights. She was tapped to direct a major fundraising initiative for a left-wing art center in Harlem that had been underfunded by the WPA. Her community had called upon her and the unique skill set she had been building as a social worker, public intellectual, and hostess with an address book of powerful and resourceful friends. And that, it seems, became more important than any promises she'd made to Henry about having children. The campaign thrusted her into the spotlight in ways she had never been before, putting her politics on clear display. It could potentially land her in the crosshairs of anti-communist elected officials. Was she ready to tangle with the New Deal government that employed her husband?

Becoming a Fundraiser

Harlem, Spring 1940

A crowd of hundreds, dressed in their Sunday best, filled the gallery in the Harlem Community Art Center (HCAC) at the corner of Lenox Avenue and West 125th Street. Since its founding in December 1937, it had become a popular gathering spot for a cross section of Harlem Negroes, from the poorest to the wealthiest. Social club meetings, nickel dances, and theater after-parties—nearly any group could hold an event there. But its student showcases gave Harlemites an opportunity to support the adolescents and adults who were enrolled in the HCAC's free courses on painting, lithography, metalwork, and sculpture. Harlem youth whom the media had written off as "slum lad[s]" were embraced at the HCAC and

encouraged to see themselves as the future of American art. Jacob Lawrence; Gwendolyn Knight, an immigrant from Barbados; and Robert Blackburn, the son of Jamaican immigrants, were among the HCAC's star students.

Mollie sauntered through the gallery, taking in the watercolors and lithographs created by novices who had been allowed to unleash their imagination. She loved supporting this type of art. Her and Henry's growing art collection—which included Aaron Douglas and Romare Bearden originals—reflected their deep commitment to Negro contemporary art. HCAC students were being taught in this Africa-centered plastic arts tradition. The HCAC's philosophy, articulated by its founding director, Augusta Savage, was "look around you and paint." Students were being taught that the plastic arts were an insurgent medium, which they could use to create new worlds, new possibilities—to imagine freedom on their own terms.

Mollie got a bit choked up as she engaged with students who stood proudly by their creations. *These showcases are a smart move*, she likely thought. She could see current HCAC director Gwendolyn Bennett's strategy. Inviting neighborhood folk into the HCAC for an event like this enabled them to connect with the students—the center's lifeblood. And the more invested they felt in the students' success, the more willing they'd be to give money to cover the center's high monthly overhead. Coaxing everyday people to contribute generously involved locating potential donors' heartstrings and pulling ever so gently, finding that sweet spot between sentimentality and social responsibility.

Gwendolyn and members of the center's interracial faculty greeted parents, spouses, and community stakeholders. They explained that classes had twenty or more adults and children

learning together. The adult students came from all walks of life: elevator operators, construction workers, domestics, and department-store janitors and clerks. Many were recent migrants, and most were un- or underemployed. For some, taking classes at the HCAC was about developing a practical skill that could help them earn supplemental income. For others, it was a creative outlet. And they had the benefit of learning from Gwendolyn and other leading figures of the New Negro Renaissance, including Aaron Douglas, Louise Jefferson, Langston Hughes, and Romare Bearden.

Mollie admired the radical arts curriculum that the center's teachers had established. She had put aside her desire to be a biology teacher and had fully embraced her career in social work. But the HCAC was a shining example of the type of progressive New Negro educator she had hoped to be. HCAC instructors consciously decentered European artists whom the mainstream arts world considered foundational. Instead, they traced a genealogy that centered ancient African and Asian visual traditions in ways that rejected linearity and embraced non-Western cosmologies and alternative understandings of time and space. Africa, the Caribbean, and the US South emerged, then, not as places that were given art by Europeans or played the role of primitive muses of white modern artists but as spaces where people had been making and remaking art since the beginning of time.

Gwendolyn—"Gwennie" to her friends—had become one of the country's leading Negro arts educators. Born in 1902 in the cotton-growing town of Giddings, Texas, Gwendolyn earned a BS in fine arts education from Columbia University's Teachers College and a BA in art from Pratt Institute in 1924. She taught design and painting at Howard University's Art Department for three

years. A scholarship from Delta Sigma Theta sorority, of which Gwennie was a member, enabled her to study art in Paris in 1925. Then she, along with Aaron Douglas, received funding from the prestigious Barnes Foundation in Merion, Pennsylvania.

Gwennie was lured back to New York to work as an editor and illustrator for the National Urban League's *Opportunity* magazine. She joined the literary circle that orbited around Harlem's 135th Street Library, which included Langston Hughes, Jessie Redmon Fauset, Alain Locke, and Countee Cullen. Bennett's monthly *Opportunity* column, The Ebony Flute, garnered her a loyal audience who read her unflinching takes on race and gender inequality. Like most Black artists, Gwendolyn had faced many hardships during the Great Depression, which had all but derailed her art career.

The HCAC had given her new hope. Finally there was a place where she could put her skills as a trained arts educator to good use. She was the director of the Harlem Artists Guild—a collective of emerging and established racial-justice-minded Black artists—when they first began having conversations about how they could use WPA funds to help finance an artistic hub in Harlem. In Bennett's vision for the arts in Harlem, the center would be the "nucleus of a National Race Museum," which would house and display the works of Negro artists. Although the nation's capital was home to the Smithsonian museums, many believed that Harlem was the cultural epicenter of Black America.

"The entire community of Harlem is interested and stimulated," Bennett told a reporter. "It is planned to make this community art center felt even more widely, so that the city, as a whole, will keenly watch its progress and will aid this endeavor." In a later interview she expounded upon her vision: "The long line of visitors from Harlem and from the rest of the world, and the growing esprit de

corps among the people who worked in the center, began to pour into it the life blood necessary to make it a living, breathing force in the community."

Mollie remembered how hard Gwennie and Augusta had worked to compel bourgeois Negro activists to support the arts more energetically. Some had joined the HCAC Sponsoring Committee, the majority of whose ten members were Black. A. Philip Randolph, who led the Brotherhood of Sleeping Car Porters and the National Negro Congress, was the inaugural chairman. Rev. Lorenzo H. King, who pastored one of the largest and most progressive churches in Harlem, was vice chairman. Dr. C. B. Powell, a prominent Harlem dentist and owner of the *Amsterdam News*, was treasurer. Eunice Hunton Carter, assistant district attorney of New York City; James Baker, administrative supervisor of the NYC Department of Welfare; and social worker and Urban League activist Lester Granger also served on the committee.

The center had the support of First Lady Eleanor Roosevelt, who wrote about her visit to the HCAC in her syndicated news column, "I think we have here a most interesting addition to the cultural life of Harlem and the city in general." Less than two years after its opening, the HCAC was heralded in the press as "one of the most significant aspects of Harlem life." Another called it "the most colorful" of the WPA art centers. The first WPA community art center was established in Raleigh, North Carolina, in late 1935, and by the early 1940s nearly fifty art centers had popped up in places as small as Roswell, New Mexico, and Sioux City, Iowa, and as large as Minneapolis, Washington DC, Birmingham, and Miami. They represented the type of American democracy FDR dreamed of building, which was sustained by and served the laboring class.

The Harlem center was by far the standout. More than twenty

thousand visitors—ten thousand in its inaugural year alone—from around the globe had made their way to Harlem to visit the center. Albert Einstein, the theoretical physicist and Jewish refugee from Nazi Germany who supported racial justice, came to view an exhibition during Negro History Week. An editor from a prominent Paris newspaper wrote in the HCAC guest book: "One goes many places, seeing many things but being little impressed; but here, indeed, one sees a true impression of a New World." It was a popular destination for civic organizations with visitors from Scotland, China, Palestine, and Japan.

Mollie was utterly dismayed when Gwennie explained to her that the center was woefully strapped for cash. Its funding crisis was intertwined with complex local, state, and federal politics. Since it had opened, the HCAC had been running "on a shoestring." Initially, the HCAC was fully financed by the WPA. Audrey McMahon, regional director of the Federal Art Project, stated that the HCAC's annual operating budget was approximately $100,000 and made it clear that the Harlem community would have to assume more of the cost. *How* Black New Yorkers could raise enough money was not the federal government's problem. Negro institutions, from K–12 schools to colleges and universities, were chronically in a precarious financial situation, given just enough resources to be forever beholden to white benefactors and blamed for their inability to become self-sufficient.

It pained Gwendolyn to have to speak with reporters about the HCAC's money challenges. "The Federal Government promises to continue to pay the expence [sic] or salary of the teachers and all needed help," she stated. Disclosing that the New Deal was supporting the center longer than it had anticipated underlined the notion that Harlem needed a handout. Stories with headlines such

as "Harlem Helping Art Center Get Cash for Paint" and "Harlem Pushes Fund to Assist Its Art Center" that ran in the *Amsterdam News* spun a different narrative, focusing instead on the enterprising ways that Harlemites were raising funds. Community leaders were eager to secure the center's autonomy. Even those who valued the WPA understood that, for Negroes, it was rarely beneficial to be in the government's pocket.

Despite its financial woes, the HCAC was outperforming most of the other centers in terms of enrollment numbers and the prestige it was bringing to the Federal Art Project. Gwendolyn and the staff were starting to feel some "uneasiness about the limitations of the space in the future." Standing before the small crowd at a public meeting of the Sponsoring Committee, Gwendolyn reported that during its first three months of operation 558 children and 392 adults had enrolled in the program, and 9,132 drop-in students had attended classes. By the end of the year, enrollment had increased to more than 3,000 students. The HCAC had already outgrown its current facility and would need to acquire a larger space. Where would they get the money?

Bennett understood that in order to sustain the HCAC, she and her team would have to create what she called "a truly mass sponsorship." They had to cultivate a donor base among progressives of all races and incomes, from "housewives" to "the upper classes," who "need something to do." Despite being overburdened with requests for money, the community took seriously the responsibility of raising cash for the HCAC. Among people of African descent, giving was a moral and social responsibility regardless of income. For many, this imperative came from their Christian faith's mandate to tithe 10 percent of what they earned. For others, it was a commitment to a mutual aid practice derived from the West Af-

rican *sou-sou* tradition, Caribbean friendship societies, and other non-Western modes of giving, which would have been especially familiar to West Indian migrants.

Everyday Harlemites were givers, and according to the *Amsterdam News* they gave "generously" to HCAC, setting ambitious goals to keep its doors open, including establishing a building fund for its expansion. In the summer of 1938, HCAC students reportedly raised $15,000, a feat the *Daily Worker* deemed "an unusual achievement for a community like Harlem." The center also received financial support from Black labor unions. Randolph's Brotherhood of Sleeping Car Porters was the first to send HCAC a check, for $2,000. In return, Gwendolyn Bennett announced, the center would offer a series of lectures and exhibitions specifically for trade unions. Receiving $17,000 total from its grassroots supporters was a huge deal for the HCAC. But it would be nearly impossible to raise large sums like this each month, to cover its six-figure annual operating budget, not to mention support a building fund. Throughout the next year, the HCAC was barely making its way and remained heavily dependent upon WPA funding.

Bennett asked Mollie to chair the HCAC's Program Committee, which would in essence make her its lead fundraiser. In many ways, Mollie was the obvious choice. She frequented HCAC events, was good friends with its leaders, and had a leftist vision for racial justice empowered by the Negro arts. Above all, she was well connected. She knew every Negro of import from New York to DC, Chicago and back, and even some wealthy whites. As a social worker, she was a keen observer of human behavior. She understood people's motivations, their pleasures, and their needs. She could turn an abstract idea into a well-laid plan of action. At that time, many social workers were taking their professional skills and

moving into public relations, event planning, foundation philan-
thropy, and NGOs. Mollie chose to use her skills to aid the Black
Freedom struggle instead of working for a white organization, if
one would have hired her.

Yet the HCAC building drive would be her first large-scale
fundraising initiative. It was risky to give a nascent fundraiser such
a crucial responsibility. It was one thing to plan small parties for
friends but another to cultivate donors and execute big events.
And if civic-leader heavy hitters such as journalists Bessye Bearden
(mother to Romare) and Geraldyn Dismond (who would later go
by Gerri Major) or scholar-activist Eslanda "Essie" Robeson hadn't
been able to raise enough money when they headed the committee,
how was Mollie supposed to pull it off? These women were known
for having powerful contacts in high places and for being able
to cut through bureaucratic red tape, whereas Mollie hadn't yet
amassed that level of juice and political influence. But the HCAC
was out of options. Plus, Mollie had youth on her side; maybe she
could tap into the interests of young Negro professionals in ways
the elder women could not. She was already under a lot of stress at
her day job with the Department of Welfare, so she thought twice
about taking on another obligation. But she concluded that fund-
raising for the HCAC would be a welcome change of pace. Plus, it
could take her mind off of her marital woes with Henry, who was
still living in Washington, DC, full time.

Mollie set right to work coordinating what would become her
first fundraiser, a cabaret dansant held on June 16, 1940. She and
other members of the planning committee met at the home of Alta
Sawyer Douglas in the illustrious building at 409 Edgecombe in
the Sugar Hill section of Harlem. Essie Robeson, Bessye Bearden,
and Louise Thompson were all there. Together, they mapped a so-

cial schedule for the HCAC. Every event would be strategically planned, with a signature gala that patrons could look forward to each year. To secure donations, a fundraiser had to entice donors to save the date on their social calendar and commit to giving a definite sum, which would help the organization meet its annual budget. The event had to be so utterly entertaining that folks could not wait to open up their pocketbooks to attend.

As the name suggests, a cabaret dansant was not a high-energy, sweatbox dance of the sort that everyday Harlemites associated with the HCAC. With tiered seating, tables, and box seats costing more than standing-room tickets, Mollie envisioned this event as appealing to those with upper-middle-class tastes and incomes. Mollie had persuaded Bob Douglas, the manager of Harlem's famed Renaissance Ballroom and Casino, to donate the space. Mollie tapped her connections at Café Society, the left-wing jazz joint downtown where Mollie was a regular, to secure Tallulah Bankhead, Hazel Scott, and the Café Society's Golden Gate Quartet as entertainment.

Publicity was still their "weakest spot," Mollie told the members of the committee. The previous committee had done a great job in corralling working-class Harlemites to attend. Mollie and her team did not consciously aim to displace these regulars. But they had to figure out how to spread the word about HCAC's new programming to attract big-dollar donors. They decided to take a two-pronged approach to publicity. First, they partnered with someone who was a whiz at creating flyers and other graphics. Then they chose prominent people they knew to serve as honorary sponsors. These sponsors' names on the invitation would confer prestige on this worthy cause. Mollie insisted that the Program Committee create its own letterhead. To ask individuals to be honorary sponsors and vendors to donate food, beverages, and entertainment,

they needed to look like an official organizing body. And Mollie loved seeing her name atop the stationery as committee chair.

The last step was to engage members of the press in covering developments at the HCAC. Mollie befriended Mayor LaGuardia's press aide, John Slocum, and coaxed local papers to spread news of the HCAC's "emergency appeal." In June 1940, Mollie told the press: "Unless the citizens of Harlem respond to this call, the continuation of the cultural program at the center will cease and the community will lose one of the most progressive institutions of its kind set up in recent years." The *Amsterdam News* dubbed Mollie and her Program Committee "the socialites," which gendered and trivialized their work. But all of those women understood that fundraising was a crucial part of the Black organizing tradition. Social justice movements floundered without strong financial backing. And not everyone could do this work. Master fundraisers had to be skilled and versatile. Under the veil of genteel womanhood, these savvy strategists could win over supporters. As the *Afro-American* recognized, "people are willing to pay for pleasures," such as dancing and stage shows, and this "give and take" model of fundraising was effective. Mollie was now in the business of crafting memorable social experiences in exchange for donations.

Unfortunately, the cabaret night did not raise the $15,000 needed to get the HCAC back in the black, but it was a sign that there was an economically solvent, vibrant Black upper crust whom the HCAC could tap to donate to the center. The HCAC really needed an endowment to buy a building of its own, which is what Chicago's South Side Community Art Center founders had done. Until then, it would be shuttled from one government-owned building to another—provided that public funding continued at all. It had been booted out of the expensive building at 290 Lenox

Avenue and into 107 West 116th Street, between Lenox Avenue and lively Seventh Avenue. In this new space, the HCAC could now at least afford to pay its own rent.

The financial stability necessary to buy a building of its own, or at the very least secure a favorable long-term lease, could not be achieved on the small contributions of porters, domestics, numbers runners, and elevator operators. Each month had brought more debt to pay off. Now they needed a large infusion of cash. The challenge was that they still wanted the bulk of the money to be raised by the community so ordinary Harlemites would feel that the center belonged to them.

The HCAC's funding exposed an acute structural issue: the Sponsoring Committee was asking cash-strapped Negroes for money they simply did not have. Most African Americans were struggling to get by. Few were homeowners; renters paid slumlords exorbitant rents for poorly maintained apartments. They had to buy necessities at inflated prices. They had little access to ordinary checking and savings accounts and were denied small loans. The debate about the HCAC's financial crisis reflected a larger Depression-era conversation among Negro public intellectuals and politicians about government funding and private philanthropy. Assemblyman James E. Stephens of Harlem argued that despite "a general disposition on the part of the white man to give the Negro philanthropy," what Negroes really wanted and needed was more action to get "economic justice," their "just share of the economic opportunities." They needed to form a "united political front" to demand state appropriations and not "beg for what will be handed out."

Mollie's fundraising philosophy was grounded in what we today call "gala circuit philanthropy." Galas remain a popular style of fundraising because the promise of entertainment and networking

entices even those who don't care about the cause to pay money to secure a ticket. They are far less tedious, for attendees, than door-to-door fundraising and other forms of mass philanthropy. But they also have drawbacks. The cost of throwing an event might consume half of the funds raised. Galas also marginalize people who cannot afford the price of admission and create a cultural barrier for those who do not have the requisite social graces to blend in. And in the Depression Era, some believed galas reproduced the logics of conspicuous consumption that reeked of Gilded Age indulgence. Galas wouldn't liberate anyone from poverty. But Mollie likely reconciled these contradictions by deciding that Negroes deserved a taste of the good life too.

In February 1941, Mollie launched what would become her signature fundraising event: the Beaux Arts Ball, a costumed fundraiser, at the Savoy Ballroom. This lavish affair was a major departure from the HCAC's fifteen-dollar dances: tickets to the ball started at more than three times that amount. The Beaux Arts Ball would be even grander than the dansant. The committee recruited dancer Katherine Dunham to be a sponsor for the initial ball, along with Lieutenant Governor Charles Poletti, Colonel Theodore Roosevelt III, Orson Welles, Paul Robeson, and Ethel Waters.

Mollie wasn't the first to host a beaux arts, costumed ball. But hers was inspired by Caribbean carnival and queer Harlem culture—namely the legendary Hamilton Lodge, No. 710's annual drag ball. The ball was a night of racial fantasy cosplay, with some of the most prominent Black and white people in the Greater New York area dressing as can-can girls, Carmen Miranda, Scarlett O'Hara, ladies of the Spanish Court, and Tarzan and Jane.

Costumes enabled gala goers to slip into the skin of "the other," to masquerade and imagine what it would be like to have or to

give up privilege and inhibitions for a night, knowing they could safely retreat to reality at dawn. For some, this type of otherwise taboo cosplay that allowed them to delight in the fleshiness of pleasure would have been worth the price of admission. Phil Thomas won the best costume prize—a cruise to the West Indies, valued at $1,500—for his Sheik of Araby getup. Runner-up prizewinners were awarded artworks by HCAC students. Mollie solidified herself as the queen of the gala circuit when she showed up at the ball dressed as Marie Antoinette—a queen theme she would continue over the years.

The Program Committee told the press that the proceeds from the ball would go toward paying off the HCAC's current debt and launching the much-discussed building fund. Bessye, Alta, and Eslanda remained on the committee. New members included Helen Harden, who became one of Mollie's close friends, and thirty other people who contributed their practical skills in publicity, graphic design, and catering or access to people in their address books. A network of socialites and middle- to upper-middle-class Negro arts patrons spread the word, making the Beaux Arts Ball *the* event of the season. For most attendees, these gatherings were pure entertainment. Many had no deep interest in the arts but loved their community and wanted to contribute to its future. Others became art collectors and attended gallery exhibitions at progressive venues such as McMillan Gallery and Downtown Gallery, which showcased contemporary Negro art.

Harlem, Spring 1941

As Mollie and the other women of the HCAC Program Committee were cultivating more Negro art enthusiasts and donors, right-wing politicians intensified their attacks against the center.

No one wanted to be affiliated with communism now that World War II was raging in Europe and the USSR was not yet an Allied power. In April 1941, the press leaked a story that Gwendolyn Bennett was one of nine WPA supervisors who was suspended because she was alleged to be involved in communist activities. Affiliation with communists and Nazis violated the Emergency Relief Appropriation Act's section on "subversive activities," which required that all such employees be terminated. The body popularly known as the House Un-American Activities Committee began a long investigation into the charges against Bennett, and until she was cleared she could not serve as the center's director. It didn't help that Gwennie was married to Richard Crosscup, a white Harvard graduate and progressive educator, at a time when interracial marriage was still rare and taboo. They likely would have targeted her for this transgression alone.

This was exactly the kind of negative press that Gwendolyn had feared. She knew that any allegations of communist ties would drive away the philanthropic base of respectable Negroes they were cultivating. The HCAC knew the charges were bogus and were intended to cast aspersions on the center, which might force it to close. The Sponsoring Committee supported Gwennie, and in an act of solidarity refused to appoint a new director in her absence.

Mollie watched what was happening to her friend Gwennie, knowing that it might not be long before the feds targeted her as well. One day in July 1941, investigators came to her office at the NYC Department of Welfare to speak with Mollie and her supervisors. Henry, who was himself under FBI investigation in Washington for his ties to left-wing cooperatives, had coached her in advance: "Do not refuse to testify under any circumstance"

and "avoid identifying anyone as a Communist" who is not already publicly affiliated with the Communist Party. If questioned about her work with the HCAC, Henry suggested she tell them: "In working on the Harlem Art Center committee, [I am] aiding the government in establishing a much-needed cultural center." He also recommended that Mollie start thinking of a list of references whom "no one could well afford to question," such as Eunice Hunton Carter, Lester Granger, and John Slocum, and "who could testify on your behalf if necessary." It was a wrenching time for them all, as they watched friends and comrades be interrogated and investigated by government agents. Many fell into desperate financial straits as a result of lost jobs and tarnished professional reputations.

Union leaders often asked Mollie to chair defense funds for people, like prominent Panamanian-born labor activist and attorney Ewart Guinier, who were also under investigation. She had become the leading fundraiser for the Left, and the unions knew if anyone could garner financial gifts it was Mollie Moon. Politically, she wanted to aid as many people as she could, but with her own potential investigation looming and a desire to keep her professional reputation intact, she was unsure if she should. Henry and Lester Granger warned her against it because at the core was the question of communism, and Mollie's trip to the USSR made her vulnerable. Granger told Mollie he was "tired of nigger men losing their heads over Communism and white tail." Southern politicians were willing to destroy African American men's careers for even giving the impression that they were colluding with communists or sleeping with white women. Granger couldn't understand why so many Negro men would walk right toward these land mines, knowing the dangers of doing so.

Harlem, Winter 1942

The government-sanctioned attacks against Gwendolyn and other left-wingers affiliated with the HCAC had raged on for nearly a year after the initial probe. In wasn't until January 1942 that Gwendolyn was cleared of all charges. The HCAC was still standing but had been badly wounded in the battle with Congress. Financial troubles were mounting, and when the United States entered World War II, government funds were redirected toward national defense and the arms industry.

Mollie was planning the second annual Beaux Arts Ball when she received a call from Audrey McMahon on January 30, 1942. "WPA cannot at this time afford to have any publicity connected with the project," McMahon said. She was concerned about the event's "Victory" theme—a play on the Double V campaign that African Americans were supporting for victory over fascism abroad and over racism at home. McMahon also questioned the committee's plan to give some of the funds raised to the Harlem Center for Active Service Men. "Myself and other local WPA officials have decided it is unwise and will lead to more criticism." She closed by saying: "If the Center as it stands—now gets any publicity—it may mean the end." Mollie and Audrey had never seen eye to eye. McMahon represented the best and the worst of white progressive government officials who controlled the flow of money to the Negro community. The personal control McMahon exerted over the funds made her feel more like an adversary than an ally. But the weariness in Audrey's tone that evening let Mollie know that the end of the HCAC and the WPA was imminent and inevitable.

If the center were to be closed soon, Mollie was going to ensure it went out with a social whirl to end all social whirls. On March 13, 1942, Mollie and her committee held the second Beaux Arts

Ball. They had amended the invitations to satisfy McMahon's concerns, while partnering with the Harlem Center for Active Service Men and adding Allied War Relief to silence critics. Press coverage leading up to the event encouraged Negroes to put the Beaux Arts Ball at the "top of your season's list of charity affairs." The costume prizes were nine-hundred-dollar and four-hundred-dollar defense bonds. The crowd was not as large as the first ball, but it was a "brilliant affair." The Committee had even hired horse-drawn carriages to bring ball attendees from Harlem subway stations to the Savoy, since the government had enacted gasoline rations. Even amid a world war, Mollie was invested in Black luxury. Because of the somber wartime mood, most were not in costume, although a few came dressed as clowns, Turkish harem girls, Spanish señoritas, Aunt Jemima, and South Americans in straw hats. In keeping with her queen theme, Mollie came dressed as Queen Elizabeth. Perhaps knowing that this might be the last Beaux Arts Ball, people danced a little more exuberantly, allowing themselves to sweat out their coiffed hairdos and to eat and drink in a manner that veered into the socially indecent.

Without so much as a public farewell, the doors of the Harlem Community Art Center were closed sometime in 1942 when the WPA lost its funding. There was no press coverage in the major Negro or left-wing publications. The most high-profile Black community art center in the country had closed, and there was not even a peep about it until decades later. During and immediately following the war, there were virtually no venues for African American artists to exhibit their work. Unemployment, housing insecurity, drug abuse, and violence increased as police brutality and corruption intensified. Harlem was labeled an "urban wasteland" by politicians and journalists.

The HCAC's leaders picked up the pieces of whatever egos and dreams had been shattered in the wake of its closure. All were weary from years of battle with the government, politicians, and one another. Gwendolyn Bennett cofounded the George Washington Carver School in Harlem in 1943, a progressive school that educated mostly poor neighborhood children. That same year, Bessye Bearden died, and the community paid tribute to the woman who had devoted her life to racial justice. She had been the first woman to serve on the New York City School Board, and she had been on the executive board of the National Urban League and the treasurer of the National Council of Negro Women. The political salons she hosted in her living room brought together the intellectuals and artists who moved through Harlem. Her death symbolized a changing of the guard, with Mollie now positioned to continue Bearden's work, seamlessly blending the political and the social.

Mollie's next opportunity came shortly after her good friend Lester Granger—who had been on the HCAC's Sponsoring Committee—was appointed executive director of the National Urban League in 1942. The NUL had been founded in New York City in 1910. Like the NAACP, the Urban League was established by an interracial coalition of progressives. It aimed to improve the economic conditions of people of African descent in cities during the Great Migration. The organization established affiliates across the country. New York City was home to NUL headquarters and had its own affiliate. There was a great deal of overlap between the national leadership and the Greater New York affiliate, and together they exerted a strong gravitational pull on the other Urban League affiliates across the country, although many were developing their own successful initiatives that advanced the NUL's economic agenda.

Granger envisioned a new social unit for the NUL that would be part public relations, part fundraising. He had been impressed with Mollie's direction of the HCAC Program Committee and asked her to head this NUL auxiliary. The NUL needed a face-lift to recruit more members and to attract more donors, both of which helped to fund the operating budget. Granger gave Mollie nearly free rein to imagine this new vehicle that would carry the NUL into a new era.

Mollie had learned many lessons during her time with the HCAC and had a better understanding of what it took to be a successful fundraiser, event planner, and grassroots philanthropist. She brought all of that wisdom to this new endeavor, which she called the National Urban League Guild. The Guild was an "interracial volunteer club of young professional people" that quickly became the hip and stylish arm of the NUL—like the Urban League Young Professionals today. Many of the women who had served with Mollie on the HCAC Program Committee—including Alta Douglas and Helen Harden—joined the Guild. They set about helping Mollie organize and convene events to educate the public on social justice and civic issues of the day, promoting "interracial understanding" among college students and sponsoring special projects that "interpret the social and economic problems of the Negro population." In less than a year, the National Urban League Guild had fifty-eight active volunteers in New York City. Mollie's goal had been to keep the inaugural group small yet potent, believing that if they made a deep local impact that garnered national attention, more people would want to launch guilds elsewhere.

Mollie managed to hold down her full-time job with the Department of Welfare while she spearheaded Guild work, which was even more demanding than the HCAC fundraising. It helped that Henry had finally gotten a transfer to a government office in

New York. Now the Moons could give up the apartment in Washington, where they had never lived together full time. Their life as a power couple would begin in earnest in New York City, four years after they had exchanged vows. Mollie finally terminated the lease on her beloved apartment in San Juan Hill, trading it in for a more distinguished locale: Sugar Hill. The Moons moved into a three-bedroom apartment on St. Nicholas Avenue, joining a neighborhood of illustrious Black civic leaders and entertainers. And now, with their careers flourishing and Mollie's fulfillment in her civic life, they could revisit the issue of starting a family, though it would still be years before they welcomed a child.

World War II ended in 1945, when German armed forces surrendered to the Allies—led by the US, Great Britain, the USSR, and China. The movement for racial equality gained momentum after the war, fueled by returning veterans. The Urban League and the NAACP became even more essential organizations in this fight. And Mollie's Guild flourished, as she helped to establish auxiliaries on the East Coast. Her reputation as a civic leader and fundraiser spread. By the late 1940s, Mollie was a national figure in the Urban League, known as much for her sultry image and tantalizing parties as for her well-honed skills in public relations and fundraising for nonprofits. Yet more fame and notoriety brought more gossip and innuendo about extramarital affairs. People speculated that her relationship with Henry could not survive the attacks on their marriage.

———

The Rockefeller Affair

Harlem, May 1948

"The success of our activities has been the result not alone of the hard work of the committee, but the generous support of the newspapers and radio," Mollie told the members of the National Urban League Guild who had gathered in the Moons' impeccably decorated living room at 940 St. Nicholas Avenue. "The Negro press and certain of the dailies have been most cooperative in all our activities." Guild members present included Mollie's friend Alta Douglas, muralist Selma Day, society writers Betty Granger and Fannie Keene, Marie Poston, whose husband Ted was Henry's best friend, and Marilyn Kaemmerle, a white woman who'd recently graduated from the College of William and Mary. The

women sat with their ankles politely crossed, in conservative skirts and blouses, as they nibbled on the light fare Mollie had on offer and chatted about the Guild's summer calendar. This year will be the Guild's biggest year yet, Mollie knew. And the man sitting cross-legged on her floor would have a lot to do with it.

Winthrop Rockefeller, or Win, as his friends called him, often sat on the floor at National Urban League meetings. Although he was the son of one of the wealthiest men in America, he wanted to appear as an equal to his African American colleagues. And you couldn't be more down-to-earth than on the floor, he reasoned. Win had been appointed the sponsor of that year's NUL mobilizations, and in that capacity, he was charged with working in "close cooperation" with Mollie and the Guild.

For six years, the National Urban League Guild had enacted Mollie's vision of becoming a world-class auxiliary of the NUL that could raise sizable donations among the New York Negro elite for its parent organization. When the NUL's executive director had first approached Mollie about forming a Guild, she hadn't had much formal experience in the fundraising arena beyond her work with the Harlem Community Art Center. But she had vision and a useable skill set that was easily transferred: an astute political mind, a network of friends from New York to Washington, and perfect taste. Mollie recruited women from within her circle of friends to join the Guild. She strategically cultivated relationships with reporters and local business owners. And she had a following of regular attendees who eagerly flocked to Guild fundraising events. All the monies the Guild raised went directly to the Urban League headquarters to be used at the executive committee's discretion. As Granger told *Opportunity*, Mollie and her New York City Guild women had sparked a grassroots "Guild movement"

throughout the country. Other Guild chapters, connected to their local League, began sprouting along the East Coast and even in the Deep South. They emulated the New York Guild's model of fusing entertainments with messaging about the power of social change.

In the Guild's early days, Mollie articulated its left-wing political genealogy, making clear that although it was aligning itself with the NUL's motto of "interracial social action" it would continue to operate within the radical Black organizing tradition. Mollie told the *Pittsburgh Courier*: "This group was the outgrowth of a group organized in 1938 to assist in the financing of the Harlem Art Center, which originally had been established with WPA funds.... Although its membership is open to both races and sexes, it is composed primarily of young colored women engaged in professional work." Notwithstanding the connections with Win Rockefeller and other wealthy whites she had to develop as a means of raising money, her commitment would always be to Negro women and the Negro community more broadly.

Now that Mollie's National Urban League Guild had built this momentum, it had to elevate and expand its agenda rather than rest on its laurels. Mollie had increased the scope and scale of the Beaux Arts Ball she used to host for the Harlem Community Art Center to fit the NUL's mission. It had become a thriving costumed fundraiser that raked in upwards of $30,000 for the NUL each February. The ball was lauded in the press as "an interracial get together," "a magnet for the Negro social crust as well as crowds of liberal whites" where "champagne, whiskey and good spirits flow until early dawn." With the support and massive network of the NUL, the Guild had diversified its activities to include an exclusive summer party and cocktail parties as well as exhibitions.

The Guild had found a natural rhythm, but stepping into the

national spotlight had initially been a shock to Mollie's system. The Urban League was a behemoth—in comparison to the Harlem Community Art Center—with a sizable national headquarters staff and affiliates in many major cities across the country. She was play- ing in the big leagues now, alongside the most powerful people in the largest city in the country. The social services the NUL provided meant it had the attention of not only local and state politicians but also the White House and major business leaders across the country. Mollie used to have to plead with the mayor's office to send a representative to the Art Center's events. But they showed up willingly to League events, considering it politically expedient to schmooze with Negro community leaders and shake hands with their constituents.

Mollie's position with the NUL had forced her to relinquish some of her previous opposition to interracialism. Before, she could pick and choose the leftist whites—mostly artists and writers— with whom she'd want to partner. But now she had to cater to white racial liberals and economic and social conservatives alike to garner their support for the NUL. It was exhausting work. Still, she imagined the Guild as an African American women's power- base, where they could create a voice and visibility for themselves in ways that were ordinarily closed to them. The Guild's African- rooted traditions of mutual aid and paying it forward shaped its vision of American democracy.

Mollie and Henry Lee Moon had finally actualized their dream of becoming a racial-justice power couple. Henry had left his fed- eral government job to take a position as director of publicity for the national headquarters of the NAACP. It was a very prestigious opportunity; he was among the most powerful men in the coun- try's most powerful civil rights organization. In the NAACP, he at-

tained the prominence that he'd imagined having in his early days in journalism. Henry had recently published his debut book, *Balance of Power* (1948), which put him in the forefront of the national conversation about the importance of securing the Negro vote.

The Moons welcomed a daughter, whom they named Mollie Lee. Mollie balanced motherhood and being a wife with her full-time work with the Department of Welfare and her NUL volunteerism. She had become the blueprint for "having it all." The Moons wanted to leverage their power to demand sweeping reforms in the realms of economic justice and full enfranchisement.

Due to their high-profile positions in the NUL and the NAACP, the Moons' dinner parties at their Sugar Hill apartment became grander and included a star-studded roster of old and new friends who made up their social network. At the core, still, were their friends from the *Black and White* cast: Langston Hughes; Loren Miller and his wife, Juanita; Ted Poston; and Thurston Lewis. Political figures Walter White and Roy Wilkins of the NAACP, Ralph Bunche, Paul and Eslanda Robeson, and writers Ralph Ellison and Richard Wright were also frequent guests. The Moons befriended Victoria and Richard Bourne-Vanneck—or Vicki and Dick, as they were commonly called—an interracial British couple who'd recently moved to New York. Vicki was born into a prominent Black family in Cardiff, Wales; her grandfather was a decorated officer in the British Royal Navy. She spent her early childhood in New York with her mother before returning to England, where she finished high school. After a minor career in stage acting, she married Dick, a white gentleman who was born into wealth. He cast aside his white privilege to assimilate into New York's Black society, forgoing any potential business ties to prejudiced whites. The couple had bought *The New York*

Age—a prominent Negro newspaper whose origins traced back to the late nineteenth century and activist T. Thomas Fortune. The Bourne-Vannecks were committed to maintaining the paper's political independence while offering biting commentary on politics and economics in the fight for "unrestricted citizenship for every American."

Carl Van Vechten, the white writer, photographer, and arts patron, was known to make appearances at Mollie and Henry's parties. So was Bucklin Moon, a liberal white editor at Doubleday, who came to the Moons' parties to scout Black writers. He had been Henry's and Walter White's editor, and the Moons introduced Bucklin to Henry's first cousin, novelist Chester Himes, who lived in Mollie and Henry's spare bedroom while he launched his literary career. A string of labor activists with the interracial, left-wing-led Congress of Industrial Organizations appeared at the Moons' gatherings as they crisscrossed the country, organizing strikes and protests. And even African and Caribbean dignitaries paid their respects during visits to the US. Unlike in the Washington, DC, days, the Moons were no longer on the fringes; they were the nucleus of this group of racial justice warriors. And Mollie had been crowned the grand dame of Harlem society.

Despite the Moons' meteoric rise up the national social and political ladders, it was Mollie and Win Rockefeller who were discussed in the press as the Urban League's power duo. The more established Mollie became within the League, the more Granger invited her into its inner workings. She was meeting with the wealthiest white League supporters in New York City and advising on matters of fundraising and race relations. With Mollie and Winthrop, the NUL had brokered the political marriage of Harlem's biggest and most beautiful fundraiser to the wealthy, charm-

ing playboy with "almost movie-star good looks" and the legendary family name.

By the time Mollie met Win in the early 1940s, he had perfected his tortured rich boy persona. Win was the grandson of oil magnate John D. Rockefeller. Win's father, John Jr., and his mother, Abby Aldrich Rockefeller, the daughter of a wealthy and influential politician, had expanded the family's oil empire even further in the 1920s. The Rockefellers' visibility, global influence, and unbridled power was unparalleled. Winthrop rebelled against the family brand. He had been expelled from Yale for poor conduct and become a hard-drinking womanizer, dating actresses and cocktail waitresses. He was obsessively driven to convince the world that he was a man of the people. It had started when he fled to Texas after his ouster from Yale, at the height of the Great Depression, where he worked as a roughneck in the oil fields alongside the poorest whites and Negroes of the South. "Win [was] the most troubled of us and never quite fit in," David Rockefeller, the youngest of Win's siblings, remembered. Winthrop resisted the pomp and circumstance of it all. Moreover, he was sickened by the greed and corruption that lay hidden beneath the polite smiles and superficial charitable gestures that emanated from behind the walls of the Rockefeller fortress.

Granger and the NUL leadership hoped that attaching the Rockefeller name to its programming would exponentially increase the amount of funds they'd be able to raise. But Win wanted to be more than a prominent name; he wanted to be active in the planning. He had been an infantry soldier during the war and had returned a few years earlier with his eyes open to the horrors of American racism. Winthrop had cut his teeth as a fundraiser and organizer working for the Greater New York Fund, building his own donor contacts and spearheading multimillion-dollar campaigns. He

aimed to do all that he could to help Negroes achieve full integration. To prove the depth of his commitment to the NUL, in 1952 he sold $1 million of Standard Oil stock to purchase a new building for its national headquarters. His staunch public support of racial equality was an act of rebellion against members of his social class.

Mollie was no stranger to white men. In Europe, she had dated a few. But to be politically linked with a white man was new. The publicity generated by a gorgeous Negro woman and a slightly younger, wealthy white man tacitly trafficked in racialized and gendered stereotypes. In Harlem, Mollie was a respected social worker with deep ties to the community. Yet in the eyes many whites, she likely conjured up images of the mulatto bed wench who was available for the pleasure of white men. Win and Mollie's public friendship likely stoked fears of miscegenation and illicit sex—despite the fact that both Mollie and Win were married. Perhaps their marriages to other people even fanned the flames of gossip. The only thing juicer than a rich white man sleeping with a beguiling Black woman was if he was cheating on his white wife and the Black mistress on her Black husband. Ironically, it was good for business for the NUL. The adage "All publicity is good publicity" rang true. Winthrop was helping to recruit millionaires to the Urban League's cause, and Mollie was playing the role of beautiful helpmate who was secretly masterminding the fundraising.

But a storm was brewing around interracialism, private philanthropy, and racial capitalism. And here were Mollie and Winthrop, who had become the faces of the power of this campaign to secure full integration. Innuendo about the nature of Mollie and Winthrop's relationship caught fire, fueled as it was by Black activists' suspicions that wealthy white donors sought to contain Black protest and direct it into channels that did not threaten their own power and prof-

its. Plus, the pairing would have been unsettling to Henry. He was a secure man, and he and Mollie had what some gossipy folks thought to be an unconventional marriage. But the excessive linking of Mollie to Win would have brought uncomfortable comparisons between Henry and a man who had considerably more money, power, and influence. That would have been a blow to any man's ego.

However, Mollie and Henry likely discussed the new dynamic and chalked it up as a cost of their heightened visibility. It was better to ignore the chatter and do what was best for the League. Working with Winthrop was a maneuver that came with clear benefits for the NUL and its programming and fundraising goals. But to avoid crossing an unsettling line of compromise, Mollie would have to consciously determine how to maximize the gains without selling herself out.

The women gathered in Mollie's living room that May afternoon decided that they could really make people's tongues wag if the Guild held its summer party at the Rainbow Room and both Mollie and Winthrop signed the invitations. Win, of course, eagerly agreed, seeing the gesture as one that would stick it to the New York upper crust as much as it would aid the women of the Guild. Every act of defiance—symbolic or otherwise—widened the gap between Winthrop and his family. So he supported Mollie's causes and stood beside her as she battled Jim Crow. People would come to Urban League events largely for the spectacle of it all. They wanted a chance to shake hands with Winthrop and be photographed at a Mollie Moon event.

Midtown Manhattan, August 1948

The Rainbow Room was on the sixty-fifth floor of Rockefeller Center, a massive complex of commercial buildings on twenty-two

acres of prime Midtown Manhattan real estate that Winthrop's father had built in the early 1930s. The venue was once an exclusive cabaret, the type of establishment where Negroes could perform to the delight of white folks or work as service staff but could never enjoy as patrons. Ornate crystal chandeliers, a rotating dance floor, and a high ceiling that offered an unobstructed view of the Manhattan skyline gave the space its opulent charm. During World War II the Rainbow Room was forced to cease its operations as a cabaret and supper club, and it had only recently reopened to the public. Now Winthrop and Mollie were proposing to welcome Negro guests there for the first time, bringing it back to its former glory with their carefree dancing and drinking. Mollie Moon and Win Rockefeller were going to break the color line, and they were going to do it in grand fashion.

The Guild's summer party was distinct from the Beaux Arts Ball. Unlike the ball, where people came in costume, with many dressed as skimpily as possible, this was an after-five affair. And it was exclusive, by invitation only, whereas the ball aimed to sell as many tickets as possible to a cross section of Harlem and beyond. The summer party was to fete the NUL's loyal supporters and paid staff, who now numbered more than four hundred across the country. In summer, New York City emptied out, as many headed for second homes on Martha's Vineyard, in the Hamptons, or in Westchester County. The summer party was the soirée for those who stuck around and for out-of-towners for whom New York City nightlife promised the adventure of a lifetime. The event was usually held at the Savoy. But with the large-scale fundraising initiative the NUL was planning that year, they needed Mollie to step up the summer party as well.

When the cosigned invitations went out to guests, the event

almost instantly incited a buzz of chatter among society writers, attendees, and detractors alike. Some whites were disturbed by the fact that Winthrop had opened the Rainbow Room for the Urban League. But "nobody was going to buck the landlord. That's how we broke the color barrier," Mollie famously told the *New York Times*. Some Negroes were upset that the League, and by extension Mollie personally, had partnered so audaciously with the Rockefellers. It was further evidence of the League's anemic politics and pandering to whites in the vain hope that by parading into the Rainbow Room in their finery for a night of cocktails and dancing they would be forcing white New Yorkers—and all Americans—to see them as equals.

Most Black society writers viewed the summer soirée as a triumph. Nora Holt of the *Amsterdam News* offered the most colorful commentary: Mollie "rubs the magic lamp of Aladdin and presto, Mr. Winthrop Rockefeller proffers his most fabulous possession as an evening of fun and frolic." Dancing the night away in the Rainbow Room would be "as near heaven as some of us poor bedeviled mortals will ever get." The sexual innuendo of Mollie's influence over Win Rockefeller—that she could rub his lamp and get her way—hinted that their relationship wasn't platonic. Holt had put in print exactly what her readers were likely thinking.

That evening, the Rainbow Room was electric with energy. Guests came dazzlingly dressed in off-the-shoulder gowns, sequins, loose marcel waves and pompadours, smart tuxedos and shoes shined to perfection. Mollie had donned a sleek, cream-colored cocktail dress and an ornate, showstopping necklace and matching earrings. Her loosely coiled hair was parted down the middle and slicked back into a subtle flip that hit the nape of her neck, which accented her angular cheekbones and wide, straight

smile. She made the rounds, greeting guests and posing for photographs. For much of the night, she and her large party, which included Win, were seated at one of the room's elevated corner tables. The menu featured seafood cocktail, prime rib, and chiffon cake. Whiskey sours, gin fizzes, and champagne were on steady pour. Ordinarily, a dinner such as this in the Rainbow Room would cost more than two hundred dollars.

In typical Mollie fashion, she had recruited some of her favorites from Café Society to offer the entertainment. Boxer-turned-actor Canada Lee was the emcee. Billie Holiday, wearing a long-sleeved dress with embroidery across the neck and shoulders, kept the audience transfixed as her red-stained lips carved sounds into the air: "Southern trees bear a strange fruit." She held each note, allowing scenes of brutality against Black flesh to become etched on the soul. And then she moved into her melancholy rendition of "Lover Man," singing of another kind of heartache. A singer and stage actress who had been part of the Moscow *Black and White* cast also had sets. The evening closed with Sy Oliver and his orchestra playing bebop and samba standards that got couples out of their chairs, swaying and shimmying across the slowly spinning dance floor.

Fannie Keene, a Brooklyn-based society writer and Guild member, wrote proudly in her *Amsterdam News* column Keene Observation: "Once again the National Urban League Guild scored a triumph." The *Chicago Defender* proclaimed, "This was the first occasion when Negroes had entertained at night in the Rainbow Room." Some reporters speculated that this event in a venue formerly closed to Negroes was a turning point in the history of race relations in New York.

Harlem-based *Chicago Defender* writer Lillian Scott believed that other journalists were getting lost in the glamour and miss-

ing the obvious class politics involved. Lillian was an ambitious journalist who had begun her career writing for the Detroit-based *Michigan Chronicle* after graduating from the Ohio State University in 1944. Born in Savannah, Georgia, in 1923, Lillian represented a younger generation of Negro radicals who were using print media to publicly challenge capitalism and wealthy white philanthropists. An offer from the *Chicago Defender* to join its Harlem desk had given Lillian a chance to move to the Big Apple. Soon she had taken over the monthly column Along Celebrity Row. Lillian transformed it from a typical purveyor of society chatter into an exploration of the intersection of society, celebrity, and racial justice.

Attending as many social events to benefit racial equality as she could, Lillian studied the interpersonal politics, competing social agendas, and hypocrisy of the social elite. In her snarky and incisive commentary, she pointed to the fault lines in the Urban League's plan to persuade wealthy white allies to support its campaign to end racial discrimination in the workplace. Lillian had no loyalty to the older generation of Black leaders and felt no need to write praise songs about the interracial world Mollie Moon was making. She maintained just enough goodwill to be invited to its spectacular events.

Lillian Scott's favorite target was Winthrop Rockefeller. As if she were on the Win Rockefeller beat, Lillian lurked in his vicinity to hear gossip that would lend credence to her suspicion that his liberal rich boy persona was merely a cover, more a ploy to anger his parents than a real commitment to Negroes. Lillian was a bit kinder to Mollie, mostly because Mollie was not rich enough to rankle Lillian's anti-capitalist skin. But because she saw Mollie as a facilitator of this hoax, she did not praise her either. Her approach was to decenter Mollie from coverage of her own events. Striking a

blow to Mollie's ego would be punishment enough for her partnership with the likes of Winthrop Rockefeller.

Lillian had scored a coveted invitation to the summer soirée. Immediately, she criticized the elitism of charging eighty-five dollars, which included a mandatory sixty-dollar charitable donation to the Urban League. The price was prohibitive for everyday Negroes, even though it was considerably cheaper than a typical night of eating and drinking at the Rainbow Room. The event's exclusivity was obvious in the choice of venue. The Rainbow Room held only three to four hundred people, one-tenth the capacity of the Savoy. Only those white and Black elites who could pass the unspoken test received an invitation. Lillian reported that unlike the rollicking Savoy galas, at this event "everybody was there scanning everybody else's dress, hair-do, and escort."

Lillian found Winthrop in the crowd. As she shook his hand, she opened her mouth to ask him "why he wasn't home holding Bobo's hand as they expected a Winthrop Jr., soon" but thought better of it. Bobo was Barbara Sears, the daughter of Lithuanian immigrants whom Win had married earlier that year after a disconcertingly brief courtship. "The coal miner's daughter weds the billionaire's grandson" in the "Cinderella wedding of the century" was splashed all over the society pages. Now Lillian thought that Winthrop had already tired of his wife and returned to his playboy ways. In that Along Society Row story, Lillian began stoking the flames of rumors about Win and Mollie. If his do-gooder philanthropist bit was just an act, and he'd rather be with a group of people he barely knew than with the wife who would give birth to his first son and namesake a few weeks later, who was he eagerly consorting with? Lillian continued to drop hints about her speculations for her readers throughout the year.

Harlem, September 1948

September 15 marked the start of a week-long mobilization and fundraiser coordinated by Mollie and Win. The week culminated in a benefit show and dance to galvanize support for the League's work against job discrimination. "Urban League Week" was sponsored by the NUL Service Fund, and Granger had appointed Mollie to be its chair. Members of the fund committee coordinated fundraising efforts across the League's various national auxiliaries—the National Urban League Guild, the Women's Division, and so forth—and set the fundraising agenda for the entire organization.

The chair of the Service Fund enjoyed a tremendous amount of power and visibility. Under Mollie's leadership, the Service Fund appointed Winthrop the honorary chairman of Urban League Week, which gave them yet another opportunity to partner on a large-scale fundraising venture. To build enthusiasm for the week of events, Winthrop addressed more than three hundred campaign workers at Harlem's 135th Street Library. Only a lucky few found seats; most stood shoulder to shoulder, and others packed into the hallways. The heat and humidity were stifling; people pulled out their hand fans, rhythmically waving them to keep cool. Yet and still, people wanted to hear from Winthrop Rockefeller and perhaps get to shake the hands of Win and his brother John D. Rockefeller III. "It's not enough to contribute money," Win was known to say in his donation speeches. "People must make the gift of themselves, of their own time, their creative talent and spiritual strength." It was a message well tuned to his crowd. The Ephesonian Choral Ensemble then gave a rousing performance of Negro spirituals that set off a round of call-and-response and hand clapping that stirred up the spirit of giving, after which a collection plate was passed.

Later that week, it was Mollie's turn to take the spotlight at the volunteer workers rally held at the Renaissance Ballroom and Casino. Mollie drew on her own personal narrative to galvanize the crowd of everyday Harlemites.

"At an early age I became aware of my obligation to participate in organized efforts to level the onerous barriers which locked me and my people in a ghastly cultural, political, and economic ghetto. . . . Neither I nor my family had sufficient income to make significant financial contributions to this cause. We did, however, have commitment, energy and time to contribute."

Giving of their time to aid the movement for racial equality was just as important as giving money. Mollie was conjuring the spirit of generosity that most people of African descent had been raised with. She offered practical strategies for soliciting donations and love offerings in Harlem, where they did door-to-door canvassing. In the spirit of mass philanthropy, the team created stickers to be displayed in the windows of their homes, storefronts, and cars for people who had donated to the Fund. Sach's, the Jewish-owned department store with a large Negro clientele, had coin boxes where people could make small contributions.

According to the Black press, the 1948 Urban League Week was the largest, most widespread philanthropic campaign ever staged in Harlem.

Harlem, December 1948

Overall, Mollie's and Winthrop's fundraising year was a stellar success. The Guild's elite summer party in the Rainbow Room and the Service Fund's mass campaign on the streets of Harlem had, on balance, received positive press coverage across the nation in hundreds of Negro newspapers. Mollie was walking into her emerging

role as a New York City social juggernaut with grace and aplomb. *Life* magazine even ran a multipage spread about the Beaux Arts Ball with the headline "Life Goes to a Ball in Harlem."

Mollie decided to partner with the New York Urban League affiliate to honor Winthrop for his "unselfish devotion and untiring efforts." On December 12, 1948, a select group of invited guests assembled in the new Skyline Ballroom on the top floor of the Hotel Theresa, known as the "Waldorf of Harlem." Mollie saw to all of the planning herself. She coordinated a private cocktail hour, sans press, before the dinner where VIPs could mingle. At a dinner buffet for all invitees, they lavishly praised Winthrop for being a "leading spirit" in the financial campaign for the NUL and Greater New York Urban League.

As Mollie took the stage, she put the crowd at ease, jokingly telling them not to worry. She wouldn't be asking for any money tonight! Mollie began effusively praising Winthrop, her friend and partner in the fight for racial equality. Lillian Scott, who was there covering the event for her column, heard a tone of adoration that went beyond the bond between comrades. *Could these two be lovers?*

Lillian believed her suspicions were confirmed that night by none other than Bobo Rockefeller. She had been clipping at Bobo's heels in hopes of catching her without her plastered smile and hearing the truth about her husband and her marriage. Bobo was not a classic beauty; Lillian described her as "charming and simple." Mollie, people agreed, was beguiling and "delicately curved" like a crescent moon. The two women seemed like opposites: Bobo stuck in Winthrop's shadow, fighting to retain his affections, and Mollie a power broker whose public persona rivaled Win's. Lillian was within earshot when Bobo, all smiles, told a gaggle of reporters: "Mr. Moon and I are going to organize an organization for all

the husbands and wives of Urban League workers to work twice as hard and solve all their problems so they can stay home."

The statement was out of Bobo's mouth and on the record before she realized the weighty implications of this utterance. She viewed herself and Henry as spouses who had been pushed aside by partners who spent more time together trying to solve the "race issue" than with those to whom they had promised their love. Bobo saw what everyone else was seeing between her husband and Mollie. And by naming Henry, it effeminized him, turning him into the worst kind of cuckold, whose wife had so much power that she was the man in their relationship. It is impossible to know what the conversation between Mollie and Henry was like after Lillian's column on the Hotel Theresa event was published. It would, however, be hard to believe Henry was unbothered by being thrown in alongside the neglected socialite wives of important white men. Perhaps he was able to put his male ego aside to comfort his wife, who was the one directly under assault.

In the late 1940s, the stakes were high around interracial sexual contact. Black men and boys across the South were still being lynched over allegations that they had looked at, flirted with, or touched a white woman. In 1944, a Black Alabama woman named Recy Taylor was gang raped by six white teenaged boys and young men who were never indicted for the crime. Rosa Parks and other African American women activists in the South had launched a campaign to end racial-sexual violence and to get justice for survivors. Even in northern and midwestern cities, Negro domestic laborers faced the daily threat of rape at the hands of the white men in whose houses they worked. Most states still had anti-miscegenation laws on the books, and even in states that had abolished those laws opposition to interracial couples remained

virulent and sometimes violent. The color line was so stark that many believed Negroes and whites should not socialize or interact in any way that could lead to consensual sex.

If reporting on Mollie and Win's affair had remained confined to Lillian's column, the situation might not have been as bad as it became. The heightened publicity from the NUL's events that year created a visual record of Mollie and Win's interactions. They stood together before a fusillade of camera flashes for photographs that were published in daily newspapers and monthly magazines across the country. Most of the photos were completely innocent, showing the pair speaking at rallies or handing out prizes. Others, and their accompanying captions, alluded to the possibility of something more tawdry hiding in plain sight.

A photograph in *Ebony*, from the 1949 Beaux Arts Ball, featured Winthrop's long-suffering wife, Bobo, in the foreground, taking in the entertainment, while a smiling, tuxedo-clad Winthrop lurked in the background with Mollie, dressed in a curve-hugging goddess-of-the-sea getup, complete with an ornate headdress. She is bending forward in her strapless gown, mere inches from Winthrop's face, her décolletage on full display. They could have been discussing something as mundane as when to announce the winners of the costume prizes. But the frozen image of the three hinted at a torrid love triangle, in which Bobo was blithely unaware of the secret Mollie and Winthrop were sharing. Yet these images, which continued to circulate well into the 1960s, permanently—and, for some, problematically—tethered her to Winthrop and rumors of sexual impropriety.

Black men were considered effective race leaders if they had connections with a Winthrop Rockefeller type, but the gender dynamics were different for women. Some viewed Mollie's accomplishments

with skepticism, assuming that she had to do it "on her back"—
that the only way an attractive Negro woman could get a powerful
white man to do anything she wanted was to have sex with him.
To be known as someone who slept with men, particularly white
men, for social advancement and favors would sully a woman's
reputation within the race. The other implication—of being "in
bed" with white folks and their money—was equally damning. So
even if she wasn't actually having sex with Win, she was politically
intimate with him, and that still made her a sellout to the race.
And some considered this a disavowal of radical principles and
the movement for racial justice writ large. Lillian knew that her
reporting on the matter was stoking both flames as she fed her
readers with the tawdry and the political.

Despite the social stakes and blows to her reputation, Mollie
never publicly addressed the rumors. It was far less commonplace
in the 1940s than it is today to make press statements about one's
personal life to get ahead of a damaging story. Mollie instead be-
came a master at presenting herself as unbothered by petty gossip.
She had gone from rarely being mentioned in the press in the 1930s
to now seeing her name in print constantly, dozens of stories a
month in the local papers. Sometimes the facts were wrong. Some-
times *she* had fed the story to the press. But no matter how she had
learned to steel herself against attacks, the words and innuendoes
about her burned. She likely wanted to lash out, to clear her name,
to air out others' far dirtier laundry. But she refrained. This is the
cost of being a prominent civic leader, she reminded herself.

———

Park Avenue Elite

Manhattan, Spring 1949

One evening, Henry and Mollie were sitting at the dining room table in their spacious Harlem apartment. They were reading the newspaper, as usual, while a slow jazz tune hummed quietly on the record player and their daughter, Mollie Lee, entertained herself with toys. Reading the dailies together was one of Mollie and Henry's rituals. In the early years of their marriage, it was a way to stay emotionally and intellectually connected to each other. Now Mollie's position with the National Urban League and Henry's with the NAACP required that they stay abreast of breaking news in the African American community.

Henry's back stiffened, as it often did when he read something

disturbing. Mollie looked over at him, sensing his unease. He read aloud from his paper: "'NAACP Denies Separate Lists Ever Existed.' *Damn it!*" Henry said in frustration. As NAACP publicity director, he had attempted to forestall this situation days ago, when he, Walter White, and Roy Wilkins had first been told that alleged NAACP donor letters with racist undertones had been leaked to the press. Henry had drafted a statement to quash the rumor before it became a major headline. But they'd heard earlier that day that the National Negro Publishers Association—the Black equivalent of the Associated Press—had run an unflattering story about the controversy, which would be picked up by hundreds of Negro papers across the country. Seeing the headline in bold print distressed Henry.

The story alleged that the NAACP was courting wealthy white donors while marginalizing its African American base. The NAACP's "uptown" letter, targeted toward Negroes, encouraged them to become engaged members who toiled on the front lines of the NAACP. Meanwhile, the "downtown" letter, which was allegedly sent to wealthy whites, offered special perks and access to exclusive events in exchange for their monetary support. Were it true, it would be a damning revelation: the very organization that claimed it was committed to dismantling racial segregation and inequality was encouraging it among its ranks in exchange for white money. "There is no foundation at all for such a report," the story quoted Henry as saying. "We have never depended on 'white' contributions. We have white members, we want white members, and we seek friends wherever we can find them."

But the story offered evidence to the contrary, pointing to the NAACP Anniversary Ball, which that year had been held at a hotel on Central Park South, an area where Negroes were often

racially profiled and harassed. Worse even, the widow of an African American man who was lynched in Georgia wasn't even invited to the exclusive, invitation-only ball. In capitulating to white donors, the NAACP was turning its back on the real victims of anti-Black violence. The coup de grâce was the claim by the National Negro Publishers Association that the NAACP loved chasing after white money, but whenever it was holding a fundraising campaign in a Black neighborhood, Negro press offices were "bombarded with phone calls" to secure advertising space in their papers. In other words, NAACP headquarters expected the Black press to help them secure Black dollars when it was expedient for them but otherwise wanted little to do with everyday African Americans.

Such stories reinforced the growing belief among the Black poor and working classes that "NAACP" stood for "National Association for the Advancement of *Certain* People"; it catered exclusively to elites. Immediately after World War II, the NAACP had seen a massive growth in its membership. Black people of all social classes were flocking to the organization, which seemed to be at the vanguard of the racial justice movement. At its peak, the NAACP had approximately fifteen hundred branches and half a million members, most of them African American. Internally, however, the NAACP leadership was floundering as Walter White became mired in his own personal scandals and the old structure could not sustain the organization's massive growth. As Roy Wilkins later recalled, "We had a big membership . . . and a large income, but we did not know how to use them."

Ella Baker, the director of branches, resigned from the NAACP because of its lack of responsiveness to its local members' new ideas and militant activism. It was these local bodies that advocated most

fiercely for the working poor. By the time the "separate lists" story was published, the NAACP was losing members rapidly. Those Negroes who used to diligently scrape together their coins, giving to the NAACP as religiously as they tithed to their church, were deciding to throw their support elsewhere. Less than a year after the "separate lists" article was published, the NAACP's membership had fallen to roughly 390,000.

The NUL wasn't faring much better in the court of Negro opinion. The League occupied a different space in the African American political landscape than did the NAACP. It was a visible community presence, and many benefitted from the NUL's social services, but they had difficulty describing exactly what the NUL did or who it comprised. Unlike the NAACP, the NUL had no formal membership; people made financial contributions but weren't offered the opportunity to belong and to participate in policy decisions. The Urban League had local chapters across the country, called affiliates, whose staffs carried out the national headquarters' vision of economic justice by organizing community-based projects and programs. In the 1910s, the NUL's financial backing had come from a few affluent whites, as had the NAACP's. But in the 1920s and 1930s, the League's base of African American supporters grew substantially, especially as the masses of domestic and blue-collar workers sought assistance from the League. By the 1940s, a good portion of its funds were coming from African Americans of all social classes. As the organization professionalized, local League staffs consisted mostly of college-educated organizers, which gave the Urban League an air of elitism.

Lester Granger was fending off insinuations by young militants about who the League was in partnership with and where its money was coming from. The Urban League certainly had its own

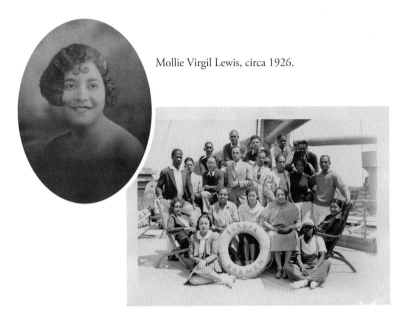

Mollie Virgil Lewis, circa 1926.

Louise Thompson (*floor, left*), Dorothy West (*floor, right*), Mildred Jones (*row two, seated far left*), Mollie Virgil Lewis (*row two, seated far right*), Frank Montero (*row three, second from left*), Langston Hughes (*row three, third from right*), Henry Lee Moon (*row four, second from left*), Loren Miller (*row four, far right*), and other *Black and White* cast members aboard the USS *Europa*, en route to Moscow, 1932.

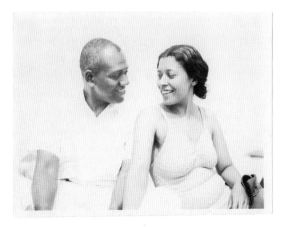

Henry Lee and Mollie Moon at the beach, circa 1939.

Links Social Club, Los Angeles, circa 1938.

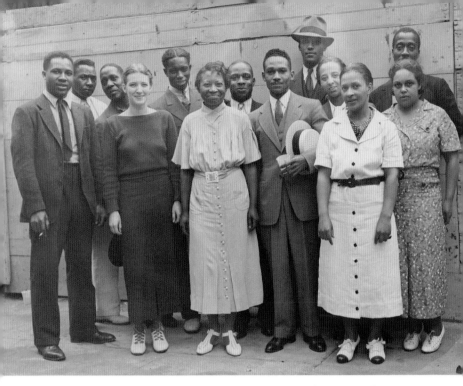

Augusta Savage (*front row, second from left*), Louise Jefferson (*second row, second from right*), Gwendolyn Bennett (*second row, far right*), and other members of the Harlem Artists Guild, circa 1938.

Henry Lee Moon portrait, 1945.

Henry Lee Moon, Ruth Pruyn Field, Mollie Moon, and Ed Perry
at Henry's book party for *Balance of Power*, 1948.

Ed Perry, Ruth Pruyn Field, Henry Lee Moon, Ida Mae
Roberson Cullen, Arthur Spingarn, Mollie Moon, and
Harold Jackman at Henry's book party
for *Balance of Power*, 1948.

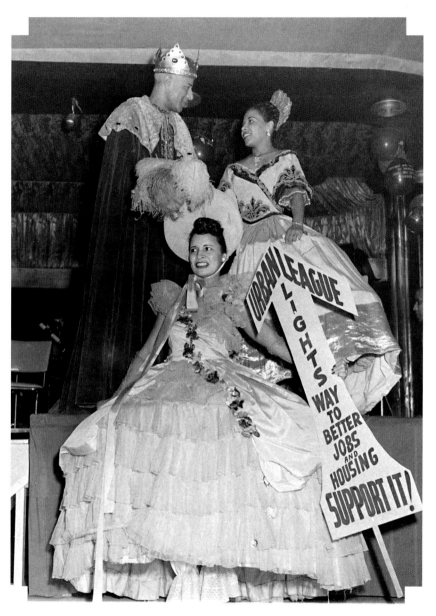

Costume competition contestants at the National Urban League
Beaux Arts Ball, Savoy Ballroom, Harlem, New York, 1949.

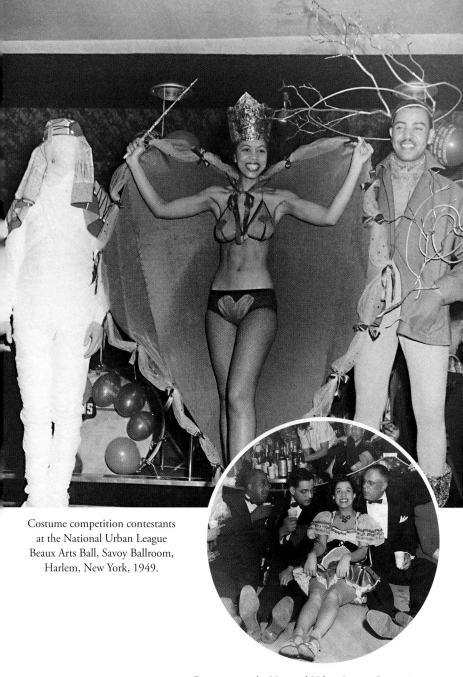

Costume competition contestants
at the National Urban League
Beaux Arts Ball, Savoy Ballroom,
Harlem, New York, 1949.

Partygoers at the National Urban League Beaux Arts
Ball, Savoy Ballroom, Harlem, New York, 1949.

Mollie Moon and Winthrop Rockefeller discuss plans for a National Urban League capital campaign in a Harlem cocktail lounge.

PARK AVENUE FACES THE RACE PROBLEM
Wealthy socialites give their names, time and money to help Negro groups

Barbara "Bobo" Rockefeller, Mollie Moon, and Winthrop Rockefeller at the National Urban League Beaux Arts Ball, Savoy Ballroom, Harlem, New York, 1949.

fundraising events catered to the tastes of the white upper crust: exclusive Hollywood film screenings, Broadway theater nights, a private Marian Anderson concert. These events were the public-facing element of a two-pronged strategy devised by Granger and others on the NUL's executive committee and board of trustees to secure big-dollar donations from New York's monied elite, which included high-net-worth individuals, family foundations, and corporations.

The first aim was to recruit influential Park Avenue socialites who would adopt the Urban League as one of their pet projects and encourage other women in their social circle to as well. The second was more covert: NUL leadership would grow the Urban League Fund, a pool of money that had been raised from the elite. A select group—including white NUL supporters such as Lloyd K. Garrison, the attorney and great-grandson of abolitionist William Lloyd Garrison; members of the Rockefeller family; and the Russell Sage Foundation—would then decide how that money was divvied up among Urban League affiliates and how it could be invested to promote future growth. The public was unaware of the existence of the Urban League Fund, as were most of the League's rank-and-file staffers.

Mollie Moon, an NUL insider, not only knew of the Urban League Fund but also likely helped them to devise the plan. Mollie had become one of the most powerful women in the League. She was secretary of the NUL executive committee, a trustee, and chair of the NUL Service Fund, a branch of the Urban League Fund. Mollie still helmed the National Urban League Guild, which had sixty active members in New York City and was continuing to establish new guilds across the South and Midwest. She was a bona fide star on the social justice philanthropy scene. Her Beaux Arts

Ball was *the* fundraising event to attend in New York City, not just for Negroes but for a growing audience of upper-crust progressive whites and other allies as well. It's difficult to know exactly what Mollie personally thought about the Park Avenue plan. As someone who loved material things and believed Negroes should enjoy luxury, she might have reveled in a strategy that placed her in proximity to wealth. On the other hand, it's difficult to believe that the woman who criticized capitalism and interracial activism would have espoused a plan that further marginalized Black folk. She intentionally continued holding the Beaux Arts Ball uptown because she wanted it to be accessible to Negroes; any whites who wanted to attend would have to make the trek.

But political activists' core beliefs often become warped, or their dreams are deferred, when they accept compromise as a necessary evil to bring about change by working from inside the system. And there were two realities that perhaps made Mollie more amenable to the strategy. The major issue was that the movement for racial equality was tremendously expensive. Every quarter, the executive committee examined the League's expenditures, which were in the hundreds of thousands of dollars. They had to pay staff salaries, fund national and some local programming, and provide employment and other services for those in need. As anti-Black violence intensified across the South, the NUL had to increase monetary support given to Southern affiliates. Small-dollar contributions from everyday folks and larger offerings from the network of African American social clubs and church groups across the United States were helpful and appreciated. But even they weren't enough to cover the price tag placed on freedom.

The other reality was that someone Black had to spearhead this Park Avenue initiative, and Mollie was likely the best person

on the executive committee to do it. She had learned to speak the language of the wealthy, put them at ease, and even advise them on what causes merited their gifts. Yet fundraising was a risky balancing act. She needed to remain down-to-earth enough to speak to day laborers and numbers runners, affirming their dignity and appreciating their generosity according to their means. She also had to keep up her own performance of middle-class Black womanhood, which meant dressing fashionably, attending the right cultural events, and continuing to expand her social network. The League always wanted to present a Black face to the public, even if the racial dynamics behind the scenes were more complex. Having Mollie serve as the de facto social leader of this initiative would satisfy that imperative.

In her role as chair of the Service Fund, Mollie had to come face-to-face with the do-gooder wives of the millionaire titans of industry who participated in the Urban League Women's Division. They were a different kind of creature; beneath their polite smiles were fangs. They were just as ambitious and cutthroat as their husbands and had connections to politicians and the most influential people in mainstream media. Most had learned to speak the language of antiracism, but their racial biases sometimes surfaced in the form of biting microaggressions. Still Mollie likely felt that if she were at the helm of the Park Avenue elite initiative, she could ensure it operated within a Black organizing approach to fundraising. She could carry on in the spirit of the community women who had taught her the collective power of African American generosity when she was a child. Building a bridge between the Guild and the Women's Division could be a step toward democratizing philanthropy, taking back the word from the wealthy whites with whom it had become synonymous.

* * *

A few weeks after the "separate lists" controversy, the NUL Women's Division hosted an intimate fundraiser and recruitment event at Gracie Mansion, the official residence of the mayor of New York City. Its current occupant was Democrat William O'Dwyer, who had opened Gracie's doors at the behest of influential socialite and philanthropist Fleur Cowles. The dignified house, designed in the Federal revival style of architecture, sat at the edge of Manhattan with unobstructed views of the East River. Few African Americans, other than those who had been servants in the mansion since the Revolutionary War, had ever been there. Lester Granger remarked to the group that day, "I'd always heard of Gracie Mansion, even though I never knew exactly where it was, and today I'm in the joint."

Granger had personally recruited Fleur Cowles to join the League. A writer and editor whose husband was Gardner Cowles Jr., publisher of *Look* and heir to the Cowles media empire, Fleur was known for her edgy-yet-elegant style. For the Women's Division gathering, she was decked out in a long crimson wool shawl with fringe that was strategically tied around her waist and woven through her arms. It looked like it might all fall apart if she raised her elbows even a little bit. Winthrop Rockefeller, Gloria Vanderbilt, and Lloyd Garrison mingled with the small crowd that had congregated around several shabby wooden folding chairs with "Department of Public Works" stamped across the back. Also in the room was fashion designer Ceil Chapman, whose celebrity clients included Grace Kelly, Marilyn Monroe, and Elizabeth Taylor; and her design peer Nettie Rosenstein, who pioneered the "little black dress." Maggi McNellis, the radio star; Phyllis Cerf,

the actress-turned-publisher who was married to Bennett Cerf, co-founder of Random House; and actress Virginia Pine all chatted politely and mingled with other guests. Mollie Moon and *Chicago Defender* writer Lillian Scott were likely the only African American women in the room.

Fleur Cowles and Phyllis Cerf, who had recently begun donating to the League, launched into their spiel about the good work of the NUL. "A sense of guilt makes me realize I haven't done my share to make this country a better place in which to live," Fleur confessed. "Once you talk to Granger, who is a perfectly wonderful human being, you're hooked." Phyllis shared with a laugh that her husband had told her the Women's Division was "a cinch to raise a lot of money" because they were already masters at getting their husbands to give them cash. But Phyllis's friends had been asking her if it was appropriate to approach people about giving money during these "trying times." And by trying times, what they really meant was: *Should we be asking our rich friends to give to a Negro cause?* "I always tell them: 'a Negro's times are trying from the day he is born.'" Their appeals were designed to assuage any fears among those assembled who hadn't already committed to the League to suit up and join the fight for racial equality. Mollie likely had to stifle a sigh as she observed these ultra-privileged white women explain racism to their friends.

Mollie's NUL Guild and Fleur's Women's Division functioned in the same city, under the same umbrella organization, but they had two different purposes and target audiences. This separation between the two major women's fundraising arms contributed to the belief that the NUL and the NAACP had segregated donor lists. The Women's Division in New York City had been majority white and upper class in the 1920s. Its composition shifted as more

middle-class African American women joined the League in the Depression era. But once Mollie established the Guild in the early 1940s, most of them migrated there, where they felt more comfortable. Granger's recent push to recruit rich white women meant that the Women's Division became a self-segregated space where the Fleur Cowleses of the world, as egalitarian as their outlooks might have been, socialized and organized together.

Women's Division fundraisers, which were targeted toward the monied elite, brought in more funds than Mollie's majority–African American events. For example, Jeanne, Fleur, and other Women's Division leaders invited stars of stage, screen, and radio, and members of the business elite to a lighthearted art auction called Paintings by Famous Amateurs. It featured badly executed works by General Dwight Eisenhower, Bill "Bojangles" Robinson, Joe Louis, and Jackie Robinson. Winthrop Rockefeller proudly told the press that the auction would clear between $187,000 and $250,000. Granger was undoubtedly pleased with this massive financial windfall. But Mollie couldn't help but observe that an event like this was not accessible to the League's everyday Negro supporters. It once again appeared like the NUL was hosting an event that catered to wealthy white folks.

Mollie's only attempt to coordinate an event cosponsored by the Women's Division and the Guild was a bust. The *New York Times* announced that Jeanne Vanderbilt would sponsor a "County Fair" themed variety show at the City Center casino in June 1949. Born in 1919 to a prominent New York City family, Jeanne was the effortlessly gorgeous and impeccably styled second wife of sportsman Alfred Gwynne Vanderbilt Jr. (the great-great-grandson of the patriarch, Cornelius "Commodore" Vanderbilt), who was said to be worth $300 million. Jeanne selected her committee mem-

bers. Tallulah Bankhead; Ruth Pruyn Field, who directed the Field Foundation; Austine Byrne Hearst, who had married into the Hearst publishing empire; Caral Gimbel, heir to the Gimbels department store fortune who had married Major League Baseball player Hank Greenberg; and gossip columnist and professional hostess Elsa Maxwell were all on board.

It seemed that this would be a perfect opportunity for Mollie to collaborate with Jeanne, who was perhaps her closest friend in the Women's Division. And more important, it was a chance for the Guild to benefit from the mainstream publicity and big-dollar donations that followed the Women's Division events. This could put the two women's groups on a more equal footing in the eyes of the public, help quiet some of the rumors of racial division, and create a space for African Americans to attend one of these big-dollar events.

Jeanne, Bobo Rockefeller, and others showed up to launch the fair and take publicity photos for the mainstream dailies but left shortly thereafter. Lillian Scott sardonically told her readers that by the time she arrived the "major Leaguers" had "taken off en masse for a cool weekend in the countryside." After looking forward to "being chummy" with the "country club set," she was disappointed to realize she was left with "the regulars of the Guild." Lillian's insinuation that Jeanne and her leisured peers had left the Black women to do all the work was a scathing but astute critique of the League's approach to big-dollar fundraising. The white women understood their role was to drum up interest in the League among the white upper crust and secure fancy door prizes and large donations. Once that front-end work was done, they felt no obligation to socialize with the masses. This left Black women of the Guild, and the few middle-class white

women in their ranks, to do the heavy lifting required to run the event and clean up afterward.

By all measures, the fair was a disaster. Mollie told members of the Negro press: "Not only has there been a financial loss, but considerable public misunderstanding had been generated due to poor promotion and mismanagement." She could not directly take Jeanne and the Women's Division to task, most certainly not in a mainstream paper such as the *New York Times*. But she could offer an explanation as to what, from her perspective, had happened. It was a clear attempt to salvage her reputation. She shared that, for the first time in the Guild's eight-year history, she and her team did not handle the promotion. Instead, they had hired PR professional Alice Richman, a decision that proved "most unfortunate."

Richman was likely a white woman who had come recommended by someone in the Women's Division. After the event, Richman complained about Mollie to influential white supporters of the Urban League. She painted a damning picture of Mollie Moon the autocrat, who mismanaged the budget and marginalized the members of the Women's Division because of her refusal to work collaboratively. Richman released an official statement accusing Mollie of failing to advertise the event in the Negro press, rejecting help with staging from people who weren't in the League, and failing to secure the needed theatrical talent. She said Mrs. Moon "needlessly wasted" the "fundraising potentiality" of the Guild.

Mollie had been criticized as a micromanager before. League members knew that she would insist upon taking the helm of anything she was involved in, never fully trusting others to do it as well as she could. But Richman's decision to publicly lambast Mollie and side with her friends in the Women's Division fanned the flames of racial dissension within the League while leaving the

larger race and class issues at play unaddressed. Jeanne and the others were excused for any role they might have played in the situation.

The League remained neutral, even as the situation devolved into a messy blame game. In a statement to the press, NUL publicity director Guichard Parris only confirmed that the League expected a substantial financial loss. Lester Granger wrote to Guild members expressing regret over the way the event had unfolded and encouraging them to "continue the good work" they'd been doing. He even wrote to Henry personally, apologizing for how Mollie had been dragged through the mud by the press. But the gossip about the failed event continued to brew. James Hicks, a society writer whose column Big Town was syndicated in several Negro papers, told his readers that he and other reporters had received anonymous letters, allegedly from Guild members, weighing in on the "tiff" between Mollie and the Women's Division, and spilling tea so piping hot that it "would burn the ribbon off a typewriter if published."

Despite the finger-pointing, gossip, and innuendo, this dispute should not be reduced to a catfight between women. The fact that people were willing to ruin the reputations of other women by giving grade A gossip to reporters reflected the larger stakes. The veritable segregation between the two women's groups was a social display of the inequalities inherent in US capitalism: the members of the Women's Division could raise more money because their whiteness afforded them access to wealth and privilege that their Negro counterparts did not have. The structural inequality of postwar American society was exposed within the League itself.

It was exacerbated by the gendered politics of fundraising. While fundraising was supposed to be altruistic, it was deeply

marked by competition between people with outsize egos. No one batted an eye when Winthrop Rockefeller aimed to outraise Henry Luce during one of the League's capital campaigns. But competition among women fundraisers was regarded as unlady-like. Moreover, women's fundraising was dismissed as a hobby of the ladies-who-lunch crowd, not the labor of trained strategists. Many—including many wealthy husbands—believed that social-ites used the monthly allowances given to them by either their spouses or their family trust funds to donate to various causes.

But most of the women in the Women's Division and certainly the Guild defied this stereotype. They—Mollie included—only leaned into the housewife image when it was socially advantageous to do so. These women were ambitious working professionals who made use of the skills they had acquired in their careers to become effective fundraisers. And for Black women especially, it was an honor to use those skills in the fight for freedom. Mollie wanted her Guild to be able to raise money for their people, at a time when returning Black soldiers brought new urgency to the fight for equality. To be shown up by rich white women felt like letting the race down. It had become personal, not because Mollie despised the women of the Women's Division but because capitalism breeds competition for limited resources.

In the moment, Mollie likely remembered why she had been so vehemently opposed to interracial organizing in the 1930s, believ-ing that Negroes needed to unite to solve their own problems. And now that she was a major fundraiser, she realized that the power of money made interracial activism even more problematic. Wealthy white folks would never be willing to give up their privilege or side against their network of friends to support Negro equality. Be that as it may, she did not have the power to unilaterally change the

direction of the NUL's Park Avenue elite fundraising strategies. Recent events had shown Mollie that her position on the NUL executive committee gave her autonomy to shape the direction of the Guild, but not much else. In many ways, it was the racial-justice version of golden handcuffs: Mollie was invested in the larger mission of the NUL and reveled in her nominal power, which kept her wedded to the organization even when she could see it was making a major misstep.

Manhattan, Winter 1950

Ironically, Mollie found herself represented as the face of interracial fundraising and organizing. In February 1950, *Ebony* published a story with the headline "Park Avenue Faces the Race Problem," which praised the white progressives of New York society for becoming active members of the National Urban League and fighting for "the cause of the Negro." Centering on Winthrop, Jeanne, Fleur, Mollie, and Lester, the piece heralded their model of cross-racial activism as a step in a positive direction for race relations. *Ebony* told its readers that Winthrop and his brigade weren't "social butterflies" who were merely on a "slumming expedition" to be seen publicly as "do-gooder[s]." They had a "devotion to ideals" and a commitment to "down-to-earth work." This brand of liberal white allyship was no doubt inspired by Gunnar Myrdal's 1944 study of US race relations, *An American Dilemma: The Negro Problem and Modern Democracy*. The two-volume study was commissioned and financed by the Carnegie Corporation, and many social scientists and philanthropy managers saw it as the progressive's bible on how white people, especially those of means, should commit themselves to antiracism work.

The Civil Rights Movement was introducing new ideas to

family foundations, and white philanthropists wanted to benefit from racial-equality capitalism. Some might have had a deep commitment to integration, while others were willing to offer donations for the tax break. But the fuller picture was more complex. Supporting Negro causes, particularly education and healthcare initiatives, was lucrative. It made white corporations appear invested in equality and the public good—two buzzwords—rather than merely their own capital gains. This generosity won them legions of new African American consumers who were eager to spend their dollars on the other side of the color line.

Philanthropic foundations were motivated to give because they wanted to be regarded as at the vanguard of social change, more adept than the bloated US government at tackling the country's most salient issues. The more liberal philanthropies wanted to set themselves apart from old-guard philanthropies that focused on safe causes such as historic preservation, conservation, and science and technology. Taking on a cause such as securing the Negro right to vote strengthened their bona fides while keeping politicians on both sides of the aisle appeased. It was a way to give and make money without disrupting the status quo—a win-win scenario. Many in the African American community could see behind the façade, while others were dazzled by the big donations and sponsorships reported in the dailies.

Ebony considered the political salons, cocktail parties, and art auctions hosted by the Women's Division a sign of their commitment to grassroots activism in the form of fundraising. It was not the frontline activism that labor unionists, domestic workers, and military vets were engaged in, with pickets, protests, and marches. But *Ebony* distinguished between this socially conscious "plush Park Avenue socialite set," who were willing to give of their time

as well as their money, and the philanthropists who merely tossed money down to the masses from their gilded towers. White people like Winthrop, Jeanne, and Fleur, *Ebony* assured its readers, were allies who were "examining the bitter facts of America's race problem and joining with organizations attempting to do something about it." The NUL was the "chief beneficiary" of their generosity because its reliance upon empirical evidence and social-science-based solutions appealed to their political sensibilities.

Mollie and Lester were portrayed as the Negro architects of social change who were spearheading this bourgeois economic-justice movement in New York. Stories ran across the Negro press about Mollie and her Guild members being honored by the "glamour set of Pahk Avenoo" at the home of Ruth "Kitty" Lehman and her husband Robert Lehman, head of the Lehman Brothers investment-bank empire.

It's no wonder that a publication like *Ebony* saw this form of philanthropy as key to solving the race problem. *Ebony* founder and president John H. Johnson and his wife and business partner Eunice Johnson wanted to convey the luxe lives of the Black middle class. This depiction of Black life centered on consumer culture, portraying overseas vacations, high-end home appliances, and haute-couture fashion as both normal and aspirational for Negroes. The magazine also dedicated full editorials to Negro social clubs, which had expanded exponentially around World War II. The most prominent among the new organizations were Jack and Jill of America and The Links, both founded in Philadelphia by the city's established Black elite. That Mollie and Lester had ties to white wealth, ushering in the rest of the race with them as they entered these vaunted spaces, was a sign that the race was moving in the right direction: up.

Skeptics like Lillian Scott had serious doubts. Sure, members of the Park Avenue elite were hosting social events for the Negro cause, and some were risking their reputations among conservatives as they advocated for integration. But the pace at which this change would happen was decidedly slow. In a speech at the NUL annual conference in Omaha, Nebraska, Winthrop argued: a "new racial era has come into being without advertisement." People of darker hues around the world are not asking for your permission. They are "demanding a fuller share of the benefits," and "we must be doing something constructive toward racial equality all the time." Despite his use of militant parlance, Winthrop leaned into the rhetoric of gradualism, never demanding immediate change. It was easy for those who weren't facing the daily terrors of Jim Crow to support gradual integration. But Negro Americans needed justice now. Radical Black intellectuals, including Claudia Jones and Paul Robeson, who were calling for the dismantling of capitalist systems that bolster racial discrimination and economic exploitation, were facing extreme repression from government officials and staunch opposition from moderate Negro intellectuals. Meanwhile, members of the Park Avenue milieu were garnering reputations as race relations demigods, who were reimagining the future of philanthropy and being invited to speak about race and equality issues.

* * *

Despite the rising tide of objections to the Urban League's partnership with white elites, its leaders pressed ahead. The second piece of Granger and the NUL board's Park Avenue elite strategy was to grow the Urban League Fund. The Fund had started taking

form at the end of World War II when organizations such as the NUL and the NAACP had received an influx of cash from supporters across the country. The bulk of the funds came from New York donors, where US wealth was concentrated. The donations sparked an all-out money war between the Manhattan-based Urban League national office and the local New York City Urban League affiliate over which should benefit most. Donors, too, were confused when they received two fundraising requests from what appeared to be the same organization.

Granger's solution to the fundraising problem was to call a meeting with Edward S. Lewis, director of the NYC League affiliate, as well as the white presidents of the national and New York Leagues, to hash out the matter. He also invited the executive directors of the Russell Sage Foundation and the Rockefeller Brothers Fund (RBF), both of whom were among the League's key advisers. The group discussed creating a joint fundraising report that could be sent to donors on behalf of both branches of the organization, which would "eliminate competitive fundraising" and thereby "increase the overall income from Greater New York." It was from these talks that the Urban League Fund was established in 1945. They formed an official committee, which set the percentages that each New York–based entity would be granted from the total funds collected. And they appointed a fund director: Frank Montero.

Mollie and Henry had known Frank Montero for years. They met him when they'd all traveled to Moscow to film *Black and White*. At the time, Frank was still an undergrad at Howard University and was the youngest member of the cast. The Moons had kept abreast of his career moves over the years through their good friend Dr. Ralph Bunche, who had been Frank's mentor since his

Howard days. Following in Bunche's path, Frank had dedicated his life to public service, earning a master's degree in social work from Columbia University and then another master's in public administration from New York University. He was a natural fit to direct the Urban League Fund. Through this position he became one of the early Black American philanthropic administrators and advisers. He regularly attended fundraising conferences to learn how to grow massive donor bases and solicit major contributions. He worked closely with the Harlem-based Negro accounting firm of Lucas & Tucker, which conducted the Fund's annual audits.

Frank's goal was to establish the Fund in a manner similar to the RBF and other foundations. This would ensure that the Urban League Fund would meet all federal tax standards and that it would be attractive to potential donors. Many foundations had strict rules regarding whom they would fund. They contracted with entities such as the National Information Bureau, Inc., to run background checks on any potential grantee and present its board of directors with a detailed confidential report that outlined the organization's origin story, political tactics, key leaders, and so forth. The National Information Bureau reported that the NUL relied more upon "improv[ing] understanding and cooperation" than "continuous and aggressive attack," which made it a more desirable grantee. Boards would evaluate this information along with the standards for funding that they had established in their bylaws, often called the "Basic Standards in Philanthropy." There were several key criteria that needed to be met, including that the grantee was a legit organization with an established board, a clear agenda, a sound fundraising plan, and an annual audit by a reputable certified public accounting firm.

By 1950, Frank had grown the Urban League Fund significantly.

It alone was raising half a million dollars annually on behalf of the NUL and the local New York affiliate. And NUL leaders gave Fund managers greater authority to expand the Fund's reach. The Fund had a large role in supervising and distributing the total income of each organization. In fact, though it wouldn't be revealed until years later, the Urban League Service Fund that both Mollie and Winthrop Rockefeller had chaired was an outgrowth of the original Urban League Fund.

The NUL had built a strong roster of high-net-worth donors and corporations. Utility companies such as General Electric and New York Telephone Company; American Airlines; Sears, Roebuck and Company; and Seagram's were all donors. So were social clubs, ranging from Alpha Kappa Alpha to Les Femmes Modernes. Individual donor rosters revealed a list of the usual families known for their generosity: the Vanderbilts, Lehmans, Fields/Trees (of the Marshall Field's department store empire), the Rockefellers, and the Dukes. Eunice and John Johnson, under the banner of their Johnson Publishing Company, were among only a few African American big-dollar donors. Individuals who gave $1,000 or more per donation and corporations and foundations that gave $5,000 or more were considered top donors. Frank helped to organize these donor rolls into thick booklets, with details about who gave what to which causes, and the last time the donors were engaged. With this committed donor base, the NUL could start investing in stocks and bonds to grow the fund's size over the years, in hopes that a steady flow of money could help support the larger movement for racial equality.

The problem wasn't that having a fund was uncommon or something a Black organization should not aspire to. It was mostly the lack of transparency with the Negro public that bred distrust.

The everyday operating structure of the Urban League was opaque for non-Leaguers, and even most within the League had no awareness of the backdoor dealings of the NUL and its Fund. It was clear at the time that the League, and perhaps the NAACP as well, preferred it that way. Leaders like Granger thought it was best for their image in the Black community if they appeared to not be capitulating to white money, which most Negroes feared would lead to whites controlling the direction of the burgeoning movement for full citizenship rights and economic equality.

But the implications of the Urban League Fund went beyond merely taking money from rich white folks. The establishment of the Fund signaled a shift in the NUL's orientation. The League was aligning itself with the turn toward racial equality capitalism among philanthropists. By molding the Fund to suit the practices of foundations, they were colluding with philanthrocapitalists whose practices of generosity were rooted in and benefitted from Jim Crow tax policies and Gilded Age financial logics. Corporate and foundation philanthropy was a capitalist, imperialist enterprise. It was designed to uphold white supremacy and the economic subjugation of people of African descent in the United States and around the world. When Black radical intellectuals looked at the Urban League's money sources, they recognized that no fund of this nature could ever produce racial equality because it was built with the master's tools. The more the NUL moved away from Black grassroots giving traditions and toward a foundation philanthropy model, the more they were accepting an institution that would never lead to Black Freedom.

Lester Granger knew the social terrain was so fraught between Blacks and whites at the time that the NUL could never publicly admit to the existence of the Urban League Fund and still ex-

pect to keep its Negro supporters. To appease the NUL's African American base, Granger released a statement in 1950, which ran in *Ebony*: "The National Urban League is not dominated by big business, nor does its philosophy stem from its wealthy supporters." Granger emphasized that he understood the power and prestige that the white upper crust brought to the League but vehemently stated that "regardless of their money and social connections," they "are a definite minority on its board and committees." But it was a sleight of hand meant to distract from the reality that at least half of the NUL's donations were coming from white elites and corporations that wanted a stake in the movement.

Black Wealth

Cleveland, Fall 1952

A group of seventy-five well-heeled women representing Urban League Guilds across the country gathered in a three-room suite at the Hollenden Hotel in Cleveland. They were in town for the National Urban League annual conference. Mollie Moon's New York–based Guild had booked the suite for the big kickoff party they'd hosted a few days earlier, where more than a hundred Leaguers spent the evening drinking, eating, and laughing. But the mood in the room this day was more corporate than festive.

The women were engaged in talks about how they could consolidate the work of the Guilds and "tighten the strings" to form "a more closely knit" organization. NUL executive director Lester

Granger had called for Mollie and other leaders to provide "clarification and re-evaluation" of the purpose of the Guild. This was not an unreasonable ask. The women's group had grown rapidly in the late 1940s and was gaining momentum in the early 1950s. Yet it was still organized on an "informal basis, without a constitution or any rigid by-laws," as it had been in 1944, when it had only forty-five members. At that time, the leaders thought that too much structure could hinder the Guild's work, which was more social than political. Their biggest concern was how to recruit members. We're "selective but not exclusive in any snobbish sense of the word," Mollie had said.

Now the Guilds needed to fortify their purpose to help carry the movement forward. The major issue was that the movement itself had shifted. Grassroots Negro activists and organizers were no longer calling for racial equality, which was palatable to white folks; they were demanding civil rights, which challenged the status quo. The groundswell of activism across the country among the Negro poor and working classes could not be denied. And this political fervor was changing the strategies that power brokers like Mollie had been implementing.

African Americans had become even more outspoken in their criticism of the major Black organizations that they believed were beholden to white money. It was obvious to Lester Granger, Mollie, and others within the NUL's senior leadership that they must adopt a different approach, at least publicly. Secretly, the Urban League Fund and its events would continue as planned. But the League would emphasize the national network of Urban League Guilds that catered to and mobilized the Black elite and working-class strivers in cities across the country. This new focus helped to untether Mollie from the all-white Women's Division and its

antics, allowing her to concentrate on mobilizing her own community.

The Black middle class was expanding rapidly and becoming more wealth conscious. Mollie and Henry had joined the wave of Negroes leaving the city for the suburbs. The Moons had bought an apartment in a new co-op called Queensview Homes, which was built on nine acres of open space in Long Island City, Queens. Mollie had been reluctant to leave Harlem, but Henry was persuasive. They could give their daughter, Mollie Lee, a better life in Long Island City. Thousands of Negroes—although not the working-class masses—were able to take advantage of FHA loans and the benefits of the GI Bill to purchase homes outside of the ghetto, integrating formerly lily-white neighborhoods, from Queens, New York, to Compton, California. Middle- and upper-class Negroes' desire for homeownership attested to their aspiration to build generational wealth. They sought more space and privacy in the suburbs, surrounded by green lawns, fresh air, and access to outdoor recreation.

Mollie knew she and the Urban League Guilds across the country had to capitalize on this social momentum. Engaging wealthy Black donors as well as those in the expanding Black middle class might be the only way to break the yoke white philanthropy had on the movement. And Guild women could cultivate these new-money Negroes into big-dollar donors. African Americans had always had a spirit of giving and often out-gave members of other races within their same income bracket. But most Negro Americans had not been taught how to use the charitable donation tax codes to their benefit, especially when giving large sums. They needed to be educated on how giving with the heart of a freedom fighter and the mind of a philanthropist was key to wealth building.

The labor required to carry out this heavy lift of rebranding

the NUL and expanding its donor base fell on the shoulders of Guild women across the country. Meanwhile, NUL leaders still saw them as glorified party planners. It was demeaning.

A vocal contingent of Guild members wanted to professionalize their work. They came to Mollie, who, as the organization's founder, was in the best position to state their grievances. There was major tension between the volunteers of the NUL Guilds and the "professional" auxiliaries, interest groups the NUL had organized based on occupation. The members of these auxiliaries were treated as superior to the volunteers, even though most of the volunteers were also professional women and many had earned advanced degrees. A toxic potion of classism and sexism on both sides made the tensions more troublesome. Some Guild women hated being dismissed by male industrial workers. The industrial workers' councils were strong because they had the backing of unions and of individuals with pro-labor politics, such as civil rights attorney Pauli Murray. And many of the industrial workers, shop managers, and telephone operators—of both sexes—considered the social workers, teachers, and stay-at-home mothers of the Guilds bourgeois princesses whose volunteer work was an extension of their elitism. While there was some truth in the stereotypes, the label "volunteer" didn't fully capture the work the Guilds were doing.

Nell Blackshear, a social worker and stalwart visionary leader of the Atlanta Guild, was one of the most outspoken voices demanding more respect from the NUL. As tensions grew over this issue, Nell told Mollie that she would no longer attend the national conference if the NUL leadership relegated Guild members to soft, apolitical roles, hostessing luncheons and teas on behalf of the Clerical Council and other professional groups. She was tired of watching those groups build infrastructure while Guild members

poured tea. Nell, the institution builder, wanted to see the Guild lead its own workshops and panels about volunteerism and the art of soliciting funds.

Mollie agreed with Nell that the Guilds could and should be doing more. But Mollie, always the politician, did not want to strain relationships with Granger and others on the NUL executive committee. She had to encounter them daily, while Nell did not. They needed to "do a good job" on their public events "without creating other problems for the National office," Mollie responded. But Mollie also did not want to alienate her strongest allies in the South. Nell was fully committed to the work of the Urban League, and her Guild brought in more money than the others.

They reached a compromise. The women from Guilds across the country would meet separately during the Cleveland conference to evaluate where things stood. This would be an opportunity for them to air their grievances and frustrations. Then they could plot a strategic way forward, without male influence or intervention.

Once gathered, the first order of business was to figure out how to fix the organization's complicated structure. When Mollie had launched the National Urban League Guild a decade earlier, her goal had always been to create additional chapters under its banner. But expansion did not happen uniformly. Some local Guilds, like that in Elizabeth City, New Jersey, were initiated by Mollie and the New York Guild. Other times, the initiative came from regional Urban League offices, which was how the Guilds in Atlanta, Louisville, and Memphis were established. And in other instances, Leaguers who already were doing similar work joined the Guild movement while still retaining their original name, such as the Urbanaides in Chicago.

This infrastructure was unstable. Not only was it was decentral-

ized, but also the collection of Guilds didn't have an effective coordinating committee or a sororal structure. Rather than becoming an alpha Guild using a chapter system similar to Black Greek-letter sororities and fraternities, the National Urban League Guild had come to exclusively serve the national headquarters. It was revered among the other Guilds as the model of what volunteerism could look like, but New York, with its concentration of millionaires and big business, was worlds away from African American life in other parts of the country. In places like Cleveland, Ohio; Fort Wayne, Indiana; and Providence, Rhode Island, Guild members drew on the models of the Women's Club Movement their mothers and grandmothers had participated in at the turn of the century. This disarray created confusion about what this Guild movement was, who was leading it, and what it could become.

Each Guild had its own initiatives. The group in Grand Rapids, Michigan, was deeply committed to integration and saw itself as instrumental in acculturating Black American and European migrants alike to its racially progressive city. The New York City Guild was taking a more militant stance, adopting the NAACP Legal Defense Fund's model of direct action followed by lawsuits. The Fort Wayne group focused on what might be considered charity work: feeding the homeless and sponsoring holiday toy drives. The Urbanaides of Chicago had created a dazzling social calendar, highlighted by its wildly popular annual Fashion Revue.

As the women of the Guilds gathered in Cleveland to decide the fate of the movement, their aim was not to make this wide range of work fit a uniform model or to make any Guild adhere to a particular initiative, but rather to consolidate and to claim all those projects as integral to a capacious Guild movement. It was a genius idea, really.

A buzz of excitement grew in the room as the women fed off

one another, putting voice to the work they did and could do for the League. *We can grow to be as influential as the National Council of Negro Women*, some likely thought. Taking this step to name their work for the public would be a step toward claiming more ground within the NUL but also helping to shape the political ideologies of the larger movement for civil rights. This would be an opportunity to create an Urban League Guild school of thought about community organizing and grassroots fundraising.

They voted to name this newly formed body the National Council of Urban League Guilds, which they informally referred to as "the Council." Mollie Moon was voted its first chairwoman. The rest of the executive committee was appointed by the Guild members present in the room, with women from Cleveland, Grand Rapids, and Fort Wayne taking office. Each Guild could select delegates to attend Council meetings. Soon they finalized the Council's new agenda and launched its publication, *The Guildscript.*

Leaguer and local Cleveland reporter Jacqueline Balthrope was heartened by the show of professionalism and comradeship she saw on display that day. She wrote in her Cleveland *Call and Post* column: "It's a woman's world[,] men[,] . . . and you might as well resign yourself to the fact. The hand that rocks the cradle may not rule the world, but it wields a lot of power." Balthrope's words proved prescient. The National Council of Urban League Guilds quickly established itself as a force, not only within the NUL but also across the Civil Rights Movement and the Negro nonprofit sector.

Long Island City, Queens, 1952

Mollie returned home from the conference energized by the Council's agenda. She and the women had managed to chart a path forward without too much conflict and turmoil.

Preparing to carry out this plan, Mollie opened her desk drawer and thumbed through her file of *Ebony* magazine clippings. She collected editorials with headlines such as "Society Rulers of 20 Cities" and "The 10 Richest Negroes in America." For a money woman like Mollie, this was homework. To be an effective fundraiser, she needed to have a deep understanding of the "money landscape." She had to know who had the money, where these people lived, and who gave regularly and to which organizations. Even seemingly minor details such as what they preferred for lunch or where they vacationed in the summer was useful information. *Ebony*'s coverage of the rising Black millionaire class and the image-conscious socialites was a gold mine of data.

According to *Ebony*, "Negro society . . . is coming apart at the seams." The influx of African Americans and West Indians to cities across the country had disrupted old society rules. "Social arbiters will admit privately that they have tossed in the sponge as far as determining who's who in the colored social register," *Ebony* opined. It used to be that family name, fair skin, and generational wealth were the keys to being in Black high society. But now social prominence and a healthy bank account were all that was essential. Black doctors and businesspeople who didn't come from blue-vein families, as well as high-profile civic leaders and intellectuals— even some who were openly gay—became the faces of postwar Black society.

Gangsters, numbers runners, and madams were also among the new elite. Harlem crime boss Ellsworth "Bumpy" Johnson and his wife, Mayme Hatcher Johnson—a former sex worker and bar hostess—drove Cadillacs, wore custom-made clothing, and lived in a fancy Mount Morris Park apartment. They frequented the theater and hobnobbed with Negro luminaries. *Jet* magazine even

referred to Bumpy as a celebrity of the Negro world. Brothers Ed and George Jones dominated the Chicago underworld. By the time they retired from the game in 1946, having converted most of their illegal gains into blue-chip stocks and bonds, they were on *Ebony*'s list of the ten wealthiest Negroes in America. Ed had a reported net worth of nearly $40 million and the deeds to more property in the Bronzeville section of Chicago than any other African American. These titans of the underground economy were often the most generous philanthropists in the Negro community, funding holiday dinners, food giveaways, and Black-owned record labels and other small businesses.

In this new social matrix, possessions and leisure activities leveled the playing field, allowing criminal bosses and their wives and girlfriends to occupy as legitimate a space in society as did Black judges. If they both owned a yacht and summer homes on the same beachfront, they were moving in the same circles. Sure, some notions of propriety created varying degrees of separation, but not nearly the gulf that had existed in the past.

Cities that used to be of little social import now had a thriving Black elite. Oklahoma City, Louisville, Indianapolis, Cincinnati, Birmingham, and Houston were on the map. In these networked cities, *Ebony* explained, "the new upstart intellectual, Café Society and just-filthy-rich cliques are rapidly routing the diehard drawing-room set." The new Black elite trendsetters and social arbiters were rejecting the hierarchies and staid rituals of the genteel tradition. They wanted to socialize in ways that benefitted the public good as well as their own reputations.

The number of Negro social clubs with a philanthropic mission grew exponentially. Black high-society women were often active members of Jack and Jill, The Links, the sorority they pledged

in college, the NAACP, and their local Episcopalian or Method-
ist church. These multiple allegiances enabled African American
women to amass a great deal of local, or even regional, power.
Women's organizations similar to The Links sprouted in cities and
suburbs across the country: the Clubwomen in Philadelphia, the
Raggedy Anns in Atlanta, and the Hillbillies, a Harlem social club
of women who lived in the Sugar Hill neighborhood. Men formed
their own groups, such as the Pacific Town Club in Los Ange-
les and the Pyramid Club in Philadelphia. Some long-established
Negro men's clubs also thrived by recruiting this rising generation.
For example, a young Martin Luther King Jr. joined The Boulé,
the first Black Greek-letter fraternity, founded in 1904, which had
prominent members such as W. E. B. Du Bois and Ralph Bunche.

Other social clubs were organized around leisure pursuits.
Bridge clubs became more popular after local YMCAs held classes
to teach Negro strivers how to play this highly cerebral game. Those
with a penchant for gambling formed poker clubs. The number of
Black art collectors increased as people recognized that fine art was
an appreciable, wealth-building asset as well as a sign of cultural
sophistication. Folks including National Urban League Guild
member Rae Olley Dudley and her husband, renowned attorney
and US ambassador to Liberia Edward R. Dudley, even converted
their summer homes on Sag Harbor, Long Island, or Oak Bluffs,
Martha's Vineyard, into gallery spaces. They coordinated art auc-
tions for their elite circle, where they could buy and trade their art
and meet up-and-coming artists. Black equestrian clubs grew in
popularity. The Los Angeles Crop 'n' Tail Riding Club, of which
Dorothy Dandridge was a member, and others like it hosted barn
dances and rodeos and coordinated regular trail rides. Another el-
ement of the elite owned racehorses and held huge soirées during

the Kentucky Derby in Louisville, where there was a long tradition of prizewinning Black jockeys.

This nationwide cohort of monied Negroes was expanding and becoming more vocal as the struggle for racial justice intensified. People of African descent living in the United States were just beginning to shed their various regional identities and coalesce around a national Negro identity. West Indians and Afro-Latinos maintained many of their ethnic distinctions from US-born Negroes, but because they, too, experienced anti-Black discrimination and violence, they were swept into this political "Negro" alliance, though it would never be without its tensions and frictions.

Most among them were determined to shed Uncle Tomism. Many social-justice-oriented Negro Americans viewed the old guard as reluctant to rock the boat or offend influential white people. This attitude, more than skin color, divided the Black elite. The adage that you "never eat your watermelon with a knife and fork" reminded those who were upwardly mobile not to disavow their Blackness out of shame only to pick up the affected mannerisms of upper-class whites. "The Negro of today has attained a racial pride, dignity and militance," *Ebony* said. Like Walter White of the NAACP, many light-complexioned African Americans took great pride in adopting the pro-Black stance of the increasingly militant Black elite. There seemed to be enough consolidated power to create an economic infrastructure that could aid the movement for civil rights. It took a while to consolidate an effective apparatus, but Mollie could already see the potential.

Mollie became the face of this emerging group of socially conscious Black elites. She wasn't a celebrity in the traditional sense, but the national focus on the fight for civil rights was catapulting her into the limelight as a celebrated activist. *Ebony* named her the

social ruler of New York City in its "Society Rulers of 20 Cities" editorial. A dazzling photo of Mollie at the Guild's Beaux Arts Ball solidified her brand as the queen of the racial justice gala fundraiser. The national notoriety helped to buffer some of the rumors that had circulated in Harlem about Mollie and Winthrop Rockefeller. Sure, some people kept gossiping and speculating, calling her uppity and dredging up her party-girl past. But the overwhelming amount of positive coverage in publications like *Ebony* and *Jet* gave Mollie Moon more leverage locally.

The New York chapter of the elite Negro social club called The Women named Mollie "Woman of the Year" during its opulent annual Bal de Tete. This was a major honor, and Mollie's close friends Ralph Bunche and Jeanne Vanderbilt presented her with the plaque. Following this group's lead, the mainstream *New York Journal-American* named Mollie its "Woman of the Week," recognizing her for "15 years of toiling in the cause of interracial good will." In addition to her work with the Guild, Mollie was appointed chairwoman of Harlem Hospital's women's auxiliary. Mollie became a spokesperson for child advocacy and Black adoption, serving as a board member of the Spence-Chapin Adoption Service. Mollie was regularly listed by *Amsterdam News* and *The New York Age* among the most influential social leaders, alongside Mary McLeod Bethune and Dorothy Height. In this esteemed company, Mollie's spirited combination of hostess with the mostest, fundraiser, and race woman made her a bona fide power broker.

Mollie's popularity even helped her mother, Beulah Rodgers Lewis, climb out of financial hardship and into the ranks of Negro society in Detroit, where she was active in local Republican Party politics and in her church. Mollie regularly traveled to Detroit to spend time with Beulah, who would host dinners for Leaguers who

were conducting business in Motor City. Organizing and hosting for racial justice had become the family business.

It was an odd space to occupy. Mollie hadn't joined the movement to become famous. She'd felt compelled to unite with her community in the fight against lynching and economic exploitation in the 1930s. Now that the movement was trendy among white and Negro elites alike, she had a following of admirers and fans. People wanted to look like her and dress like her. There's no question that Mollie's light skin and loosely coiled hair added to her desirability among color-struck Negroes. *Ebony* had a reputation for upholding colorism, largely selecting models who could pass the notorious brown paper bag test (if one's skin was darker than a brown paper bag, they were considered too dark to be desirable or socially acceptable in some circles). Though in her mid-forties, which was considered old for a cover girl, Mollie modeled in cooking advertorials in *Ebony*. In turn, local newspapers published her recipes. People across the country could now cook like Mollie Moon. Mollie knew she was doing the work she felt called to perform. And the inner part of her that had always believed her drop-dead good looks were meant for Hollywood might have delighted in her newfound fame. But some part of her had to question whether it was morally right to become famous on the backs of slain Negroes.

* * *

Debates about the direction of the movement—who should represent it, who should financially support it—prompted a larger question. Could mobilizing a Black millionaire class actually remedy racial inequality? *Ebony*'s article "Time to Stop Begging" argued that it could. The magazine had been a supporter of the

NUL's strategy of engaging the Park Avenue elite in the 1940s. But it was starting to publish stories condemning white philanthropy. The 1940s had marked the end of the "philanthropic pipeline" from white hands to Black institutions that had defined the American age of philanthropy. "The sooner Negro Americans can stand financially on their own feet taking care of their own, the sooner will the day of true equality for all Negroes—rich as well as poor—be a reality." The danger of depending on white money, *Ebony* asserted, was that it most often came with "anything from implied to outright control of policy." Black institutions, ranging from historically Black colleges and universities to the NUL and the NAACP, had capitulated to white interests. White donorship had turned Negro institutions into dependents that reproduced the white supremacist racial hierarchy.

Ebony touted Black capitalism as the panacea. The magazine reported that Negro America now boasted more millionaires than half the nations in the world. And these people—particularly those entrepreneurs whose businesses had benefitted from Jim Crow—had an obligation to be "plowing it back into the welfare of their people." In its article on the richest Negroes in the country, the magazine named the people it believed the community should turn to as leaders of this new Black philanthropic base. Handsome brothers Bill and John Sewell were trust-fund babies who'd inherited millions in oil money. Augustine A. Austin had amassed a fortune in New York real estate. His holdings included the elegant building at 409 Edgecombe, along with several other properties in Sugar Hill and five buildings on the illustrious Riverside Drive. Brothers Theo and Ulysses Bond were the wealthiest Negro farmers. After inheriting the family empire, they invested in a laboratory, Bondol Labs, that manufactured embalming fluid. Controversial spiritual

leader Father Divine, whose $30 million made him the country's richest Negro religious figure, was also on *Ebony's* list.

These businessmen were joined by a rising class of philanthropic celebrities. At the time, most Negro celebrities, especially those who were just coming into wealth, operated as individual donors. They often did not even keep records of their giving or seek tax deductions for their contributions because the African American families and small organizations they were called upon to support did not have tax-exempt status. The prestige associated with being a giver was enough reward for some. Vocalist Marian Anderson, whom *Ebony* named the richest Black woman in America, was among the most politically engaged. Her regular concert tours and recordings netted her an annual income in the millions. She regularly donated from her largesse, lent her name to various causes, and refused to play in segregated venues.

Sportsmen Jackie Robinson and Joe Louis were among the early Negro celebs who were attempting to formalize their philanthropic efforts. Jackie and Joe sought to avoid the mistakes that their elder Bill "Bojangles" Robinson had learned about the hard way. Near the end of his life, Bojangles confided to the *Afro-American* that his "private philanthropies . . . are things I rarely discuss, and then only with my very closest friends." It was considered gauche among the old monied to boast about one's giving. His friends constantly warned him that he gave away too much money. Bojangles told the paper that he had donated roughly $12 million to charity and that his appearances at benefit events had netted the organizations he sponsored nearly that much as well. But now the elderly Bojangles was "almost broke," and he was looking for a younger generation of Negro philanthropists to carry on the tradition of generosity.

Jackie and Joe began attaching their names to splashy social

justice events. Joe's grand "entry into philanthropy" came when he sponsored a luncheon to benefit cancer research at the luxe Hotel Astor in Times Square, using his name as chairman to draw other big names, such as Eleanor Roosevelt, to the cause. "I have always been ready to help anybody who was hurt," Joe told the press. Jackie became a highly sought-after speaker and sponsor of NAACP and Urban League fundraisers across the country. Joe, Jackie, and Bojangles all produced artwork to be auctioned at the National Urban League's Paintings by Famous Amateurs exhibition. This was one of Bojangles's last philanthropic efforts before his death. The belief was if Negro business leaders and celebrities with a national profile were touted as the race's philanthropists—on par with the Rockefellers—it would inspire more nouveau riche Black society folk to make large monetary contributions to local organizations and affiliates.

Sociologists such as E. Franklin Frazier agreed that accepting white money was a problem, but he was equally critical of the myth of Black capitalism. Frazier had yet to publish *Black Bourgeoisie*, his scathing critique of the Negro upper classes, but he was already making his research findings known. Frazier believed *Ebony*'s obsession with "mirror[ing] the happier side of Negro life" distorted the truth of African America's financial situation so greatly that it was dangerous.

According to Frazier, the empirical data revealed that at the close of the 1940s, more than 30 percent of Negroes across the country were living in poverty, earning less than $6,000 a year. Only 0.3 percent of Negroes made over $75,000, and most of them lived on the East Coast, the Mid-Atlantic, or the West Coast, where the cost of living was higher. Lambasting *Ebony* in his lectures, Frazier reminded his audience that the median income for whites

was double that of Negroes. And those top earners within the Negro upper class made as much as the average white man in middle management who likely did not even have a college degree. Frazier believed the takeaway was clear. Capitalism had failed African Americans, and simply adding "Black" before capitalism wouldn't close the wealth gap between Negroes and whites. Nor would it redress the exploitation of African American labor that dated back to slavery. Despite the *Ebony* editors' triumphant picture of a Negro race that had a collective income of $125 billion, they were nowhere near as "unbound and independent" as the magazine claimed.

Mollie listened to the speeches and read the books and articles by the leading Negro economists. Frazier was among this cohort. So were Sadie T. M. Alexander, a University of Pennsylvania alumna who was the first African American in the country to earn a PhD in economics; Joseph Houchins, a labor economist with four degrees from Cornell University who had served in President Franklin Roosevelt's Black Cabinet and taught economics at Howard; and Henry's old boss Robert Weaver. Mollie was both intellectually curious and strategic. She understood that she and the women of the Urban League Guilds across the country had to operationalize these discussions about race and economics to appeal to Negro donors across the class spectrum.

As a social worker, Mollie engaged with poor and working-class African Americans every day in the field. She understood that impoverished African Americans didn't want to be shamed for their financial circumstances. The rhetoric of Negro social conservatives claimed that the Negro masses were poor because they were lazy and lacked self-discipline. Respectability, then, was the road map to financial well-being. Meanwhile, the social scientists who pinpointed structural inequality as the root cause of poverty made

poor folks feel they would never overcome their economic plight. The racial wealth gap that Frazier spoke of was real. But the people who felt that gap most acutely were often the ones who most needed to believe wealth was attainable.

Mollie knew that most everyday African Americans were Matthew 14 people—*Jesus fed five thousand men with five loaves of bread and two fish* kind of people. They had faith. They had hope. And to them, there being roughly 150,000 upper-class African Americans sprinkled across the country who made more than $75,000 a year sounded like progress. They could look at *Ebony's* stories about the dozen Negro millionaires who were going to miraculously uplift the race from poverty and believe it was possible.

It's why the biblical elements that Sadie Alexander weaved through her lectures on racism and economics resonated with people. Alexander minced no words when she called discrimination a "malignant growth in the economic body of the nation." But she, the granddaughter of an African Methodist Episcopal bishop, also strategically deployed Christian rhetoric, describing African Americans as "God's chosen children . . . leaven in the bread of [the] American way of life." If the masses believed they were God's children and they were the leaven in the bread that made it rise, surely the Lord could multiply their money and raise them out of poverty. Generational wealth would be theirs if they extended their faith. And Mollie and the women of the National Council of Urban League Guilds would help them match their faith with works.

—

Cold War Tensions

Harlem, Spring 1953

Cacophonous laughter echoed through Alta and Aaron Douglas's apartment at 409 Edgecombe Avenue. Alta loved to entertain at their place. This evening in March 1953 had provided as fitting an occasion as any. Aaron was away, teaching at Fisk University in Nashville for most of the year, but Loren and Juanita Miller were in town from Los Angeles. Alta had been determined to entertain her visiting friends in grand fashion. The "personable and popular" couple had dashed from the airport to change into more elegant attire for what the *Amsterdam News* would later describe as an "intimate cocktail party and supper" with two dozen old and new friends. Loren was part of the NAACP legal team led by Thur-

good Marshall. The victory in *Shelley v. Kraemer*, the landmark decision that struck down racially restrictive covenants on real estate, had elevated Loren and Juanita among Black civic leaders. They had society friends from coast to coast; the guests assembled that night reflected the Millers' popularity.

Mollie and Henry had made the trek over from Queens, as did Vicki and Dick Bourne-Vanneck. Langston Hughes, who had been best friends with the Millers since the early 1930s, would not have missed it. Artist Charles Alston and his wife, the star heart surgeon Myra Logan, were in attendance. So were Roy Wilkins and his social worker wife Aminda "Minnie" Badeau Wilkins, who lived just down the hall from Alta and Aaron. Robert and Ella Haith Weaver were among the group. After receiving her PhD in speech pathology, Ella had taken a position on the faculty at Brooklyn College. Bob had left the federal government to join his wife in New York and was currently the director of Opportunity Fellowships at the John Hay Whitney Foundation, which awarded grants from $10,000 to $30,000 to people of "exceptional promise" from socially marginalized groups.

This houseful of heavy hitters had all ascended to the Black professional elite while each championed her or his own vision of racial justice. Some members of this group of civic leaders had come together during the Depression, guided largely by the intellectualism of the New Negro Renaissance and the transformative potential of socialism and communism. Many of them, like Mollie and Juanita, had made careers in municipal and state government. These were not the highest paid jobs available to Negroes, but they offered more security than business or private practice. This gave them great influence within the Black community but also tempered their politics because they had to toe the line in order to

retain their jobs. Negro women were especially vulnerable because of the intersecting forms of discrimination they faced. But they were using the practical skills they'd learned on these jobs—everything from bookkeeping and fundraising to developing large-scale surveys and conducting field research—to build an infrastructure for the burgeoning Civil Rights Movement. It was insurgent work, they believed, taking the tools they'd learned in the proverbial master's house by day and repurposing them for their racial justice cause by night.

Juanita Ellsworth Miller was a native of Los Angeles. She had followed what was expected of a Black woman of her generation, earning a degree at the University of Southern California (USC) and going into social work. Eventually she became deputy director of California's department of social welfare. Juanita was a race woman whose social activities reflected her political commitments. A charter member of USC's Upsilon chapter of Delta Sigma Theta, founded in 1924, Juanita served as president of the graduate chapter in LA. She cofounded the Los Angeles–based League of Allied Arts in 1939 which raised funds for established and emerging Negro artists. She belonged to The Links and was a life member of the NAACP. Like Loren, Juanita was a sought-after public speaker who addressed local churches and NAACP meetings on topics such as child welfare and social services. Juanita was an understatedly attractive woman. She wore her hair in a side-parted bob with soft curls and was stylish but not ostentatious. Her tall frame and regal facial features gave her a graceful air as she moved through rooms filled with the who's who of Black society.

The *Amsterdam News* would characterize the party in Juanita and Loren's honor as centered on a "lavish buffet spread" with whatever food and drink guests might dream of, as the friends launched

into convivial "chatter sessions." But was that all that took place? Or was the "candlelight splendor" a cover for something more covert?

* * *

The onset of the Cold War in the late 1940s and early 1950s had sparked a virulent wave of anti-communism that made the repression of the early 1940s look relatively mild. The so-called House Un-American Activities Committee (HUAC)—which had surveilled Mollie, Henry, and other radical Negroes in the New Deal era—had continued its battle to suss out potential national traitors in Hollywood, creating the infamous blacklist. Meanwhile, Joseph McCarthy, the junior Republican senator from Wisconsin, was insisting that communist sympathizers and Russian spies had infiltrated the United States government and its armed forces. He made it his mission to find and make an example of anyone whom he regarded as questionable or suspect because of his or her past or present associations with supposed leftists. The investigations and hearings conducted by HUAC and McCarthy generated an atmosphere of extreme suspicion. McCarthy believed that President Truman, like Franklin Roosevelt, had left-wing sympathies. He focused especially on members of Truman's so-called Black Cabinet, such as Ralph Bunche, Thomasina Johnson Norford, Sadie Alexander, and Anna Arnold Hedgeman, whom he condemned as communist sympathizers if not communists themselves.

Loren Miller, the guest of honor, had gotten in the crosshairs of HUAC and its cronies in 1951 when he bought the *California Eagle* from his mentor and collaborator Charlotta Bass, who'd been ready to retire. Charlotta, like Loren, had been deeply committed to writing about housing discrimination, Ku Klux Klan violence,

and police brutality in the *Eagle*. Loren carried on the work they'd begun together. It had been the passing of the generational baton. But it had triggered a fierce attack from HUAC. Bass had been under FBI investigation for decades, with the feds obsessively labeling her a communist despite her insistence to the contrary. HUAC used the label "communist" as a catchall for any Negro's politics that were left of center, and Bass had been a leader in the Los Angeles branches of the NAACP and Marcus Garvey's Universal Negro Improvement Association. In 1952, Bass was selected by the Progressive Party to run for vice president of the United States, becoming the first African American woman to do so.

Because California had passed a state law requiring newspaper owners to declare they were not a threat to national security, a conservative California US congressman claimed that Loren, like Bass, had violated that code. They dredged up HUAC reports that Loren had signed a Communist Party election petition in 1932 and had written a piece for the *Daily Worker* titled "Why I Will Vote 'Red.'" He had indeed written the piece just before he and the other members of the *Black and White* cast had set sail for Moscow. He had believed deeply in the transformative power of communism. It was a time when many Negroes like Loren were looking for solutions to mass poverty.

Loren was born in Nebraska in 1903 and was raised in Kansas. He was the son of a former slave and a white woman who had given up any security of her race and gender to cross the color line. He moved around quite a bit as a young adult in search of education, even attending Howard briefly, before earning his law degree from Washburn University in Topeka, Kansas. He was admitted to the Kansas Bar and practiced law in that state before moving to Los Angeles in 1929. He studied for the California Bar Exam, one

of the toughest in the country, and was admitted in 1933, just after he'd returned from Moscow.

Loren had severed his ties with the Communist Party in 1939, right before the passage of the Smith Act, which permitted the US government to jail suspected communists. This move followed the NAACP party line under Walter White, who feared that any other course would expose the organization to prosecution and public persecution. HUAC's accusations never went anywhere. Loren purchased the *California Eagle* and used it as his platform to continue Bass's social justice work, and his writings throughout the 1950s made him a man of the people.

But the threat of government repression and individuals' differing responses to it took a toll on relationships and alliances. Alta's dinner marked the first time that Henry and Loren were seeing each other face-to-face since they'd had a lengthy correspondence about communism. Just a month before the cocktail party, Henry—who was still the NAACP publicity director—decided to protect himself and make a bold statement about his politics by writing a piece called "Why I Never Joined the Community Party," which he wanted to appear in a top national publication. To preserve his relationship with Loren, Henry sent him the draft. The piece discussed their Russia trip in detail. Though Henry did not name Loren, he shared enough details that Loren could be identified by those who knew about him. After reading the piece, Loren wrote Henry: "I respect the fact" that you did not use my name. "I am engulfed by the miasma of fear that broods over the nation. The use of my name will do me no good and almost certain harm." He could not fault Henry—who unlike Loren had publicly denounced Stalin and the USSR in 1933—for further distancing himself now that McCarthy was hunting for

communists. But he was glad that his good friend hadn't sullied his name in the process.

Other conversations were not as harmonious. To inoculate themselves against the premature end of their careers, people were willing to sell out their former friends. Walter White and Roy Wilkins, the NAACP's second-in-command and editor of *The Crisis*, were under pressure from the US State Department. The two conspired to publicly denounce Paul Robeson because of his pro-worker, anti-capitalist stance, which led him to be condemned by the mainstream media as the "Black Stalin" at the outset of this second Red Scare. The NAACP was always eager to disassociate itself from communism in an effort to curry favor with political elites, who were outraged by Robeson's fiery speeches denouncing white supremacy. In speaking out against Robeson, who had once represented the best of the race, they helped to put an end to his professional career. His passport was seized, his concert dates canceled. His income went from $1 million annually to about $20,000. Some people at Alta's dinner table were still salty over what they saw as a state-sponsored hit job on Robeson.

Mollie was never fond of Roy Wilkins. Few were. Wilkins was smug and detached—as cold as the Minnesota winters of his youth—and came across as arrogant and excessively urbane. Politically, she could see Roy and Walter's strategy. Those who supported their view argued that denouncing Robeson was essential to preserving the NAACP. The whole was more important than one or two Negroes—Robeson, and Du Bois before him. Wilkins later admitted: "I just didn't like the way Communists did business. . . . It was hard enough being black, we certainly didn't need to be red, too." Still, Mollie did not condone their actions.

Before this witch hunt, Paul and Eslanda Robeson had been

held up as exemplars of Negro excellence. Everyone who was anyone among civic leaders wanted to belong to their inner circle. Mollie had worked closely with Eslanda—"Essie," as she was known to her friends—to raise funds for the Harlem Community Art Center. The Robesons had been her people. *How could Roy and Walter throw their folks away over the white man's political struggle?* Her heart simply could not make sense of it. Mollie was not bothered when Robeson later used *Ebony* as his platform to call out Walter, Roy, and Jackie Robinson—whom Robeson insisted was just "spitting out words that Lester Granger had put in his mouth." Robeson still had a legion of supporters, including younger radicals in the nation's largest urban centers, who were prepared to mobilize against anti-Black violence and government repression.

Many activists whom Mollie and Henry had been close to in the early 1940s also sided with Robeson. Louise Thompson Patterson, who had assembled the *Black and White* cast on behalf of the Communist Party USA (CPUSA), and her husband, William Patterson, were among Robeson's staunchest allies. The Pattersons were key figures in New York's radical Black left. Louise had become a prominent organizer and fundraiser for the radical left, having refined her skills considerably since her failed attempt at raising funds for *Black and White*. Louise and Mollie had done some of this work together. But once the Feds began investigating Mollie's communist connections in 1941, Mollie had opted to leave the fundraising for suspected communists' legal defense funds to Louise. Her strategic fundraising mind had been an asset to Robeson and others caught in the government's crosshairs.

The Pattersons had deep ties to the Council on African Affairs

and the Civil Rights Congress—CPUSA-affiliated organizations that attracted members who were disenchanted with the moderate politics of the NAACP and NUL. This contingent also tended to be critical of the civic leaders who they believed were more committed to their government jobs than the people. Alphaeus Hunton, in whose house Mollie and Henry had gotten married, Shirley Graham and W. E. B. Du Bois, Claudia Jones, Essie Robeson, and others were part of this Black radical community.

In December 1951, William Patterson and Paul Robeson had submitted the monumental "We Charge Genocide" petition to the United Nations on behalf of the Civil Rights Congress. The book-length document was a damning indictment of US white supremacy, documenting the thousands of African Americans who had been lynched since the abolition of slavery, rampant police brutality, and systemic racial discrimination. Most of the people in Louise and William Patterson's radical network had signed the petition, risking their professional status and their passports to do so. The civic leaders assembled at Alta Douglas's house had not.

Relationships between the two camps had become even more fractious in the years since "Genocide." The alliance between the US and the USSR that had defeated Nazi Germany and fascist Italy was ruptured by the onset of the Cold War. Some within this assorted group with left of center politics were able to maintain personal relationships despite their divergent geopolitics. For others, the earth was scorched between those who disavowed Stalin and the USSR and those who still believed in the Soviet project. Everyone was on shaky ground as they questioned one another's politics and wondered what it meant to be part of the Negro left wing in the early 1950s.

Writ large, those who struggled for racial and economic justice

were targets of state surveillance and threatened with prosecution. People who held government posts or headed nonprofits that relied on federal support were especially vulnerable. The most effective strategy was to go underground. Correspondence within Mollie and Henry's group of Negro civic leaders slowed or ceased altogether, since the government controlled the postal service. Mollie and Henry had written frank and expressive letters to each other incessantly in the late 1930s and early 1940s. Although they now lived together, each had to travel frequently for work, and the other parent stayed home with young Mollie Lee. Yet they seldom wrote letters when one of them was away. People like Langston Hughes allegedly purged their personal papers, destroying any letters or other documents that could link them to the Communist Party. Letters that were sent kept to the most basic messages or used coded language.

Both civic leaders and members of the radical left learned to do their talking face-to-face, not even over phone lines, which could be tapped—that familiar *click* sound indicating that a government agent might be listening in. They were not just being paranoid. Loren Miller and many others were being surveilled by the FBI. This was a common experience among activists, then and now.

Their social life was part of what we can think of as a fugitive practice, the sort of concealment their ancestors had carried out since the days of the slave trade to organize under cover of the mundane. They could keep up appearances for the public, as events like this one at Alta and Aaron's house were a perfect misdirection. They were doing exactly what was expected of their social class. No one would bat an eye at these bourgeois Negroes assembling at this apartment, in this building owned by Augustine A. Austin, the Jamaican-born real estate mogul who was rumored to be the richest Black person in New York at the time.

But privately, these events were think-tank sessions where the heads of several of the major civil rights organizations and their auxiliaries could discuss the needs and the direction of the movement. Sometimes these debates were cordial. But once the liquor started flowing, things could get quite heated. These people had different intellectual and political leanings, and some were more naturally in sync personally and politically than others. When the conversation turned to controversial issues, the factions were exposed.

That night, discussion of the most pressing question concerning Negroes in 1953 was bound to arise. Henry was certain that securing the Negro vote was the top priority, as it was key to attaining full citizenship and electing local and national officials who would support the cause of the Negro. He explained, as he'd argued in his book *Balance of Power*, that voter education and mobilization had to come from the grassroots, through labor unions and community organizations. Loren agreed that voting was important, but he was adamant that something had to be done about the housing crisis. Millions of Negroes were either unhoused or living in slum conditions across the country. Loren had a way of delivering his points with the fire of an op-ed writer and the savvy jargon of an attorney.

Bob Weaver, too, saw the need to reform housing policies. He had confronted the housing crisis as an administrator in the US Housing Authority. He would be appointed as New York State rent commissioner in 1955, and in 1966 would be chosen as secretary of the newly formed federal department of Housing and Urban Development (HUD). Always the elder statesman, Weaver could stop a room cold as he opened his mouth to speak. Langston, the wordsmith whose every sentence sounded like poetry, made a

case for the power of the Negro arts, pointing to the Aaron Douglas originals that held watch over their convening. Juanita, an art enthusiast who was one of Langston's biggest patrons, agreed that the arts should not be left behind.

Mollie, ever the pragmatist, tilted her head to the side, whiskey soda in one hand, the index finger of the other extended and flexed with energy. *Yeah, yeah, all you Negroes talking that good talk. But how you gonna make it happen without the money, the moolah, the cash?* Her index finger now bent with the rest as she rubbed her fingers together in the universal gesture that conveyed: "Gimme money." Everyone burst out laughing. Mollie could cut the tension in a room with her big humor.

Roy, seizing the opportunity to make nice with Mollie, agreed. He told the group they couldn't really sustain anything without financial support from the masses. His words would have come out as matter-of-fact, devoid of charisma or passion, which would have made them fall flat after Mollie's full-bodied performance. Still, the two were on the same side of the debate this time. Once Roy became head of the NAACP in 1955, he launched big-dollar capital campaigns. He worked to recruit new members but also to solicit funds from non-members. Wilkins's approach to organizing was akin to that of the head of a philanthropic foundation. He was corporate, strategic, almost too rational for his own good. Unlike many impassioned activists, Wilkins believed that even grassroots racial justice work should be run as a business. That characteristic came back to bite him later.

Mollie almost recoiled at the thought that she and Wilkins had concurred on the importance of fundraising. His belief that victories in the courts were the only path to racial equality meant that almost everything the organization raised should go toward the

NAACP Legal Defense Fund, whereas she had a more robust and well-rounded view of how funds should be allocated to aid the cause.

The group went on debating, laughing, eating, and drinking well into the night. These clandestine meetings were necessary. There was no way to bring together a brain trust like this, from different organizations, with differing politics and vocations, to form the kind of alliances necessary to sustain a movement without breaking bread together. And the reality was that African Americans were facing an interlocking set of issues: poverty, unfair housing, police brutality, disfranchisement.

The crux of the matter was less about what needed to happen first and more about how to mobilize a national coalition to tackle these issues simultaneously. Everyone gathered at Alta and Aaron's apartment played a significant role, although today most are relegated to the margins of history. They emerged as leaders at this moment of repression, and much of the cooperation between them was veiled. The times were shifting so quickly that we often overlook the infrastructure builders in the years before widespread direct nonviolent action. But it was in covert meetings like this across the country that the secret society gathered and laid the foundations for a strategy that allowed each organization to make a distinctive contribution to the movement.

CHAPTER 10

Black Freedom Economics

Manhattan, Spring 1956

Mollie was called into the Midtown Manhattan headquarters of the National Urban League for an emergency executive board meeting. As committee secretary, she furiously took notes while an exasperated Lester Granger explained the reason for the meeting. Several of the Southern NUL affiliates were suffering financially. Groups of influential white segregationists had applied pressure to local Community Chests across the South, threatening to stop making financial contributions if they continued to donate any of those monies to the Urban League or other civil rights organizations. Community Chests and United Funds raised money from people of all socioeconomic backgrounds and distributed it to local organizations that were invested

in the town's public good. Local NUL and NAACP affiliates had typically received sizable annual gifts from these pooled funds. But the NAACP's victory in *Brown v. Board of Education*, which ruled racial segregation unconstitutional, had changed everything.

Hardest hit were the Urban League's affiliates in Little Rock, Arkansas; New Orleans, Louisiana; and Jacksonville, Florida. Activists in these major urban centers were among the most militant in the Deep South. Communities such as Jacksonville's LaVilla neighborhood—dubbed the "Harlem of the South"— were coordinating strategic boycotts and protests. These mobilizations incensed white racists. Granger had received word that the Little Rock Urban League was experiencing "rough sledding since its expulsion from the United Fund."

The New Orleans League executive director had explained that "the climate of race relations in this area is such that there is little disposition on the part of the United Funds or industry to appropriate funds for Negro betterment programs." The affiliate was now in "dire financial straits." Meanwhile, the community need was higher than ever, and the New Orleans affiliate's budget was steadily increasing. The executive director had stopped receiving his salary, laid off the rest of the paid staff, and devoted himself entirely to raising funds.

When the Jacksonville affiliate was founded, it had the backing of city officials and business professionals of both races. At the time, the NUL was seen as a politically moderate, interracial social service organization that was primarily concerned with aiding the poor. But now Jacksonville's financial situation looked just as disastrous as that of Little Rock and New Orleans. The Jacksonville executive director notified headquarters that "a White Citizens' Council anti-Negro campaign persuaded the Chest to drop the League."

Addressing the financial situation across the South would require the joint effort of the power brokers who strategized about the movement around dining room tables and those on the movement's front line. A gulf had emerged between the two factions. Grassroots organizations, which mostly comprised the Negro working poor and students, wondered how those New York big shots could determine what the movement required if they never got their suits dirty. Activists in the trenches weren't being paid for their labor or feted at fancy galas. But they were the force agitating for voters' rights, labor rights, and equal pay. The reality was that both factions were needed to sustain the movement. And that fact became dangerously clear after *Brown*. They had to work to establish what we can think of as a Black Freedom financial grid that would allow them to raise money within their social networks and move it across the country. At this moment of crisis, they had to act quickly.

* * *

Well before the *Brown* case was heard in the Supreme Court, the more radical branches of the NAACP, the NUL, and other organizations were staging actions to integrate local business establishments. These demonstrations were particularly common in cities that had legally abolished racial segregation in public accommodations but still tolerated it in practice. Such campaigns against Jim Crow often focused on travel and leisure—spaces that middle- and upper-class Negroes now demanded access to.

In the late 1940s and early 1950s, African Americans initiated countless acts of daily resistance and filed hundreds if not thousands of lawsuits against hotels, restaurants, theaters, and

department stores across the country. The educated middle class in particular believed that winning civil rights leveled the playing field and was crucial to achieving racial equality. The only real way to dismantle apartheid was to take a bulldozer to the laws that enabled it. Once this legal order was demolished, they thought, systems of racial terror, unfair labor practices, and workplace discrimination would disappear. Black Americans would be allowed to participate in capitalist society as equals and be able to afford the same consumer goods as their white counterparts. For others, these direct actions against leisure establishments were less about entitlement and more about strategy. Effectively challenging Jim Crow there could help set an important legal precedent.

An interracial group of about thirty men and women active in the Congress of Racial Equality (CORE) integrated the Bimini Baths near what today is Koreatown in Los Angeles. Back then, it was a geothermal hot spring with a public bathhouse and pools, a Turkish bath, a rooftop garden, and other amenities. It was named after the Bahamian island of Bimini. The Bimini Hotel, under the same ownership, was across the street. Mexican Americans were allowed to swim there, but only when the water was deemed too dirty for whites. It would be drained after they left. But Blacks were banned. CORE led a four-month campaign to break the color line at Bimini. At first, the group of eight who attempted to enter was turned away. Then the manager threatened to spray them with a high-powered water hose. The protesters persisted, and over the months of their demonstration their number grew. Finally, management relented and allowed the group of thirty to enter.

NAACP attorney Loren Miller filed a lawsuit in the Superior Court of California in Orange County against Knott's Berry Farm on behalf of his six Negro clients who said they were denied en-

try because of their race. The group of African American women and men alleged that the manager told them outright: "There are 400,000 Negroes in Los Angeles and if we serve Negroes we will have to close down. I just can't permit Negroes to come down here." This complaint was one of many against Knott's Berry at the time. Miller believed the best strategy was to file for an injunction instead of a suit for damages, because the injunction would subject the Knott's Berry Farm manager to jail or prison rather than paying a small fine for illegal discrimination.

Mollie and the National Urban League Guild secured a court victory against The Pierre hotel in Midtown Manhattan in 1952. The Pierre was a grand hotel on New York City's Upper East Side. Its forty-one-floor tower overlooked Central Park and upscale shopping on Fifth Avenue. Mollie had decided that The Pierre, with its air of European refinement, should be the location of the Guild's next summer party. She had called the hotel a few weeks earlier to book the rooftop garden for the evening of July 20 and to arrange catering. The only thing left to do was pay the five-thousand-dollar deposit to hold the date. With her purse dangling from the crook of her arm, dressed in a power skirt suit, Mollie arrived to make her payment in person. Seeing her race, the hotel refused to honor her booking, offering conflicting explanations: "The hotel [is] all booked up." "The roof garden [is] being painted."

Mollie returned home and phoned the law offices of Carter, Smith, Watson & Wright, a team of hungry young Black lawyers—children of the Black aristocracy—eager to try a career-defining civil rights case. Lisle C. Carter Jr. was the son of a prominent dentist and the renowned former New York assistant district attorney Eunice Hunton Carter. Lisle and his law partners helped Mollie sue The Pierre and the banquet managerial

staff for violating sections 40 and 41 of the New York State civil rights law banning discrimination on the basis of race.

The linchpin in Mollie's case was sworn testimony offered by Elizabeth Fillman, a white woman who worked in the National Urban League Guild with Mollie and was married to a wealthy Wall Street attorney. Mollie had instructed Fillman to walk into The Pierre a few days after Mollie and attempt to book the rooftop for a private event on the same date. Fillman testified that the banquet manager met with her face-to-face. He asked her, point-blank: "Will any colored persons be attending this event?" He reminded Fillman that The Pierre was a "high class hotel." Once she assured him that no Negroes would be present, he accepted her booking without any further questions. When announcing his verdict, the presiding judge, Abram Goodman, said to the court: "When the defendant's agents saw that the plaintiff was a colored person, they refused to do business with her." Mollie was awarded $6,700.

The Black press heralded the court victory as a triumph for the Civil Rights Movement. The Baltimore *Afro-American* opined that the Guild was "more militant than the parent group which organized it," an obvious dig at the Urban League's leadership, which, in contrast to the NAACP, had not yet made the courts into an arena of struggle. Mollie's lawsuit over the rooftop garden was a step toward freedom, a reclamation of humanity for every Black person who had lived under Jim Crow.

The NAACP Legal Defense team's 1954 victory in *Brown v. Board* was the culmination of numerous lawsuits that chipped away at Jim Crow on the city and state levels. But the white backlash to the blow that had been struck against segregation and their white privilege was intense, especially in the South. White Citizens' Councils (WCCs) began forming after the ruling. Their leaders

were among the elite, the old-money Southern gentry whose generational wealth in land had been amassed off the backs of the enslaved. Their members were people who had used GI benefits and other government incentives to become teachers, dentists, doctors, and lawyers. In almost every city, the business elite, particularly bankers, composed a substantial portion of a WCC's membership. It was quite common for the president of the local bank to be the president of the local WCC. In just a couple of years, White Citizens' Councils had hundreds of thousands of members across the South, with local, state, and regional headquarters. In Mississippi, WCCs were so enmeshed in local and state politics that they had quasi-official status and even received state funds.

The White Citizens' Councils understood that the way to apply real pressure to civil rights organizations was to strangle the flow of money. They targeted anyone who was a known activist, as well as individuals and organizations that sympathized with the cause or donated money. Using their control of banks and other financial institutions, WCCs denied Negro farmers mortgages, withheld government food subsidies for the poor, cancelled car insurance policies, and threatened the pensions of local teachers. They pressured the predominantly white board members of historically Black colleges and universities that received state funding to fire administrators and faculty and expel students who participated in civil rights demonstrations. Even if only one member of a family was active in the movement, a WCC would pursue economic and social retribution against them all.

While the WCCs prided themselves in their refined approach to racial intimidation, vigilante violence was their underground counterpart. The Ku Klux Klan and other white supremacist groups were given the names of people and organizations the WCCs were

targeting and launched full-scale violent campaigns. The Negro section of Birmingham, Alabama, was bombed so many times that the city was sadly nicknamed "Bombingham."

The Klan firebombed NAACP branches and ran their leaders out of town. Or, in the case of Jacksonville NAACP radical activists Harry and Harriette Moore, the Klan executed them. The Moores had been teachers in the Florida public school system and had worked closely with Thurgood Marshall to agitate for equal pay for African American teachers. They also had investigated lynchings across the state, seeking legal forms of justice. On Christmas night, 1951, the couple's twenty-fifth wedding anniversary, Klan members lobbed a firebomb into the Moores' bedroom window. It detonated under their bed and left the couple severely wounded. Jim Crow laws prevented Harry and Harriette from being taken to the nearest hospital for treatment. Henry died during transit to the colored hospital, and Henrietta succumbed to her injuries a week later.

In August 1955, fourteen-year-old Emmett Till was lynched in Money, Mississippi. His open casket at his funeral let the whole world see the savage beating by white vigilantes that had ended his life.

African Americans fought back. Many took up arms to defend their homes and families. Networks of Negro professional organizations, church groups, beauty shop and other small business owners, and social clubs organized boycotts against white businesses whose owners belonged to a White Citizens' Council. Perhaps Southern African Americans' bravest strategy was simply refusing to leave. They stood their ground in the community and tried to establish some sense of normalcy, even as the towns and cities around them were becoming veritable war zones.

The Montgomery bus boycott, which began in December 1955, represented the power of African Americans organizing across class lines to end Jim Crow in the Alabama city's public bus service. Young Atlanta-born pastor Dr. Martin Luther King Jr., elected president of the Montgomery Improvement Association (MIA), became the national face of the movement. But it was local women who coordinated the grassroots efforts. Teenage activist Claudette Colvin, who was active in the NAACP Youth Council, and later Rosa Parks, also a member of the NAACP, had put their bodies on the line, by sitting in the empty whites-only section of the bus or refusing to give up their seats in the Black section to white riders. Their arrests had sparked outrage because African American riders were the bus service's largest clientele but received the worst treatment. The Black section of the bus was always overcrowded, while the white section was almost always empty. Still, bus drivers and white passengers could demand that any African American rider give up his or her seat in the Black section if the whites-only section became crowded. It was a degrading and humiliating practice, not to mention challenging for the disabled. Jo Ann Robinson of the Women's Political Council initiated a boycott after Parks's arrest, and women spread the word through church and social club networks. On the first day, forty thousand Negro riders boycotted. Members of the Negro elite donated their fine automobiles to the movement to help support an alternative transportation system.

NAACP activist and Montgomery native Georgia Gilmore spearheaded the MIA's fundraising efforts. Gilmore, a talented cook and domestic laborer, had experienced the inhumane treatment on the buses firsthand. She showed up on the first day of the boycott with fried chicken sandwiches that she sold to boycotters. The food became so popular that Gilmore and others organized

the Club from Nowhere, which provided fried chicken, fish, and pork chop dinners with sides of collard greens and lima beans, and peach pies and pound cakes. They raised hundreds of dollars every week by selling their delectables at laundromats and beauty shops across town. The proceeds all went toward funding the alternative transportation system, paying for gas and auto repairs.

The MIA sustained the bus boycott for more than a year. On December 20, 1956, the US Supreme Court upheld the ruling of the federal district court in Montgomery that segregation on buses violated the Constitution, and the boycott was effectively ended. But violent white backlash against the court victory made Montgomery a powder keg. Negro Americans were attacked and beaten, law enforcement unfairly arrested those involved in the boycott, and the courts held them without bail.

Everywhere they turned, the one-two punch of WCCs and the Klan was striking a devastating blow to Negroes' cross-class alliances. WCCs' widespread economic reprisals kicked off an economic crisis that continued well into the 1960s. Civic leaders had to strengthen the bonds between their organization's national headquarters and its local branch leaders, as well as those across the various organizations. The NAACP, NUL, CORE, National Council of Negro Women, Brotherhood of Sleeping Car Porters, and United Negro College Fund (UNCF) were at the center of this coalition. In 1957, Southern Christian Leadership Conference would be added to the mix.

Black branches of the YMCA and YWCA were important players, as were Greek-letter Black fraternities and sororities. Masonic temples and other fraternal orders such as the Benevolent and Protective Order of Elks were essential, as were the Order of the Eastern Star and social clubs such as The Boulé, The Girl

Friends, and The Links. Jackson, Mississippi, businesswoman Clarie Collins Harvey and her organization Womanpower Unlimited would become a fundraising force. An often-overlooked organization in this matrix was the American Bridge Association (ABA), which since 1948 had been led by Victor Daly. A Cornell University graduate, Daly was a civic leader deeply committed to racial justice. In his role as a high-ranking official in the US Employment Service, he advocated for fair job opportunities for all African Americans, especially the most marginalized. And he helped to transform the ABA from a national body of the Negro elite who enjoyed competitive bridge to one with a racial justice focus. The ABA pledged thousands of the dollars it raised each year from its annual national tournament—which attracted upward of ten thousand Negroes from across the country—to the NAACP, NUL, CORE, and UNCF.

Black women across the rural South, many whose names have been lost to history, coordinated bake sales and fish fries to raise money for local efforts. Drawing from the strategies that had paid for new church roofs and school supplies, they were now using their fundraising skills to fund bail campaigns and voter registration drives. Many of these same women housed the Northern movement volunteers who had started traveling south to coordinate mobilizations with local activists. They offered what little food and toiletries they had to the volunteers. It was these everyday acts of generosity that buoyed the movement.

* * *

Meanwhile, at the meeting Lester Granger had assembled in Manhattan, the National Urban League had decided to implement a

strategy to aid its Southern affiliates that soon proved untenable. The NUL executive committee and board of trustees voted to draw money from the secret Urban League Fund that it had been building since the end of World War II. Affiliates in need could apply to NUL headquarters for a substantial loan to keep them afloat. The repayment terms were unclear, but in any case the arrangement multiplied the financial strain. The League was still receiving approximately half a million dollars a year from philanthropic families and corporations. But it was blowing through the money even more quickly. Between the League's regular overhead and the loans it was dispersing, its depleted bank accounts sank deep into the red. And affiliates that were facing racial terror amid an escalating movement for civil rights would never be able to repay the loans.

In this moment, Mollie Moon and the National Council of Urban League Guilds became indispensable, helping the NUL raise money, build strong interracial alliances, and sustain its relationships with other Negro organizations.

CHAPTER 11

Rule with a Satin Glove

Manhattan, 1961

Mollie was opening mail in her office at the National Urban League headquarters. In the pile of correspondence was a letter from Charles F. Harlins, executive director of the Phoenix affiliate of the Urban League, complaining about what he saw as the insubordination of the local Guild. He scolded the women of the Phoenix Urban League Guild, and by extension Mollie, for wielding too much power and usurping the authority of the board of trustees and of Harlins. He was prepared to take drastic measures to deactivate the Guild. Mollie skimmed the letter and chuckled. Many of the male leaders simply could not handle the power position the Guild women had assumed, especially

since they'd established the National Council of Urban League Guilds.

Mollie decided to forward Harlins's letter to NUL head Lester Granger. *He can deal with this chauvinist bullshit*, she likely thought. After all, these men had long weaponized patriarchy to keep women in their assigned place. She already knew where Granger would stand on the matter. By 1961, the National Urban League Guild and its affiliates had raised nearly $900,000 for the national headquarters and had helped to increase supporter numbers tenfold. Over the past nearly twenty years, the Guild had proven itself to be an indispensable force.

And Mollie knew what Harlins likely did not: the NUL was in serious debt. Funneling money to Southern affiliates who were enduring an all-out war with white segregationists had bled the organization dry. And while Phoenix was of growing prominence on the map of Black society, it was in the boondocks of the financial grid that social justice organizations were forming. The gravitational pull of the money still centered in New York City. And the only person who knew this as well as Mollie was Granger.

At the time, Lester Granger was laid up in a hospital bed in Harlem, which he had converted into a makeshift office. He read Harlins's letter. Despite his "crotchety" mood, he placed his typewriter on his lap and painstakingly pecked out each sentence of a strongly worded response. Granger was "a little disturbed" by Harlins's report that the Guild and the League in Phoenix "have not enjoyed the best of relationships." Nonetheless, he wanted to dissuade Harlins from allowing his ego to get in the way of a good thing. If Harlins would be reasonable, he could see that the Guild was his greatest ally, and he could harness its power to aid

the League by raising funds and local support for its social justice initiatives in Phoenix.

Despite Granger's support of the Guild, his comment that an Urban League Guild was "nothing more or less than an auxiliary of the Urban League which creates it" reflected the paternalism of the organization and the ways it dismissed the work of women volunteers. Granger told Harlins it was the job of the board of trustees—guided by its male leaders—to keep the Guild in line with its vision instead of letting the tail wag the dog. Guilds should not have an agenda that is separate from or has not been approved by branch leadership, Granger warned. And they were not to exercise a supervisory or leadership function outside of polite luncheons and teas at the National Urban League annual conference. League executive directors—a position typically held by men—had to be "tactful, firm, and skillful" in dealing with the Guild's leadership. If not, "he can find that they will get away from him and be more of a nuisance than a good." Granger closed his letter by encouraging Harlins to reconstitute the Phoenix Guild with fresh, cooperative leadership. And, in what Mollie must have considered a surprising blow, he advised him to do so "entirely apart from" the National Council of Urban League Guilds.

Granger's directive perhaps reflected his own intimidation by the Council and its power. He was known among women Leaguers for having far more progressive gender politics than the other men in the NUL and the broader Civil Rights Movement, but his paternalism often showed when it came to the Guilds. He wanted to keep the Council feminine and genteel—the ultimate helpmate—not a power player.

The council, however, had another agenda. Its national programming in support of racial equality included robust balls,

dances, and teas, among the more glamorous events. Guilds also sponsored speaking events and lectures and hosted town-level meetings where political candidates could meet with their constituents to talk about their Negro agenda and seek support from African Americans. These programs gave women of the Guilds unprecedented access and authority among local and state politicians who wanted to stay in good standing with African American and progressive white voters. Another major push, particularly in Cleveland and Providence, was social events for international students who were coming to their cities for higher education. These activities not only connected Guild women with a younger generation but also exposed European, African, and Caribbean students to the Guild movement's approach to race relations. The "Guild story is being spread internationally," St. Paul, Minnesota, Guild member Mary C. Herzog told her peers in the Council's quarterly publication, *The Guildscript*.

When Mollie had come to Lester Granger in 1952 about the Guild women's desire to create a central governing body, he imagined that the Council would simply be a banner under which the growing number of Guilds across the country would meet to exchange ideas and experiences at the NUL annual conference, in a manner similar to the executive secretaries and other special interest groups within the League. And perhaps that is how it started. But a decade later, it had its own infrastructure within the larger NUL and had become quite astute at raising and moving money across the country. The Council had amassed so much power by 1961 that Granger and the NUL board of trustees had reprimanded its leaders, telling them they were "off-base" in their endeavors and that they must work together to consider a new structure that wrested power from the Council.

Even as he fought to try to keep the women contained, Granger knew, just as he advised Charles Harlins, that he'd better not cut off his nose to spite his face. The Guilds kept bringing in more and more money. In 1954, Granger reported to the press that Mollie and her Guild movement had raised a quarter of a million dollars. But by 1961, that number had tripled. Granger also understood that, in the unspoken competition between the big civil rights organizations, it was the work of the Guilds that had made the NUL's infrastructure enviable. The NUL's ability to expand its auxiliaries was evidence of how Lester and Mollie's partnership, forged in the early 1940s, was paying off.

Meanwhile, the NAACP had decided in 1954 to consolidate its women's fundraising groups into a single women's auxiliary, mimicking the Guild's structure. Roy Wilkins saw the Urban League as a "friendl[y] threat" to the NAACP in their battle for support and money amongst everyday Negroes. Wilkins later confessed: "The League was quietly hiring better-prepared staffers than we were, opening new offices, and expanding in other ways." The NAACP still received more money annually through small- and large-dollar donations. But the League was far more successful in moving money around its financial grid to get it where it was needed. And that mattered, especially when it came to media optics. Most organizations had been accused of misappropriating funds—either by their own members or by their enemies—at some point. It was negative press that all organization leaders wanted to avoid.

NUL's Guild women had made themselves indispensable. Still, not all the existing Guilds had come under the Council's umbrella. Some Guilds did, but not without a great deal of coaxing from Mollie. Shirley Lee, chairwoman of the Providence Guild, was at first reluctant to join. Mollie sent her a personal letter, asking

that they "talk some of these things out" at the next National Ur-
ban League conference. Eventually, the Providence Guild joined
the fold because it was more advantageous to "draw strength from
each local group," as Mollie had phrased it. Mollie and the Council
continued planting new Guilds. In 1954, famed society editor Ger-
trude "Toki" Schalk Johnson, who had experienced minor fame
as a fiction writer during the Harlem Renaissance, led the newly
formed Pittsburgh Urban League Guild. This addition was cru-
cial, since Pittsburgh was a key industrial city with one of the most
powerful and widely circulating Black newspapers.

In 1958, Mollie helped to establish the Philadelphia Guild. Phil-
adelphia had long been distinguished by its free, educated Black
elite. And Urban Leaguers, such as economist and lawyer Sadie
Alexander, became more important to the movement. Alexander
was tapped to speak at events, offering a Black-woman-centered
perspective on the economics of racism and the importance of
economic equality. At the luncheon celebrating the launch of the
Philadelphia Guild, Granger praised the hundreds of Guild volun-
teers as "the kind of women who—at times—neglected their home
chores to give time and service to the cause of the NUL."

When Mollie took the podium, she said nothing about feminine
self-sacrifice. Instead, she declared forthrightly, "The primary pur-
pose of volunteers serving the Guild is raising much-needed funds
for the NUL." This was a huge rearticulation of the Guild's work.
In earlier years, leaders spoke about civic-minded women using
their skills to create social events for the NUL—a "helpmate" role
more in line with Granger's vision. Now the Council had taken on
the slogan "The Organization with a Purpose." It clearly saw itself
not simply as an auxiliary but as its own organization that could
benefit from the infrastructure, interracial network, and prestige of

the old-guard organization while maintaining its own semiautonomous identity.

The NUL's designation by the IRS as a 501(c)(3) nonprofit organization enabled contributors to write off their donation on their taxes. It was difficult for predominantly Black organizations to obtain 501(c)(3) status, and many fledgling Black organizations with smaller budgets never attempted to do so. Some worked under the auspices of a more established charity. Others collected donations but found it more difficult to land large sums from wealthy individuals or corporate foundations. The Guilds used the NUL's tax-exempt status to rake in big dollars. Images of Mollie handing fifty-thousand-dollar checks on the Guild's behalf to board member Marietta Tree, with Jeanne Vanderbilt representing the Women's Division, circulated in the Black press.

The bulk of the money was being brought in by New York City. But Atlanta and Cleveland also raised a decent pot of money each year. With Guilds in New York City; Providence, Rhode Island; Elizabeth City, New Jersey; and Pittsburgh and Philadelphia, Pennsylvania, the Council had created a fundraising corridor on the East Coast. The Baltimore Guild was the Council's gateway to the Mid-Atlantic. The Urban League's Southern regional publicity director, Isobel Chisholm, had established Guilds across the South. There were also robust Guilds throughout the Midwest. And with the Phoenix Guild in play in the Southwest, the Guild movement was consolidating power. The men of the old guard were alarmed at this erosion of their influence, which is why Granger was trying to encourage Harlins to relaunch the Phoenix Guild with women who would not want to join the Council.

Mollie Moon was, effectively and unapologetically, elevating herself and her peers to premier fundraisers who could stand

alongside the African American community's most prominent "bag men." The term came from the underground economy; it referred to the trusted policy men who collected the money from folks playing the numbers. Men in the above-ground economy had appropriated the term. High-society bag men were African American men whose social stature and interracial networks gave them access to large sums of money. They had the power and the juice to help raise funds for almost any good cause. People would come to the bag man and explain their need, and the bag man would say whether he could or could not honor their request. Bag men were often not independently wealthy themselves, but they could raise money from those who had inherited or acquired wealth.

The most prominent women of the Guild were bag women in their communities. They were well networked within and beyond the NUL and had strong relationships with local television, radio and print media, access to capital, and close relationships with local and state government officials. St. Paul leader Mary C. Herzog said that Guild women had the power to "reach into the life of the community" and shape its dynamics. According to Herzog, Council-affiliated Guilds constantly received letters from other Black organizations asking for help. They couldn't always give financial assistance, but they would help the organization distribute its literature or cosponsor the smaller organization's projects. This was a very strategic form of partnership. It allowed Guilds to serve as philanthropies—the generous givers to organizations in need—and it was "a fine method for public relations," Herzog explained. Guild women were always aware of the optics.

Not everyone saw these steps toward professionalism as progress. During one of the NUL conferences, several members expressed concern that the Guild movement was becoming too

elitist. Each Guild had its own membership policy and methods of recruiting. Most recruited through their own social networks. The Providence Guild held receptions open to the public and sent prospective members its bulletin for three months. At the other end of the spectrum, Grand Rapids had one of the strictest policies. It limited its Guild to sixty-five active members, who each paid twenty dollars in annual dues: ten dollars went to the Guild, ten dollars to NUL. Names of prospective members were presented to the group and then voted upon. They checked their rolls annually, and anyone who had not contributed financially or done some volunteer service was designated as inactive. Active members' names were listed in their bulletin as an incentive to keep members engaged and paid up. Some of the younger, more progressive women who had joined the Guild movement felt these practices reproduced a certain type of membership and created barriers to entry for others. Their complaints exposed a fissure in the Guilds that soon widened.

The Atlanta Guild was far more democratic than the New York Guild. It advertised its meetings in the *Atlanta Daily World*, which gave more people opportunities to join the ranks. "Membership in Guild is open to all women interested," it announced. The Guild was mostly looking for people with a willingness to give of their time and other resources. Because of the nature of class stratification and career opportunities for Black women in Atlanta, a greater range of occupations was represented in its Guild: social workers, K–12 teachers, and beauticians. The quintessential profile of the Atlanta Guild woman was well dressed, well traveled, stylish, and well kempt, with some sort of professional or vocational training.

The Oklahoma City Guild reflected the class politics of this state capital at the crossroads of the South and the West. The OKC

Urban League affiliate had formed in 1946. Social worker Cernoria D. Johnson served as the first head of the Oklahoma City Urban League, coordinating with the NAACP and other local organizations to build on the momentum generated by Ada Lois Sipuel Fisher's Supreme Court case against the University of Oklahoma law school. Under the leadership of educator and Alpha Kappa Alpha member Thelma Gorham, an influential group of Guild volunteers was instrumental in giving the fledgling League affiliate an organizational structure, establishing its basic program, and adopting an approach to community engagement. Gorham, the daughter of a domestic laborer, worked well with the city's Negro women, who were mostly employed as laundresses and domestics, along with a strong contingent of beauty culturalists.

The Black educated class in Oklahoma City was very small, consisting of doctors, lawyers, teachers, and social workers. These people headed up the NAACP and Urban League affiliates and participated in a host of social clubs that focused on everything from bridge to savings. The city had a strong Zeta Phi Beta chapter and clubs for women in church ministries as well as savings clubs, such as the Thrift Club and the 20th Century Club.

This network of organizations supported schoolteacher and NAACP activist Clara Shepard Luper as she conducted what is believed to be one of the first sit-ins against segregation in the country, in 1958. Luper, who was also a member of the Zeta Phi Beta chapter, went on to challenge segregation at more than a hundred public places across Oklahoma: restaurants, cafés, theaters, hotels, and even churches. In 1960, Martin Luther King Jr., who had risen to national prominence after the events in Montgomery, came to Oklahoma City. He helped lead a citywide boycott to desegregate eating establishments and to avoid shopping at places

that upheld Jim Crow, which lasted through the Christmas season. Oklahoma City was a model of what effective coordination between the Urban League, its Guilds, and the NAACP and other social and civic organizations could accomplish.

* * *

Mollie sat at her dining room table reading the *Amsterdam News*. She'd gotten word that there was a story about her and the Guild in that day's issue. She always watched the press with an eagle eye to see exactly what the society writers were saying about her and her friends. It still amused Mollie that people found her interesting enough to write about, as if she were a bona fide celebrity.

She found the story. "Well Done," read the headline. "For plenty of years now these lovely women have put their shoulders to the wheel of Civil Rights and steadily pushed," the article stated. "And today they yield to no one when the honor roll of freedom fighters is called." We can't leave the "battlefield" of civil rights, but the National Urban League Guild has taught us "there is indeed some time to relax and play on the actual battlefront." The unnamed author likened the Beaux Arts Ball to a twenty-four-hour furlough for weary racial justice soldiers.

Mollie likely was overwhelmed. *They got it. They got it right*, she perhaps thought as she grabbed her scissors and neatly cut out the news story to add it to her archive. Hundreds of stories had been written about the Guild and the Council in the organization's history. But few had gotten to the heart of why the women did this work. Most stories reveled in the glitz and glamour of Mollie playing hostess in a designer frock. Yet this story saw the Guild women as freedom fighters. And that was a huge honor at a time when

Martin Luther King Jr., Rosa Parks, and James Farmer were becoming household names within the African American community.

The recognition in the *Amsterdam News* arrived amid intense battles within the League about the type and level of influence the Council should have in the movement for civil rights. Direct nonviolent actions such as those led by Clara Luper in battleground states like Oklahoma spread across the South. At sit-ins, marches, protests, and other demonstrations, Black people demanded change. In cities from Nashville to Mollie's hometown of Hattiesburg, Mississippi, younger African Americans stood on the front lines.

Historically, the National Urban League had not used such methods to spark social change. It was mainly a social welfare organization, and the most militant action it advocated was consumer boycotts of businesses that refused to hire Black employees. The NAACP, on the other hand, was focused entirely on winning civil rights, and its 501(c)(4) tax designation allowed it to be overtly political. But the tide was turning within the League as more of its members, particularly younger professionals, wanted to be front and center in this new phase of the movement.

The women members of the Guilds and their leaders never came to any consensus about nonviolent direct action; many believed their work was conducted in a different arena. But Mollie seemed to be moving the organization toward a more militant stance in the 1950s. Her decisions to stage direct actions and file suits in court signaled that she wanted the organization to participate in this shift toward nonviolent direct action as well as legal resistance.

After Mollie and the New York Guild sued The Pierre for racial discrimination, and won, she sued a taxi company that had refused to take her; her daughter, Mollie Lee; and one of young Mollie's

Jewish school friends back to Queens from Manhattan. "Well, sir, your tag was up, I got into the cab, so please take us where we want to go," Mollie Lee remembers her mother replying. "Oh, all you dumb niggers are the same, aren't you?" The cab driver began berating Mollie as Mollie Lee and her friend looked on. Mollie Lee's friend was astounded and afraid: "He called us niggers! Did you hear that? He called us niggers!" she whispered to Mollie Lee. Mollie put her feet up on the taxi's jump seat, folded her arms, and refused to move. "Sir," she said, "if you won't take us to Queens, you can take us to the closest police station." According to Mollie Lee, he dropped them at the police station, where Mollie filed a police report. Mollie called her attorneys and filed a racial discrimination lawsuit. Mollie Lee remembers that she had to take a day off from school to accompany her mother to court, though she doesn't recall the outcome of the case.

Mollie wanted to be publicly recognized for her work in sustaining the Civil Rights Movement by leading the Council and expanding the NUL's reach. Yet others within and beyond the NUL found it difficult to define the role Mollie played. Her long association with entertainment and parties, particularly the carnival-style Beaux Arts Ball, where guests wore sexually suggestive disguises, linked her to a form of erotic display. That image was underlined by her own features, which for some cast her as the exotic and racially ambiguous other. At the same time, she was a highly educated professional woman with loads of business savvy and a profound commitment to racial equality.

However, she did not fit the mold of a civil rights leader. When the Administrative and Clerical Council of the Urban League honored Mollie in 1959, they described her as "a dynamic personality, with inexhaustive energy, an indomitable will and ingenious

ideas." The *Pittsburgh Courier* described her as the "beauty with a social mission" who was managing to juggle her race work, her business, and her marriage and child. Although intended as a compliment, the beauty that was part of the Mollie Moon brand was at once a blessing and a curse. It trivialized and feminized her in ways that disempowered her and her woman-centered mission. She always cultivated a feminine image. But she was a boss, as her correspondence makes clear. She rarely explained her actions, even if the press deemed them controversial. She didn't beg to be liked or ask permission to lead. Mollie understood how to use her femininity to her advantage, but she was not just some socialite.

Still, Mollie was viewed as more a Black Perle Mesta—the Washington, DC, socialite and political hostess who had been the US ambassador to Luxembourg—than a Mary McLeod Bethune. But African American women were not allowed to be US ambassadors. Mary was the closest there was to a Black stateswoman. And the political voices at the fore had determined that Mollie was not Mary material. Instead, Dorothy Height, the former national president of Delta Sigma Theta sorority, had been named Bethune's heir apparent. Dorothy had taken over the reins of the National Council of Negro Women in 1957 and was quickly becoming a leading national voice for the rights of African Americans and women. Mollie and Dorothy had similar profiles, but Mollie was a more polarizing figure. Dorothy had no ego and avoided a top-down approach to leadership, which some found more appealing than Mollie's style.

Daisy Bates, who was seven years Mollie's junior, was also developing a national platform in the late 1950s. Born in rural Arkansas and orphaned as a child, Daisy became a voice for the Black working poor. She and her husband had bought the *Arkansas State Press* in 1941 and modeled the newsweekly after the *Chicago Defender*

and *The Crisis*. They published hard-hitting stories about the horrors of Jim Crow and, rejecting gradualism, emphasized the need to accelerate the struggle for full citizenship rights. Daisy had her chance to enact her vision when she was elected president of the Little Rock NAACP branch in 1952. Building on the legal victory in the Supreme Court's 1954 *Brown v. Board of Education* decision, Daisy led a boots-on-the-ground fight to integrate the city's public schools. Her outspoken opposition to the deeply entrenched white power structure in Arkansas led to death threats and the closure of the newspaper in ways reminiscent of attacks against Ida B. Wells at the turn of the century. By 1960, Daisy had moved to New York City, where she joined the Black political and social upper crust and began penning her memoir, *The Long Shadow of Little Rock*.

Mollie had great respect for Daisy and for Dorothy. She never felt they were receiving attention they did not deserve. But she already sensed that the frameworks the media and movement leaders relied on to understand Black women's labor and leadership were far too narrow to encompass the fullness of her contributions. That was endlessly frustrating. Henry Moon, as the public relations director of the NAACP, had a clearer professional position, even though he, too, worked mainly behind the scenes. Henry was one of the smartest men in the organization's national leadership, and he did as much as anyone to communicate the NAACP's vision and strategy to its members and the American public. Still, he never garnered the type of attention that its executive directors did. As Roy Wilkins, Whitney Young, Martin Luther King Jr., James Farmer, and A. Philip Randolph were becoming the nucleus of this shifting movement, Henry was left on its fringes. But Henry did not covet the spotlight. He was content with being a member of the brain trust; he did not need to be its face.

Despite the changing tides in the national Civil Rights Movement and the ways Mollie was already being written out of the movement narrative, she was still highly regarded as a star bag woman in New York City. Much attention, then and now, was focused on the Southern struggle. But there had been and continued to be a Northern struggle for civil rights, and it, too, was entering a phase of direct action. School integration, access to housing and affordable healthcare, and combating police brutality, which had become even more heinous as police corruption went unchecked, continued to be the major causes that everyday Black New Yorkers rallied around. Employment discrimination, the Urban League's signature cause, also remained a perennial issue. Members of the Urban League and the Guild were actively involved in these struggles as they participated in issue-oriented campaigns with activists in other organizations within the Black community.

Race-relations consulting became another career avenue for African American women with Mollie's skill set and Rolodex. Mollie had started her own public relations firm with Marilyn Kaemmerle, a white woman who was one of the early members of the National Urban League Guild. Their firm's headquarters were in Midtown Manhattan at 505 Fifth Avenue. They began Moon and Kaemmerle Associates, Inc., in 1949 with "small capital" but a "wealth of knowledge of people, institutions, and the practices which form American public opinion." Their clients included insurance companies, nonprofits, and musicians. "We are probably the first two women who ever joined hands in a public relations business, and I am certain we must be the first two who saw the possibilities of a firm that was interracial right from the top leadership down through the line," Mollie told the *Pittsburgh Courier Magazine*.

Moon and Kaemmerle Associates, Inc. was short-lived, but

Mollie continued her public relations work under the banner Moon and Associates. When people hired Mollie's company, they were essentially paying for her expertise in race relations. Her role resembled that of today's diversity, equity, and inclusion consultants. As the nonprofit sector was being established, Black women were marginalized in that world, so they had to either build their own consulting firms or work within Black organizations to professionalize their race work. In 1950, writing in the *Pittsburgh Courier Magazine*, Toki Schalk Johnson referred to them as "petticoat executives," which she considered empowering language that described women who were not born into generational wealth and did not control companies, nonprofits, and philanthropic foundations but instead used their skills as hostesses, people pleasers, and culture afficionados to bust down barriers in the business world.

* * *

As Mollie's star in the world of fundraising and race-relations work continued to rise and the Council kept consolidating power, the Beaux Arts Ball increased in size, scale, and popularity. The event had long been held at the Savoy Ballroom. After the ball was featured in *Life* magazine in 1950, Mollie came under pressure to move it to a larger venue downtown. She knew that meant making the ball more appealing and palatable to white donors. But she always resisted. In 1954, she told *Ebony*: "The Beaux Arts Ball belongs to Harlem." This way, it retained its reputation as New York's "most democratic social event," the place where "rich and poor rub elbows."

Ebony romanticized this mixing of Pullman porters and mail clerks with bank presidents, bohemian artists, and famous entertainers. "The Beaux Arts Ball is more than an event. It is an

institution. It brings people of many colors and classes and occupations, mixes them up and everybody has fun." At one of the balls, Winthrop Rockefeller was photographed dancing with a Negro domestic worker. The great equalizer was the costumes. In traditional Caribbean carnival celebrations, the costumes were a way to turn the world upside down, allowing the enslaved and underclasses to dress like the wealthy and powerful and to switch places with them, although only temporarily. At the Beaux Arts Ball, too, the costumes were a way to shake up the social order. Holding it at the Savoy meant that wealthy whites had to come uptown, giving Black Americans the home court advantage. When the Savoy closed in 1958, Mollie was forced to find another venue. So the following year she held it in the South Bronx.

The next year was the first Beaux Arts Ball ever held south of Harlem. The 1960 event coincided with the Urban League's fiftieth anniversary. It was held in Midtown at the Roosevelt Hotel. The theme of that year was *Gaslight Follies.* Josephine Baker, who was on a publicity tour to announce her return to Broadway, was the honored guest. By this point, the Beaux Arts Ball was akin to the Met Gala today. *Ebony* celebrated it as "Negro society's biggest, gayest, most cosmopolitan and glamorous social event." Marian Anderson was in attendance. So was Daisy Bates. Frank Horne and Mercedes Rector (who were now married) came from Washington, DC. Gordon Parks had brought his good friend, designer and heiress Gloria Vanderbilt, and her husband, Hollywood director and screenwriter Sidney Lumet. Of course, Rockefellers and other white millionaires were there. People wanted to be photographed at this ball because it conferred social status. White liberals used it to burnish their credentials as racially progressive, a label that was gaining clout as movement activists became veritable celebrities.

The New York Age dubbed Josephine Baker and Mollie "La Baker and Ze Queen," with "ze" playing on the fact that Mollie had lived in Berlin in the 1930s and spoke German. Oh, how much had changed since Mollie had dreamed of becoming the Josephine Baker of Berlin! Now, with the Beaux Arts Ball, she had found her stage. Photos of them together showed Josephine in a sleek evening gown and polished pillbox hat, looking utterly of the moment, and Mollie dressed as actress Lillian Russell, in a big, brimmed vaudeville-style hat and fishtailed dress, as they posed with that year's Beaux Arts Ball pageant queen.

The 1961 ball was even grander. It was held at the Waldorf Astoria, one of the most prestigious hotels in New York City. And more guests than ever attended. "The largest guest list in the 21-year-old history of the Guild included members of the royal houses of Europe, New York tycoons, diplomats, artists, dignitaries in every field of endeavor, TV and stage stars," the *Pittsburgh Courier* reported. Mayor Robert Wagner and Governor Nelson Rockefeller were in attendance, alongside several European counts, princesses, and barons. Their presence was also a sign that the ball was no longer Harlem's, and it never would be again. Guests such as Lena Horne and Ella and Robert Weaver, who was now the administrator of the Housing and Home Financing Agency in the Kennedy White House, were a reminder of the past. By this point, all of Mollie's major League events were held in Midtown, including the summer party, which had been held at the Rainbow Room since 1948. For Mollie, the success of moving the ball to the Waldorf was not in seeing white people engaging with African Americans but in seeing her people have access to the finest digs in the city. *Negroes deserve luxury too*, she believed.

Prizes included $1,500 in cash and a roundtrip ticket to Ber-

muda, sponsored by a Black-owned travel agency. But of course, the wealthy white folks in attendance did not need to win these meager prizes. For Mollie's core African American audience from the 1940s and 1950s, these prizes were amazing luxuries. That year, the F. & M. Schaefer Brewing Company, a longtime sponsor of the Ball, upped its prize for the Miss Beaux Arts Pageant from $2,500 to $50,000, in addition to the one-year modeling contract to be a Schaefer pinup girl. F. & M. was trying to capitalize on the mainstream's growing fascination with (light-complexioned) Negro models. Participants saw winning as a route into the international fashion world. Up-and-coming model Doris Chambers won.

The ball itself raised a reported $100,000 for the National Urban League. The Guild took in even more through ticket sales and donations, but the bigger, bolder ball also meant higher expenses. It is impossible to find out exactly how much it cost to put on, but given accounting records from past balls, the sum could easily have amounted to $50,000. In her public statement to the press about the record-breaking amount of money the National Urban League Guild had raised, Mollie specified that the funds would be used for two NUL initiatives: the Tomorrow's Scientists and Technicians project, which was a 1960s version of today's STEM programs, and America's Many Faces, the League's national photography project.

In her *Pittsburgh Courier* column, Roberta Bosley Hubert remarked: "Gone are those intimate fun-filled evenings when the Guild held its Beaux Arts Ball at the Savoy and every-body wore a costume." Now only Guild members and the few who were vying for the prizes came dressed according to the theme. The crowd was more obsessed with designer gowns, fur coats, diamonds and pearls. Back in the day, people looked forward to seeing folks in their costumes, with the tantalizing possibility of a wardrobe mal-

function. In 1957, for example, *Jet* ran a photo with the caption "Banned," which depicted Mollie telling one guest that her costume was "too scanty." The woman, who appears to be white, is wearing tiger-print pasties over her breasts, and a small matching skirt that shows her butt cheeks. This was all part of the fun.

Now the ball was more of a political event. New York politicians knew that the Beaux Arts Ball was where they had to go to meet their Black constituents, and they wanted the Mollie Moon cosign. "It would be obligatory for those politicians to get up there, make a speech, get a picture taken with Mollie Moon," Mollie's godson Richard P. Bourne-Vanneck (son of Victoria and Richard Bourne-Vanneck) remembers. Mayor Wagner, Governor Rockefeller, and US senator Jacob Javits all attended. Over the years, the organizers had expanded the list of people whom they enlisted to judge the costumes: socialite and art collector Mary Benedict Astor, wife to the heir of the Astor empire; Helena Rubinstein; Carl Van Vechten; and Madame Henri Bonnet. They even extended an invitation to the Duke and Duchess of Windsor—also known as the former King Edward, who had abdicated his title, and his wife, the American divorcée Wallis Simpson. The royals declined because they would not be in the city on that date.

Some people, men especially, looked at Mollie—and all the power she had amassed—and felt she didn't "know her place." She was flying too high, pushing the boundaries of what was acceptable for a Negro woman. And with her ally, Lester Granger, nearing his mandatory retirement as head of the Urban League, many could see that it would only be a matter of time before a male leader clipped Mollie's wings.

CHAPTER 12

———

Sidelined

Midtown Manhattan, Winter 1962

On February 16, 1962, a crowd of three thousand partygoers gathered in the Grand Ballroom of the Waldorf Astoria hotel for the National Urban League Guild's annual Beaux Arts Ball. That year's theme, "Carnival in Rio," brought the ball back to its roots, conjuring the sensual energy of carnival that Mollie had originally imagined when she held the first ball in Harlem more than twenty years earlier. Live samba music pumped all night, as Black and white costumed bodies swayed and sashayed across the dance floor, hips gyrating suggestively. Mollie Moon, now in her mid-fifties, was adorned as the Queen of Carnival. She had squeezed into a strapless gold gown that accentuated her cleavage and hugged her

curvaceous hips before gathering into a jaw-dropping train that trailed behind her as she greeted guests, who had shelled out $100 for tickets and $1,000 for VIP boxes and tables.

Once the costume parade began, hundreds of brightly colored helium balloons were cut loose inside the massive ballroom. They floated above the dance floor and into the tiered box seating that lined the room. Later in the evening, the winner of the Miss Beaux Arts Pageant was crowned. Actress Ruby Dee was among that year's judges. George Norford, the African American NBC producer, was the creative director of the "lavish production." He and his political insider wife, Thomasina Johnson Norford, were major Black donors to the National Urban League. First Lady of the Big Apple Susan Edwards Wagner was in attendance, as were Ella Haith Weaver and Rae Olley Dudley, whose husbands were prominent in local government. Orin Lehman, who had followed his great-uncle into public service rather than work in the family's investment bank, was honorary co-chair of the ball. The other co-chair, Austrian baron Theo von Roth—who described himself as one of the best party givers in the world—produced extravagant, high-society galas for charities. The European aristocrat had planned more than 150 parties to date, including the International Debutante Ball. With Von Roth and the other distinguished committee members on board, Mollie was able to raise nearly $100,000 for the NUL.

The real stars of the evening were Whitney Young and his wife, Margaret Buckner Young. Whitney had been installed as the executive director of the National Urban League in late 1961, so this Beaux Arts Ball was his formal introduction to New York society. Looking dapper in a conservative suit, Whitney addressed the Leaguers and their supporters, sharing his delight at being chosen

to lead the NUL into a new era at a crucial time in the nation's history. The Civil Rights Movement had become the most pressing domestic social issue of the day.

Whitney's Kentucky drawl oozed charm, even as he spoke of such weighty issues as racial and economic justice. His six-foot-two, husky, athletic frame and his full head of wavy hair made him look more like a jazz bandleader than the economic policy wonk he was. The crowd stood rapt, consuming his every word. Many women found him irresistibly sexy. One of his and Margaret's couple friends said of Whitney: "He had an extraordinary magnetism and seductiveness about him." When he walked into a room, women swooned.

After he left the stage, Whitney moved through the crowd like a seasoned politician, shaking hands with everyday supporters of the League and moguls alike. "He is already a legend within his first year" because of his youth, his "dynamo approach" to his new role, and the "keen mind" behind the "friendly smile," *Pittsburgh Courier* society editor and Urban League Guild member Toki Schalk Johnson wrote about the evening in her column, Toki Types About Women Around the World. Toki's commentary on Margaret was less effusive. She's "doll-size," a "pretty, pretty picture." But Margaret was more than a pretty face. She was an educator who had given up a post as a professor of educational psychology at Spelman College to move to New York to play a helpmate role to her ambitious husband. Margaret was whip-smart and charismatic, but she did not crave the spotlight or need to be showered with admiration as her husband did.

Whitney and Margaret had met at Kentucky State Industrial College, when Whitney was a junior and Margaret a sophomore. Whitney joined Alpha Phi Alpha fraternity and was considered a

strong leader by his peers. Margaret, the daughter of working-class Kentuckians, was attractive, popular, and extremely bright. The two married in 1944.

Margaret earned a master's degree in educational psychology and testing from the University of Minnesota. And Whitney used his GI benefits to earn a master's in social work, writing a thesis on the two local Urban League affiliates. Despite her advanced degree, Margaret focused on motherhood and homemaking, while Whitney began his professional career in race relations with the St. Paul Urban League in 1947. His first role: industrial relations secretary. Whitney's star rose quickly, locally and then nationally. He became one of Lester Granger's brightest protégés. To develop his potential, Granger supported Young's candidacy for executive director of the Omaha, Nebraska, League affiliate in 1950. He remained in that post for four years. Whitney left the League in 1954 to become dean of the Atlanta University School of Social Work while Margaret taught at Spelman. He was impatient with being tethered to a desk as the movement for Black Freedom was unfolding around him. Once the opportunity arose for him to lead the National Urban League, he took it.

Living in New York City was a huge departure for the Youngs. They had been part of bourgeois Black society in Atlanta. Their friends, Atlanta University president Rufus Clement and his wife, Pearl, were the nucleus of elite Negro life. But the staid society of Black Atlanta was a far cry from New York City's cutthroat and highly transactional social scene. As the NUL's new executive director, Whitney entered the city with an assurance of social influence. Margaret had stayed out of the spotlight as much as possible while Whitney had climbed the ranks of the Urban League in Minneapolis and Omaha. Now, as wife of the national executive

director, in New York City of all places, she was expected to become a civic leader who reflected her husband's political agenda, and attend social events, dressed to the nines.

The saving grace for Margaret was that Whitney thought it best for them and their two daughters to live far outside the city. They made a home in New Rochelle, in Westchester County, where monied whites resided. Whitney reasoned that a move to a subdivision just off the scenic Hutchinson River Parkway, with quiet streets lined with newish houses, would demonstrate his commitment to integration. Most middle-class African Americans who aspired to move to the Westchester suburbs in the 1960s were relegated to neighborhoods such as Parkway Gardens, where photographer Gordon Parks, musician Cab Calloway, and comedian Jackie "Moms" Mabley had homes. In contrast, the Youngs settled into a seven-room split-level home on Mohegan Place, a bastion of white privilege, five miles away from Parkway Gardens. The daughters, Marcia and Lauren, were tasked with integrating New Rochelle's public schools.

Stepping out at the Beaux Arts Ball, Margaret likely could sense the energy of the people in the room: the women who wanted her husband for more than just his leadership abilities, the do-gooder white millionaires who wanted a Black friend to make themselves look liberal, the League members who were envious of Whitney's meteoric rise, and the white hands of power that had helped him get there. Margaret must have known that Whitney's time in office was going to be a wild ride.

Mollie greeted the Youngs with the same kind of effervescence she always extended to high-profile guests at her ball. And make no mistake, by 1962, Beaux Arts was *her* ball. It was an institution synonymous with the Urban League, Mollie, and her Guild.

She had outlasted Lester Granger by creating a vehicle that, even though it was no longer the highest grossing fundraiser the NUL hosted, was the longest standing and remained the most popular. This gave Mollie a special kind of social capital.

No one could see the tension that existed between Whitney and Mollie. It wasn't loud or angry. It was the quiet kind that lingers between two people who had been on opposite sides of a battle and were now in a situation where outward peace and harmony were required, but the issues that created the chasm had never been addressed.

* * *

It all went back to Young's campaign to become NUL executive director. At age sixty-five, and after twenty years of service to the NUL, Granger had been mandated to retire. It, in essence, marked the end of the New Negro generation's era of leadership.

Mollie had been on the committee charged with building the slate of candidates and then selecting and interviewing finalists. The committee consisted of Mollie, a white woman, and two men (one white, one Black), drawn from the NUL board of trustees. Whitney had not initially been Mollie's pick; she supported Alonzo Graseano Morón—Granger's choice to be his successor. When Whitney showed up at the NUL headquarters for his finalist interview he was appalled to see that the committee had set up a makeshift bar and was serving cocktails for the finalists and the other Leaguers who had come to socialize. One by one, the handful of candidates disappeared for their brief interviews with Mollie and the other committee members. *Who turns an interview into a cocktail hour?* Whitney likely wondered. He later told others

in the NUL that the committee was "under the influence" during the interview process. He thought it was terribly unprofessional.

The decision was between Young and Morón. Morón, who was born in the US Virgin Islands in 1909 and had earned a bachelor's from Brown University and a graduate degree from Harvard Law School, had been the first Black president of Hampton Institute. He received three of the four committee votes, Young only one. Mollie had voted for Morón. When pressed to explain why, a male committee member recalled Mollie saying that Morón was more experienced. Morón had the statesmanlike qualities that played well for the organization in public. According to this committee member, Mollie said that Young did not have "enough age and balance—he didn't look the part."

And he "had a reputation for being fast with the ladies." According to someone in the room that day, Mollie allegedly shared she had seen, with her own eyes, Young hugging a blond-haired, blue-eyed woman with loads of money at a National Urban League convention. Another committee member fired back that Morón's wife was alleged to be an alcoholic, who might be an embarrassment to the organization. The factional debate devolved into personally disparaging remarks. One of the men on the committee had put a bug in Whitney's ear about the critical things Mollie—believing she was speaking to committee members in confidence—had allegedly said about him, and Whitney likely hadn't forgotten what he'd been told.

Ultimately, after another round of interviews and votes, Whitney received unanimous support. Morón was so highly offended that he, a man of his stature and accomplishments, was being asked to interview again that he bombed the second interview. He just could not move beyond his sour attitude. Young soared in this sec-

ond round. His performance made it hard to deny that he was the stronger candidate. Of course, the committee was not basing its decision solely on that interview. A great deal of political maneuvering had gone on behind the scenes between the first and second round.

Mollie understood, going into the final vote, that Young was "Kimball's boy," referring to Lindsley F. Kimball, current president of the NUL. Kimball was a white nonprofit management specialist who had worked for the Rockefeller Foundation since 1938 and had been one of John Rockefeller Jr.'s closest advisers. The year before Granger's retirement, Kimball had set a plan in motion to help Young get appointed executive director. It had been Kimball who had encouraged Young to leave his post at Atlanta University, where Young felt deeply unfulfilled. Kimball had pitched what we might think of today as a "gap year," during which Young could attend an elite institution to expand his knowledge and extend his network. Kimball would provide the money for it all, drawing from Rockefeller funds.

Young took Kimball up on his offer and decided to spend the year at Harvard University. Kimball connected Young to a network of philanthropic executives from the Russell Sage and Carnegie foundations and policy and economics scholars at Harvard, MIT, and Brandeis. Young would now be mentored by people who had national influence.

Despite Mollie's reversal, Young likely still saw her as an obstructionist, not simply to his candidacy but more fundamentally to his vision for the future of the League. She was a Grangerite, and Granger loyalists no longer had any real power in the NUL. Young did not go so far as to seek revenge, but it was clear that he saw Mollie as redundant, a holdover from the Granger era who had no real role in his new order.

* * *

Back in the 1950s, when Whitney Young was himself a Grangerite, he was deeply committed to Granger's vision for the League. In a speech Young gave at the 1959 NUL annual gathering in Washington, DC, he told the leaders that the organization should avoid jumping into the fray of the burgeoning Civil Rights Movement alongside other organizations such as the NAACP, CORE, and the SCLC. Young argued that the League's best strategy was to continue to focus on its economically oriented social service work: jobs, housing, healthcare, and education. Most white social service organizations were not serving the needs of African Americans and did not understand their plight or were not committed to addressing it. Instead of replicating the work of the NAACP and other well-established groups, he thought the League should continue to chart its own path. He likely did so to strengthen his position and visibility in the NUL by demonstrating his oratorical and leadership skills while not rocking the boat by suggesting a more radical approach than he knew they were ready for.

By the time Young became executive director, he had changed his stance. He now believed that the NUL should place itself at the forefront of the movement. Failing to do so would mean falling behind the people and making itself and its economic agenda a mere relic of the past. Yet, given its status as a 501(c)(3) organization, the NUL could not participate in sit-ins, strikes, and other forms of political action. He set about threading a difficult needle. Young wanted the League to adopt the militant stance taken by grassroots organizers across the country. He believed the League should demand that whites grant African Americans equal rights without them having to beg or ask for permission to be seen as full

citizens. He wanted Black people to enter the room on their feet, never on their knees.

It wasn't that Granger had been a pushover. He, too, had sought equal rights and did not beg. But some felt he had wanted to schmooze with the Park Avenue elites he recruited as much as he had wanted to leverage their money. Young was far from a revolutionary, but he reflected the mood of a generation younger than Granger's. He wanted the NUL to approach its work with a collective discipline that reflected his vision of militancy, no doubt informed by his own stint in the US Army during wartime.

At the same time, Young wanted local and national League leaders to double down on the organization's long-standing goal of becoming a professional social work agency. The knowledge and strategies Young had developed during his gap year at Harvard and MIT were on full display. Through his meetings with grassroots organizers and scholars in the Boston area, he had recognized that community centers, organizations, and corporate leaders were willing to pay consultants who possessed the policy and social services expertise of the League's professionals. If the NUL became a research hub and think tank for policy makers, it could increase its prominence while becoming an indispensable force in the movement for civil rights. He wanted to distinguish himself and his League colleagues—skilled professionals with real qualifications—from those he saw as "race leaders" who were thrust into the spotlight because of their flights of oratory or affirmations of Blackness but who might not have the skill set to hold the position being offered to them. Foundations like Taconic were shelling out $60,000 annually in consulting fees to leading race leaders. Young observed that white Americans were clamoring to find Black men (more often than women) who could explain

for mainstream audiences what the press had dubbed the "Negro revolt."

Whitney Young's ideological approach to organizing in his early years as national executive director should be thought of as "militant professionalism." Militant professionals were committed to a fully integrated America. Most had a college education and beyond, typically in fields such as social work, social psychology, and urban planning and policy. They were an even more assertive contingent than the civic leaders of Mollie's postwar era. These militant professionals were responding to the shifts in the movement that were thrusting people like Dr. Martin Luther King Jr. and Malcolm X to the forefront of the national conversation.

Young believed the main goal of militant professionalism had to be to use its influence with corporate America to integrate the business world. They needed buy-in from the corporate world to help bust up Jim Crow. He banked on the fact that they would rather deal with him than the fiery Malcolm X or the formidable James Farmer of CORE. Young juxtaposed himself to these bogeymen to bolster the notion that a rational approach to racial justice that relied upon empirical data was more effective than threats or protests. Young knew full well, though, that African Americans needed the whole range of leadership styles and tactics to get white folks to do anything. In sum, he sought to prove that activism and social services went hand in hand.

In many ways, Young was advancing what Mollie and women of the Urban League's own National Council of Urban League Guilds—the Council—had been fighting for in the 1950s: to be recognized for their professional skills and the ways they could form a national network to benefit the movement. Male leaders under Granger had stymied the Council's efforts. But by the early

1960s, under Young, it was clear that the Guild women had pointed the way to the future, and they would have been even more successful had they been allowed to do the type of institution building they'd imagined.

New York, Spring 1962

In his first two years as executive director, Young focused on four areas that became cornerstones of the militant League he was raising up: fundraising, recruiting influential board members, expanding the number of League affiliates, and appointing a new crop of militant leaders.

Young had inherited a financial debt—an estimated $1.2 million—so severe that he was barely able to make payroll. Developing a more effective fundraising strategy was his day-one task. Lester Granger had been a visionary regarding how to build the NUL's financial infrastructure through the Urban League Fund (which had only become public knowledge in 1958). But the economic reprisals spearheaded by Southern White Citizens' Councils had helped to bankrupt the League. Young opted to dissolve the Urban League Fund altogether and turned to his trusted philanthropic foundation managers to help him devise a new plan. This strategy included having League affiliates apply for grants from the League's foundation partners.

Kimball, the expert in nonprofit management, and the philanthropists he'd formed relationships with, including those with the Rockefeller Brothers Fund and the Taconic and Field foundations, all provided enough funds to bail the NUL out of debt. In April 1962, the *Amsterdam News* reported that the Carnegie Foundation had given the NUL $2 million. Like most foundation money, this donation came with strings. It had to be used solely to fund the

League's youth programs. Most white foundations felt more comfortable throwing money at educational programs that focused on mentoring "disadvantaged youth" than on programs that addressed the economic needs of adults, and very few were willing to contribute to the organization's operating expenses.

Young had to get his hands on funds that came without such stipulations. Much of the money he raised during this initial capital campaign was secured at private luncheons with business leaders such as David Rockefeller, president of Chase Manhattan Bank. At a meeting held at the Four Seasons, for example, 150 of the leading businessmen in the country—most of whom were based in New York—heard speeches by Mayor Wagner, Whitney Young, and Frederick Richmond, president of the Greater New York affiliate of the Urban League. The luncheon kicked off a joint campaign to raise money for the city and the League. The fundraising goal was $3 million for an emergency budget for a special New York Commerce and Industry committee. The strategy was to show the cost of racism to businesses, not just to African Americans and to society, and to position the Urban League as a partner with business in efforts to address the problem.

Richmond impressed upon the men that racial prejudice was costly, in fact $7.5 billion a year costly. Businesses would actually be more profitable if they ended employment and consumer discrimination. Wagner said they all had a part to play to prevent "the disease of Birmingham from becoming violently apparent in New York." This was a loaded statement. By referencing Birmingham, Alabama, the mayor was drawing a distinction between Southern and Northern racism, not so subtly telling the men that their money could ensure that Black New Yorkers did not rise up and precipitate violent conflict in the streets. The antidote to this kind

of mass racial rebellion, Wagner implied, was Whitney Young and the Urban League, "because of its proven responsible leadership over 53 years." It was a familiar divide-and-conquer tactic: better to deal with the bourgeois Negroes than the revolutionary radicals.

In any case, it proved that Young was willing to openly advocate and adopt the strategy of raising funds from the elite that Lester Granger and Frank Montero had been doing covertly through the Urban League Fund in the late 1940s. Granger had been afraid of backlash from the League's African American supporters. Young, on the other hand, boasted about those ties as one of the newly rebranded National Urban League's greatest strengths.

* * *

Once Whitney Young had established a pipeline of funds from corporate coffers to the League, he set about recruiting new members of the board of trustees with deep pockets and shining social reputations. This meant replacing board members who did not fit the profile. Mollie, a board trustee and NUL executive secretary, was among the first people to be removed. Journalist James Booker broke the news that Mollie was no longer on the executive committee or the board of trustees, which was evidence of some tension within the League. In his *Amsterdam News* column Political Pot, where he dished out all the "Uptown lowdown," he wrote that word was coming over "the burning wires" that the "selection of Mrs. Dorothy Hirshon to replace Mrs. Mollie Moon as Secretary" had "caused raised eyebrows" when it was announced at the 1962 Urban League annual conference.

Dorothy, who was also a member of the NUL board, was born into an upper-class white family in 1908. She attended elite private

schools and junior college, studying art history. In her heyday, she was considered one of the most beautiful and best dressed women in Southern California society. She had even been sketched by influential French visual artist Henri Matisse. Dorothy had married and divorced John Randolph Hearst, a son of the newspaper magnate, and William S. Paley, head of Columbia Broadcasting System. In 1953, after becoming a millionaire from that divorce settlement, she married stockbroker Walter Hirshon. In middle age, Dorothy became involved in philanthropic programs to support education and the arts, as well as serving on the New York City Commission on Human Rights.

Young's decision to rotate Mollie off the executive committee and replace her with a wealthy white woman spoke volumes to many observers, especially because Mollie had been so central to the inner workings of the League under Granger. The optics were worsened by the fact that Dorothy Hirshon also served on the Taconic Foundation's board of directors. Taconic was one of the NUL's biggest donors. Hirshon's executive appointment at the NUL was likely an act of political back-scratching, considering she voted each year on the NUL's grant requests to Taconic.

Others within the League attempted to smooth the public friction by stating that it was merely the end of Mollie's term. Still, it looked suspect because, along with Hirshon, white folks—including Dwight Zook of North American Aviation, James Linen of Time Life, and Secretary of State Dean Rusk—were appointed to the board. Several prominent Negro educators, such as the president of Bennett College in Greensboro, North Carolina, and the national leaders of Black fraternal and service organizations were also selected because of their influence among the Black elite.

Young set a goal of establishing twenty new League affiliates

by 1965. The first thing he did was identify local affiliate directors who were ineffective and either coax them into stepping down or give them advanced training in a leadership boot camp governed by Young's militant professionalism philosophy. The new chapters were in cities that had the financial base to keep an affiliate up and running. His target cities were Saginaw, Michigan; Colorado Springs, Colorado; Sacramento, California; and Madison, Wisconsin. It was much more difficult to establish affiliates in the South, where Black people were still struggling economically and facing intense white-supremacist terror.

The NUL had tried and failed to set up an affiliate in Albany, Georgia, at the height of civil rights activism there. An affiliate in the southwest Georgia town would not be established until the late 1960s, with the help of a strong Guild. It had also proved impossible to form an affiliate in Greensboro, North Carolina, when young people in the college town were leading a strong sit-in movement. Young leaned on his friends in corporate America to help provide the funds to establish an affiliate in Tampa and to resuscitate the Little Rock, Arkansas, affiliate, which had been nearly bankrupted during the Little Rock school integration crisis and economic reprisals by the local White Citizens' Council. Young partnered with Winthrop Rockefeller, who became the governor of Arkansas, to try to make inroads in his state.

As the number of affiliates grew, so did the NUL operating budget and staff. In 1962, its operating and program budgets were approximately $6.8 million combined; by 1964, they would be nearly $12 million. The paid staff expanded from 30 in 1961 to 110 by 1965. Young was not a micromanager. He recruited more regional directors and empowered them to guide affiliate staffs. He aimed to put highly competent local leaders in place who had great

ideas and embodied the militant spirit he thought was needed in the moment.

Talent and vision superseded gender for Young, though women who worked in his administration likely experienced his deep paternalism and hypermasculine bravado. Some might have resented it. Young purged many of the people who were Granger's age. After all, Granger had retired, so wasn't it time for them to sit down too? They had served the League well. Young took money from his corporate and foundation backers to train younger people to take their place. His hands-off leadership style freed up Young from being bogged down by the day-to-day tasks of running the organization. He preferred to be out in the field, which for him meant meeting with corporate heads, with leaders of other major civil rights organizations, and with President Kennedy.

Among these leaders in power positions within Young's administration was Cernoria Johnson. Cernoria had served as executive director of the vital Oklahoma City Urban League affiliate, guiding the organization as local activists launched some of the earliest sit-ins. She had left that post to become a consultant on intergroup relations for the national board of the YWCA. Young believed that with the acceleration of the Civil Rights Movement, they needed a leader in Washington full time who could navigate the federal government, mobilize locals, and be a liaison between the League and other leading social and political groups in the nation's capital. He decided it was time to bring Cernoria back into the NUL fold. With her extensive local and national experience, she'd make a great director of the National Urban League's Washington Bureau. "The Urban League's concerns in nationwide developments will receive accelerated public attention," Young told the press when announcing Cernoria Johnson's appointment in 1962. To extend

her networks, Cernoria became deeply connected to the Black elite club world in Washington, joining The Links, Jack and Jill, and an alumnae chapter of Zeta Phi Beta sorority.

One of her major League contributions would come in 1964, when she and Young worked closely to organize a three-day conference on economics in Washington, which brought together more than three hundred national Negro leaders. It was part of Young's antipoverty agenda for the NUL, which aligned with President Lyndon B. Johnson's multimillion-dollar War on Poverty. Young wanted the League to be front and center to ensure that the needs of the Negro poor were being addressed. Skeptics believed it was Young's play to become the first African American with a cabinet seat in the Johnson administration—though rumor had it that Young had already turned down a federal job earlier that year. Co-chairing the conference enabled Cernoria to become a sought-after lecturer on Black economics. "Social services are no substitute for social action," she would tell the crowd gathered at the Ohio Welfare Conference in Cleveland in 1964. "Negroes are going to have to become politically astute. We must become sophisticated enough to manipulate our political power."

Young created an altogether new position for Isobel Chisholm Clark in 1962 as well: assistant director for administration. Before the Philadelphia native and Howard University alumna became a director in the child welfare department of St. Thomas, US Virgin Islands, where her new husband practiced medicine, she had been public relations director of the Urban League's Southern Region, establishing several Guilds there. Once she stepped into her new role, Isobel, like Cernoria, became a member of The Links. She was an active member of Delta Sigma Theta, and her husband was

a member of Omega Psi Phi. Stories about her activities appeared on the society pages of *Jet*.

In her new executive post, Isobel was responsible for working with United Funds and Community Chests to repair relationships that had been strained during White Citizens' Councils' wave of economic reprisals nearly a decade earlier and increase their annual donations to the NUL. This was one of Young's priorities, and with Isobel Chisholm Clark as one of the League's chief fundraisers, the money allotted to the League increased. In addition to big-dollar fundraising in the mass philanthropy tradition, Isobel was responsible for creating promotional materials for local Urban League affiliates and promoting volunteerism with the League in cities that had no League affiliate.

Cernoria and Isobel had two things in common. Both had received master's degrees from the Atlanta University School of Social Work, where Young had later served as dean; he was tapping that network to recruit experienced professionals to the NUL staff. And both were willing to be active in social clubs in order to advance their work with the League. In contrast, Mollie did not have a degree in social work, although she was a longtime caseworker with the NYC Department of Welfare, where she had been employed since the Depression began.

Mollie never wanted to become a club woman. Club snobbishness and strict notions of propriety were not her cup of tea. The more radical civic leaders of her generation, too, had rejected elite club memberships. However, under Whitney Young's militant professionalism ideology, being a social club joiner was an asset. It was another sign of the times that had changed within the League. This might have, in part, been what motivated Mollie, in 1965, to reactivate her membership with her sorority, Alpha Kappa Alpha.

She had been initiated into Pi Chapter at Fisk University while she was enrolled at Meharry Medical College. But once she became politicized, Mollie turned her attention to other causes and allowed her membership with the sorority to lapse. Now it seemed Mollie felt the need to strengthen her ties with Black women, to build with them, especially since the patriarchy was alive and well within the NUL.

While Mollie had done her part to professionalize volunteer work and translate her fundraising and race relations skills into paid consulting jobs, she would never have been taken as seriously as NUL fundraiser William R. Simms. In 1962, Young appointed Simms to head the Urban League Fund. Simms had been coordinating the League's local and regional fundraising for a decade. He had cofounded the National Society of Fund Raisers (now the Association of Fundraising Professionals) in 1959. The professional organization was integrationist in principle; its other cofounders were Benjamin Sklar, a development administrator at Brandeis University, and Harry Rosen of the Federation of Jewish Philanthropies. This connection made Simms an even more attractive candidate for Young, who likely wanted to tap the resources of the rapidly growing professional association. Plus, it was another concrete way the League could claim to be helping to establish the US nonprofit sector. The Urban League Fund had come a long way since Frank Montero had run it, when he had to cobble together models for fundraising by attending corporate solicitations conferences. Young would dissolve the Fund altogether in the coming years, but for now, Simms was its new face.

All around her, Mollie saw women and men who had benefitted from the ground she'd plowed being elevated to national visibility. Meanwhile, Mollie and the National Urban League

Guild, of which she still served as the president, were further marginalized. Under Granger, the National Urban League Guild, which was headquartered in New York City, functioned as the male leadership's right-hand women. Even after the establishment of the National Council of Urban League Guilds, under which many of the Guilds across the country were organized, Mollie's Guild held much sway. There was no way anyone could get Mollie to step away from leadership of the New York–based Guild, and with the decline in its power there was not much competition for the position. The National Urban League Guild became Mollie's little fiefdom.

When Young could not force leaders to step down, he marginalized them and stripped them of their influence. In a move aimed to further sideline Mollie, he masked his intentions by appearing to honor the institutional structure she and the women of the Council had built (and of which Mollie had been the first chairwoman) to further their volunteer work. He empowered the current Council chairwoman, Cleveland's Aleathia H. Mayo. Aleathia was a legal stenographer with the Cleveland Board of Building Standards and Building Appeals who had been president of the Cleveland Urban League Guild for years. Young worked closely with Aleathia—not Mollie—to spearhead League/Guild initiatives. Aleathia, in turn, consulted with Mollie on these matters, since many of the Guild women still heralded Mollie as the guiding light of the Guild movement.

On the one hand, it might have been affirming for Mollie to see people like Isobel Chisholm Clark and William Simms building upon her legacy. On the other, she likely could not help but feel she had been cast aside long before she was ready. Whitney's praise and elevation of Aleathia would have been a particular blow,

seeing as there would not have even been an Urban League Guild had Mollie not had the vision for it in 1942. Taken together, these developments pushed Mollie into a more trivial box as socialite and party planner. She had resisted being confined to that box for years, but now her main claim to fame was fundraising through the Beaux Arts Ball and the Ebony Fashion Fair, a hip new traveling fundraiser. But as larger tensions around money, corporate philanthropy, and the National Urban League started to brew, Mollie might have felt fortunate to not be in the national spotlight.

Nickels and Dimes

Midtown Manhattan, June 1963

The National Urban League will no longer be "a nickel and dime organization," Whitney Young asserted during a meeting of key League players in 1963. They could always tell when Young had come back from a big meeting with leaders of industry, white people with access to *real* money, because his declarations about the fiscal health of the NUL always became more pronounced. This particular meeting had been one with the leaders of the major civil rights organizations and a young philanthropist named Stephen Currier. Whitney believed it would change the course of the Civil Rights Movement.

No more nickel and diming. Mollie Moon was used to Whit-

ney saying as much. It had become one of his favorite declarations when speaking to corporate executives and members of the press. And each time he did, Mollie heard in it a double-edged comment. On the one hand, it was dismissive of the mostly African American small-dollar contributors who had kept the organization afloat, people who might not have had much financially but were deeply committed to mass everyday acts of giving on behalf of the race. On the other hand, pulling off the large-scale social services endeavor Whitney imagined, while keeping the League fiscally healthy, would require a sizable and steady influx of cash. How could Whitney accomplish this without marginalizing any of the important players in the organization's money matrix? Relying on corporate dollars risked making the Black elite feel as if they'd been sidelined. But relying on the Black middle and upper classes would marginalize the Black working class and reignite smoldering intraracial class tensions. Balancing appeals to those supporters was a delicate dance. Whitney could not completely disavow Mollie, since she was the prima ballerina who could execute this dance convincingly. Her events were a buffer, even once they became more of a symbolic gesture than a powerhouse fundraising initiative.

The wildly popular Ebony Fashion Fair still gave Mollie leverage over society—influential women who needed acceptable fundraisers to throw their names behind. Such work was the responsibility of women in leadership of civil rights organizations and the wives of major civic leaders who belonged to Black high society or aspired to join it. This was an expectation not even the Civil Rights Movement could change. In fact, raising money for the movement became even more important for society mavens, who had to show that they served the interests of their people. Ticket prices ranged from roughly twenty-five to one hundred dollars and came with

a subscription to *Ebony* or *Jet*. In cities from Washington, DC, to Peoria, Illinois, power brokers like Mollie hosted Ebony Fashion Fair events to fund local nonprofit organizations, racial justice causes, and HBCU scholarships.

The idea for the Fashion Fair had originated in New Orleans in 1956. Jessie Covington Dent, an accomplished pianist and socialite, and the wife of Dillard University president Albert W. Dent, reached out to media mogul John H. Johnson of Johnson Publishing about cohosting a fashion show fundraiser for Flint-Goodridge Hospital. The show was such a success that Johnson and his wife, the fashionable and cosmopolitan Eunice Johnson, decided they should make it an annual touring fundraiser. Ripping "Fashion Fair" straight from *Ebony*'s monthly column of the same name, Ebony Fashion Fair took shape under the leadership of Johnson Publishing's home services director, Freda DeKnight. The traveling fashion extravaganza launched in 1958 with the theme "Ebony Fashion Fair Around the Clock," featuring American and European designers, a few models, lively music, elaborate stage props, and colorful commentary by DeKnight.

Mollie had brought the first Ebony Fashion Fair to New York City in 1959. She, of course, was the perfect person to introduce such an event to the Big Apple. She had been good friends with Eunice and John Johnson for over a decade by that point, which gave her an inside track over other civic leaders who might have had the idea to host a Fashion Fair event in the city. Plus, she had upped her designer-fashion game, adding Balenciaga sheath dresses to her wardrobe. And like Eunice Johnson, Mollie increased her international travels—to Europe, South America, and Africa—where she also procured garments hard to come by in the States.

She was the fair's NYC ambassador, and under Mollie's leader-

ship, it was a smashing success. The Guild added the Fashion Fair to its annual event schedule. By 1963, the extravaganza had found a loyal following among Big Apple socialites. Mollie recruited Dorothy Hirshon, the white socialite who had replaced her as NUL executive secretary; Rae Olley Dudley, an early Guild member whose husband, the former US ambassador to Liberia, was about to be appointed a justice of the New York Supreme Court; and Whitney's wife, Margaret Young, to be co-chairs. If Whitney Young was going to relegate her to a sideline role, she would be the best socialite and event planner there could be. No man could take her power. This Ebony Fashion Fair coup on Mollie's part showed that she still reigned over New York society; she had become an institution.

Despite the popularity of the Ebony Fashion Fair, the NUL under Whitney Young's new fundraising plan would rely less on special events. Less money would go toward planning them, which also meant that less money would be raised. The year 1963 would see the last of big special events during Young's tenure. Between the Fashion Fair, the outer-space-themed Beaux Arts Ball, and the NUL's other events, the women raised a reported $1.1 million. Attendance at the ball began slipping in 1964. Although the media touted that year's Beaux Arts Ball as attracting the "largest turnout ever," no number was given. By 1966, the NUL was only raising approximately $228,000 from all of its special events combined. During its heyday, the ball alone could raise nearly that much.

An older socialite had a heart attack and died at the 1968 African heritage–themed ball, which also cast a pall over the otherwise festive event. The front-page-news story of the death (which went undetected for several minutes as those friends in the dying woman's box were transfixed by the dramatic choreography taking place

on the dance floor below) was a morbid sign that Mollie's genera-
tion was becoming senior citizens. And younger people were not
flocking to their events in the same way they had in the 1950s.

Some racial justice organizations were abandoning altogether
the large-scale gala-circuit fundraisers that had become extremely
popular after World War II. The Congress of Racial Equality
(CORE) was opposed in principle to the capitalistic impulse of
the gala fundraiser. Budding activist and director of CORE pub-
lic relations Dorothy Pitman (later Pitman Hughes) learned this
the hard way. In 1964, Pitman planned a big New York City ex-
travaganza to raise money for CORE's work in Mississippi, which
intensified after an interracial group of voter-registration activists
was murdered. The event raised more than $300,000 for CORE
and cost the organization more than $150,000 to produce. Harry
Belafonte, Marlon Brando, and Lee Strasberg were among the
event's celebrity sponsors. The response to Pitman's event "tore at
the fabric of CORE." CORE members were shock troops on the
front lines of the struggle, not the gown-and-tuxedo crowd. Nor
did they believe in spending nearly $200,000 to promote conspic-
uous consumption. To CORE, galas reflected the worst elements
of consumer capitalism. Shortly thereafter, news broke in the *Am-
sterdam News* that Pitman had been removed from her position
and was suing CORE.

The organization preferred fundraising events that featured
the rising crop of race-conscious and racial-justice-minded Black
performers such as Harry Belafonte, Sidney Poitier, Diahann Car-
roll, Odetta, and Belafonte's South African protégé, singer Miriam
Makeba. Dick Gregory's CORE comedy benefits cost less to pro-
duce (especially because Gregory and others often waived their ap-
pearance fees) and brought in upward of $450,000. These events

felt to CORE like they were targeted toward the masses, not the wealthy elite.

Whitney Young was not against flash. He had no ideological objection to gala events. Under his model, however, the NUL would not rely upon the whims of unpredictable socialites to raise funds. Corporate America was where the real money and influence resided. Lester Granger had employed a similar model. In Granger's day, corporations with less than $1 billion in gross sales were called upon to donate $5,000, while those with more than $1 billion were asked to give $50,000. Young more than doubled those asking figures, which enabled him to grow the NUL's pot rapidly and exponentially. By 1968, the organization was bringing in more than $34 million in corporate donations annually. He also secured federal government funding for the NUL's social services programs, which rose from $2.1 million in 1966 to nearly $100 million by the early 1970s. Young's relationships with PepsiCo and Philip Morris—which had been established under Granger and nurtured by Frank Montero—helped to open the door for Time Life and even the recalcitrant Henry Ford II, who never gave to civil rights organizations.

At the end of Lester Granger's tenure as executive director, the NUL was receiving roughly $3.3 million in total donations annually, with approximately $600,000 coming from foundations and $700,000 each from corporations and individual donors. The other half was a combination of contributions from its everyday supporters, allocations from local United Fund and Community Chest drives, clubs and organizations, and special events.

By 1965, Young had shifted the dynamics. The NUL was now receiving nearly $18 million total in monetary gifts annually, with more than three-quarters of that money coming from foundations, corporations, and wealthy individual donors. Everyday supporters'

contributions had nearly doubled, in part through the new Urban League affiliates Young had established. Young had also strengthened the NUL's ties with labor unions and increased their donations. He even had quadrupled the amount of money coming from clubs and organizations.

In addition to the white multimillionaires he was courting, Young sought to engage the country's few Black-owned banks. Harlem's Freedom National Bank, which opened in 1964, became one of the largest, and stayed open until 1990. Having learned the lessons from the failure of the Dunbar National Bank, which had been under the Rockefellers' control, Freedom was founded by race-conscious civic leaders, including Jackie Robinson and Rose Meta Morgan. Young also engaged Black insurance companies. But he knew that the key was to tap the social clubs, especially The Links, the Elks, and the sororities and fraternities.

* * *

Members of Black middle and upper classes were in a precarious position during the height of the Civil Rights Movement. According to Bill Davidson's story "Our Negro Aristocracy," which appeared in the *Saturday Evening Post* in January 1962, "Few persons realize, in this day of sit-ins, school-desegregation riots and other racial strife, that there is a rapidly growing class of Negroes in the United States who are wealthy, well-educated, possessed of distinguished ancestry dating back in some cases to the Revolutionary War and who belong to what can only be described as High Society." Davidson juxtaposed this elite with the "slum-dwelling, downtrodden, struggling Negro minority" that gets the front-page treatment in newspapers.

This representation of the elite as the "other side of the coin" gave the impression that Negroes had the potential to be far better off than they were. It exploited class tensions among African Americans, appealing especially to those who did not want to be associated with poverty and wanted Black history to be about something more than slavery and struggle. Many of them distanced themselves from the Civil Rights Movement altogether. It also delegitimized African Americans' calls for reparative justice. According to Davidson's statistics, twenty-five Negroes were millionaires, four hundred made at least $500,000 a year, and ten thousand earned between $100,000 and $500,000 a year, putting them into the upper-middle and upper classes. If that was the case, many white Americans asked: Why are we atoning financially for slavery? Stories like this distorted the reality that the vast majority of Negro Americans were living below the poverty line and suggested that those who did were personally responsible for their situation.

Stories praising the Black elite proliferated in big-city newspapers. The *New York Times* covered Black high-society weddings; mainstream Detroit papers wrote about a Black millionaire who had been granted membership in the most exclusive yacht club in the world, on the French Riviera, and was the first Negro to enter his horses in the exclusive Madison Square Garden National Horse Show. Other papers across the country followed suit. There was the story about the Negro judge who resided in a mansion on the edge of the Bel-Air Country Club, the most exclusive on the West Coast. The Negro families who owned second homes with twenty-five-acre estates. Negroes who were regular ticket holders at the Metropolitan Opera. The Negro girls who came out to society at the International Debutante Ball.

This social fodder had previously only been covered in the

society pages of Black newspapers, or, for those who'd really made it, in *Ebony* or *Jet*. Now it appeared in the mainstream press. The recurring theme in these stories was that, at least outside of the Deep South, these people did not experience racism. They had been fully integrated into American society and enjoyed its material rewards. Even those who chose to live in Crenshaw among other Blacks or in Atlanta, where housing segregation was still de facto in place, lived just as lavishly as white people. The sons and daughters of elite Negro families were marrying into monied African families, creating a diasporic power base of money, influence, aristocratic titles, and positions as ambassadors and UN dignitaries.

Black firsts reinforced the idea that Negro Americans could succeed, despite all the odds, by working twice as hard for half as much as whites, or working four times as hard in an exhausting attempt to earn as much. This was what today we term "Black excellence." Hard work and respectability had long been part of the African American ethos. By the 1960s, the quest for wealth and high educational achievement had become inextricably linked to the Civil Rights Movement. Many believed that securing equal rights and financial freedom would return Negroes to the position of wealth and power that had been their birthright in precolonial Africa— and as children of God—but had been denied them in the United States due to racism and Jim Crow. Once they were elevated to their rightful place, the full, collective power of Black excellence would dramatically change the social and cultural landscape of the United States. Wealth, the thinking went, was the ultimate marker of Black Freedom. Many poor and working-class children who came of age during the civil rights era, especially, believed and became invested in the notion of working twice as hard to achieve excellence, and they passed it down to their children and grandchildren.

But excellence, others recognized, was not getting Negroes free at all. Some felt it was a dangerous performance that only helped African Americans cozy up to white folks. James Hicks and other Black political journalists were highly critical of the Negroes who had been the civic leaders of the 1950s who seemed poised to do something for the movement. Back then, the prevailing thought was that they needed Black leaders on the inside to confront the powers that be on behalf of the Negro community. Once they were successful, however, most became house cats, nice and cozy in their posts that the people had agitated for. They had become so caught up in the trappings of the upper class that they were of no use to the people.

Chief on Hicks's list of targets was Mollie and Henry Moon's good friend Robert Weaver. In August 1963, Hicks wrote in his *Amsterdam News* column, Another Angle, that Weaver, who was now head of the US Housing and Home Financing Agency, was one of the "'big leaders' whom we are literally dragging along with us." Weaver was one of the high-ranking Negro civic servants who had "benefitted the most" from the civil rights struggle while doing the least for the people. Meanwhile, "little children are proudly facing vicious police dogs and little frail Negro women are proudly throwing their small bodies before huge trucks" in mass demonstrations.

Many members of Negro society remained strongly committed to racial uplift and were active in the NAACP, the National Council of Negro Women (NCNW), and other well-established groups. Consider Kathryn Kennedy Wilson Dickerson, wife of distinguished attorney and politician Earl B. Dickerson, who served as president of the Chicago NUL and on the board of the NAACP and belonged to Kappa Alpha Psi fraternity. The

Dickersons were of Mollie and Henry's generation. Kathryn had attended the Art Institute of Chicago and been one of the founders of the South Side Community Arts Center in 1940. Once the movement took off in Chicago, the Dickersons were among the civic leaders in the mix. Davidson quoted her as saying, "How can Negroes like us who have our heads above the water be smug, while there are masses of our people still struggling below the surface to attain first-class citizenship?" In other words, she felt it was her duty to support those who had been most marginalized through mandates of Black excellence.

But not everyone took her stance. Some participated in pickets and sit-ins alongside the working poor, but others preferred their cushy, integrated lifestyles and took comfort from the fact that their occupational achievement and wealth seemed to supersede their race. They even went as far as rejecting the label "Negro" and most certainly "Black" to identify simply as "American"—aligning their goals and interests with the white mainstream. Whitney Young had to figure out how he could speak a language that appealed to this influential and wide-ranging group of elites, while not alienating any one faction. He needed access to their high earnings and strong networks.

In a talk called "Negroes: The New Power," given at a symposium on race relations early in his time as executive director, Young railed against the idea that "color-blind policies and programs" could ever "offset . . . prejudice, discrimination and segregation in the community" and the idea that the Negro was a "relatively powerless, passive recipient or beneficiary of . . . the efforts and actions devoted to his plight." He was aware that "many people of goodwill" propagated these misguided beliefs, but he was determined to correct them. Young emphasized the Black community's "growing

economic sophistication and capacity" and observed that even the "vast majority" who "still live at or below a bare subsistence level" are willing to direct their "economic power" to consumer boycotts and rent strikes. During the 1950s, according to Young, the Negro middle class in the US had tripled in size. In virtually every major city, the number of Negro wage earners who made over $40,000 a year multiplied ten- or twenty-fold. This economic growth meant that Negroes in urban centers formed a "critical swing bloc" of voters, with power not only to elect Black officials in Black districts but also to affect citywide politics.

Young knew it was key to cultivate a relationship with The Links, Inc., which boasted more than ninety chapters in forty states and twenty-five hundred motivated, deep-pocketed, and influential members. Links women clocked millions of volunteer hours each year, raising money for various causes and organizations. In 1979, The Links would develop a philanthropic foundation in an effort to take their acts of Black generosity to another level. Young wanted the National Urban League to be front and center in any of The Links' initiatives. He started by cultivating relationships with regional directors, who invited him to speak. Then he was called upon to deliver an address at the organization's national conference in 1963. He told the women assembled, "As an intelligent group of outstanding Negro women, the Links recognize the true nature of civil rights struggle and the important role of the Urban League in that struggle." It was pandering at its finest. But it paid off. In March 1964, The Links of Greater New York hosted an Easter luncheon in the Imperial Ballroom of the grand, newly built Americana hotel in Midtown Manhattan. Young sat on the dais and was a featured speaker, and the proceeds from the event went to the NUL and the NAACP. By

the close of the 1960s, Young had received nearly $800,000 from The Links.

But Young was not deluded about the size or economic power of the Black middle and upper classes. He understood that the majority of African Americans were living at or near the poverty line, and the NUL's programs were designed to address their plight. In an essay that ran in the *New York Times* on October 6, 1962, Young had outlined the organization's ten-year "crash plan," or "more than equal" program, which was built upon the same "moral, political, and economic credo" that compelled the US government to devote billions of taxpayer dollars toward rebuilding Europe after World War II, supporting refugees, and providing assistance after natural disasters. That same energy needed to be applied to what he thought of as a "Domestic Marshall Plan," which would repay Negroes for centuries of unpaid labor and exploitation set in motion by the global slave trade. Young's plan had received major funding and public support from the Rockefeller Brothers Fund and the Taconic Foundation.

Young wanted the US government to commit to a ten-year shift in public policy that would support what he called "compensation," which today we call reparations. In the early 1960s, the language of reparations was becoming associated with revolutionary Black nationalists, even though the concept had been applied, unevenly and inconsistently, in eighteenth-century state courts to compensate individuals who had been enslaved. Black nationalist Queen Mother Audley Moore led the reparations movement in New Orleans in the early 1960s, where she organized a group of poor and working-class Black women through the Universal Association of Ethiopian Women. After Student Nonviolent Coordinating Committee leader James Forman penned the "Black Manifesto" in

1969, the association between reparations and Black nationalism became intimate and seemingly indissoluble. Young understood these shifting political dynamics and opted to use the term "compensation," which sounded corporate and thus rational to business professionals who regularly issued checks to their employees.

"The effects of over 300 years of oppression cannot be obliterated by doing business as usual," Young wrote in the *Times*. He pointed out that there was a 45 percent gap in earnings between Negro families, who earned an average of $30,000 annually, and white families, who averaged $57,000; that gap had widened by 2 percent over the past decade and would have "tragic consequences" if the call for Black economic justice went unheeded. "A strong back and a will to succeed are no longer sufficient to break the bonds of deprivation," especially in a non-agrarian, technologically advanced society, Young emphasized. In other words, the problems African Americans faced were structural and institutional. Working harder, exercising self-discipline, and saving rather than spending was not enough. A change in national policy was required.

The actual nuts and bolts of Young's plan were not radical, but his plan was more progressive than that of many of his contemporaries. Young believed that the US government owed Black people for the labor and property that had been stolen from them and the economic obstacles it had placed in front of them for generations, impoverishing the Black masses in a wealthy society where the working and middle classes lived more comfortably. Young's compensation plan called for qualified Negroes to be the first applicants hired for jobs that paid a living wage, going beyond tokenism, which brought only one or two Negroes into a workplace. Similar measures were proposed for access to public housing and education. Young stressed that even amid what the white media

dubbed the "Negro revolt," the goal of the vast majority of Negro Americans was "not to change the fabric of our society, but to enter into partnership in that society."

But whites, even white liberals, could not get behind Young's demands for compensation for decades of discrimination. The vast majority of white Americans believed that Negroes deserved equal rights, and a smaller majority believed that civil rights was the most pressing domestic issue of the time. Still, despite Young's laundry list of reasons why compensation was deserved, it sounded to most white Americans like preferential treatment, which they firmly rejected. Their reasons all stemmed from the notion that compensation itself was racist. Many believed there was no way to calculate the actual financial costs of slavery and Jim Crow. They balked at the estimated one-trillion-dollar price tag the media often attached to Young's ten-year plan, believing if there was a way to calculate a dollar amount, it could never be that high. Others held on to their conviction that the plan unfairly penalized all white people along with the few whose ancestors had owned slaves. The kicker was the notion that compensation would destroy Black Americans' ambition and drive to achieve, causing them to become mediocre in the same way it had white, plantation-owning Southerners who had relied upon their racial privilege to retain their social status.

Young's core structural critique of inequality was not altogether new. Sociologist E. Franklin Frazier had written about the resulting economic problems of American racism in his polemic *Black Bourgeoisie* in the 1950s. But Frazier had been so antagonistic to the Black middle class that most disregarded his smart economic assessments. Young made these points without faulting middle- and upper-class Blacks for having made it and for believing in the

power of their dollars. Nor did he browbeat poor Black folks and tell them they needed to pull themselves up by their own bootstraps lest they shame the race. This perspective was both part of Young's strategy and a reflection of the beliefs he had formed as a young man in Kentucky who saw the plight of Black sharecroppers and the strides made by the Black middle class and wondered why education and financial security were things they had to struggle for. It made Whitney Young a particular kind of leader. His Black left-wing detractors saw his compensation plan as serving racial and economic liberalism, rather than revolution. Young's white and Black critics saw it as bound to arouse such vehement opposition that it would impede gradual progress.

Many supporters thought Young's economic approach was yielding not only benefits for the League but also well-paid, secure jobs that opened pathways into the Black middle class. They pointed to successes, such as the first Black elevator operator at Rockefeller Center. The first Black secretary hired at RCA. The first Black sales representatives at Gulf Oil and at Trans World Airlines. And the first Black teacher hired in Westchester County. Young's on-the-job training programs and Skills Bank were a success. *TIME* would later report that, in one year alone, Young's Urban League secured forty thousand jobs for unemployed Negroes and eight thousand better jobs for those already employed. These things boded well for his argument that Black people's lack of achievement in corporate America did not result from their own deficits but from structural barriers. Young had a clear critique of what we call "respectability politics." Success depended not on Black people behaving better but on upending institutional inequalities. He supported capitalism but demanded that everyone have equal access to its benefits.

Mollie and the women of the New York Guild were modeling the community-centered economics that Young was preaching about. Mollie in particular wanted to make sure that "no more nickel and diming" didn't mean casting aside the working poor, particularly the youth. Much of the money the New York Guild raised was earmarked for the NUL's youth programs, such as its Street Academy. The program was designed to give remedial training to high school dropouts. Before Daniel Day became the legendary fashion designer Dapper Dan, he was a Harlem youth who had run afoul of the law. In his early twenties, he joined one of the Urban League's programs to give Harlem youth new skills. He took classes in journalism through a partnership between Columbia University and the Urban League, which eventually paid for him to travel to Africa. Undoubtedly, Mollie helped to raise funds that supported this initiative—though Dan likely would never have known it to thank her personally.

March on Washington

Spring 1963

Word had begun spreading across civil rights networks about a large-scale demonstration in Washington, DC, to protest racial injustice. The movement for civil rights had entered another intense period of direct nonviolent action in response to waves of police brutality and vigilante violence, voter suppression, and employment inequality. For every step forward activists had taken, white segregationists were trying to force them back into the bondage of Jim Crow. The more radical activists aimed for the protest in the nation's capital to be so disruptive that it would generate enough public outrage to force President Kennedy to pass a major civil rights act.

There was much to be done to help coordinate what would be called the March on Washington for Jobs and Freedom. Fundraisers and grassroots organizers from every corner of the Black Freedom financial grid would have to coordinate ways to raise funds for buses, buy supplies for protest signs, buy food for sack lunches, and print program booklets, among other things. It would take every skill that money organizers like Mollie Moon had amassed over the long arc of the movement to pull off a successful and impactful march.

Black women across the country took up the charge, coordinating efforts in their cities and rural communities to ensure they were present and accounted for on the day of the march. They bustled from organizational meeting to organizational meeting, coordinated phone trees, often spending hours on the telephone recruiting people to lead various tasks and initiatives. The most influential called in favors with the elite African American businesspeople in their Rolodexes, such as Birmingham millionaire Arthur George Gaston, who had given thousands to the movement. He and others of means liked to give discreetly so as not to become targets of White Citizens' Councils.

Mollie could feel the fervor in the air that stirred up when African Americans began to rally en masse. It was the spirit of the ancestors, those who had laid the groundwork for the organizing traditions they were now using. She had felt it before, back when A. Philip Randolph had initially planned a march on the federal government for jobs and labor equality in the early 1940s. Then, she was a young radical who was eager to make a bold statement about economic injustice. Now, as a woman in her mid-fifties, she left much of the political pyrotechnics to the young foot soldiers of the Student Nonviolent Coordinating Committee (SNCC)

and the Congress of Racial Equality (CORE). She and the Guild formed a base of support around the major organizations that had assumed the role of coordinating the march, working in tandem with government officials.

All told, more than 250,000 people would descend upon Washington on August 28, 1963, for what would go down as the largest mass civil rights demonstration in history. But the road to getting there was filled with conflict and compromise that nearly ripped the movement apart.

Successful mass actions helped to elevate the leaders of the nation's major civil rights organizations. The group that met regularly with President Kennedy to discuss race relations was tagged the "Big Six," even though there were more than six of them. When Whitney Young became the executive director of the NUL, Roy Wilkins held the corresponding position at the NAACP. Not only did the two organizations have overlapping membership and often collaborated on local campaigns and national issues but also the two men got along well. The older Wilkins welcomed Whitney and Margaret Young warmly, and Whitney knew that he should take care not to alienate Wilkins, who had already devoted more than thirty years to the NAACP. A. Philip Randolph was another seasoned leader; a labor organizer and socialist, he had spearheaded the struggle to desegregate the US armed forces and defense contractors during and after World War II. His protégé, Bayard Rustin, was a brilliant organizer who belonged to the pacifist, interracial Fellowship of Reconciliation, but his homosexuality meant that he was often kept behind the scenes. Brilliant political strategist and organizer Anna Arnold Hedgeman was a vital member of the organizing committee, though her contributions are often overlooked.

Dorothy Height, who headed the National Council of Ne-
gro Women (NCNW), spoke quietly but forcefully on behalf
of Black women, though the males in the group relegated her to
the role of figurehead. James Farmer had founded CORE, which
was dedicated to civil disobedience to achieve justice. The leaders
of newly formed and rapidly growing organizations were Martin
Luther King Jr. of the Southern Christian Leadership Conference
and John Lewis of SNCC. Even though Farmer and Young were
the closest in age, they were ideologically unaligned. Farmer and
the youngster Lewis, who were nearly twenty years apart in age,
formed an alliance. Liberal white leaders, representing the unions
and churches, were also thrown into the Big Six, when it made
sense to leverage their influence.

Since these organizations all needed more funds, they com-
peted with one another for donations from foundations, corpo-
rations, and wealthy white liberals. In 1961, the Taconic and Field
foundations funded the Voter Education Project, a drive across
the South that was coordinated by the NAACP, NUL, CORE,
SNCC, and SCLC. Voter Education Project leaders such as Sep-
tima Clark were charged with researching and finding solutions to
low voter registration and turnout in the South. The Voter Edu-
cation Project had bipartisan support. But rumor had it that the
project had been the brainchild of President Kennedy, who was
trying to quell the radical energy created by the sit-in and Freedom
Rides movements and redirect the young activists toward efforts
that were moderate and politically productive for him, like voting.

As it went, Kennedy had turned to young philanthropist
Stephen Currier and other foundation leaders in his circle of
surrogates to have them throw money behind the project. And
Kennedy also invited Harry Belafonte, who had a great deal of in-

fluence over SNCC, to his Hickory Hill estate in Virginia, where he persuaded Belafonte to speak with SNCC leaders and strongly encourage them to redirect their efforts toward voting under the banner of the Voter Education Project. Belafonte reportedly did so, inviting SNCC leaders and others involved in the Freedom Rides to one of his DC concerts and giving them $10,000 of his own money to support the voter-education venture. The money would have been hard to pass up for cash-strapped young activists. However, most could still see that this was a power play by the Kennedy administration. They resented what they called co-optation—today we call this "movement capture"—or what happens when financially vulnerable organizations are coerced by powerful funders to change their political course.

The resentment between the young radicals of SNCC and CORE and the old-guard organizations festered. The problem came to a head in 1962, with intense infighting. Many of these debates were over differences in ideology and strategy. The Urban League could not lobby for legislation or conduct political protests without jeopardizing its 501(c)(3) status. The young militants in CORE and SNCC seemed too radical to the NAACP and the SCLC. In return, the younger activists thought the others were too tied to tradition and to behemoth organizations that moved too slowly. Dorothy Height and Black women's issues were almost always sidelined. And Wilkins was so fiercely jealous of King's charisma that he tended to oppose anything King proposed without giving it serious consideration.

Yet money was, perhaps, *the* fundamental issue that kept them from working together effectively. Liberal whites were throwing them guilt money to show that they were on the right side of history. As with most things, the majority of the money was coming

from New York and other cities on the East Coast. For example, in 1963 and 1964, the Taconic Foundation alone gave approximately $10 million in grants, gifts, scholarships, and other contributions. The leaders were then stepping on one another's bags by soliciting money from the same donors.

Young, the bag man extraordinaire with the closest ties to those who led major corporations and philanthropic foundations, took the lead in fixing this problem. He spearheaded the formation of the Council for United Civil Rights Leadership (CUCRL). The council was backed by Stephen Currier, who was married to Audrey Bruce Currier, the granddaughter of banking tycoon Andrew Mellon. When people like Currier decided they wanted to get into philanthropy, they sought out advisers to help them determine which causes to support and which leaders to connect with. Lloyd K. Garrison, a Taconic Foundation board member who was a longtime supporter of the Urban League, introduced Currier to Whitney Young.

Young and Currier were close in age, and they developed a different kind of bond than Currier and the far more senior Granger had established near the end of Granger's term as executive director. Young and Currier became friends who often talked shop about race-relations work, among other things. Young frequently praised the Curriers and the Taconic Foundation for bringing "creative imagination" to the cause of civil rights. Whitney said of Stephen and Audrey Currier: "They were white in complexion but saw this as an accident of birth—not as a symbol of advantage, privilege, or superiority over other human beings of color." Young felt that Taconic, founded in 1958, was one of the boldest philanthropic foundations. The Curriers did not tread the same, safe terrain as other foundations, which gave to tried-and-true causes,

Mollie Moon chats with Jeanne Vanderbilt and Fleur Cowles of the
Urban League Women's Division, circa 1949.

Mollie Moon
with Urban League
colleagues at
New York's
progressive radio
station WMCA,
circa 1949.

Romare Bearden shows his work at the annual art exhibition hosted by the exclusive Pyramid Club in Philadelphia, circa 1948.

Mollie Moon with family and friends in Cleveland, circa 1940.

Mollie Moon photographed by Carl Van Vechten, 1956.

Mollie Moon photographed by Carl Van Vechten, 1956.

Josephine Baker, Mollie Moon, and the newly crowned
Miss Beaux Arts Ball, 1960.

Mollie Moon photographed in her Long Island City home by Louise Jefferson, circa 1953.

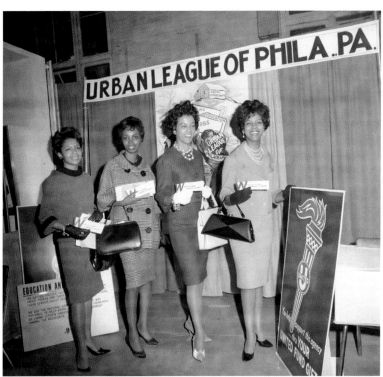

Members of the Urban League of Philadelphia's Guild Art Committee, circa 1963.

Mollie Moon Sues N. Y. Socialite For $1 Million

Mrs. Moon, Mrs. Jacobs

Urban League Guild founder and national president Mrs. Mollie Moon asserts that prominent New York socialite Mrs. Sophia Yarnall Jacobs made "false and defamatory" statements about her that "injured her good name and reputation, and subjected her to great shame, disgrace and humiliation." Mrs. Moon is seeking $1,-000,000 in damages. Atty. John Hill admitted to JET that he filed the suit, in Mrs. Moon's behalf in New York County Supreme Court. The suit stems from remarks allegedly made by Mrs. Jacobs, a former president of the Urban League of Greater New York, at the Urban League's national convention in Philadelphia.

Mollie Moon and Sophie Yarnall-Jacobs.

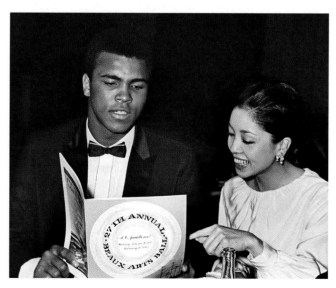

Muhammad Ali and a guest during the 27th Annual Beaux Arts Ball, 1967.

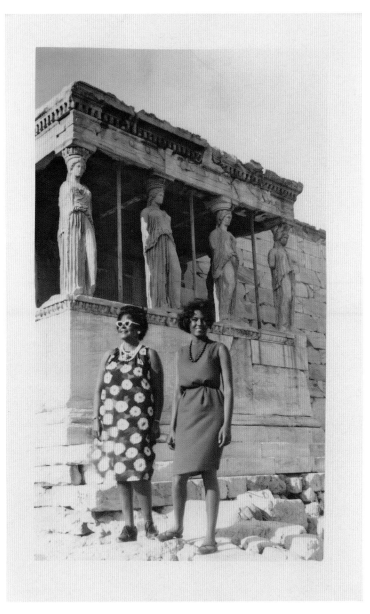

Mollie Moon and Mollie Lee Moon Elliot at the Acropolis
in Athens, Greece, circa 1975.

such as medical research and education. Taconic instead supported "unpopular" and "not yet fully-respectable causes." The Curriers, whose foundation was relatively small, were hands-on administrators who participated actively in the groups they supported. They gave money "with no strings attached" because they trusted that Negro leaders and organizations were capable of managing money. Young noted that this stance stripped away a layer of paternalism that almost always came with foundation philanthropy.

Utilizing their money and Stephen Currier's business acumen would bring to the NUL "stability and financial resources when they are most desperately needed." Stephen's money gave him a place at the table and power to shape the direction of the national movement. Whitney started toying with the idea of introducing Stephen to the other Big Six leaders. Several NUL leaders were concerned that if Whitney pointed Stephen and Taconic toward other movement organizations, they would lose some of the money. But Whitney saw the possibility of a different power play. By being the one who used a major NUL donor to fund the CUCRL, he would ingratiate himself with the other leaders. He could carve out a unique position for himself as the bag man and distinguish himself when the Big Six met with Kennedy and his advisers. If Whitney held the power of the bag, he could control the movement. If Whitney was not happy, they couldn't play ball.

Manhattan, June 1963

During a conversation, Whitney and Stephen decided to assemble the Big Six at the Carlyle Hotel in New York to discuss how they could meet their financial needs while quelling some of the infighting. Before the meeting, Stephen went to members of his Taconic board of directors and gained permission to give up to $1 million to

meet movement leaders "emergency needs"—as long as the CUCRL met the board's funding provisions standards. The Carlyle meeting was a success, though there was much debate and compromise on all sides as the Big Six determined which donors to accept money from, which member organizations to add, and which civil rights causes to champion. Lawyers, accountants, and money administrators were part of the long and convoluted détente. If everyday citizens could have seen what all high-level corporate maneuvering went into what they likely believed was organic grassroots action, they would have been gobsmacked. The CUCRL was born that day, and the Big Six leaders appointed Whitney and Stephen co-chairmen. The Field, Stern, and Taconic Foundations became the CUCRL's major donors.

The *New Journal and Guide* reported that the CUCRL was formed because the Big Six were "determined not to waste their energy in criticizing each other and confusing supporters of civil rights." The implication was that all of the big personalities were getting in the way of the work. But the reality was that tensions within the Big Six leadership continued to intensify as state-sanctioned and vigilante anti-Black violence rippled through the South in response to nonviolent direct actions. Molotov cocktails, attack dogs, and water hoses were tools of terror. And the violence begat more marches and protests. Black Southerners refused to be daunted in their quest for freedom. Together, these two dynamics increased the need for money and made it harder to get money across the Black Freedom financial grid and into the Deep South, where it was greatly needed.

Harry Belafonte would later find this out the hard way, during Freedom Summer—the massive voter-registration drive across the South, organized by SNCC and other civil rights organizations.

"We've got a crisis on our hands down here," the man on the phone said. "We need help." "What do you need?" Belafonte had asked SNCC leader James Forman, the man on the other end of the call. "At least fifty thousand dollars," Forman replied (the equivalent of nearly $500,000 today). "How soon do you need it?" Belafonte asked. He'd given money to SNCC in the past and had coordinated benefit concerts headlined by folks such as Nina Simone, Joan Baez, Dick Gregory, and the Kingston Trio. Forman told him, in no uncertain terms: "We're going to burn through the rest of our budget in seventy-two hours." Belafonte pledged to raise the money, and then get it from New York City to rural Mississippi, somehow, some way.

Belafonte instantly set about fundraising the $500,000 so he could deliver the money to Mississippi in three days. He and his wife, Julie Belafonte, hosted a fundraiser (organized by Julie) at their Upper West Side apartment. Harry also flew to Montreal and Chicago to speak at in-home fundraisers organized by his friends—"White guests bearing check books," as he described them. He was eventually able to raise nearly $700,000, which he converted to small bills and placed in a suitcase. Belafonte enlisted his good friend, actor Sidney Poitier, to accompany him on this perilous journey to the Deep South. The two biggest Black celebrities in the world at the time took a commercial plane from Newark, New Jersey, to Jackson, Mississippi—unaccompanied by any security guards. Then they hopped on a tiny Cessna to a private landing strip in Greenwood, Mississippi, where they were met by SNCC volunteers, who drove them to an Elks Lodge on the outskirts of Greenwood, where a group of around a hundred SNCC volunteers were gathered. "When Sidney and I walked in, screams of joy went up from the crowd," Belafonte remembered.

Leaders like Forman often turned to their celebrity contacts to help raise funds. Forman, who had lived his life between his native Chicago and rural Mississippi, could see that tensions were high among the Big Six leaders. Asking for money only exacerbated the problem. Also, that ask came at another cost. Forman knew that Whitney Young had access to large amounts of cash because of his corporate ties. While Forman and others in SNCC had a strong critique of capitalism, they desperately needed money. And Forman was good at asking. He went to Whitney for financial assistance on behalf of SNCC, and Young used the funds at his disposal to establish fellowships that allowed SNCC to pay for organizers' basic living expenses, enable young leaders to get an education, and ensure that experienced staffers earned advanced degrees in relevant fields such as law and the social sciences. But that money tacitly came with pledging allegiance to Young in ways that Forman was likely not altogether comfortable with. Belafonte, who was nearer in age and ideology to Forman than Young, was a better ally, although he, too, had political entanglements with the White House and did not have the means to drop a donation of $500,000 on SNCC every time Forman made a phone call.

Movement leaders had come to expect friction as a cost of doing business. "I think 1962 was perhaps the lowest moment for the civil rights movement in the Kennedy years," Roy Wilkins wrote in his autobiography. The infighting was especially bad. According to Wilkins, the radical leaders of SNCC and CORE were furious that Dr. King would sweep into voter registration drives and other actions they had painstakingly organized with local grassroot activists, bringing the media with him so he could get credit for their work. Wilkins said that many of the young activists had taken to

calling Reverend King "Da Lawd" behind his back, a not-so-subtle parody of his exaggerated sense of self-importance.

Yet no one could deny that King was a master orator who could conjure up the spirit of the Holy Ghost to walk with the people. Wilkins tended to emphasize that the younger folks had a problem with King to justify and deflect attention from his own jealousy of the upstart leader. But Wilkins was correct about what he called the "mediagenic" element King brought to the movement and the amount of ink that was being spilled to cover his comings and goings. Since World War II, the NAACP had been the darling of the national press. Now it was being rapidly displaced by newer, more radical groups. Wilkins resented the fact that the NAACP, NUL, and SCLC had been putting up all the money for these groups' actions and organizing drives "only to be insulted for being on the wrong side of the generation gap" by SNCC and CORE leaders. Wilkins thought that generational conflict was destroying the movement.

* * *

The biggest initiative taken by the Big Six during these dynamic but difficult years came in 1963, when the CUCRL began to plan the March on Washington for Jobs and Freedom. The Taconic Foundation supported the staff who organized the mass demonstration. The CUCRL also received donations from individuals, the largest for $1.9 million. King gave the $500,000 he received from winning the Nobel Peace Prize. The New York City chapter of Jack and Jill contributed $10,000. Corporations made smaller contributions. The March was a corporate- and philanthropic-foundation-sponsored event. Despite attracting a massive crowd

of Black and white participants, including contingents from grass-roots organizations in far-flung communities, it was a carefully or-chestrated and scripted gathering, not a radical action.

Malcolm X, the firebrand minister of the Nation of Islam, was critical of the Big Six organizations and their leadership for cozying up to the government and big business. He thought the Bandung Conference held in Indonesia in 1955, where leaders of African, Asian, and Middle Eastern nations announced their re-fusal to align with either the US or the USSR during the Cold War, was the model of liberation that people of African descent in the United States should pursue. Led by the Third World, it demonstrated the power that could come from solidarity among peoples of color, who constituted the majority of the global popu-lation. Economic cooperation and the recognition and protection of human rights were two of the central goals of this alliance. Seen from this perspective, the struggle to attain equality with whites in a nation-state that prided itself on its capitalist economy and its military power was not only futile but also a fool's errand.

Malcolm was an astute political thinker and social analyst, and he presented his radical views in ways that appealed to everyday Black Americans. Roy Wilkins recalled Malcolm as "a mesmeriz-ing speaker, the toughest man in a debate that I've ever seen. None of us could touch him, not even Dr. King."

In November 1963, mere months after the March on Wash-ington, Malcolm delivered his legendary "Message to the Grass Roots" in Detroit. In the speech, Malcolm likened the Big Six to "house" Negroes, servants who carry out the will of their white masters, while the "field" Negroes rebel against their enslavement. Malcolm X regarded the conflict among the Big Six movement leaders—which Wilkins felt was detrimental to progress—as fun-

damentally healthy for a true grassroots uprising. Without these "Uncle Toms" standing in their way, the masses could rise up in rebellion, as grassroots activists such as Mississippi native Fannie Lou Hamer, Gloria Richardson in Cambridge, Maryland, and radical local leaders of the NAACP and NUL had shown. Malcolm saw the CUCRL and the "Farce of Washington," as he commonly called it, as a coordinated effort by Kennedy, the Big Six, and white capitalists to quash this revolution. "Let me show you how tricky the white man is," Malcolm X told the crowd before explaining that Currier's donation to the CUCRL of $1.5 million came with his being appointed co-chair of the organization. He was able to buy the movement and to put in place the same power base that had gotten Kennedy into office: business-oriented trade union leaders, members of the Jewish elite, Catholics, and liberal Protestants. "They didn't integrate it; they infiltrated it." And "as they took it over, it lost its militancy. . . . Why, it even ceased to be a march. It became a picnic, a circus."

That the founding meeting of the CUCRL took place at the Carlyle, often called "the New York City White House" because Kennedy had a residence there, was further evidence for Malcolm of how this group manipulated the media to make the Big Six the face of the March on Washington when the people had a far more radical vision. "A million and a half dollars—split up between leaders that you've been following, going to jail for, crying crocodile tears for. And they're nothing but Frank James and Jesse James"— bandits who stole the movement out from under the Black masses.

Malcolm would have been disturbed but not at all shocked by how the CUCRL also trotted out members of the Big Six to speak at exclusive events in front of big-dollar donors. These command performances were the trade-off for taking the Taconic money. For

example, Dr. King was invited, at the behest of Rodman Rockefeller, a leader in the Westchester County Urban League affiliate and son of New York governor Nelson Rockefeller, to address ninety guests at a luncheon at Governor Rockefeller's Pocantico Hills estate. The luncheon raised $500,000 for the Westchester Urban League.

The CUCRL disbanded in 1967, largely because the money dried up after Stephen and Audrey Currier were presumed dead when the small plane they had chartered crashed into the Caribbean Sea somewhere between Puerto Rico and St. Thomas. Whitney Young penned an obituary for the couple in the *Chicago Defender*.

* * *

As the movement rolled into the mid-1960s, the violence only intensified, leading to the assassination of key figures in the fight for racial justice. Mississippi NAACP leader Medgar Evers was assassinated in front of his Jackson home on June 12, 1963. Later that year, on November 22, 1963, President Kennedy was assassinated in Dallas, Texas, as his motorcade made its way through a crowd. Malcolm X (now going by the name Malik el-Shabazz) was assassinated on February 21, 1965—presumably by members of the Nation of Islam, from which he had severed ties in the spring of 1964—while giving a speech at the Audubon Ballroom in uptown Manhattan. Despite the violent retribution in direct and indirect responses to nonviolent forms of protest, Whitney Young believed the organizing style of the era was "much more than either mass acts of desperation or the products of rabble-rousing by a minority of dissidents." The protests "have been accompanied by the emergence of a whole new rank of leadership in the Negro community." This contingent "express[es] its group impatience with gradualism

and tokenism," using "reasoned resolve to demand more and faster response to Negro needs and rights," Young said in a speech before a diverse group of civil rights organizers. The movement had to plow ahead.

A growing number of young radicals disavowed the old leadership. Integration was no longer the aim for a large swath of the Black population. *TIME* reported in 1967 that the unemployment rate was two to four times higher among Negroes than whites, and three-fourths of the nation's twenty-two million Negroes were living in slums in major cities. Demands for reparations increased. Harlem Black nationalist James Lawson demanded that every Black person in America receive $60,000 in reparative justice.

Newsweek stated that the Civil Rights Movement was fractured beyond repair. Poverty and despair in Northern and West Coast ghettoes were drawing attention away from the South. Cities from San Francisco to Omaha, Chicago to Rochester, were erupting in protests and riots. "There is no city in the US in the summer of 1967 that's really free from the possibility of violence," the magazine reported a civil rights leader as saying. *TIME* contended that the people in these ghettoes had no respect for Whitney Young and his peers, who were still preaching reform and integration: "In wretched Negro slums, the more moderate Negro leaders pack no clout."

But the young radicals would soon come to realize just how difficult fundraising could be. They would find themselves going into the lavish homes of the Park Avenue elite, dressed in radical garb—berets, dashikis, leather jackets, and denim jeans—regaling them with hood tales in hopes of being given a few thousand bucks for their cause. Others cozied up to the white liberals of Hollywood, using their LA mansions, with in-ground pools, as venues

for fundraiser parties to support their various community breakfast and healthcare programs. Some male activists—who claimed to be the staunchest Black nationalists—even dated the white women who helped usher them into this world of wealth and resources. It was all a philanthropy racket into which everyone, regardless of their politics, was conscripted. But the press downplayed the corruptive, white money element, instead choosing to amplify the beef between the young Black radicals and the old Negro moderates.

Newsweek explained these dynamics in historical terms. The younger people who were followers of Trinidad-born SNCC leader Stokely Carmichael had entered kindergarten when the US Supreme Court declared segregation unconstitutional in *Brown v. Board of Education*. They were prepubescent during the early sit-ins of 1960 and 1961. Now they were coming of age during the Black Power era. To them, Whitney Young, Roy Wilkins, and A. Philip Randolph seemed like dinosaurs. Carmichael, who was in his mid-twenties, was their peer who they felt could relate to their plight (even though he had been born into a respectable, working-class Trinidadian family). The radical Left was committed to mobilizing people in the underground economy, the gang members, prostitutes, and drug dealers on the margins of the margins.

Tom Buckley, a reporter for the *New York Times*, argued that Black leaders of so-called moderate organizations, like Whitney Young, were losing on another front as well. According to Buckley, Young and Wilkins had "incurred political debts the size of payments on a Harlem Cadillac." Having access to President Johnson and pushing him to pass the Civil Rights Act of 1964 and the Voting Rights Act of 1965 came at a price. When Johnson needed good publicity about the Vietnam War, despite strong and growing popular opposition to escalating military intervention, he sent Young—a

World War II–era Army veteran—there in 1966 and 1967 to come back saying that the US was bringing democracy to Vietnam and preventing communism from taking over Southeast Asia.

Young did not want to do it, especially since King had taken a strong antiwar stance. Young's reputation took a major hit. It appeared that he was in the government's pocket for sure. He and Wilkins opposed the war only after Johnson had left office and Nixon announced plans to withdraw from Vietnam. This made Young and Wilkins look like race traitors, especially in view of the disproportionate number of young Black men who had been drafted and sent to fight in Vietnam.

"Whitney sells out for a bottle of champagne," one movement leader said. It didn't help that by 1967 Young had moved into a mini-mansion on Oxford Road in New Rochelle that abutted the Wykagyl Country Club. He was accustomed to flying first class and was earning roughly $300,000 a year from the NUL. Even Young loyalists started to wonder what kind of compromises he was making behind closed doors if the ones that became public were so egregious. Meanwhile, King had started disavowing golf and other activities he deemed bourgeois. Dr. King had been sensitive to the critiques people had lobbed at him and his activist wife, Coretta Scott King, in the early 1960s—about their vacations, his silk pajamas, and Coretta's pearls and pillbox hats. Now King was looking more and more like a man of the people.

The *New York Times* estimated that, by the close of the decade, only about $3.8 million of the roughly $270 million the NUL was receiving came from Black Americans. Most of the money came from private, tax-deductible donations, government contracts, foundations, corporations, and Community Chests. The money was profoundly and undeniably white.

Young had to stop running from the term "Black Power," even though it was anathema to his white corporate base. He opted to defang the phrase by redefining it. "Black Power, according to my definition, is a very powerful thing," Young said during a press conference. "It means pride . . . it means that a group has a right to participate in its destiny and to have an influence on its own community affairs." Under Young's new Black Power mantra, the NUL had started shifting its rhetoric from one about full integration to offering "options" for how African Americans could live. For those who did not want to integrate, the NUL—with the help of approximately $20 million of Ford Foundation money—launched a series of "community control" projects that riffed off of radical Left concepts.

The NUL also partnered with nonprofits to renovate housing and day-care centers. The more progressive Urban League chapters even shuttered their fancy downtown headquarters (which had been a sign of their militant professionalism) and set up shop in the ghetto. Still, there was even more tension within the NUL house, as executive directors of more radical chapters in places such as Los Angeles, Cleveland, Miami, Washington, and Boston were questioning Young's approach. One question they regularly asked was: What good is it to put Black folks in jobs if the culture of the workplace is still racist and built on Jim Crow logics? Many did not think reform was enough. The system needed to be overhauled.

As the tensions between African American male leaders intensified, Mollie found herself a target of the vitriol in the most unexpected ways and from the most unlikely source.

Betrayed

New York City, 1965

The old rumors about Mollie and her alleged affair with Win-throp Rockefeller reemerged in the early years of the Black Power movement. People had long whispered that she and Henry were in an open marriage. Although such agreements were uncommon, people thought that some couples in the Moons' social circle lived unconventional lifestyles. For example, it was rumored that Walter White, then head of the NAACP, had regularly brought his mistress, a white South African woman named Poppy Cannon, to the Moons' apartment at 940 St. Nicholas Avenue, where they were accepted as a couple even though everyone knew his marital status. White divorced his Black first wife to marry Cannon in 1949, a

256 · TANISHA C. FORD

move that many in the African American community considered a betrayal of the race. Eslanda and Paul Robeson, who were believed to be in an open marriage, allegedly flirted with and pursued other people at the Moons' parties.

Others assumed Henry was willing to be publicly cuckolded because he was a closeted gay man. His and Mollie's marriage was nothing more than a ruse that gave him cover from homophobia— which would have been particularly important when he worked in the federal government—and allowed Mollie to find sexual pleasure with whatever man she wished. The source of this social tittle-tattle is unclear, but it was fueled by Henry's genteel, introverted personality and his close friendships with Ted Poston and other men.

The rumors were juicier than whatever truth might have lurked beneath them. And in some ways, Mollie's reputation as a sexually liberated party hostess with a ribald sense of humor helped to sustain her prominence. People were curious about the Mollie mystique. They wanted to be invited to her sensational parties.

When Mollie was considered Lester Granger's right-hand woman, people hesitated to print negative gossip about her. They feared her power and influence. It allowed her to reap the benefits of incessant publicity—whether it was good or bad did not matter—while shielding her from serious attacks. Mollie had never bothered to rebut or even address her critics publicly. Instead, she just reminded them each year when she donned her new queen costume for the Beaux Arts Ball that she reigned supreme over Harlem society. But Mollie's diminished status in the Urban League had exposed her to greater risks. And it was worsened now that even the beloved Whitney Young was being called a sellout. The entire National Urban League enterprise was under assault

by young radicals who were garnering around-the-clock media attention.

* * *

The Moons could not have anticipated that Henry's first cousin, novelist Chester Himes, would emerge as Mollie's most ruthless critic. In 1965, Chester's searing, satirical novel *Pinktoes*—which centered on a lascivious character named Mamie Mason who was eerily similar to the real-life Mollie Moon—was published in the United States. This was the same cousin whom the Moons had invited to live with them at their Harlem apartment while he launched his career. They had introduced him to industry insiders. Mollie had even thrown the book-launch party for his critically acclaimed debut novel *If He Hollers Let Him Go* (1945).

Initially, Himes could not find a US publisher for *Pinktoes*. There was no way that a publisher based in New York was going to bring out a scathing critique of the city's economic and social power brokers. It was likely that editors with the major imprints hobnobbed with the Moons and white elites in their circle. And Negro leaders such as Walter White and Lester Granger held so much sway as the Civil Rights Movement accelerated that publishing dirt on them, even if it came from a Black man, would put any white liberal on the wrong side of history.

Himes had to publish with the Paris-based Olympia Press in 1961. Olympia was known for publishing controversial erotic fiction with erudite writing, such as Vladimir Nabokov's *Lolita* (1955), which British and North American publishers would not dare touch. The Himes book fit this bill. "Pinktoe" was a colloquial term that African Americans used to describe whites who enjoyed

and sought out sex with Black partners. Himes used it satirically to mock the wealthy white philanthropists and arts patrons who had intimate liaisons with Black women and cleared their consciences by supporting racial equality and other good causes. *Pinktoes* was deemed avant-garde by the sexually liberated French.

Now, as the Black Power movement was coalescing, two prominent US publishers, G. P. Putnam's Sons and Stein and Day, were clamoring to publish the book. That the two publishing houses were willing to team up to release *Pinktoes* in North America in 1965 speaks to the dramatic shift in the political and cultural landscape. They believed there was enough money to be made from *Pinktoes* that it was better to partner than to lose money fighting over publishing rights in court. Writ large, US publishers were starting to see that there was money to be made in publicly humiliating the old-guard Negro leaders who were now considered "moderates" in comparison to the younger, hipper Black radicals who had burst on the scene. And publishing warmed-over gossip like the Mollie and Winthrop rumor, instead of the piping-hot tea of the moment, might have insulated the publishers from criticism.

The plot of *Pinktoes* centers on a Negro woman named Mamie Mason who connects these generous givers to their Black and sometimes unsuspecting partners during interracial romps she hosts at her Harlem apartment. As a pop-culture archetype, the "Mamie" figure was often associated with blues music and the hedonistic lifestyle that was linked with the gutbucket sounds from the Deep South. Himes describes Mamie Mason as a "strikingly attractive," "big-boned, hard-drinking, ambitious" madam, with features that look like "East Indian Maharanees," the wives of the maharajas who ruled independent princely states

in India. She is a social climber who befriends anyone who is anyone, calling all of them her "best friend."

Mamie, who has "the instincts of a lecherous glutton," is selling Blackness to create an "abundance of interracial loving" to solve the "Negro Problem." All she really wants, however, is to "serve the Negro Problem up to white people and be loved by white people for this service." Himes is also critical of the white folks who use Mamie's services to ameliorate any guilt they might feel about their capitalist riches and the widening wealth gap between the races. "There is nothing more inspiring to a fifteen-thousand-dollar-a-year [around $150,000 today] white man . . . than a trip to Mamie Mason's in Harlem and seeing how Negroes manage on one-third of that income and listening to them laughing," Himes writes. He is skewering white elites for their fascination with the "happy darkies" stereotype and Mamie Mason for providing the fodder.

It was a damning, buffoon-like portrait of Mollie Moon. Perhaps the only part of the book that Mollie might have appreciated was that Chester chronicled the ruthless gossip that followed her. In one *Pinktoes* scene, during a party at Mamie's, a group of unidentified women, clearly jealous of Mamie and her beguiling beauty, are caught whispering absurd bits of gossip about her: "I hear Mamie has cancer in her rectum," one says, perhaps alluding to rectal cancer being the result of partaking in the taboo act of anal sex. "She's been named correspondent [*sic*] in you-know-whose divorce," says another. Himes's use of "correspondent" was a play on words. If a "correspondent" is someone who writes another person regularly, and a "co-respondent" refers to someone who's been named in a divorce filing as having had an affair with the (male) spouse, then Himes was calling Mollie a habitual home-wrecker.

In a desperate effort to make Mamie less attractive to their

husbands, the women characters try to sabotage the food-loving Mamie. They tempt her—a woman who has major weight insecurities—with huge portions of delectable eats, in order to ruin her figure so she can't squeeze into her signature black satin sheath dress. Mollie Moon had endured body shaming for decades. Male society writers studied her fluctuating weight and commented on every pound she gained and lost. Himes used the Mamie character to name this social torture that Mollie was subjected to.

Had Mollie done so herself, it would've read as an overly privileged and gorgeous woman who benefitted from her sexy image complaining about her less attractive underlings calling her names. In their eyes, joking about her weight battles knocked Mollie off her pedestal. These were blows she was simply expected to take. However, that nod of sympathy toward Mollie through the Mamie character would not have erased the Moons' anger over *Pinktoes*.

The Moons were offended that Chester had violated the family's code. Henry's mother and Chester's father were siblings. Like Henry, Chester was raised in a middle-class household; his father was a professor and his mother a schoolteacher. Chester's family moved to Cleveland from Missouri during his adolescence and relied heavily upon the support of Henry's family as they settled in. Henry was Chester's brilliant older cousin who was already walking in the path of Black excellence that his parents expected. Chester was on his way as well. He enrolled at the Ohio State University, where he pledged Alpha Phi Alpha. He used the settlement money he received from a workman's comp lawsuit to appear as if he came from a very wealthy Black family, like some of his fraternity brothers.

But he couldn't shake the desire he had for prostitutes, which he had developed during solo forays into the brothels of Cleve-

land's Tenderloin district. There he learned the hierarchy that controlled the sex trade. Young Chester absorbed the idea that sexual relationships were transactional in nature. There was something intoxicating about the realness of it all. In college, the brothels were a counterbalance to the performance of Black wealth he was living on campus. Chester's "Fake it 'til you make it" charade was cut short after he was expelled for taking some male and female classmates to a local brothel—where, unbeknownst to them, he had been regularly soliciting the services of a prostitute who believed she was dating the college lad.

African American boys like Chester, even those from the middle class, did not have the security of a Winthrop Rockefeller, who had been allowed to leave Yale "voluntarily" instead of being officially expelled for misbehavior (his parents were able to bury the specifics). Winthrop had dropped out of society and worked as a roughneck in the Texas oil fields, slumming it among the working poor. But because of his family's name and their money, he was able to reinvent himself as a liberal philanthropist and civil rights supporter who eventually became a governor. Meanwhile, after Himes's expulsion, he committed armed robbery to score cash and was eventually sent to prison. That realization of how race and class collided in a thunderstorm of systemic racism interrupted any dream of upward mobility Himes might have had.

Chester and Henry both wanted to be writers, but Chester's writing career took off first once he was released from prison, after serving an eight-year sentence. Henry was working for the federal government in Washington, DC, at the time. The two exchanged batches of stories they were working on. "I just wish I could get down to business like [Chester] has and work up a pile of manuscripts," Henry wrote to Mollie. "Some are good and others, only

mediocre, but the boy's got the stuff already." Despite any jealousy, Henry supported Chester's career and the Moons introduced him to their friends, people in the literary world, including Ralph Ellison, Richard Wright, and Langston Hughes (who had also attended high school in Cleveland). Henry and Mollie even took Chester in at the end of the war when he was nearly destitute. He lived with them until he won a Julius Rosenwald Fund fellowship for Negro authors in 1944. Mollie was good friends with the managers of the Rosenwald Foundation, which no doubt helped. *And how did he repay us?* Mollie likely thought. *By writing that damn book!*

Himes's astute critique of class politics and philanthropy in *Pinktoes* was filtered through his obsession with Mollie. Chester had always had a contentious relationship with Henry and Mollie. Chester felt like they—Mollie in particular—looked down on him. He secretly hated the way Mollie had been able to worm her way into white society, even though she occasionally exhibited the social mannerisms of the working-class South despite her best efforts to hide them. Chester had found some success with his first novel. But whenever he was mentioned, he was always identified as an ex-convict or a troubled street hustler. Some people deployed these terms as honorifics, ghetto credentials that made him a righteous social commentator.

Chester simply couldn't shake those labels. It would be easy to understand if Chester Himes, who had a vexed relationship with the Black and white upper classes, longed to reconnect with the boy he once was, who had shown so much promise. But being unable to shed his ex-con identity drew him closer to the Black working poor and the underground economy, even if that wasn't where he wanted to be or felt most comfortable. Chester was trapped in a no-man's-land that felt partly a reflection of systemic racism and

partly of his own making. Moving to Paris in the early 1950s helped to ease these feelings of shame and guilt. But it also gave him a safer distance from which to fantasize about his cousin's curvy, gorgeous wife. She became the fictional character he could lash out against, inflicting his own pain and ignominy upon her in ways he'd never dare do in real life.

Chester had first started writing about Mollie in the late 1940s, while he was crashing in the Moons' spare bedroom. Unbeknownst to them, Chester had been covertly studying the Moons and their friends like a cross between a gossip columnist and an amateur ethnographer. There is a Mollie figure in *Lonely Crusade* (1947), whom he also named Mamie. In *The Primitive* (1955), written in Paris, Himes fleshed out the Mollie-inspired character more fully, unleashing his anger upon her. Here she was named Maud, which Chester perhaps intentionally chose because it rhymes with "bawd" (or *baud* in French)—a word meaning a madam or brothel owner. Chester refers to Maud as a "bitch," "whore," and "madame." She is a "cheat, liar, thief, master of intrigue, without conscience or scruples, and respectable too." Maud's respectability makes her dangerous; it gives her entrée into rarefied spaces where she can manipulate the white elite. "Here's a whore who's friend of the mighty, lunches with the Mayor's wife, entertains the rich, the very rich, the Rocke-fellers, on all kinds of interracial committees, a great Negro social leader."

Himes also penned disparaging characters based on Mollie's good friends Alta Douglas and Juanita Miller. Chester's wife at the time, Jean, adored the polished and refined Juanita. She had helped Jean get a well-paid job and had ushered Jean into Los Angeles society, which made Chester dislike Juanita all the more. It was rumored that some of the other characters in *Pinktoes* were based

upon Walter White, Paul Robeson, Lester Granger, E. Franklin Frazier, and St. Clair Drake. And the naïve artist character, Julius Mason, was based on Chester himself.

But his writings about Mollie, particularly as Maud, were especially visceral. Chester had dated a woman named Maude shortly after he dropped out of college. The real-life Maude, like Mollie, was a light-complexioned woman of low birth from the South. Himes had impregnated Maude and then abandoned her, an act he could never forgive himself for. Giving a character the physical features and social status of his cousin's wife and naming that character after a woman with whom he'd been sexually intimate allowed Chester to imagine what it would be like to have sex with Mollie. Thus, Maud the character became a surrogate through which Himes could take out his sexual frustrations on Mollie and women like her. These bourgeois women, he believed, would never see him as anything more than a thug who was good with a pen. Himes used the fictional Maud to exorcize his demons surrounding his treatment of the real Maude. Writing these fictitious versions of Mollie might have been therapeutic for Himes, but they certainly damaged Mollie's reputation.

When Himes came up with the idea of writing about philanthropists and race leaders who moved through Mollie and Henry's parties, he thought the madam-trick-hooker paradigm was a perfect analogy. The madam or pimp was at the top. The "trick" or "john" was in the middle, being taken advantage of financially while still having the money to call some shots. The prostitute was the most vulnerable and exploited person. Chester saw the transactions at the Moons' parties as predatory and exploitative in a similar way. He abhorred the politics of these monied do-gooders and the Black pimps who pointed them to people and causes to sup-

port in order to help solve the race problem. In Himes's depiction of this swirly game of vice and giving, everyday Black Americans were the only ones getting screwed.

Chester knew *Pinktoes* would draw the ire of Black society. In a letter to photographer, writer, and arts patron Carl Van Vechten—whom, ironically, Himes met through Mollie—Himes admitted that he knew the pieces he'd been writing about the Black elite would be "repugnant to those Negroes who define their progress in terms of their similarity to upper-class whites." Himes had been sending Van Vechten early drafts of what would become *Pinktoes*. Van Vechten, whose own novel, *Nigger Heaven* (1926), had made him a polarizing figure in Black and white communities, thought the pages Himes had sent him were disgusting. His reaction was so stark that Himes felt compelled to apologize, explaining that his own callousness often blinded him to when his portrayals of retributive rape and other forms of violence crossed the line between entertainment and unacceptability.

* * *

In 1965, *Pinktoes* was dropped into the middle of a racial powder keg. The media had a field day promoting the book. *Variety* announced in its chatter column on the publishing industry that Himes's book on "interracial togetherness and sexual integration" would soon hit US bookstores. The *New York Times* promised readers that, since it was a reissue of an Olympia book, "sex isn't lacking." In other words, the mainstream press was hyping *Pinktoes* as a juicy, interracial, erotic page-turner. The book played into the panic around interracial sex and mixed-race children, which was still the third rail of race relations, a topic so controversial that

most opted to not touch it. But here was Himes lewdly provoking white Americans—who tacitly were still bemoaning how they'd lost legal and de facto control over Black women's bodies after emancipation—with a Negress who was not only screwing white men of her own volition but enticing sexually repressed rich white women to fuck Black men as well.

All of this salacious publicity was drumming up potential sales. As its publishers had hoped, *Pinktoes* was praised by a cross section of literary critics. George Schuyler, the former socialist who had become a supporter of the right wing, wrote in the *Pittsburgh Courier* that *Pinktoes* was "a hilarious tour de force on the ramifications of the civil rights cause where those who seek to save the race, do so mostly in bed." Literary critic James Bannerman, writing for the Toronto-based *Maclean's* magazine, recommended *Pinktoes* to his readers because a Negro author was writing about upper-middle-class Negroes—a group that was usually never the topic of novels—with "a truly fascinating blend of triviality, sexuality, and honest bad taste." By the fall of 1966, more than a year after its initial US publication date, *Pinktoes* was still number eight on the *Chicago Tribune's* bestsellers list.

The publishing industry was profiting from dissension within the Civil Rights Movement. Mollie Moon, who was never as visible as Whitney Young or Martin Luther King Jr., became the punching bag for everything that was wrong with interracialism and liberalism, though she would never have the same public platform to defend herself as these men had. Sure, there were criticisms of Young and Wilkins, but those were political critiques that remained at an intellectual level, involving debates over strategy.

The vitriol against Mollie was hypersexualized. It is difficult to say whether *Pinktoes* made people start thinking of Mollie as

a madam, but it definitely cemented the idea for any reader who could identify the thinly veiled character in the book. Her body and her gastronomic and sexual appetites—at least in this male fantasy—were symbolic of her problematic racial politics. To them, she was rotten to the core, and moral corruption could not be fixed by a change in ideology.

Even if readers believed every word of Himes's fictional account, the events satirized in *Pinktoes* were drawn from the late 1940s. *Pinktoes* didn't hit US bookstores until twenty years after Himes had lived with the Moons. Still, the fictional account of Mollie's younger life that Himes had painted became mapped upon her present-day life, as if it were her current reality. Present-day Mollie—who was nearing sixty—was now an amalgam of the wanton images people had been projecting upon her sexualized body for decades: jezebel, old bawd, bed wench. It was symbolic of how slavery had marked Black women as inherently lustful, while their status as chattel property rendered them less than human. It had real implications in everyday life.

White women got to age into dignified grand dames. For many white folks, Mollie would always be seen as performing in a sexual manner inappropriate for her age. It didn't help that photographs of her in the curve-hugging costumes she wore to galas in the 1940s and 1950s were still circulating in newspapers and magazines. A person who did not encounter her in daily life would have believed this simulacrum of images was an accurate, present-day representation, making tales of her sexual voraciousness seem all the more believable.

Josephine Baker experienced a similar kind of perpetual sexualization. Baker, who was Mollie's age, was still discussed and fantasized about—until she was well into her sixties—as the leggy siren

who performed topless in a banana skirt. Even today, such images of her remain the most widely circulated, keeping her visually imprisoned in her twenties. Wearing her official French military uniform was Baker's attempt at countering this image. Other Black women, including Eartha Kitt, Tina Turner, and Pam Grier, also experienced this enduring sexualization.

But they were all entertainers. Mollie was not. She was a civic leader and professional African American woman, and she wanted to be treated with the respect she had earned. Intellectuals and activists such as Anna Julia Cooper had been fighting since the nineteenth century for African American women to be seen as morally upstanding mothers who passed down the wisdom of mature womanhood to their daughters, not as bawds who corrupted them.

Breathless coverage in the Negro press of Mollie and Henry's seemingly exorbitant lifestyle on civil servant salaries didn't help matters. They sent their daughter, Mollie Lee, to an exclusive New England boarding school for girls, where some of her classmates were celebrities' children. She likely received a generous financial aid package, especially because her parents were civil rights leaders, but it still smelled of privilege. In 1963, when she was sixteen, the Black press reported that Mollie Lee was studying at the Alliance Française, affiliated with the University of Paris, where she was living with a "very wealthy" French family. This finishing-school experience was part of young Mollie Lee's introduction to high society. In 1965, the Black press reported on the "blowout" debutante party Mollie and Henry hosted for Mollie Lee, with three hundred guests in the East Suite of the New York Hilton hotel, which reportedly cost the family $40,000.

A few years later, when Mollie was asked to comment on

Eartha Kitt's protest against the Vietnam War and poverty in the Black community while an invited guest of "Lady Bird" Johnson at the White House, Mollie replied: "Miss Kitt, of course, is entitled to her opinion and to the free expression of it. However, it seems that with her commitment, she might well have declined the invitation to attend the White House luncheon as have others who strongly disagree with Administration policy." This statement led coverage in the *Amsterdam News*. Young Black radicals, who praised Kitt's confrontational message, would have deemed Mollie's stance moderate and accommodationist. Her public behavior seemed to confirm much of what came to the surface once *Pinktoes* was published stateside.

* * *

The kind of toxic masculinity Mollie encountered in the aftermath of *Pinktoes* mirrored some of the gender dynamics within the National Urban League, and Black women with influence were beginning to call it out. In Whitney Young's matrix, Black women whom he deemed worthy could play a role, but never a leading one. The most outspoken person on the matter was Pauli Murray, the brilliant gender-nonconforming lawyer and activist who had come of age with Mollie Moon and the other young Black radicals during the Great Depression.

One of Pauli's earliest jobs was as a field representative for the National Urban League's *Opportunity* magazine. Pauli was supervised by Lester Granger, whom Pauli described as "one of those rare human beings" who "inspired total devotion." Granger allowed Pauli to use their own "imagination and initiative." The two could debate and disagree about the political and social issues of the

day, and Pauli could trust that it would never interfere with their mutual respect. It was this peer relationship with Granger that had kept Pauli committed to the League over the decades. Lester Granger's gender politics were not perfect, but he was far less paternalistic than most men of his generation, not leading with a politics that relegated women to particular roles. It's why he and Mollie had worked so well together all those years.

Pauli could see the shift when Whitney Young directed the NUL. Whitney, Pauli believed, was a sexist whose animosity toward assertive women was fueled by his own outsize ego. Pauli and Whitney engaged in public debates about the role of women in the movement, pushing Whitney and the other male leaders of the Big Six to see that it was not enough to have Black women, like Dorothy Height and Anna Arnold Hedgeman, in the room if they could not speak or had no power to make change. Whitney had to concede that his adherence to traditional gender roles could be a problem, even for the women he believed he had elevated to leadership positions. Perhaps because Pauli Murray was queer and was not wedded to the politics of femininity and desirability that Mollie and other African American women in the League were, Pauli could critique this system of gender oppression directly. By contrast, Mollie and other women had to work behind the scenes, making small and calculated pushes against sexism.

In 1966, however, Mollie made a decision that would blow the lid off the League and its gender and sexual politics. Whitney Young did not see it coming.

CHAPTER 16

A Reckoning

New York City, 1966

"Many socialites and civic activists are reeling from the dizzying effects generated by a $1,000,000 libel and defamation of character suit brought Tuesday against wealthy and affluent Mrs. Sophia Yarnall Jacobs," an October 1966 *Afro-American* story read. Mollie could only imagine the looks on the faces of Black society when they learned that she was suing Sophia, a white woman of means and power, for defamation. Two of the most visible women in New York's high society, both connected to the Urban League, were about to duke it out in court. Reputations were on the line, as well as nearly $10 million in today's figures. Black newspapers and magazines across the country picked up

the story, and in some cities it was front-page news. *What in the hell is going on behind the scenes?* Many readers, especially those who followed the society columns as religiously as *Days of Our Lives*, were itching to know.

Mollie's attorney had asked her on several occasions if she was sure she wanted to go through with her suit against one of the most influential white women on the East Coast. "Sophy," as her friends and family called her, was born into a wealthy Pennsylvania family of coal barons in 1902. She inherited a fortune before marrying Reginald Robert Jacobs, a prominent Philadelphia banker. In 1954, the divorced mother of two moved to New York City, where she became involved in various liberal causes. Her largesse made her instantly popular. Sophia was chosen to become president of the Greater New York Urban League affiliate in 1955, a move that likely would have offended the Black women who had been toiling in the organization for decades. She was deeply connected with the League. As New York League president, Sophia was on the subcommittee of the secret Urban League Fund in the 1950s, when even the most high-ranking Leaguers were unaware of its existence. She held that office until 1960 but remained on the National Urban League's board of trustees for decades. Sophia was also president of the National Council of Women, the oldest non-sectarian women's organization in the country, from 1960 to 1963.

Sophia Jacobs was a true New York power broker, an insider, a do-gooder white woman in her mid-sixties, just a few years older than Mollie. Mollie and Sophia had worked together countless times during the more than twenty years Mollie had been associated with the NUL. In fact, Sophia had been on the sponsoring committee of the Beaux Arts Ball earlier in 1966, along with Dr. Ralph Bunche, Shelley Winters, Rodman Rockefeller, and Duke Ellington.

Mollie was undaunted by Sophia's titles, money, and powerful friends. She had consulted with Henry, who was still the NAACP public relations director, because his reputation was also affected by the alleged claims in the lawsuit. The Moons had agreed; they would move forward with the suit. According to the media coverage, which drew on documents filed with the New York County Supreme Court, Mollie stated she was told by several people at the 1966 National Urban League annual conference in Philadelphia that Sophia had said, "Mollie's main function [is] to ride around in big cars and provide liquor and women to the executives of the Urban League program." Sophia allegedly added that Mollie "tries to see how many men she can seduce." Mollie argued that Sophia's words "were intended to mean a woman of loose moral character" who attempted to "entrap the male friends and husbands of other women" in the "crimes of adultery and fornication." Mollie stated that Sophia's "false and defamatory" remarks "injured her good name and reputation, and subjected her to great shame, disgrace, and humiliation."

Sexual mores were changing in the late 1960s, but Black women who were not morally respectable were still ridiculed by members of their race and targeted by the racist and sexist stereotype of the wanton jezebel that circulated among white folks. Women of Mollie's generation had been raised on the notion that sexual propriety was key to their very survival, as well as their social and professional reputation. But Mollie's reputation had long been threatened by attacks against her character. Many women and men in and beyond high society believed the portrayal in Chester Himes's *Pinktoes*, that Mollie was a habitual cheater and temptress.

By the time of the lawsuit, the rumors of Mollie Moon's alleged affair with Winthrop Rockefeller back in the late 1940s had

reached such mythic proportions that a younger generation was now linking her to Winthrop's younger brother, David Rockefeller, who was still living in New York after Winthrop had left for Arkansas a decade earlier.

Mollie's waning power in the League also meant that she was losing sway with the NUL's high-society supporters. She had guarded these networks fiercely, never tapping the well of favors too often on behalf of random Negroes who had begged her to make introductions and intercessions. Doing so, she thought, would always keep her in good stead with the white elite. But now she was constantly being reminded of how easy it was even for white liberals to cast her aside. It might help to explain why an African American woman who had been at the center of messy society chatter for the past thirty years had now decided to sue a white woman who had higher status within the League and more social power than she. African American women were socialized to bite their tongues and not air people's dirty linen in public, especially when doing so would soil their own good name.

Black women always had to be cognizant of their reputation. In contrast, white civic leaders such as NUL trustee Marietta Tree could have affairs openly and use their relationships with prominent political figures to move up within the Democratic Party. Tree's intimacy with Adlai Stevenson, then the United States ambassador to the United Nations, had helped her to get appointed as US representative to the UN Commission on Human Rights during the Kennedy years. Black women could not leverage sex to gain opportunities ordinarily denied women in the ways white women could, though some might argue that Mollie had more chances than most. And now that her daughter,

Mollie Lee, was married and a mother, Mollie was perhaps more concerned with protecting her reputation. She would not have wanted Mollie Lee to be hurt or degraded by the slurs against her.

Still, it was not as if Sophia Yarnall Jacobs had made these claims in *public*, in a newspaper or magazine or during a speech. Thousands of people attended the Urban League national conference, but the NUL was its own insular world. Everyday people were not privy to the happenings at an NUL conference. So even if Sophia had made these remarks in front of a few Leaguers, they would not have become prominent news. This suggests that Mollie was instigating something a bit more calculated.

Sure, Mollie was part of a long line of African-descended women who'd had to defend their sexuality in public. But Mollie was also a strategic public relations professional who understood the power of a lawsuit and of the press. She would use the courts to defend the reputation and advance the power of Black women. In this case, Mollie's goal would be to make a damning attack on the cronyism and sexism of Whitney Young's Urban League and expose white women's complicity.

When Whitney had rebranded the League, Sophia was one of the holdovers from the Granger era whom he'd chosen to keep around. It's no mystery why. She was certainly the prototypical rich and influential white liberal Whitney wanted on the board. Plus, Sophia knew where all the bodies were buried; her long institutional memory would be an asset. But Mollie being ousted from the inner circle of the NUL while Sophia remained was bound to cause tension.

Mollie and her Guild and Fleur Cowles and the Women's Division had a similar beef. Competition had fostered Cold War

conditions between the two factions. Mollie did not always play well with white women, especially white women whom the Black men in leadership had elevated into positions of power over her. Behind their genteel manners, they committed quiet micro-aggressions against Mollie and other Black women. For too many white women, supporting civil rights did not mean allying with Black women. In fact, it might have seemed to Mollie that being favored by Black male leaders made white women like Sophia feel as though they could sidestep Black women altogether. Perhaps they saw Black women as mere bit players in the fight for racial equality whom even Black men did not fully respect. Mollie preferred white women who were not seeking validation from Black men. Whatever else could be said about Marietta Tree, Mollie and Marietta always got along well. Marietta never tried to step on Mollie's toes or demean her.

Perhaps what rankled Mollie most was the way that Sophia, a white woman born to wealth who also married money, had diminished Mollie's role to that of a madam who procured pliable, loose women and booze for high-ranking men of the League. It reeked from the stench of every sexualized racial slur that had been used against Black woman by white women as well as both Black and white men. On the one hand, Sophia had been implying that Mollie was an old bawd, a brothel owner who was not only corrupt but also exploited younger women. On the other, Sophia's alleged statement that Mollie was still trying to seduce men at her advanced age had made her even more pathetic because she refused to accept the fact that no one saw her as desirable anymore.

Sophia's smear implied that Mollie was no longer a key power player in the NUL; the men had relegated her to the role of procuress because they didn't want to be "in bed" with her politically.

White women like Sophia and Dorothy Hirshon, a millionairess, philanthropist, and art collector who had replaced Mollie on the NUL executive board, would always have a seat at the table because of their generational wealth. Their money gave them power and access, which would serve them long after their beauty faded. This disparity likely lacerated Mollie to the bone. She had tolerated the sexism of Black men within the movement, who often did not take Black women seriously despite the smarts and leadership skills that made their work essential. Because they did not have the money a woman like Sophia had, they were often marginalized, seen as helpmates and hostesses. Mollie and the Guild had long fought this male disregard. And yet here was Sophia Yarnall Jacobs, who purported to be a friend to the race, perpetuating this racist and sexist rhetoric.

Sophia's animosity exposed the flaws in the emerging women's liberation movement, which wanted to paint a picture of sisterhood among women of different races and classes. If Whitney Young did not stop Sophy from spreading scurrilous gossip, even to defend himself and other male NUL leaders from her allegations of their own bad behavior, then Mollie would sue to protect herself and make sure the entire African American world knew what was going on.

It was a power play.

Mollie would show that despite Young's sidelining her, she still had social influence. And African Americans would make such a stink about Sophia Yarnall Jacobs and her remarks, which were an assault on all Black women everywhere, that Young would have to do something about it.

Whitney Young was likely pissed off when word of the impending lawsuit landed on his desk. And the fact that stories in the

Black press—in Norfolk, Virginia; Philadelphia; Cleveland; and Baltimore—had dropped on the same day, with almost the same quotes, suggested to him that Mollie and her attorney had made a concerted effort to leak the story to the National Negro Publishers Association, the Black equivalent of the Associated Press. Young, like most leaders, never wanted news of major discord within his organization to appear in the press, especially when resistance to the NUL was at a high. Young militants, like those in the Student Nonviolent Coordinating Committee, had started chanting, "Black Power," and disavowing interracial activism, and even moving from nonviolent protest to armed resistance when they came under attack from police officers and white vigilantes. An implosion among its women was the last thing the League needed.

Young pondered what he should do and consulted with trusted advisers. After all, the suit was a civil matter. Young and his PR staff thought it prudent to refrain from making any statement on behalf of the League. Doing so would only add fuel to the flames. Moreover, their only option would be to release a mealymouthed response that did not take sides, not even to deny the allegations of immoral conduct by its male leadership. If the League dared to side with a white woman donor over a Black woman leader at this pivotal moment of Black revolt, they would look like race traitors. Teenaged radicals had already started referring to Young as "Uncle Whitney," "Whitey Young," or "the Oreo cookie," all pejoratives that signified he was a sellout, a puppet of the white man who stood in the way of his own people.

Young understood that he would look like a hypocrite if he dared castigate Mollie for any perceived indiscretions. He himself was rumored to be a womanizer. Mollie had alerted the selection committee to this innuendo before he was elected League execu-

tive director, though they almost certainly had already been aware of these stories. But once Young became head of the NUL, rumors of his numerous extramarital affairs were hotly discussed. Young frequently traveled on NUL business, sometimes to multiple cities in a single day on extended trips, where he regularly encountered new and intriguing women of all races, occupations, and class statuses. Some of his affairs were brief sexual liaisons, others long-term romantic connections. "He loved to be lionized," his elder daughter said of her father. His younger daughter, who had a much more contentious relationship with him, described him as "like a puppy who needed people around to pat him on the head and tell him he was great."

Whitney's emotional neediness caused him to get so caught up in his entanglements with other women that he neglected his home life. Margaret Young had likely long ago accepted that marrying a man like Whitney meant her husband would have some affairs, but she resented the loneliness and isolation when Whitney was constantly on the road. He was off experiencing the life he had always dreamed of, while she stayed home and tended to her motherly duties. She was essentially a single mother with an absent husband. Nonetheless, Margaret was expected to bolster Whitney's image as a major civil rights leader. The more she pressed for a deeper commitment to their marriage, the more Whitney allegedly found refuge with women he met on the road. It was even said that he would mock his wife and their marital tensions during NUL events.

But, while Mollie's perceived infidelities brought shame on her marriage, Young's brought power to his image. Young was not a proponent of the burgeoning Black Power movement. But some men within the League saw Young's ability to seduce white women

as a sign of his masculine charisma. He was a sexual renegade, in ways that conjured up images of the Blaxploitation films that soon appeared in popular culture. His confidence in his ability to bed any white woman he encountered became part of his persona. He would joke and brag about his sexual conquests with women, who were often active in the League. One Leaguer remembers Young being surrounded by a group of attractive white women at a NUL conference. Young wrapped his thick arms around the women and looked over at his mentor and high-ranking white League leader Lindsley F. Kimball and said: "This is black power!" Young was asserting himself as a virile race man who could not be stopped.

That Whitney Young could get away with making such egregious statements while still being protected by his League sycophants likely turned Mollie's stomach. Meanwhile Mollie was often hung out to dry. Earlier in her career with the League, Mollie leaned into the role of a hostess who understood what men wanted. Fetching things for men, not blinking an eye in judgment of their vices, and keeping them satisfied allowed Mollie to gain their trust and to make political maneuvers when the time called for them.

Mollie did not have to operate this way with Lester Granger, whose gender politics were more progressive. But with the retrograde men in the political arena, business magnates, and publishing giants, she had learned to slip into the character she had created during her days as a hostess in the Berlin cabaret in the 1930s, when she had dressed up as "Mona, the Indian Girl." Mollie was such a formidable figure that she could have been a political leader if she had been born a generation or two later. She had the intellectual chops and the charisma. Instead, she had to mold herself into this role if she wanted a modicum of power. She was

bound by the limited possibilities afforded her race and gender. But she was no one's madam.

NUL leadership knew they needed to swiftly resolve the lawsuit that Mollie had filed against Sophia Yarnall Jacobs. Mollie was not suing Sophia because she was an easier target than the men of the League. She had real gripes with her and other white women of her ilk. She could make a larger statement of her own about the failures of interracialism and the limits of solidarity between Black and white women by suing Sophia. Mollie Moon was "absolutely determined to put to lie any notion that Black women didn't have every bit as much dignity and class and accomplishment as white women," said her godson Richard P. Bourne-Vanneck.

At the same time, she could use the lawsuit to force the NUL to reckon with all the ways it had marginalized her over the past few years. Mollie may well have felt that she had become the target of criticisms that should have been directed at more powerful men. Including Sophia's alleged claims about the NUL's male leadership in her lawsuit showed that even powerful white women within the organization saw them as corrupt profligates. Mollie would use Sophy's alleged statement against her to bring the entire house of the National Urban League down from the inside. It was akin to pouring gasoline on your own house, striking a match, and watching it go up in flames.

Sure, Mollie would likely get singed by the conflagration, but she would not be consumed by it. Her strategic act expressed how fed up she had become with the male-led leadership that disposed of African American women as it wished. As a nearly sixty-year-old woman and grandmother who had managed a long and successful career as a social worker and civic leader, Mollie likely felt she had nothing to lose by being deemed a social arsonist.

Mollie's experiences had attuned her to what her comrade Pauli Murray had aptly named Jane Crow, the specific form of discrimination that African American women faced due to the multipliable factors of race and gender and the ways they become codified in the law and other socioeconomic policies. This lawsuit was Mollie's attack against the dual punch of sex and power that was common within the Urban League and other similar organizations. The remedy to patriarchal domination bolstered by racism that Mollie was calling out would have to be one in which she was made whole for what she had endured, a sort of social and political reparations. While she was asking for nearly $10 million in today's figures, did she truly want the money? It is unclear if she did. But it seems like the lawsuit was about more than a monetary payoff.

From Sophia's vantage point, she likely felt there was no way she was going to pay Mollie Moon that much money, but she also understood that her own bona fides as a good white liberal were in question if she took the matter to court instead of reaching some sort of settlement.

No doubt there was pressure behind the scenes to get Mollie and Sophia to settle out of court. The case made the NUL look like a band of wealthy white and Black elites who were fussing over rich people's problems while the ordinary Black people they were claiming to help struggled with real issues. They seemed out of touch. Perhaps the lawsuit was the only way Mollie felt she could protect herself and redeem her public image. The irony of it all, of course, was that so many people—men within the NUL included—had praised Mollie for bringing a lawsuit, and winning, against The Pierre hotel for racial discrimination in 1952, after the staff had denied her rooftop garden booking, and against the New York City cab company that had refused to drive her and

Mollie Lee to Queens. The Black press had deemed her militant back then.

That same savvy and fearlessness she had acquired in dealing with the US court system paved the way for her lawsuit against Sophia Yarnall Jacobs. Now some of these same people saw her action as a scorched-earth maneuver. That interpretation was reductive. Sure, Mollie had endured many injustices due to her race and gender—from surviving the horrors of Jim Crow Mississippi as a teen to getting dragged through the mud by the *Chicago Defender* for allegedly cheating on her first husband. And these encounters had steeled her in ways that some might have thought left her jaded. It did not help that Mollie's mother, Beulah Rodgers Lewis, had been suffering from a lingering heart condition. Mollie was making regular trips to Detroit to tend to her mother's needs. Yet, despite all those considerations, Mollie's lawsuit was a rational act.

The Black press reported in February 1967 that the case between Mollie Moon and Sophia Yarnall Jacobs had been settled out of court. It might have seemed like an anticlimactic conclusion to a lawsuit that had been the source of much fodder. But for Mollie, it had been a true victory—just as much, if not more so, as her lawsuit against The Pierre—because it was about reclaiming her dignity. The Cleveland *Call and Post* stated that one term of the settlement had been that Mollie would receive a letter of apology from Sophia.

In true Mollie fashion, she leaked bits of Sophia's apology to Black newspapers across the country. In it, Sophia did not deny making the remarks. Instead, she said her words were "misconstrued." Her intentions had been to say something "complimentary" about Mollie and her attractiveness, which shows that Sophy felt the entire

lawsuit was really about Mollie being offended that she'd called her old and unsexy. Nothing about the conduct of the League's male leaders was mentioned, which probably satisfied Young and his interests. But Mollie and many others within the African American community considered Sophia's public apology—no matter how trifling it was—a victory for its time. Mollie had proven that a Black woman could demand the same standard of treatment as a white woman.

* * *

Whatever feelings of joy Mollie might have derived from Sophia's public retribution were tempered when, that August, she received word that her mother, Beulah, had died in Detroit's Grace Hospital. Mollie had lost her rock.

As the turbulent summer of 1967 approached and bled into the even more volatile year of 1968, the social fireworks sparked by Mollie's lawsuit against Sophia Yarnall Jacobs were all but forgotten. Many middle-class Black Americans were going through what they deemed a "mental revolution," unlearning white, capitalist ideas and European standards of beauty, aligning themselves with the Black Power movement's call for economic justice and aesthetic redefinition. Dr. King's assassination at the Lorraine Motel in Memphis on April 4, followed by Senator Robert F. Kennedy's assassination at the Ambassador Hotel in Los Angeles on June 5, brought the movement to a preternatural standstill before unleashing a series of uprisings that rippled across the country. Whitney Young and Roy Wilkins, too, had been the targets of a thwarted assassination attempt that was allegedly plotted by the Revolutionary Action Move-

ment, but could have very well been coordinated by the FBI's COINTELPRO.

Young ended up dying in a far more mysterious way. In 1971, while on a race relations trip to Lagos, Nigeria, a fatigued and chronically ill Whitney Young drowned in a freak accident at Lighthouse Beach. The death raised many unsatisfactory questions for people within the movement who believed it could have been part of a CIA plot to assassinate Young at the height of his power. As Mollie paid her respects to Whitney Young and his wife, Margaret, and their two daughters, she could not help but reflect upon just how much death she had seen during this long Civil Rights Movement. The loss of lives, the death of social reputations, visions of freedom that had died on the vine were all engrained in her memory.

Lester Granger was still alive, but Mollie had outlasted him in the National Urban League. And now she had outlived the much younger Whitney Young. As the NUL moved into a new era, under the leadership of Young's successor, Vernon Jordan, Mollie would be one of the few from what Pauli Murray called the Depression Generation left at the League to tell its story. And as the keeper of the institutional memory, Mollie would have the opportunity to profoundly shape how that story, and her own, was told.

CONCLUSION

———

In 1989, a year before Mollie Moon's death, the National Urban League finally honored her properly by creating the Mollie Moon Volunteer Service Award. Mollie's good friend and Guild comrade Helen Harden received the inaugural award for her four decades of service to the League. At the ceremony, Mollie gave a speech. Without mincing words, she declared: "The Guild has given the League, over a period of years, a million dollars, free and unrestricted." The National Urban League Guild and the National Council of Urban League Guilds did not impose the kinds of restrictions and stipulations many of the major white philanthropies did, whose dollars the NUL both coveted and boasted about publicly. The Guild's money came primarily from Black donors. The League had never fully valued this grassroots support. Mollie took her and Helen's moment to praise the Black folks who had given to the League out of pure generosity, which was part of the African American giving tradition. Soon after, New York's newly appointed mayor, David Dinkins—the city's first Black mayor—presented Mollie with the President's Volunteer Action Award on behalf of President George H. W. Bush.

This reclamation and celebration of Mollie happened because

of Black women. In the early 1970s, when it was clear that yet
another NUL leader was going to keep Mollie on the sideline, a
younger generation of Black women journalists pushed back. In
1972, Mollie sat in the audience at the 31st annual Beaux Arts Ball,
adorned in a hot-pink and gold-brocade Indian silk gown. She was
approaching sixty-five and was still topping Black New York's best-
dressed lists. Society writers, most of them now decades her junior,
dubbed her "the doyen of sophisticated New York" and a "society
dictator," which spoke to her sustained social power over the past
thirty years. That year's ball was a tribute to the 1930s, and special
guest Cab Calloway regaled attendees with stories about the hey-
day of big-band jazz. The ball was also Black society's introduction
to Vernon Jordan, the newly appointed executive director of the
National Urban League, who had assumed the role after Whitney
Young's untimely death in 1971.

After Jordan spoke, several other men paraded across the stage,
sharing their vision for the League, telling jokes, and giving warm
welcomes to the crowd. Every prominent man in the League, it
seemed, had been invited to speak. But Mollie was passed over, even
though she had founded the Beaux Arts Ball annual fundraiser
and had tirelessly organized this event. But this time, in contrast
to the situation under Whitney Young, when Mollie was margin-
alized, there was an uproar from Mollie's old and new friends, as
well as a younger generation of Black civic leaders. They would no
longer stand by while a Black woman who'd done all the work was
sidelined by the Black men who claimed all the credit and glory.

Writing in her *Amsterdam News* column, Sara Speaking,
journalist Sara Slack called out Jordan and longtime Beaux Arts
Ball emcee Dick Campbell for their shortsightedness. "Legions" of
Mollie's friends are still "seething and seeing red" after they "gave

the mic to everyone" but Mollie. The ball had been Mollie's "brain-child from away back," and most of the people in the room would not have shown up had it not been for Mollie's innovations in African American philanthropy. Throwing even more shade at the NUL leaders, Slack remarked pointedly that a group of women were planning a luncheon to honor "marvelous Mollie" where "she will be permitted to bring her greetings too."

Just like that, Black women had thrown down the gauntlet and shamed the NUL's male leaders for their treatment of Mollie Moon, reminding them of the group's history and forcing them to reassess how it told the story of the NUL in the mid-twentieth century. Without this push, NUL leaders might have continued to tell a Whitney Young–centered story that gave him all the praise, as they created awards and gave medals in his honor. Now they'd have to invest time and energy in promoting the history of the National Urban League Guild, the Council, and Mollie Moon herself.

In part, this push by younger Black women civic leaders to center on Mollie and pay tribute to her trailblazing career was typical of the ways that a younger generation reaches back to claim their foremothers and forefathers. But it was also a sign of the power of the burgeoning Women's Rights Movement, when women activists were refusing to take a back seat to men as their mothers and grandmothers had done. More still, it reflected the groundwork and goodwill Mollie had generated in the last decade. Once it was clear that she would never have the kind of leadership position in Whitney Young's NUL that she'd had when her friend and collaborator Lester Granger was at the helm, Mollie set about claiming her own social and political terrain. She had dedicated her life to the Urban League, and her name was synonymous with it.

However, Mollie had also started to commit herself to other

organizations, reactivating her membership with Alpha Kappa Alpha sorority and becoming one of the first members of the Coalition of 100 Black Women. The Coalition was founded in New York City in 1970 and had a similar civic-minded volunteer thrust as the Guild and The Links, Inc. When the organization went national in 1981, Mollie joined its board of directors. She aligned herself with two major Black women's organizations with a strong base of power brokers in New York City. They gave of their time and money to organizations such as the NUL and the NAACP. And with that alliance, they could push collectively against the patriarchy of the two major civil rights organizations. In other words, Mollie had cast her lot with Black women, and they came through for her in ways no one else would.

Even after Mollie retired from the Department of Welfare and Henry from the NAACP in the early 1970s, she remained heavily involved in New York civic life. Mollie and Henry traveled extensively across the country and internationally, both for business and for pleasure. Vacations such as a three-week African safari were refreshing for two people who had worked hard their entire adult lives. But they were also called upon as elder freedom fighters to represent the movement. In 1972, for example, they traveled to Egypt as tourists and then to Addis Ababa, Ethiopia, at the behest of the US ambassador to Ethiopia, to attend a reception. Mollie was invited to sit at the otherwise all-white and mostly male dais. Back in New York, she was appointed to the advisory council of the Food and Drug Administration (in part because she had kept her pharmacy license current her entire career, even though she hadn't practiced pharmacy since the 1930s). She joined the board of the Dance Theatre of Harlem. She was also still the president of the National Urban League Guild and, well into the 1980s, played

a major role in planning each year's Beaux Arts Ball and Ebony Fashion Fair. She was also committed to working with Catholic Charities, which served the poor regardless of their race or religion. Mollie had converted to Catholicism shortly after the birth of her godson, Richard P. Bourne-Vanneck, whose parents, Dick and Vicki Bourne-Vanneck, were devout Catholics.

Mollie continued these rigorous civic commitments until her death. Henry passed first, on June 7, 1985, at age eighty-four. One of the ways she and their friends commemorated her husband and continued his legacy was establishing the Henry Lee Moon Library and Civil Rights Archives, which was housed at NAACP headquarters in Baltimore. The largest single donation was in the amount of a quarter of a million dollars. Mollie lived for another five years. She and Henry had seen so much loss as their friends and comrades of the Depression Generation passed away. Langston Hughes, Loren Miller, and Augusta Savage all died during the 1960s. Ted Poston died in 1974, the same year Henry had retired from the NAACP. Gwendolyn Bennett died in 1981. Chester Himes passed in 1984, followed by Pauli Murray in 1985, and Romare Bearden and Juanita Miller in 1988. Even in her late seventies, Mollie found so much she still wanted to do, and she tried to do it all. She kept traveling and serving while being a grandmother to Mollie Lee's expanding brood.

Mollie passed away on June 24, 1990. She died of a heart attack in her Long Island City home at age eighty-two. At the time, NUL president and CEO John E. Jacob said in a statement: "Throughout her life, Mollie Moon built a legacy for us all. She was a woman of high principles and standards who set the pace for her generation and others to follow. We will remember her with gratitude and with love." The *New York Times*

obituary described her "dedicated and innovative volunteerism." That she, as well as Henry, was eulogized in the *Times* speaks to the Moons' prominence in New York City. Even in the 1990s, many Black luminaries as well as women of achievement were overlooked by the *Times*.

In true Mollie fashion, she planned her own memorial service, going so far as to keep a private journal that spelled out her wishes. She opted for a traditional Catholic service and viewing; her copper casket was covered in white orchids and surrounded by other all-white blossoms. A reception—or repast, as African Americans call it—followed at the Conrad Suite of the Waldorf Astoria. The Waldorf was perhaps Mollie's favorite hotel in the city, and moving the Beaux Arts Ball there in the 1950s had been a coup. At her repast, guests feasted on a lavish buffet and imported champagne—Mollie's favorite since her Moscow days. "Taste, class, style, sophisticated elegance," the *Amsterdam News* described it. "It was as she wished."

* * *

As I read the obituaries and retrospectives of Mollie's life, I considered the power of memory. How we choose to remember people, how we choose to forget, what we omit and distort. Mollie Moon had worked with the National Urban League long enough to see four eras of leadership: Lester Granger, Whitney Young, Vernon Jordan, and social worker John Edward Jacob, who succeeded Jordan in 1982. Still, she never received the recognition she deserved.

The Black women who reclaimed and amplified Mollie in the 1970s did so out of love and respect for their elder civic leader, a woman who they knew had been in the trenches for decades, while

men, particularly white men, claimed her only when it was politically expedient for them to do so.

But even in the proud reclaiming of Mollie came a sanitizing of her personal narrative. In this later telling of who she was and why she mattered, Black women in the press, and maybe even Mollie herself, emphasized the more respectable and socially acceptable parts of her biography. No one mentioned her work in the lesbian cabaret in Berlin or her time in Moscow and her adoption of communist principles, which informed Mollie's early political thought before the onset of the Cold War. Her previous two marriages and her vexed relationship with the press were omitted. Her militant actions, as well as her salacious moments, were left out of the story. Mollie's victory in her lawsuit against The Pierre was all but forgotten, and emphasis was placed on her crossing the color line by hosting a party at the Rockefellers' Rainbow Room in the late 1940s. All these distortions and omissions allowed Mollie's narrative to become one about the most important Black high-society socialite, not one of a civil rights era institution builder and architect of Black philanthropy.

Of course, the past is often sanitized and distorted to suit present-day purposes. But as a Black woman who studies the history of the Civil Rights Movement, I saw a larger problem with how we tell the history of this era. Over the years, the Civil Rights Movement and its key leaders have been reduced in one of two ways. They are used to create a feel-good moment of triumph for our nation, when the best promises of our democracy shone through—never mind the extreme violence and police repression or the centuries of institutional racism and white supremacy. Or they are held up as exemplars of a time when African Americans had self-respect and dignity: they dressed well, were polite, played

294 • TANISHA C. FORD

within the rules, and practiced nonviolence under all circumstances.

Depictions of well-dressed Black folks at the March on Washington symbolize this "right way" to do social justice work, and activists of today involved in the Movement for Black Lives are often considered irrational, without a coherent strategy legible to the white majority. I've heard the sentiment "Dr. Martin Luther King Jr. would disapprove" expressed countless times since 2012, from people of all races and social classes. The Civil Rights Movement has become crystalized in our collective and national consciousness as this ideal movement, led by principled, charismatic male leaders, that showed the power of racial liberalism and had real legislative victories. We do this to Black radicals as well, turning people like Malcolm X and Kwame Ture (formerly known as Stokely Carmichael), and even people who are still alive, like Assata Shakur and Angela Davis, into icons with perfect radical politics and bona fides.

Historians like me have been trying to disrupt this narrative, to show that movements then and now were never simple, never perfect, and never obedient. Even the beloved MLK was a disruptor, who espoused anti-capitalist, pro-worker politics toward the end of his short life. So by telling an unvarnished version of Mollie Moon's story, I've tried to complicate the stark divide we've created between the "moderates" and the "radicals" by offering a fuller picture of some of the economic stakes of the movement.

The story of the Civil Rights Movement can never be clean and tidy, because money and the pursuit of it is always a dirty, messy business. And the reality is that movements cost money. Freedom Rides, voter registration drives, and free breakfast and lunch programs for school children all cost money. Where that money comes

from matters. Even if the money is raised within the Black community, among working-class folks, so much of what we have been taught about the social and symbolic value of money, what it signifies in terms of our own socioeconomic status, has been shaped by Jim Crow logics of wealth and attainment. It's why millions of Black people in this country chase capitalism, believing that if we can simply have equal access to the marketplace, we can ascend to millionaire status. Or, on the radical end of the spectrum, we draw what we believe are clear lines concerning what is an acceptable amount of wealth and consumption for socialist servants of the people to attain versus what is wicked and conspicuous.

What I've tried to show in *Our Secret Society* is that none of these debates about how to raise money, from whom, for what causes, or what Black success looks like are new. They were just as virulently conflicted during the Civil Rights Movement as they are today. Attacks on certain Black organizations for their perceived misuse of donated funds were lobbed at the NAACP and the National Urban League—and even at Mollie Moon personally. If my saying this makes you think, *Well, damn, there are no easy solutions*, then that's good, because it's true. There are no easy solutions for a nation that was built on the backs of enslaved Black people, who were considered fungible goods when the contours of US democracy were defined. The best innovations in fundraising, grassroots philanthropy, and mutual aid come when we stop looking for simple solutions and work to organize and build as a community, with the most economically and socially marginalized communities at the vanguard of our movement. This is the heart of the Black organizing tradition.

ACKNOWLEDGMENTS

——

This book has been gestating for over a decade, which means there are many people to thank. I'd like to begin by thanking my four research assistants who were in the trenches with me, doing various tasks that helped make writing this book a lighter lift. Melay Araya, my brilliant Schomburg Center research assistant, thank you for tracking down hundreds of newspaper clippings and creating a digital archiving system to house them. Your method was the foundation for this book upon which everything else was built. Ray Self—you joined the project when I was most in need of support. Your organization, creative ideas, and work ethic were much appreciated. Thank you for helping me make it across the finish line. Big thank-yous also to Evan Rothman and Danielle Bennett for your support of this project.

The COVID-19 pandemic shut down archives for over a year, placing an extra burden on archivists and research librarians around the world. Thank you to the archivists who digitized manuscript collections for me, fielded my numerous emails, and processed photograph permissions. Special thank-yous to Bridgett Pride at the Schomburg Center for Research in Black Culture, Ann Sindelar at Western Reserve Historical Society, Lisa Moore

of Amistad Research Center, Sonja Woods at Moorland-Spingarn Research Center, and Bethany Antos at Rockefeller Archive Center. I must also thank the wonderful Stephen Fullwood (formerly of Schomburg Center) for setting me on the right path when *Our Secret Society* was more a notion than a book project.

This book has been well supported by several foundations and institutions. Thank you for believing in me and this project. A Schomburg Center Scholars-in-Residence Fellowship helped me think through the contours of what would become *Our Secret Society*. Big thank-yous to my cohort, which was led by the inimitable and always graceful Dr. Farah Jasmine Griffin. Harvard University's Radcliffe Institute for Advanced Study was a vital incubator for this project. It was here that I was able to begin analyzing my data while living among a supportive community of thinkers and practitioners at Radcliffe and at the Hutchins Center. Shoutouts to Ja'Tovia Gary, Kaitlyn Greenidge, E. J. Hill, Evie Shockley, Andre Carrington, Kinitra Brooks, Robert Reid Pharr, and Akua Naru. Thank you to Dr. Tomiko Brown-Nagin and the Radcliffe staff for curating such a wonderfully transformative year. To Alondra Nelson, Wendy Brown, Joan Wallach Scott, and Didier Fassin: Thank you for selecting me to be a member of the School of Social Sciences at the Institute for Advanced Study in Princeton, New Jersey. It was an intense year of reading, writing, and thinking about the seminar theme: "Political Mobilizations and Social Movements." And the woods of Princeton are such a lovely place to write. I appreciated every conversation I had with my colleagues, especially extended conversations with Keisha Blain, Zachariah Mamphilly, and Douglas Flowe. Thank you to New America and the Emerson Collective for selecting me to be a fellow in the class of 2023. Your support has enabled me to connect with communi-

ties beyond the academy while helping me develop the economic and policy elements of *Our Secret Society*. Special thank-yous to Awista Ayub, Sarah Baline, Paul E. Butler, Patrick D'Arcy, Amy Low, and Megan Dino.

Writing groups became even more essential during the pandemic. Special shout-out to all of my writing communities! Cheers to my "Second Bookers"—Robin Bernstein, Dana Sajdi, Cori Field, Katie Turk, and Malick Ghachem—and the great books and articles we've written and discussed together over the past five years. Erica Williams and Mariame Kaba: Thank you for allowing me to join your respective Zoom writing groups. The accountability was everything, especially once the writing fatigue got real. Special thank-yous to Dr. Tracy Denean Sharpley-Whiting and the staff at Vanderbilt University's Callie House Research Center for the Study of Global Black Cultures and Politics for inviting me to share early drafts of *Our Secret Society* at their "Works-in-Progress" writing retreat in Newport, Rhode Island. To my Black Women's Biography co-conspirator, Ashley Farmer, and all of the other Black women life writers I've connected with in the past year, including Anastasia Curwood and Shana Greene Benjamin: Thank you. I'm excited to build upon our bond.

My most sincere thanks to the people who were integral parts of *Our Secret Society's* invisible scaffolding—the people behind the scenes who believed in this project and helped me birth it. To my Amistad editor, Patrik Bass: Thank you for sharing my vision and trusting me to bring it forth. I adore you and our fabulous conversations. Francesca Walker, you are the glue that holds everything together! Thank you for your professionalism and organization. Thank-yous to Sarah Schoof (a wonderful surprise to work with you again), Amy Sather, Stephen Brayda, and the entire team at

Amistad/HarperCollins; you are truly top notch. Thank you, Rolisa Tutwyler and the CCMNT team. Big love to McKinnon Literary, especially my agent Tanya McKinnon, editorial director Carol Taylor, and my attorney, Sekou Campbell. You all help me make magic. Thank you for supporting and encouraging me ... and for keeping my money right, lol! Grey Osterud: You are my right hand. I appreciate you for being a coach, a trusted adviser, a brilliant historical mind, and a skilled developmental editor. Emma Young, my day one! Thank you for going on this journey of writing and ideas with me for over a decade. You've become a special friend. Jenn Baker: Your insights were right on time. I learned so much from you. I believe this is the start of a special relationship. Allie Lehman, Gretchen Crary, and Linda Fleming, you are essential; thank you.

Colleagues and friends have shown love to me and this project over the years. Thank you to everyone who has read drafts, offered feedback, paneled with me, served as a sounding board, or listened to me vent. Special love to Siobhan Carter-David, Sherry Johnson, Naaborko Sackeyfio-Lenoch, Phyllis Hill, Robin Brooks, Brittney Cooper, Treva Lindsey, Jessica Marie Johnson, Sophia Chang, Amrita Chakrabarti Myers, Claude Clegg, Matthew Guterl, Khalil Muhammad, Barbara Ransby, Tiya Miles, Deb Willis, Tiffany Gill, Matthew D. Morrison, Aja Burrell Wood, Terrell Starr, G. Derek Musgrove, Tyrone Freeman, Josh Guild, Zakiya Johnson Lord, Eric Darnell Pritchard, Karen Dunak, Joanne Smith, Jared Stearns, Minkah Makalani, Talitha LeFlouria, Mark Anthony Neal, Erica Armstrong Dunbar, and Martha Jones. Thank you to my colleagues and students at The Graduate Center, CUNY. Despite my being hired during a pandemic, you all have made me feel welcomed. If I've forgotten anyone, please charge it to a tight copyediting deadline and not my heart!

Saving the best for last. To my family: There's no language to explain how much I love you. Mom and Dad, I try to tell you regularly how much I appreciate you. You've sacrificed so much to help me get here. Thank you. Malik, my big mini-me, you're my favorite person on the planet. I'm so proud of you. To the human affectionately known as "paypal bae," thank you for loving and supporting me through the years.

I dedicated this book to my beloved cousin, Aziza Bailey, who introduced me to Lawrence Otis Graham's *Our Kind of People*—one of the inspirations for *Our Secret Society*. Aziza: May this book be a symbol of my enduring love for you and the memories we made while you were in this realm. Rest in peace.

SIDEWAYS

———

An Essay on Method

H ow do you tell the complex political life story of a woman whom the media reduced to a glamorous socialite? This was the challenge I faced when I began to piece together Mollie Moon's biography and legacy.

I first encountered Mollie Moon in the archive in 2010. I was searching through old issues of *Amsterdam News* and found a story from 1963 about Mollie and the National Urban League Guild's Beaux Arts Ball. I wasn't looking for Mollie. I had never even heard of her or the National Urban League Guild. I was searching for information on a model named Doris Chambers, who was a minor figure in the dissertation I was finishing. As it turned out, Chambers had competed in the 1963 Miss Beaux Arts Pageant. And my searching for her had inadvertently introduced me to Mollie Moon. I was instantly intrigued by this Mollie Moon person. I didn't know many—maybe not any—Black Mollies. I loved the alliterative nature of her name and the way my lips had to purse and pucker to say it. I was equally dazzled by the newspaper's

description of Mollie and her party-planning prowess. From this one story, I could tell that Mollie had been a major social arbiter in Harlem. She was the queen. The grand dame.

Over the next several years, I returned to that *Amsterdam News* story, promising to write a book about Mollie Moon. In 2015, I began conducting research, in earnest, for the book that would become *Our Secret Society*. Through several historical newspaper archives, I found hundreds of articles, published in dozens of Black newspapers across the country, that extolled Mollie Moon and her hosting skills and named the Beaux Arts Ball *the* event among Black New York society. These stories typically framed the National Urban League Guild as an exclusive social club, not as a national network of volunteer fundraisers and civic leaders.

At the time, these newspapers were my primary source material. Thus, I, too, began framing Mollie as a socialite. Early drafts of the project explored the politics of hostessing and large-scale event planning. I toyed with labeling Mollie and other prominent African American hostesses "socialite activists" or "social power brokers" in an effort to name and theorize their labor. I used the concept of "Black glamour" as a guiding framework to uncover their modes of embodied activism. These so-called socialites knew everyone, had incredible Rolodexes, and had impeccable taste. I argued that they had fallen out of the historical record because they did not fit neatly into the binary paradigm of "respectable church lady" and "radical freedom fighter" that emerged from the civil rights era as the exclusive lens for seeing Black women's cultural and political activism. Using this framework, I planned to delve into the opulent world of the Black middle class to examine how conspicuous consumption, pleasure, and leisure culture both coalesced with and undermined the aims of the Civil Rights Movement.

However, after conducting research in the Henry Lee and Mollie Moon Papers at the Schomburg Center for Research in Black Culture, I realized that my line of inquiry was shortsighted. I was fortunate that Mollie had left behind papers that were, for the most part, organized and catalogued. In those boxes lay hundreds of personal letters, objects from Mollie's college years, employment records, vintage Beaux Arts Ball keepsakes, and more. The Mollie who emerged from this archive was a far more complicated figure than the Mollie presented in the society pages. She was a fundraiser with deep ties to the Black Left. My early framing of her life and work did not account for these elements of her biography.

I realized I had come to Mollie Moon's story sideways, not head-on. Let me explain. Mollie was in her mid-fifties when that 1963 *Amsterdam News* story was published and had lived a full professional life. She, at that stage of life, was a far different person than who she had been in her earlier years. Much of her early life had been virtually lost to history, allowing the image of Mollie Moon as a socialite and hostess to loom larger than it should have. Moreover, I was seeing the media's impression of her, not the way she saw or presented herself.

Upon further research, I determined that Mollie's socialite label had been the result of a concerted effort on the part of some society editors and male civil rights leaders to marginalize her role in the movement. By the 1960s, Mollie Moon was considered a polarizing figure—she'd made enemies; she'd lost favor with young radicals. Relegating her to the realms of party and play became a way to oust Mollie from her seat at the political power brokers' table. The socialite label was also a generalization and banalization of so-called women's work. "Socialite" was a catchall for any woman in *haute couture* who was a mainstay on the social scene or those

of high education or wealth who were committed to civic activities that men considered too feminine for them to engage in, such as party planning and fundraising. For example, the Black media also labeled brilliant, accomplished activists such as Eslanda Robeson, Bessye Bearden, and Gerri Major socialites.

While my language of "socialite activist" sought to complicate the term, my new revelations about the dangers of approaching Mollie Moon's life sideways indicated that this book needed a different and more nuanced framework. A sideways archive is problematic, especially when writing Black women's biography, because of the way it contorts and distorts Black women's lived realities. My sideways encounter with Mollie was reflective of a larger issue. Archives—and the archival project writ large—are a by-product of white supremacist logistics of collecting historical documents. People of African descent were never part of that project. Colonial-era archivists and librarians never intended for our histories to be central to the Western historical narrative. Sadly, most archives today still conform to this anti-Black approach to knowledge production.

Thus, writing Black women's biography means naming and confronting the violence of the archive. It also means recognizing that Black women's documents, objects, and keepsakes are rarely housed in brick-and-mortar archives. To tell our stories, we must be willing to dig in unexpected places, to utilize objects and other materials that archives and museums might consider of little value. And we must approach this work with an ethic of care that honors our subjects.

What, then, would it mean to approach a figure like Mollie Moon head-on? To resist putting her in a box or minimizing her contributions to the broader Civil Rights Movement? I first had

to create a method that would enable me to analyze these archival fragments vis-à-vis other types of data to paint a fuller, more robust portrait of Mollie Moon. I also had to think imaginatively about Mollie's spheres of influence and the eclectic array of source material that would allow me to pull these worlds together across time and space.

The more I unearthed new source material, the more I realized that Mollie's story was about a generation of Black power brokers. The book could still center on Mollie, because her journey from social worker to major civil rights fundraiser provided a new lens through which to study the long Civil Rights Movement. But I also needed to tell the stories of her peers in order to truly understand the dynamics of their "secret society." These folks were intellectuals, government aides, lobbyists, social workers, and journalists who formed what brilliant legal theorist Pauli Murray refers to as the "Depression Generation."

I discovered that these architects of change had to find ways to rebuild America in their own radical democratic vision. They had to develop a strong national fundraising plan that could push money across the country. Mollie Moon and other racial justice philanthropists of the Depression Generation melded the world-building vision of foundation philanthropy with African-derived notions of mutual aid, volunteerism, and mass giving. With this expanded cast of historical actors, the core story of *Our Secret Society* became one about local and national politics, fundraising and philanthropy, public policy, and economic justice.

Approaching Mollie's story head-on also required me to expand my expertise in several new areas. I had to utilize the methods of a material culturalist. While throwing parties wasn't Mollie's sole activity, it was a significant part of her professional and personal

identity. I wanted to know more about the venues in which she held events, the flatware, draperies, and menus at these places and to trace their provenance. Yet I did not want to reproduce the notion that these events were merely the wasteful frivolities of the upper classes. I became a student of gala-circuit philanthropy culture, accepting invitations and even paying upwards of five hundred dollars for a ticket to attend the major gala fundraisers in New York City (the city's most exclusive fundraisers can cost more than $5,000 for a single ticket). I would do informal ethnographic work at these events to understand how the curated menus, the decor and branding, and the lists of honorees were all strategically crafted to induce invitees to give—with champagne-aided abandon. The materiality of philanthropy is an underexplored topic that Mollie Moon's life makes clear in new ways.

A fortuitous result of my material culture approach was the robust list of food I amassed. I started keeping a list of every mention of food and beverages that Mollie and her peers detailed in their personal correspondences or that the media mentioned when covering these large-scale events. Studying the secret society's consumption offered a view of US culinary traditions in the mid-twentieth century. And, as a writer, these details added flavor and dimensionality to the world of *Our Secret Society*.

Money was such a huge piece of this story. Discovering that Mollie's Beaux Arts Ball was an annual fundraiser opened new lines of inquiry. I quickly realized that I needed to learn how to think like a social scientist, an NGO specialist, and a philanthropic adviser to fully understand the economics of the era and the hidden histories of big-dollar donating I was uncovering in the archive. I used Mollie's employment records to interrogate how she transferred the skills she had acquired as a social worker

to help establish the Black nonprofit sector in Jim Crow America, which was built upon New Negro ideas of economic justice and mutual aid.

The next logical question was: Where did the money they raised come from? Historically, we have been reluctant to ask about the sources that funded the Civil Rights Movement, because money suggests compromise. What if asking how our heroes were bankrolled leads us to the underground economy, the CIA, or other unsavory answers? What if we find activism capitulating to the interests of the Black elite or the preferences of white philanthropists? Where there's money, there's the danger that someone has "sold out." Yet without a willingness to dive into this muck, we're doomed to repeat the same inaccurate crisis-funding narratives that have real implications on an array of economic policies.

The "racial reckoning" of 2020, which was sparked by the police murder of George Floyd and the COVID-19 pandemic, made these questions I was asking of the past all the more relevant. In present day, we were debating how social movements are funded, the misappropriation of movement funds, "movement capture," and the need for strong Black mutual aid networks. I was seeing the Depression Generation grappling with similar issues in the period I was studying. I concluded that, both then and now, the mainstream media's coverage of US billionaires' exorbitant "guilt giving" to racial justice organizations exposes a painful reality: we, as a nation, believe that it's the wealthiest one percent who save US democracy in times of social and economic peril.

In this myth of noblesse oblige, African Americans and other people of color are cast as the pathologically poor recipients of

charity, never as institution (re)builders. The story I was piecing together told an alternative history, one of Black giving and generosity, despite a vast array of systemic economic injustices. The Depression Generation pioneered the strategic push for full enfranchisement by funneling millions of dollars across the grid to support voter registration drives and political campaigns. The fight to end voter suppression remains one of the most pressing racial justice issues today. My research indicated that African Americans from the Civil Rights Movement era till now have donated more than a billion dollars toward securing the right to vote—a basic civil right that has been increasingly eroded since the passage of the 1965 Voting Rights Act.

Today, Black-led philanthropic institutions that have built upon the foundation laid by the Depression Generation still face major barriers to fundraising. A 2020 study published in the *Chronicle of Philanthropy* has shown that nonprofits run by women of color have budgets 24 percent smaller than white-led groups, they receive less funding from high-net-worth individuals, and they are even disadvantaged by tax laws. Ms. Foundation for Women's landmark 2020 study found that of the $66.9 billion given by foundations, only 5 percent went toward funding initiatives for women and girls of color. Despite recent anti-racism pronouncements, in practice, African Americans are not central to the social change matrix powered by major foundations. *Our Secret Society* shows that all of this is consistent with a long history of anti-Black public policy around charitable contributions. It also tells the story of African American resistance and fiscal savvy, making the case that for a truly anti-racist giving policy to succeed, it is imperative for key white decision-makers to cede some of their privilege.

* * *

Our Secret Society was a difficult book to write. It stretched the limits of my thinking, my skills as a storyteller, and, at some moments, my mental capacity. But in order to tell this story head-on—in a manner that honored the Black woman at its center—I had to follow all of the new paths that the source material was taking me down while simultaneously allowing my method to evolve.

All told, offering a fuller rendering of Mollie Moon's story and its deep resonances today required me to comb through nearly thirty manuscript collections in archives across the country. I've also mined estate and auction records, and read nearly five hundred letters between members of the Depression Generation and funders. I've excavated close to a hundred old menus, Urban League Guild fundraiser cookbooks, gala fundraiser keepsake booklets, night club advertisements, and business cards. And I have amassed a digital archive of over two thousand press clippings from more than thirty newspapers. I've read white papers, sociological studies, campaign postmortems, foundation mission statements, and economic theories. I've conducted more than a dozen interviews with living descendants of the Depression Generation, prominent Black art collectors, and contemporary professional fundraisers and wealth management advisers.

My goal was to produce a rigorously researched, highly readable book that also shows the many facets of Mollie Moon—with all her flaws and contradictions—and the world she navigated. I wanted to show how Mollie and her peers grappled with moral dilemmas and fractious economic, political, and social debates, and, in so doing, induce readers to wrestle with them as well.

It is also my hope that my method can be a blueprint for researchers and aspiring writers of Black women's biography to build from. My method isn't perfect. If I were to write this book a decade from now, I might approach it completely differently, inspired by how history lives and breathes and the salient conversations of the day. Nor is this book the definitive word on Mollie Moon and her cohort of civic leaders. I hope other authors will choose to write about them.

I have drawn from the incredible body of scholarship on the Black working class and the underground economy that has been published in the past twenty years. I employed those scholars' "bottom-up" approach to reimagine how we write histories of race and class stratification—histories that challenge simple binaries of rich and poor, radical and moderate, and good and bad. Honoring the life of Mollie Moon and her fundraising legacy requires as much.

Tanisha C. Ford
Harlem
May 4, 2023

NOTES

ABBREVIATIONS IN THE NOTES

BWOHP Black Women Oral History Project, Schlesinger Library, Cambridge,
Massachusetts

CH Chester B. Himes Papers, Amistad Research Center, New Orleans,
Louisiana

DW Dorothy West Papers, Schlesinger Library, Cambridge,
Massachusetts

HLMF Henry Lee Moon Family Papers, Western Reserve Historical
Society, Cleveland, Ohio

HLMM Henry Lee and Mollie Moon Papers, Schomburg Center for
Research in Black Culture, New York, New York

JHWF John Hay Whitney Foundation Collection, Houston Public Library,
Houston, Texas

LM Loren Miller Papers, Huntington Library, San Marino, California

NDA New Deal and the Arts Oral History Project, Smithsonian Archives
of American Art, Washington, DC

NNYC Writers' Program, New York City: Negroes of New York Collection,
New York Public Library, New York, New York

NULR National Urban League Records, 1900–1988, Library of Congress,
Washington, DC

TF Taconic Foundation Papers, Rockefeller Archive Center, Sleepy
Hollow, New York

VTB Virgil T. Blossom Papers, University of Arkansas Library,
Fayetteville, Arkansas

WY Whitney Young Jr. Papers, Columbia University Rare Book and
Manuscript Library, New York, New York

INTRODUCTION

1 *added an opulent touch*: For photographs from the event, see "Rev. King Speaks at Urban League Fund Raising Fete," *Amsterdam News*, March 7, 1964, 38.

1 *It was February 26, 1964*: "Dr. King, at Rockefeller Estate, Addresses Urban League Rally," *New York Times*, March 1, 1964, 80.

3 *The states should have rights*: "Rev. King Speaks," 38.

3 *it would be better*: "Dr. King, at Rockefeller Estate," 80.

3 *human rights and human dignity*: "Dr. King, at Rockefeller Estate," 80.

4 *hobnob chattily*: "Rev. King Speaks," 38.

4 *But supplicating wealthy white folks*: Taylor Branch, *Parting the Waters: America in the King Years, 1954–63* (New York: Touchstone, 1989), 696.

7 *movement capture*: Megan Ming Francis, "The Price of Civil Rights: Black Lives, White Funding, and Movement Capture," *Law & Society Review* 53, no. 1 (March 2019): 275–309.

CHAPTER 1: NEW NEGROES IN MOSCOW

13 *tribe of friends*: Mollie Lewis to Dorothy West, August 31,1931. Letter. DW, Series II MC676, F2.12.

13 *Louise had consciously selected*: "20 Sail for Russia to Make Negro Talkie, Realistic Portrayal of Race Life Planned," *New Journal and Guide*, July 25, 1932, 5.

14 *encountered the cast*: Chatwood Hall, "New Jersey Youth Abroad Takes Russian Bride," *Afro-American*, February 25, 1933, 3.

15 *Dot and others wrote*: Dorothy West to Rachel West, n.d. 1932. Letter. DW, Series II MC676, F1.16.

15 *haute cuisine*: Dorothy West to Rachel West, n.d. 1932.

16 *living like royalty*: Louise to Lula Mae Brown, July 14, 1932. Letter. In Langston Hughes, *Letters from Langston: From the Harlem Renaissance to the Red Scare and Beyond*, eds. Evelyn Louise Crawford and MaryLouise Patterson (Oakland: Univ. of California Press, 2016), 76.

17 *Louise reasoned*: Louise to Lula Mae Brown, August 24, 1932. Letter. In Langston Hughes, *Letters from Langston: From the Harlem Renaissance to the Red Scare and Beyond*, eds. Evelyn Louise Crawford and MaryLouise Patterson (Oakland: Univ. of California Press, 2016), 82.

18 *pathetic*: Louise to Lula Mae Brown, August 24, 1932.

18 *Communist Uncle Tom*: Langston Hughes, *I Wonder as I Wander: An Autobiography* (New York: Hill and Wang, 1993), 98.

18 *disgraced the race!*: Hughes, *I Wonder as I Wander*, 88.

19 *glamorous and flighty*: Quoted from Louise Thompson Patterson's unpublished memoirs in Keith Gilyard, *Louise Thompson Patterson: A Life of Struggle for Justice* (Durham, NC: Duke Univ. Press, 2017), 83.

19 *more suitable companion*: Dorothy West to Rachel West, n.d. 1932.

20 *fled her tattered marriage*: Stephen Birmingham, *Certain People: America's Black Elite* (Boston: Little, Brown, 1977), 202.

20 *They lived with Beulah's sister*: US Census Bureau, *1920 US Census, Cuyahoga County, Cleveland, Ohio*, January 15 and 16, 1920, sheet 13. Generated by Ancestry (accessed February 6, 2021). Ten people were listed as residents in the home: Mollie, Beulah (who is listed as a lodger), Beulah's younger sister Augusta and her husband, Hamilton, two cousins, and four other lodgers. Hamilton worked as a spinner in a stamping and tool plant. Neither Beulah nor Augusta listed an occupation. One woman was a domestic in a private family home. Everyone was from Mississippi, except for two lodgers who were from Georgia and Alabama. Everyone could read and write.

20 *Rust College secondary school*: Mollie Moon, "United States Civil Service Commission Form 375," October 1940. Document. HLMM, B10 [Unprocessed].

20 *She pledged Pi Chapter*: Mollie Moon was initiated at Fisk University's Pi Chapter before they passed a petition to create separate chapters for Meharry and Fisk.

23 *Mollie toured Uzbekistan*: "Soviet Actors Deny They Are Stranded," *Afro-American*, October 1, 1932, 3.

23 *They'd been encouraged to publish*: "Group Reaffirms Its Russia Praise," *Atlanta Daily World*, November 13, 1932, 4.

CHAPTER 2: BERLIN

26 *German people*: "Student Back After Third Reich Sojourn," *Amsterdam News*, December 27, 1933, 2.

27 *the horrendous things*: Marjorie Farnsworth, Woman of the Week (column), *New York Journal-American*, November 21, 1953, n.p. Article (clipping). HLMF, Series I MSS 3628, F8.

27 *Mona, the Indian Girl*: Dorothy West to Rachel West, November 4, 1932. Letter. DW, Series II MC676, F1.16. See also Glenda Gilmore, *Defying Dixie: The Radical Roots of Civil Rights, 1919–1950* (New York: W. W. Norton, 2008), 157.

27 *No wine for me*: Stephen Birmingham, *Certain People: America's Black Elite* (Boston: Little, Brown, 1977), 202.

27 *turning down champagne?*: Birmingham, *Certain People*, 202.

27 *Was that champagne?*: Birmingham, *Certain People*, 202.

28 *investigated enrolling*: Mollie Lewis to Dorothy West, January 1, 1933. Letter. DW, Series II MC676, F2.12.

28 *A poor gal*: Mollie Lewis to Dorothy West, January 1, 1933.

28 *the kind you see*: Mollie Lewis to Dorothy West, June 26, 1933. Letter. DW, Series II MC676, F2.12.

29 *black Marlene Dietrich*: Mollie Lewis to Dorothy West, June 26, 1933.

29 *doing operatic work*: Chatwood Hall, "New Jersey Youth Abroad Takes Russian Bride," *Afro-American*, February 25, 1933, 3.

29 *passing for Indian* and *let me manage*: Mollie Lewis to Dorothy West, n.d. 1933. Letter. DW, Series II MC676, F2.12.

30 *I just put on a sari*: Birmingham, *Certain People*, 202.

30 *nearly stopped the ball*: Mollie Lewis to Dorothy West, n.d. 1933.

31 *joked about coupling*: Mollie Lewis to Dorothy West, January 1, 1933.

31 *broke and naked*: Mollie Lewis to Dorothy West, June 26, 1933. Letter. DW, Series II MC676, F2.12.

31 *Neither of us*: Mollie Lewis to Dorothy West, June 26, 1933.

31 *take some poison and end it all*: Mollie Lewis to Dorothy West, June 26, 1933.

32 *I didn't want to*: Mollie Lewis to Dorothy West, n.d. 1933.

33 *shrieking and leaping*: "Negro and Negress," *Afro-American*, February 9, 1935, 4.

33 *I have never seen*: "Negro and Negress," 4.

33 *She began hosting*: Mollie Lewis to Dorothy West, August 22, 1933. Letter. DW, Series II MC676, F2.12.

35 *I really hate*: Mollie Lewis to Dorothy West, August 22, 1933.

35 *Mollie had telegrammed*: Mollie Lewis to Henry Lee Moon, December 17, 1933. Telegram. HLMM, B1, F1.

CHAPTER 3: POWER COUPLE

38 *can't tell a waltz*: Marjorie Farnsworth, Woman of the Week (column), *New York Journal-American*, November 21, 1953, n.p. Article (clipping). HLMF, Series I MSS 3628, F8.

38 *What was only*: Nell Occomy, "Harlem by Night," *Afro-American*, June 1934, 6.

38 *He lost his insurance*: Mollie Lewis to Henry Lee Moon, September 2, 1936. Letter. HLMM, B1, F1.

39 *It's just like the bottom*: Mollie Lewis to Henry Lee Moon, September 13, 1934. Letter. HLMM, B1, F1.

39 *She would later tell the story*: Farnsworth, "Woman of the Week," n.p.

39 *She kept up the ruse*: Mollie Lewis to Henry Lee Moon, September 2, 1936.

41 *I love you*: Henry Lee Moon to Mollie Lewis, May 21, 1938. Letter. HLMM, B1, F2.

42 *Cle had earned*: Robert W. Daggs, "New Orleans News," *Pittsburgh Courier*, June 23, 1928, A7; Louisiana Secretary of State, "Louisiana Birth Records: Cleolus Leonidas Blanchet," Orleans Parish, March 13, 1904; and US Census Bureau, *1920 US Census, Orleans Parish, New Orleans, Louisiana*, January 17, 1920, sheet 20. Generated by Ancestry (accessed February 6, 2021). Cle's parents are listed as Louis A. Blanchet and Hattie Dastugue

Blanchet. They owned their home, and Louis worked as a mail clerk for the railroad, a prestigious job for a Negro in 1920. Hattie was a homemaker. They were described as Creole/Black. They could all read and write.

42 *The two married*: Williamson County, Tennessee, marriage license no. 1815, February 20, 1926, Cleolus L. Blanchet and Mollie V. Lewis. Generated by Ancestry (accessed February 6, 2021). There is a note on the record that says, "Don't pub" (i.e., don't publish news of the marriage). Theirs is the only license on the page with this notation. See also "Physician Named in Divorce," *Chicago Defender*, March 29, 1930, 13.

42 *They kept the marriage a secret*: "Physician Named in Divorce," 13.

42 *After her graduation*: Daggs, "New Orleans News," A7.

42 *Cle filed for divorce*: "Physician Named in Divorce," 13; and "Druggist Names Other Man; Is Given Divorce," *Chicago Defender*, May 3, 1930, 7.

42 *certainly did revive*: Mollie Lewis to Henry Lee Moon, n.d. 1937. Letter. HLMM, B1, F1.

42 *see those damned headlines*: Mollie Lewis to Henry Lee Moon, n.d. 1937.

42 *but I did*: Mollie Lewis to Henry Lee Moon, n.d. 1937.

42 *really looking good*: Mollie Lewis to Henry Lee Moon, n.d. 1937.

43 *all tied up*: Mollie Lewis to Henry Lee Moon, September 13, 1934.

46 *Henry's life was a shambles*: "Employes' [sic] Letter," *Amsterdam News*, March 13, 1937, 3.

47 *one of the leading*: Bessye Bearden, New York Society (column), *Chicago Defender*, December 22, 1934, 7.

47 *His commentary*: "Magazine Devoted to Social Justice Out," *Afro-American*, November 23, 1935, 12.

48 *He moved into a three-room apartment*: Henry Lee Moon to Mollie Lewis, April 16, 1938. Letter. HLMM, B1, F2.

48 *Black-owned eateries*: Margaret Cardozo Holmes, interview by Marcia McAdoo Greenlee, November 9, 1977. Transcript. BWOHP, OH-31, T-32.

50 *Working-class Negroes*: Mollie Lewis to Henry Lee Moon, May 4, 1938. Letter. HLMM, B1, F2.

50 *I have thrashed*: Mollie Lewis to Henry Lee Moon, April 23, 1938. Letter. HLMM, B1, F2.

51 *Have been trying*: Mollie Lewis to Henry Lee Moon, May 21, 1938. Letter. HLMM, B1, F2.

51 *One day*: Mollie Lewis to Henry Lee Moon, June 6, 1938. Letter. HLMM, B1, F2.

51 *Once the divorce*: Henry Lee Moon to Mollie Lewis, June 11, 1938. Letter. HLMM, B1, F2.

51 *I'm so happy*: Mollie Lewis to Henry Lee Moon, June 4, 1938. Letter. HLMM, B1, F2.

51 *If this third*: Mollie Lewis to Henry Lee Moon, April 23, 1938.

51 *delightfully informal*: Marvel Cooke, "Exotic Mollie Lewis Weds Henry Moon," *Amsterdam News*, August 27, 1938, 9.
52 *ravishing beauty*: Cooke, "Exotic Mollie Lewis," 9.
52 *completely flabbergasted*: Cooke, "Exotic Mollie Lewis," 9.
52 *Most friends were supportive*: Henry Lee Moon to Mollie Moon, August 25, 1938. Letter. HLMM, B1, F3.
52 *However, Roy Wilkins*: Mollie Moon to Henry Lee Moon, August 24, 1938. Letter. HLMM, B1, F3; and Henry Lee Moon to Mollie Moon, August 25, 1938.
52 *And a woman friend*: Mollie Moon to Henry Lee Moon, April 15, 1939. Letter. HLMM, B1, F4.

CHAPTER 4: CIVIC LEADERS

55 *Bob's wife*: "DC NAACP Drive Nets 2198 Members," *Afro-American*, May 6, 1939, 13; and "NAACP Drive Adds 2000 in Capital," *Afro-American*, April 8, 1939, 18.
56 *most cordial*: Henry Lee Moon to Mollie Moon, April 16, 1938. Letter. HLMM, B1, F2.
56 *Hastie's first wife*: "Renew Picket Fight for Jobs in DC Chain Store," *Chicago Defender*, April 26, 1941, 5.
56 *He worked under*: Louis Lautier, "Federal Payroll," Capital Spotlight, *Afro-American*, January 13, 1940, 4.
56 *Clarence Johnson*: Lautier, "Federal Payroll," 4.
56 *His wife, Louise Lovett*: Leighla Lewis, Capital Caviare (column), *Afro-American*, October 22, 1938, 6.
57 *As usual in such gatherings*: Henry Lee Moon to Mollie Moon, June 11, 1938. Letter. HLMM, B1, F2.
57 *He continued to attend*: Henry Lee Moon to Mollie Moon, October 11, 1939. Letter. HLMM, B1, F6.
57 *political window-dressing*: "Seething Unrest in New Deal's 'Black Cabinet,'" *Afro-American*, December 9, 1939, 5.
58 *Mollie made plans*: Mollie Moon to Henry Lee Moon, February 7, 1939. Letter. HLMM, B1, F4.
58 *When Bob Weaver*: Mollie Moon to Henry Lee Moon, January 22, 1939. Letter. HLMM, B1, F4. See also: Mollie Moon to Henry Lee Moon, September 20, 1939. Letter. HLMM, B1, F6.
58 *big shots*: Lautier, "Federal Payroll," 4.
58 *Weaver and Bethune were part*: Lautier, "Federal Payroll," 4.
58 *snooty set*: Louis Lautier, Capital Spotlight (column), *Afro-American*, February 13, 1937, 3.
59 *According to society writer*: Lewis, Capital Caviare (column), October 22, 1938. See also "What-Good-Are-We Outing Views with Bridge Parties," *Afro-American*, June 5, 1937, 5.

59 *Their home*: Lewis, Capital Caviare (column), October 22, 1938.

60 *Wait until we*: Henry Lee Moon to Mollie Moon, May 20, 1938. Letter. HLMM, B1, F2.

60 *She shopped at*: Mollie Moon to Henry Lee Moon, October 25, 1938. Letter. HLMM, B1, F3.

60 *Her purchases*: Mollie Moon to Henry Lee Moon, August 6, 1938. Letter. HLMM, B1, F3.

61 *My God!*: Mollie Moon to Henry Lee Moon, October 25, 1938. For Henry's response to Mollie's spending, see: Henry Lee Moon to Mollie Moon, June 28, 1938. Letter. HLMM, B1, F2. Also: Henry Lee Moon to Mollie Moon, August 8, 1938. Letter. HLMM, B1, F3.

61 *Mollie puts life*: Henry Lee Moon to Mollie Moon, June 4, 1941. Letter. HLMM, B2, F5.

61 *Everyone who comes*: Henry Lee Moon to Mollie Moon, November 5, 1938. Letter. HLMM, B1, F3.

61 *tipped the scale*: Mollie Moon to Henry Lee Moon, April 11, 1939. Letter. HLMM, B1, F4.

61 *I ate up the kitchen*: Mollie Moon to Henry Lee Moon, April 11, 1939.

62 *She bought a new*: Mollie Moon to Henry Lee Moon, October 29, 1938. Letter. HLMM, B1, F3.

63 *I wouldn't have missed*: Mollie Moon to Henry Lee Moon, January 7, 1939. Letter. HLMM, B1, F4.

63 *She concluded*: Mollie Moon to Henry Lee Moon, January 7, 1939.

64 *living dreary lives*: Mollie V. Lewis, "Negro Women in Steel," January 4, 1938. Unpublished manuscript. HLMM, B10 [Unprocessed]. This article was submitted to Roy Wilkins, editor of *The Crisis*, for publication.

65 *In the matter of race relations*: Lewis, "Negro Women in Steel."

65 *induce the women*: Lewis, "Negro Women in Steel."

65 *the usual argument*: Mollie Moon to Henry Lee Moon, January 16, 1940. Letter. HLMM, B1, F7.

65 *There were four*: Mollie Moon to Henry Lee Moon, January 16, 1940.

65 *ultra conservatives*: Mollie Moon to Henry Lee Moon, January 16, 1940.

65 *so frustrated*: Mollie Moon to Henry Lee Moon, January 16, 1940.

65 *I suppose you're ready*: Henry Lee Moon to Mollie Moon, December 2, 1939. Letter. HLMM, B1, F6.

65 *This is what Stalin*: Henry Lee Moon to Mollie Moon, December 2, 1939.

66 *Maybe the Soviets*: Henry Lee Moon to Mollie Moon, December 7, 1939. Letter. HLMM, B1, F6.

66 *Government employees were being targeted*: Henry Lee Moon to Mollie Moon, December 15, 1938. Letter. HLMM, F1, B3. See also: Henry Lee Moon to Mollie Moon, December 19, 1938. Letter. HLMM, F2, B3. See also: Lautier, "Federal Payroll," 5; and Lautier, "Civil Service," Capital Spotlight, *Afro-American*, July 27, 1940, 4.

67 *Louise Thompson*: Henry Lee Moon to Mollie Moon, January 22, 1940. Letter. HLMM, B1, F7.

67 *drank so much beer*: Mollie Moon to Henry Lee Moon, May 21, 1938. Letter. HLMM, B1, F2.

67 *nobody to take me*: Mollie Moon to Henry Lee Moon, June 4, 1938. Letter. HLMM, B1, F2.

67 *Our primary and most urgent need*: Henry Lee Moon to Mollie Moon, November 5, 1938. Letter. HLMM, B1, F3.

68 *If we're going to have a home*: Henry Lee Moon to Mollie Moon, November 5, 1938.

68 *Do You Want a Baby?*: Henry Lee Moon to Mollie Moon, January 27, 1940. Letter. HLMM, B1, F7.

68 *Does this interest?*: Henry Lee Moon to Mollie Moon, January 27, 1940.

CHAPTER 5: BECOMING A FUNDRAISER

70 *Since its founding*: Mollie Moon to Henry Lee Moon, October 21, 1938. Letter. HLMM, B1, F3.

70 *slum lad[s]*: John H. Thompson, "What Art Study Has Done in Harlem," *Chicago Defender*, May 27, 1939, 13.

71 *look around you*: Marcia Minor, "Harlem Community Art Center (Pt. 1)," *Daily Worker*, August 1, 1938, 7.

73 *nucleus of a National Race Museum*: Thompson, "What Art Study Has Done," 13.

73 *The entire community*: Simon Williamson, "The Harlem Art Center Opens," n.d., 1. Unpublished article. NNYC, B1, F2, R1.

73 *It is planned*: Williamson, "The Harlem Art Center Opens," 1.

73 *The long line*: Vivian Norris, "History of Harlem Art Center," July 14, 1939, 2. Unpublished article. NNYC, B1, F2, R1.

74 *I think we have here*: Eleanor Roosevelt, My Day (column), *Atlanta Constitution*, December 22, 1937, 12. See also "Wife of FDR Attends Opening of New York Art Center," *Atlanta Daily World*, December 27, 1937, 3.

74 *one of the most significant*: Alyse Abrams, "Harlem Community Art Center," November 27, 1939, 1. Unpublished article. NNYC, B1, F2, R1.

74 *the most colorful*: Williamson, "The Harlem Art Center Opens," 2.

75 *One goes many places*: Abrams, "Harlem Community Art Center," 4.

75 *on a shoestring*: Minor, "Harlem Community Art Center (Pt. 1)," 7.

75 *The Federal Government promises*: Williamson, "The Harlem Art Center Opens," 3.

76 *uneasiness about*: "Harlem Helping Art Center Get Cash for Paint," *Amsterdam News*, April 16, 1938, 15.

76 *a truly mass sponsorship*: Minor, "Harlem Community Art Center (Pt. 1)," 7.

76 *housewives*: Minor, "Harlem Community Art Center (Pt. 1)," 7.

77 *generously*: "Harlem Helping Art Center Get Cash for Paint," 15; and

"Harlem Pushes Fund to Assist Its Art Center," *Amsterdam News*, May 14, 1938, 19.

77 *an unusual achievement*: Minor, "Harlem Community Art Center (Pt. 1)," 7.

78 *Mollie set right to work*: "Headliners to Be at Benefit," *Amsterdam News*, June 15, 1940, 15.

78 *She and other members*: "Socialites to Hold Dansante: Proceeds Will Aid Harlem Community Art Center," *Amsterdam News*, June 8, 1940, 12.

79 *weakest spot*: Mollie Moon to Henry Lee Moon, January 22, 1942. Letter. HLMM, B2, F7.

80 *emergency appeal*: "Socialites to Hold Dansante," 12.

80 *Unless the citizens*: "Socialites to Hold Dansante," 12.

80 *people are willing*: "Capital Has Too Many Hat Passers," *Afro-American*, October 16, 1939, 22.

80 *The HCAC really needed*: Harlan Phillips, "Oral History Interview with Peter Pollack, circa 1964," Transcript. Archives of American Art, Smithsonian Institution, accessed November 17, 2021, https://www.aaa.si.edu/collections/interviews/oral-history-interview-peter-pollack-12282#transcript.

80 *It had been booted out*: "4-Year WPA Art Report Shows Project Great Cultural Aide to City," *The Daily Worker*, November 5, 1939, 4. See also "Get Ready for March 21 Ball," *Amsterdam News*, March 1, 1941, 15.

81 *a general disposition*: "Asks More Political Action," *Pittsburgh Courier*, June 20, 1931, 5.

81 *united political front*: "Asks More Political Action," 5.

83 *Phil Thomas won the best costume prize*: "Phil Thomas Prize Winner," *Amsterdam News*, March 29, 1941, 14. See also "Gothamites Planning Beaux Arts Ball," *Philadelphia Tribune*, February 14, 1942, 8.

85 *tired of nigger men*: Mollie Moon to Henry Lee Moon, August 7, 1941. Letter. HLMM, B2, F5.

86 *WPA cannot*: Mollie Moon to Henry Lee Moon, January 31, 1942. Letter. HLMM, B2, F7.

86 *Myself and other local*: Mollie Moon to Henry Lee Moon, January 31, 1942.

86 *If the Center*: Mollie Moon to Henry Lee Moon, January 31, 1942.

87 *top of your season's list*: "Gothamites Planning Beaux Arts Ball," 8.

87 *brilliant affair*: "Gothamites Planning Beaux Arts Ball," 8.

87 *The most high-profile*: Mary Schmidt Campbell, "The Studio Museum in Harlem: A Perspective," *Amsterdam News*, August 7, 1982, 36.

89 *Granger envisioned a new social unit*: "New York Gets Urban League Guild," *Chicago Defender*, August 22, 1942, 6.

89 *interracial volunteer club*: "Inter-Racial Group to Aid Urban League," *Pittsburgh Courier*, August 22, 1942, 3.

89 *interracial understanding*: "Inter-Racial Group to Aid Urban League,"

CHAPTER 6: THE ROCKEFELLER AFFAIR

91 *The success of our activities*: "Urban League Guild," *Opportunity*, Fall 1947, 206.

91 *The Negro press*: "Urban League Guild," 206.

92 *The women sat*: "Urban League Guild Plans Harlem Drive," *New Journal and Guide*, May 8, 1948, 19.

92 *And you couldn't be more down-to-earth*: "Park Avenue Faces the Race Problem," *Ebony*, February 1950, 16.

92 *close cooperation*: "Park Avenue Faces the Race Problem," 16.

92 *Guild movement*: "Urban League Guild," 232.

93 *interracial social action*: "New York's Notables by the Score Are Patrons of Beaux Arts Ball," *Amsterdam News*, January 30, 1943, 11.

93 *This group was the outgrowth*: Reba Schinault, "Urban League Guild Formed in St. Louis," *Pittsburgh Courier*, March 22, 1947, 3. See also: "An Address by Mollie Moon," National Urban League Conference, Columbus, OH, October 2, 1944. Among the papers of Henry Lee and Mollie Moon, Schomburg Center for Research in Black Culture, New York Public Library, Box 10.

93 *an interracial get together*: "Freedom in a Fancy Dress," *Our World*, February 1948, n.p. Article (clipping). HLMM, B1, F8.

93 *With the support*: Geraldyn Dismond, "Geraldyn Dismond Says: That Beaux Arts Ball Is Here Again," *Amsterdam News*, January 29, 1944, 9A.

95 *The Moons welcomed a daughter*: Mollie Moon had inherited the name from her maternal grandmother. Mollie Lee was also given her father Henry's middle name, Lee. Mollie Lee's name represents generational power—influential people and people of wealth often pass down family names. For decades, institutional racism had barred potential adoptive Negro parents from participating in the formal adoption process. Spence-Chapin Adoption Service was one of the first adoption agencies in the country to institute a Negro adoption program. The Moons, along with progressives such as Eleanor Roosevelt and Marian Anderson, served as ambassadors for Spence-Chapin and its broadminded stance on adoption and children's services. "Society Rulers of 20 Cities," *Ebony*, May 1949, 62. For more information on Mollie's involvement with Spence-Chapin, see Marjorie Farnsworth, Woman of the Week (column), *New York Journal-American*, November 21, 1953, n.p. Article (clipping). HLMF, Series I MSS 3628, F8. Mollie Lee became a third-generation Mollie.

95 *The Moons befriended*: Randy Dixon, "Former New York School Girl Marries Wealthy Londoner," *Pittsburgh Courier*, August 14, 1943, 11; and Richard Bourne-Vanneck II, interview by author, August 7, 2020.

96 *unrestricted citizenship*: Conrad Clark, "N.Y. Age Sold; Burley New Editor," *Pittsburgh Courier*, September 4, 1948, 2. See also "New York Age Reappears Under English Publisher," *Afro-American*, October 2, 1948, 5.

96 *So was Bucklin Moon*: Lawrence P. Jackson, *Chester B. Himes: A Biography* (New York: W. W. Norton, 2017), 184–85.

97 *almost movie-star good looks*: David Rockefeller, *Memoirs* (New York: Random House, 2003), 4.

97 *Win [was] the most troubled*: Rockefeller, *Memoirs*, 4.

98 *To prove the depth*: John L. Ward, *Winthrop Rockefeller, Philanthropist: A Life of Change* (Fayetteville: Univ. of Arkansas Press, 2004), 5–7, 127. The Ward book contains detailed tables of Winthrop Rockefeller's largesse. See also Winthrop Rockefeller Papers, Rockefeller Archive Center, https://dimes.rockarch.org/.

101 *nobody was going to buck*: Peter B. Flint, "Mollie Moon, 82, Founding Head of the Urban League Guild, Dies," *New York Times*, June 26, 1990, B7.

101 *rubs the magic lamp*: Nora Holt, "Guild Has Party in Rainbow Room," *Amsterdam News*, August 7, 1948, 4.

101 *as near heaven*: Holt, "Guild Has Party," 4.

102 *Once again*: Fannie Keene, Keene Observation (column), *Amsterdam News*, August 7, 1948, 18.

102 *This was the first occasion*: "350 Attend League Party at Rockefeller Rainbow Room," *Chicago Defender*, August 14, 1948, 16.

104 *Immediately, she criticized*: Lillian Scott, Along Celebrity Row (column), *Chicago Defender*, August 7, 1948, 17.

104 *everybody was there*: Scott, Along Celebrity Row (column), August 7, 1948.

104 *why he wasn't home*: Scott, Along Celebrity Row (column), August 7, 1948.

104 *The coal miner's daughter*: "The Bride Wore Pink," Manners & Morals, *TIME*, February 23, 1948, accessed September 16, 2022, https://content.time.com/time/subscriber/article/0,33009,798211,00.html. This characterization of Bobo and her marriage to Winthrop continued until her death in 2008. See also Adam Bernstein, "Actress Married Heir to Standard Oil Fortune," *Los Angeles Times*, May 23, 2008, accessed September 16, 2022, https://www.latimes.com/archives/la-xpm-2008-may-23-me-rockefeller23-story.html; and Margalit Fox, "Barbara Sears Rockefeller, Actress with a Famous Divorce Settlement, Dies at 91," *New York Times*, May 21, 2008, accessed September 16, 2022, https://www.nytimes.com/2008/05/21/nyregion/21rockefeller.html.

105 *It's not enough*: Ward, *Winthrop Rockefeller*, 7.

105 *People must make*: Ward, *Winthrop Rockefeller*, 7.

105 *The Ephesonian Choral Ensemble*: "Urban League's Benefit Dance Plans Started," *Amsterdam News*, September 4, 1948, 22.

106 *At an early age*: Jessie Carney Smith, "Mollie Moon," in *Notable Black American Women*, ed. Jessie Carney Smith (New York: Gale Research, 1992), 761. This quote is taken from a questionnaire Mollie Moon filled out about her philosophy on giving.

106 *In the spirit*: "Urban League's Benefit Dance Plans Started," 22; "Phil Williams to Chair Urban League's Drive in Coin Box Collection," *Amsterdam News*, July 24, 1948, 25; and "Heads Fund Drive for Urban League," *Chicago Defender*, July 24, 1948, 2.

107 *Life Goes*: "Life Goes to a Ball in Harlem," *Life*, February 28, 1949, 107–10, 113.

107 *leading spirit*: "Harlemites Will Honor Winthrop Rockefeller," *New Journal and Guide*, December 11, 1948, 19.

107 *As Mollie took the stage*: Lillian Scott, Along Celebrity Row (column), *Chicago Defender*, December 18, 1948, 8.

107 *charming and simple*: Lillian Scott, Along Celebrity Row (column), *Chicago Defender*, January 1, 1949, 9.

107 *delicately curved*: Holt, "Guild Has Party," 4.

107 *Mr. Moon and I*: Scott, Along Celebrity Row (column), January 1, 1949.

109 *A photograph in* Ebony: "Rich Patrons Give Their Time as Well as Money," *Ebony*, February 1950, 16.

CHAPTER 7: PARK AVENUE ELITE

112 *There is no foundation*: "NAACP Denies Separate Lists Ever Existed," *Atlanta Daily World*, March 15, 1949, 1.

112 *We have never depended*: "NAACP Denies Separate Lists," 1.

113 *bombarded with phone calls*: "NAACP Denies Separate Lists," 1.

113 *We had a big membership*: Roy Wilkins, *Standing Fast: The Autobiography of Roy Wilkins* (New York: Da Capo, 1994), 189.

114 *The Urban League certainly*: "National Urban League Records" in the Library of Congress (Part I, H2) contains old clippings, invitations, and announcements from the Urban League Fund's events.

118 *I'd always heard of*: Lillian Scott, Along Celebrity Row (column), *Chicago Defender*, April 16, 1949, 8.

119 *A sense of guilt*: "Park Avenue Faces the Race Problem," *Ebony*, February 1950, 15.

119 *Once you talk to Granger*: "Park Avenue Faces the Race Problem," 15.

119 *a cinch*: Scott, Along Celebrity Row (column), April 16, 1949.

119 *trying times*: Scott, Along Celebrity Row (column), April 16, 1949.

119 *I always tell them*: Scott, Along Celebrity Row (column), April 16, 1949.

120 *Paintings by Famous Amateurs*: "Spectators Search for Art in Amateur Art Exhibit," *New Journal and Guide*, October 9, 1948, 9.

120 *Winthrop Rockefeller proudly*: Lillian Scott, Along Celebrity Row (column), *Chicago Defender*, October 23, 1948, 8.

120 *The* New York Times *announced*: "Show to Be Given for Urban League," *New York Times*, June 9, 1949, 33.

121 *major Leaguers*: Lillian Scott, Along Celebrity Row (column), *Chicago Defender*, July 2, 1949, 8.

121 *being chummy*: Scott, Along Celebrity Row (column), July 2, 1949.

122 *Not only has there been*: "Mrs. Moon Says League Guild Fair Failure," *New Journal and Guide*, July 16, 1949, 6.

122 *most unfortunate*: "Mrs. Moon Says League Guild," 6.

122 *needlessly wasted*: "Mrs. Moon Says League Guild," 6.

123 *continue the good work*: "Mrs. Moon Says League Guild," 6.

123 *tiff*: James Hicks, "In Big Town," *New Journal and Guide*, July 16, 1949, 16.

123 *would burn the ribbon*: Hicks, "In Big Town," 16.

125 *the cause of the Negro*: "Park Avenue Faces the Race Problem," *Ebony*, February 1950, 15.

125 *social butterflies*: "Park Avenue Faces," 16.

125 *devotion to ideals*: "Park Avenue Faces," 16.

125 *This brand of liberal*: For an analysis of Gunnar Myrdal and his influence, for better and worse, on white liberals and philanthropy, see Maribel Morey, *White Philanthropy: Carnegie Corporation's An American Dilemma and the Making of a White World Order* (Chapel Hill: Univ. of North Carolina Press, 2021); and Tiffany Willoughby-Herard, *Waste of a White Skin: The Carnegie Corporation and the Racial Logic of White Vulnerability* (Oakland: Univ. of California Press), 2015.

126 *racial-equality capitalism*: This language is inspired by sociologist Patricia A. Banks's "diversity capital" framework. See Patricia A. Banks, *Black Culture, Inc.: How Ethnic Community Support Pays for Corporate America* (Stanford, CA: Stanford Univ. Press, 2022).

126 *plush Park Avenue socialite set*: "Park Avenue Faces," 15.

127 *examining the bitter facts*: "Park Avenue Faces," 15.

127 *chief beneficiary*: "Park Avenue Faces," 15.

127 *glamour set*: Toki Schalk Johnson, "Toki Types: Our Women in the World," *Pittsburgh Courier*, October 18, 1947, 8.

128 *new racial era*: Winthrop Rockefeller, "Remarks by Winthrop Rockefeller," National Urban League Annual Conference, Omaha, Nebraska, September 11, 1958. Speech. VTB, B4, F14.

128 *demanding a fuller share*: Rockefeller, "Remarks by Winthrop Rockefeller."

128 *we must be doing*: Rockefeller, "Remarks by Winthrop Rockefeller."

129 *eliminate competitive fundraising*: Lester B. Granger, "The Urban League Fund—Organization and Policies," April 6, 1961. Document. NULR, I:H4.

130 *improv[ing] understanding*: "National Information Bureau, Inc., Report on the National Urban League," September 19, 1962. Document. TF, B93, F934.

130 *Basic Standards in Philanthropy*: "National Information Bureau, Inc., Report," September 19, 1962.

131 *It alone was raising*: Granger, "The Urban League Fund." For specifics about the donors and a detailed accounting of donations, see NULR, I,

H2. For audit records and analysis, see NULR, I, H7. For the original ledgers, see NULR I, H8.

133 *The National Urban League:* "Officials Insist on Urban League Freedom from Big Business," *Ebony*, February 1950, 18.

133 *regardless of their money:* "Officials Insist on Urban League Freedom," 18.

CHAPTER 8: BLACK WEALTH

134 *tighten the strings:* Toki Schalk Johnson, "Mollie Moon Elected President of the Council of Urban League Guilds," *Pittsburgh Courier*, September 13, 1952, 11.

135 *clarification and re-evaluation:* Jacqueline Balthrope, "Urban League Guild 'Steals' Conference," *Call and Post*, September 13, 1952, 1C.

135 *informal basis:* Mollie Moon, "An Address by Mollie Moon," National Urban League Conference, Columbus, OH, October 2, 1944. Speech. HLMM, B10 [Unprocessed].

135 *selective but not exclusive:* Moon, "An Address by Mollie Moon."

136 *The Moons had bought:* Mollie and Henry Lee Moon, "Moons Abandon Harlem Heights," December 15, 1950. Postcard. HLMF, MSS 3628, F1.

138 *do a good job:* Mollie Moon to Nell Blackshear, August 11, 1954. Letter. HLMM, B10 [Unprocessed].

140 *It's a woman's world[,] men[,]:* Balthrope, "Urban League Guild," 1C.

141 *money landscape:* Nakisha Lewis (philanthropic strategist), interview by author, February 3, 2022.

141 *Negro society:* "Is Negro Society Phony?," *Ebony*, September 1953, 56.

141 *Social arbiters:* "Is Negro Society Phony?," 56.

141 *Harlem crime boss:* Mayme Johnson and Karen E. Quinones Miller, *Harlem Godfather: The Rap on My Husband, Ellsworth "Bumpy" Johnson* (Philadelphia: Oshun, 2008), 32–33.

142 *By the time they retired:* "10 Richest Negroes in America," *Ebony*, April 1949, 14.

142 *the new upstart intellectual:* "Society Rulers of 20 Cities," *Ebony*, May 1949, 62–63.

143 *Men formed their own:* "Men's Clubs Highly Praised," *Ebony*, January 1950, 40–44.

143 *Folks including:* "Rae Olley Mills Is Wed Quietly," *Amsterdam News*, February 7, 1942, 8; "Dudley to Get Post on Atty. Gen. Staff," *Amsterdam News*, April 18, 1942, 2; and Adele Logan Alexander (historian), interview by author, December 2, 2021. Alexander's parents and aunts and uncles were part of the New York "Depression Generation," as Pauli Murray calls them.

143 *Black equestrian clubs:* "Pretty Crop 'n' Tail Leaders," *Los Angeles Sentinel*, May 12, 1949, C1; "Derby Society," *Ebony*, June 1950, 35–36; and "10 Richest Negroes," 13–18.

144 *never eat your watermelon*: Alexander, interview by author.

144 *The Negro of today*: "Time to Stop Begging," *Ebony*, April 1949, 54.

145 *A dazzling photo*: "Society Rulers," 62.

145 *The New York chapter*: Toki Schalk Johnson, "New York Club Honors Mollie Moon," *Pittsburgh Courier*, December 5, 1953, 10. Mollie received tons of telegrams from family and friends, congratulating her on the honor. See HLMM, B10 [Unprocessed].

145 *15 years of toiling*: Marjorie Farnsworth, Woman of the Week (column), *New York Journal-American*, November 21, 1953, n.p. Article (clipping). HLMF, Series I MSS 3628, F8.

146 *Mollie modeled in cooking advertorials*: "Pineapple Delights," *Ebony*, June 1955, 116.

147 *The sooner Negro Americans*: "Time to Stop Begging," 54.

147 *anything from implied*: "Time to Stop Begging," 54.

147 *The magazine reported*: "10 Richest Negroes," 13.

147 *plowing it back*: "Time to Stop Begging," 54.

147 *Augustine A. Austin*: A. M. Wendell Malliet, "85,000 West Indians at Home in New York," *Amsterdam News*, June 22, 1940, 17.

147 *Brothers Theo and Ulysses Bond*: "10 Richest Negroes," 13–15.

148 *Controversial spiritual leader*: "10 Richest Negroes," 13–15.

148 *private philanthropies*: "Bojangles Has Given Million to Charity," *Afro-American*, May 29, 1948, B11.

148 *almost broke*: "Bojangles Has Given Million," B11.

149 *I have always been ready*: "Joe Louis Assumes Philanthropic Role to Help Big Cancer Benefit," *Amsterdam News*, February 21, 1948, 9.

149 *Paintings by Famous Amateurs*: "Spectators Search for Art in Amateur Art Exhibit," *New Journal and Guide*, October 9, 1948, 9.

149 *mirror[ing] the happier*: E. James West, *Ebony Magazine and Lerone Bennett, Jr.: Popular Black History in Postwar America* (Urbana: Univ. of Illinois Press, 2020), 2.

149 *According to Frazier*: E. Franklin Frazier, *Black Bourgeoisie: The Book That Brought the Shock of Self-Revelation to Middle-Class Blacks in America* (New York: Simon and Schuster, 1997), 50–54.

150 *unbound and independent*: "Time to Stop Begging," 54.

151 *malignant growth*: Sadie T. M. Alexander, "To Secure These Rights, 1948," in *Democracy, Race, and Justice: The Speeches and Writings of Sadie T. M. Alexander*, ed. Nina Banks (New Haven, CT: Yale Univ. Press, 2021), 214.

151 *God's chosen children*: Sadie T. M. Alexander, "Concerning the Loyalty Pledge Statement of Security Principles and the House Un-American Activities, 1947–1948 [fragment]," in *Democracy, Race, and Justice: The Speeches and Writings of Sadie T. M. Alexander*, ed. Nina Banks (New Haven, CT: Yale Univ. Press, 2021), 210.

CHAPTER 9: COLD WAR TENSIONS

152 *personable and popular*: "Smart Party Welcomes the Loren Millers," *Amsterdam News*, March 14, 1953, 9.

153 *The victory in* Shelley v. Kraemer: "NAACP Challenges 'Ghetto' Plan of Compton Realtors," *Los Angeles Sentinel*, May 10, 1947, 1.

153 *exceptional promise*: John Jay Whitney Foundation, "Information Sheet About Opportunity Fellowships," n.d. Document. JHWF.

154 *lavish buffet spread*: "Smart Party Welcomes the Loren Millers," *Amsterdam News*, March 14, 1953, 9.

157 *HUAC's accusations*: Alice A. Dunnigan, "Congressman Blasts Loren Miller as Being Pro-Communist," *Los Angeles Sentinel*, May 31, 1951, A1.

157 *I respect the fact*: Walter L. Gordon III, *The Saga of Loren Miller: From Colored Communist to Civil Rights Champion* (Los Angeles: self-published, 2019), 115.

157 *I am engulfed*: Gordon, *The Saga of Loren Miller*, 115.

158 *His income*: Carl T. Rowan, "Has Paul Robeson Betrayed the Negro?," *Ebony*, October 1957, 32.

158 *Mollie was never fond of*: Mollie Moon to Henry Lee Moon, August 24, 1938. Letter. HLMM, B1. F3. Mollie mentions a conversation with Roy about her relationship with Henry that deeply angered her. Her personality was better suited to Walter White's, who she thought was fun.

158 *I just didn't like*: Roy Wilkins, *Standing Fast: The Autobiography of Roy Wilkins* (New York: Da Capo, 1994), 210.

159 *spitting out words*: Rowan, "Has Paul Robeson Betrayed the Negro?," 34.

CHAPTER 10: BLACK FREEDOM ECONOMICS

166 *rough sledding*: P.R. to L.W.D., Southern Regional Council Office, November 10, 1961. Interoffice Memo. TF, B93, F934.

166 *the climate*: Urban League of Greater New Orleans, "Funding Request Summary," December 18, 1962, 1. Document. TF, B93 F934. The funding summary points to the immediate *Brown v. Board of Education* years as the start of the crisis.

166 *dire financial straits*: Urban League, "Funding Request Summary," December 18, 1962, 1.

166 *The executive director*: Urban League of Greater New Orleans, "Funding Request Summary," June 12, 1963, 2. Document. TF, B93, F934.

166 *a White Citizens' Council*: Jacksonville Urban League, "Funding Request Summary," January 29, 1963, 1. Document. TF, B93, F935. The funding summary points to 1956 specifically as the start of the crisis.

168 *An interracial group*: "Equality Group Wins Right to Swim," *Los Angeles Sentinel*, July 29, 1948, 9.

169 *There are 400,000 Negroes*: "Knott's Farm Suit Charges Bias," *Los Angeles Sentinel*, November 11, 1948, 1.

169 *She had called*: John C. Twitty, "Hotel Must Pay $600," *Amsterdam News*, April 12, 1952, 1.

170 *Will any colored persons*: "Matron Wins Hotel Suit," *Afro-American*, March 15, 1952, 19.

170 *high class hotel*: "Matron Wins Hotel Suit," 19.

170 *When the defendant's*: "Wins Hotel Bias Suit," *Atlanta Daily World*, April 16, 1952, 2.

170 *Mollie was awarded*: "Judgment Awarded in NYC Hotel Suit," *New Journal and Guide*, April 19, 1952, A2.

170 *more militant than the parent group*: "Urban League Guild Files Discrimination Charge vs. N.Y. Hotel," *Afro-American*, October 6, 1951, 8.

170 *White Citizens' Councils*: Charles M. Payne, *I've Got the Light of Freedom: The Organizing Tradition and the Mississippi Freedom Struggle* (Oakland: Univ. of California Press, 1997), 34–35.

171 *They targeted*: Payne, *I've Got the Light of Freedom*, 34–35.

174 *WCCs' widespread*: Jacksonville Urban League, "Funding Request Summary," June 9, 1964, 1. Document. TF, B93, F935.

CHAPTER 11: RULE WITH A SATIN GLOVE

178 *crotchety*: Lester Granger to Charles F. Harlins, March 21, 1961. Letter. HLMM, B10 [Unprocessed].

178 *a little disturbed*: Granger to Harlins, March 21, 1961.

179 *nothing more or less*: Granger to Harlins, March 21, 1961.

179 *tactful, firm, and skillful*: Granger to Harlins, March 21, 1961.

179 *he can find*: Granger to Harlins, March 21, 1961.

179 *entirely apart from*: Granger to Harlins, March 21, 1961.

180 *Guild story*: Mary C. Herzog, "The Urban League Guild in the Community," *The Guildscript*, 1954, 4. Report. HLMM, B10 [Unprocessed]. Herzog compiled the five-page report based on a questionnaire she developed and then circulated among all the Guilds in the Council. She read the report at the 1954 National Council of Urban League Guilds meeting.

180 *off-base*: Granger to Harlins, March 21, 1961.

181 *Meanwhile, the NAACP*: "NAACP Auxiliary Holds Meeting," *Call and Post*, December 18, 1954, 2B.

181 *friendl[y] threat*: Roy Wilkins, *Standing Fast: The Autobiography of Roy Wilkins* (New York: Da Capo, 1994), 190.

181 *The League was quietly*: Wilkins, *Standing Fast*, 190.

182 *talk some of these things out*: Mollie Moon to Shirley Lee, August 13, 1954. Letter. HLMM, B10 [Unprocessed].

182 *draw strength from*: Mollie Moon to Shirley Lee, August 13, 1954.

182 *the kind of women*: Ora Brinkley, "Hundreds at Luncheon to Launch Philadelphia Urban League Guild," *Philadelphia Tribune*, October 18, 1958, 7.

182 *The primary purpose*: Brinkley, "Hundreds at Luncheon," 7.

183 *But Atlanta and Cleveland*: National Urban League, "Contributions from the Urban League Guild," August 16, 1954. Document. HLMM, B10. This internal document was produced by the NUL secretaries.

184 *bag men*: "Bag man" is a term I learned during an informal conversation with Modupe Labode, curator of African American Social Justice History at the Smithsonian National Museum of American History, and an interview with Adele Logan Alexander. Adele Logan Alexander, interview by author, December 2, 2021.

184 *reach into the life*: Herzog, "The Urban League Guild," 2.

184 *a fine method*: Herzog, "The Urban League Guild," 2.

185 *Each Guild had its own*: Herzog, "The Urban League Guild," 1.

185 *Membership in Guild*: "Mrs. Jackson Heads Urban League Guild," *Atlanta Daily World*, January 23, 1949, 3.

186 *Under the leadership*: "Oklahoma City School Teacher Wins $5000 Fellowship Grant," *The Black Dispatch*, April 3, 1959, 6; and "Fellowship Winner Attends New York Media Institute," *Oklahoma City Advertiser*, July 23, 1959, 4. For more on the OKC Guild, see "Urban League Guild Sponsors 'Fashion Fair Internationale,'" *The North Star*, October 26, 1961, 5.

186 *In 1960, Martin Luther King Jr.*: "No Let Up Seen by Boycotters," *Daily Oklahoman*, October 4, 1961, 1.

187 *For plenty of years now*: "Well Done," *Amsterdam News*, February 20, 1960, n.p. Article (clipping). HLMF, MSS 3628, F8.

187 *And today they yield*: "Well Done," n.p.

187 *battlefield*: "Well Done," n.p.

188 *she sued a taxi company*: Mollie Lee Moon Elliot (daughter of Mollie and Henry Lee Moon), interview by author, March 7, 2021.

189 *Well, sir*: Mollie Lee Moon Elliot, interview.

189 *Oh, all you dumb*: Mollie Lee Moon Elliot, interview.

189 *He called us niggers!*: Mollie Lee Moon Elliot, interview.

189 *if you won't take us*: Mollie Lee Moon Elliot, interview.

189 *a dynamic personality*: "Mollie Moon Honored by National Urban League," *Welfarer*, July 1959, 9.

190 *beauty with a social mission*: "Mollie Moon: Beauty with a Social Mission," *Pittsburgh Courier*, December 12, 1955, n.p. Article (clipping). HLMF, MSS 3628, F8.

192 *small capital*: Toki Schalk Johnson, "Mollie Moon: Flak Artist," *Pittsburgh Courier Magazine*, December 16, 1950, 14.

192 *We are probably the first two*: Johnson, "Mollie Moon," 14. By 1951, the partnership had dissolved, and the name was changed to Moon and Associates, Inc. Mollie pivoted the business to be more of a concierge service for the Black elite, helping connect them to travel agencies and other businesses that purveyed luxuries to the affluent. For an example

of the rebrand, see: Mollie Moon to Floyd C. Mourning, March 25, 1953. Letter. HLMM, B10 [Unprocessed].

193 *petticoat executives*: Johnson, "Mollie Moon," 14.

193 *The Beaux Arts Ball belongs*: "Rich and Poor Rub Elbows at Benefit Ball," *Ebony*, May 1954, 18.

193 *most democratic*: "Rich and Poor Rub Elbows," 18.

193 *The Beaux Arts Ball is more*: "Rich and Poor Rub Elbows," 18.

194 *Negro society's biggest*: "Rich and Poor Rub Elbows," 18.

195 *La Baker and Ze Queen*: "La Baker and Ze Queen," *New York Age*, February 20, 1960, n.p. Article (clipping). HLMF, MSS 3628, F8.

195 *Photos of them together*: Lanetta White, "National Urban League's 20th Annual Beaux Arts Ball," *Pittsburgh Courier*, March 5, 1960, 4. A gentleman attendee (not Henry) played Diamond Jim, Lillian's long-term sugar daddy.

195 *The largest guest list*: "Largest Crowd in History Attends 21st Annual Gala," *Pittsburgh Courier*, March 4, 1961, 6.

195 *Prizes included*: "Guild to Sponsor 21st Annual Beaux Arts Ball," *New Journal and Guide*, February 4, 1961, 6.

196 *the F. & M. Schaefer Brewing Company*: "5,000 Prize Ready for Miss Beaux Arts," *Pittsburgh Courier*, December 24, 1960, 10.

196 *It is impossible to find*: See NULR I:K5 and K14–16 for Urban League Guild's Beaux Arts Ball expenses over the years.

196 *In her public statement*: "$10,000 Given to Urban League by Its Guild," *New Journal and Guide*, April 15, 1961, 10. See NUL Papers, I:K15 for expense reports for specifically early Beaux Arts Balls.

196 *Gone are those intimate*: Roberta Bosley Hubert, Roberta's New York (column), *Pittsburgh Courier*, March 4, 1961, 12.

197 *too scanty*: "Banned," *Jet*, February 21, 1957, 33.

197 *It would be obligatory*: Richard P. Bourne-Vanneck (Son of Victoria and Richard Bourne-Vanneck), interview by author, August 7, 2020.

197 *The royals declined*: Secretary to HRH the Duke of Windsor to Mason Melton, December 28, 1950. Letter. NULR, I:K15. This box contains numerous invitations to potential Beaux Arts Ball judges.

CHAPTER 12: SIDELINED

199 *lavish production*: "Uptown and Downtown Meet at Beaux Arts Ball," *Amsterdam News*, February 24, 1961, A1. See also "Beaux Arts Ball at Waldorf," *Amsterdam News*, February 10, 1962, 10.

199 *The other co-chair*: "A Baron's Caribbean Carnival," *Life*, March 3, 1961, 125.

200 *He had an extraordinary magnetism*: Laura Gaskins quoted in Nancy J. Weiss, *Whitney Young, Jr., and the Struggle for Civil Rights* (Princeton, NJ: Princeton Univ. Press, 1989), 45.

200 *He is already a legend*: Toki Schalk Johnson, Toki Types (column), *Pittsburgh Courier*, March 3, 1962, A11.

200 *doll-size*: Johnson, Toki Types (column), March 3, 1962.

202 *They made a home*: Weiss, *Whitney Young, Jr.*, 166.

204 *under the influence*: Weiss, *Whitney Young, Jr.*, 81–82.

204 *enough age and balance*: George Butler quoted in Weiss, *Whitney Young, Jr.*, 84.

204 *had a reputation*: Weiss, *Whitney Young, Jr.*, 84.

205 *Kimball's boy*: Weiss, *Whitney Young, Jr.*, 83.

205 *It had been Kimball*: Tom Buckley, "Whitney Young: Black Leader or 'Oreo Cookie'?," *New York Times*, September 20, 1970, accessed July 13, 2022, https://www.nytimes.com/1970/09/20/archives/whitney-young-black -leader-or-oreo-cookie-whitney-young.html.

207 *Foundations like Taconic*: Taconic Foundation, "Statement of Income, Expenses, Grants, and Fund Balance for the Year Ending December 31, 1963." Tax return. TF, B212.

208 *Negro revolt*: See "What the White Man Thinks of the Negro Revolt," *Newsweek*, October 21, 1963. The entire issue was devoted to a national poll about race relations.

208 *militant professionalism*: This is a term I've created to describe Young's ideology about grassroots organizing and mobilization.

209 *Young had inherited*: WY, Series II NUL, B12. To better understand the transition of power from Lester Granger to Whitney Young, read the NUL board minutes and executive committee correspondence.

209 *Kimball, the expert*: Whitney Young to Stephen Currier, June 25, 1964. Letter. TF, B93, F935. For National Urban League financial and personnel reports, see WY, Series II NUL, B24, F26–27.

210 *disadvantaged youth*: "Urban League Gets $215,000 Grant," *Amsterdam News*, April 21, 1962, A46.

210 *the disease of Birmingham*: "Says Bias Costs New York 750 Million a Year," *Amsterdam News*, September 21, 1963, 1.

211 *because of its proven*: "Says Bias Costs New York," 1.

211 *the burning wires*: James Booker, "Political Pot: The Burning Wires," *Amsterdam News*, September 15, 1962, 11.

212 *Others within the League*: For more on Young's new executive board and trustees, see Dennis C. Dickerson, *Militant Mediator: Whitney M. Young Jr.* (Lexington: Univ. of Kentucky Press, 1998), 139.

213 *In 1962, its operating*: Taconic Foundation, "National Urban League Program Needs for 1964," June 3, 1964. Document. TF, B93, F935.

214 *The Urban League's concerns*: "Oklahoma UL Executive Gets Full Time Post with National Body," *Chicago Defender*, February 2, 1962, 12.

215 *Skeptics believed*: Rosemarie Tyler Brooks, "Washington Round-Up," *New Journal and Guide*, December 19, 1964, A1.

215 *Social services are no substitute*: Connie Harper, "UL Director Is Speaking at Conference," *Call and Post*, October 31, 1964, 4B.

215 *Negroes are going:* Harper, "UL Director Is Speaking," 4B.

215 *Young created an altogether new position:* For more on Isobel Chisholm Clark, see "NUL Aid Speaks in Washington," *Afro-American,* April 11, 1964, 17; "NUL Names Isobel Clark to Newly Created Executive Post," *Afro-American,* June 23, 1962, 8; and Ozeil Fryer Woolcock, "Social Swirl," *Atlanta Daily World,* January 1, 1949, 3.

216 *This might have:* Cathy White, "Personally and Socially," *Amsterdam News,* November 6, 1965, 18. Another reason Mollie reactivated her membership might have been that she wanted to smooth the way for her daughter, Mollie Lee, to join the sorority as a legacy candidate (this was a common practice even before the sorority instituted a formal legacy clause).

217 *In 1962, Young appointed Simms:* "Simms Heads League Fund," *Amsterdam News,* February 10, 1962, 19.

218 *He empowered the current:* See "Aleathia Cecilia Mayo Is Bride of Ronald J. Davis," *Call and Post,* July 14, 1962, 2B.

CHAPTER 13: NICKELS AND DIMES

220 *a nickel and dime organization:* Dennis C. Dickerson, *Militant Mediator: Whitney M. Young Jr.* (Lexington: Univ. of Kentucky Press, 1998), 139.

223 *The Guild added the Fashion Fair:* Tanisha C. Ford, "Socialite Mollie Moon Used Fashion Shows to Fund the Civil Rights Movement," *Harper's Bazaar,* March 8, 2021, accessed July 6, 2022, https://www.harpersbazaar.com/culture/feafeatu/a35699722/socialite-mollie-moon-used-fashion-shows-to-fund-the-civil-rights-movement/; and "NUL Guild Sets Fashion Fair," *Amsterdam News,* September 21, 1963, 12.

223 *The year 1963 would see the last:* Nancy J. Weiss, *Whitney Young, Jr., and the Struggle for Civil Rights* (Princeton, NJ: Princeton Univ. Press, 1989), 93.

223 *largest turnout ever:* "Largest Turn-Out Ever at Annual Beaux Arts Ball," *Philadelphia Tribune,* February 22, 1964, 11.

223 *By 1966, the NUL:* Weiss, *Whitney Young, Jr.,* 93.

223 *An older socialite:* Cathy Aldridge, "Civic Leader Collapses and Dies at Beaux Arts Ball," *Amsterdam News,* February 24, 1968, 1.

224 *Budding activist and director:* Laura L. Lovett, *With Her Fist Raised: Dorothy Pitman Hughes and the Transformative Power of Black Community Activism* (Boston: Beacon, 2021), 33.

224 *tore at the fabric of CORE:* Lovett, *With Her Fist Raised,* 31.

224 *Dick Gregory's CORE:* "Gregory Benefits Raise over $50,000 for CORE," *Jet,* October 22, 1964, 6.

225 *At the end of Lester Granger's tenure:* Weiss, *Whitney Young, Jr.,* 92–93. For specifics about the donor lists, see NULR, I:H2. For audit records and analysis, see NULR, I:H7. For the original ledgers, see NULR I:H8. For NUL financial and personnel reports, see WY, Series II NUL, B24, F26–27, and TP, B93, F936.

226 *Few persons realize*: Bill Davidson, "Our Negro Aristocracy," *Saturday Evening Post*, January 13, 1962, 10.

229 *"big leaders" whom*: James L. Hicks, "The Insiders," *Amsterdam News*, August 24, 1963, 63.

229 *little children*: Hicks, "The Insiders," 63.

230 *How can Negroes like us*: Davidson, "Our Negro Aristocracy," 16.

230 *They even went as far*: *Still a Brother: Inside the Negro Middle Class*, directed by William Greaves, written by William B. Branch (New York: National Educational Television, 1968), documentary, 90 min.

230 *color-blind policies*: Whitney Young, "Negroes: The New Power," n.d., 1. Speech. Whitney M. Young Jr. papers, 1960–1977, Columbia University Libraries, Series II FH, B33, and F22. Young delivered this speech at the ACTION Conference on race relations, likely between 1962 and 1964.

230 *many people of goodwill*: Young, "Negroes: The New Power," 1.

231 *growing economic sophistication*: Young, "Negroes: The New Power," 2–3.

231 *critical swing bloc*: Young, "Negroes: The New Power," 2–3.

231 *Young wanted the National Urban League*: For Whitney Young's correspondence with The Links, Inc., see Dr. Helen G. Edmonds to Whitney Young, June 11,1962, Whitney Young to Dr. Helen G. Edmonds, June 20, 1962, and Whitney Young to D. Helen G. Edmonds, June 28, 1962, WY, Series II NUL, B132.

231 *As an intelligent group*: Dickerson, *Militant Mediator*, 291. For others of Young's addresses to The Links, Inc., see "Address of Whitney M. Young Jr., National Urban League, at the Eastern Regional Conference of The Links, Inc.," March 3, 1962, WY, Series II NUL, B132. The box also contains The Links, Inc., programs and other event keepsakes.

231 *In March 1964*: "N.Y. Links to Give Benefit," *New Journal and Guide*, March 7, 1964, 4.

232 *crash plan*: Whitney Young, "Domestic Marshall Plan: Compensation—Yes," *New York Times*, October 6, 1963, 43. See also Emma Harrison, "'Better' Rights for Negro Urged," *New York Times*, May 21, 1963, 22.

232 *Domestic Marshall Plan*: Whitney Young to Stephen Currier, June 3, 1964. Letter. TF, B93 F935.

232 *Black nationalist Queen Mother Audley Moore*: Ashley Farmer, "Reframing African American Women's Grassroots Organizing: Audley Moore and the Universal Association of Ethiopian Women, 1957–1963," *Journal of African American History* 101, nos. 1–2 (Winter/Spring 2016): 69–96.

233 *The effects of over 300 years*: Young, "Domestic Marshall Plan," 129.

233 *tragic consequences*: Young, "Domestic Marshall Plan," 129.

233 *A strong back*: Young, "Domestic Marshall Plan," 129.

234 *not to change the fabric*: "Races: The Other 97%," *TIME*, August 11, 1967, accessed July 13, 2022, https://content.time.com/time/subscriber/article/0,33009,899687,00.html.

234 *But whites, even white liberals*: Kyle Haselden, "Parity, Not Preference," *New York Times*, October 6, 1963, 128. See also "What the White Man Thinks of the Negro Revolt," *Newsweek*, October 21, 1963; the entire issue was devoted to a national poll about race relations.

235 *Many supporters thought*: Weiss, *Whitney Young, Jr.*, 96.

235 TIME *would later report*: "Races: The Other 97%."

236 *Much of the money*: Tom Buckley, "Whitney Young: Black Leader or 'Oreo Cookie'?," *New York Times*, September 20, 1970, accessed July 13, 2022, https://www.nytimes.com/1970/09/20/archives/whitney-young-black -leader-or-oreo-cookie-whitney-young.html.

236 *Before Daniel Day*: Daniel R. Day, *Dapper Dan: Made in Harlem: A Memoir* (New York: Random House, 2019), 96–107.

CHAPTER 14: MARCH ON WASHINGTON

240 *As it went, Kennedy had turned*: Taylor Branch, *Parting the Waters: America in the King Years, 1954–63* (New York: Touchstone, 1989), 481.

241 *movement capture*: Megan Ming Francis, "The Price of Civil Rights: Black Lives, White Funding, and Movement Capture," *Law & Society Review* 53, no. 1 (March 2019): 275–309.

242 *For example, in 1963 and 1964*: "990A Contributions, Gifts, Grants, Etc. Paid Out Calendar Year 1963." Document. TF, B212, F Tax Returns 1963. And: Price Waterhouse and Company to Stephen Currier, December 15, 1965. Letter. TF, B212, F Tax Returns 1964.

242 *Young frequently praised*: Whitney Young, "The Nation Mourns," *Chicago Defender*, March 4, 1967, 11.

243 *stability and financial resources*: Young, "The Nation Mourns," 11.

244 *emergency needs*: "Regular Meeting of the Board of Directors," July 2, 1963. Document. TF, B212, F Board Meeting Minutes. It's worth noting that the money Taconic gave the CUCRL was twice that of Currier's annual salary, a salary he waived every year. This money was held in something akin to a slush fund or petty cash that Currier could draw from. This donation does not appear on Taconic's 990 Form or on its itemized donations for the year.

244 *The Carlyle meeting was a success*: Branch, *Parting the Waters*, 481–82.

244 *determined not to waste*: "6 Rights Organizations Establish United Front," *New Journal and Guide*, July 20, 1963, C2.

244 *Harry Belafonte would later find this out*: Harry Belafonte and Michael Shnayerson, *My Song: A Memoir* (New York: Alfred A. Knopf, 2011), 1–8.

245 *Belafonte instantly set about fundraising*: Belafonte and Shnayerson, *My Song*, 1–8.

246 *I think 1962 was perhaps*: Roy Wilkins, *Standing Fast: The Autobiography of Roy Wilkins* (New York: Da Capo, 1994), 285.

247 *mediagenic*: Wilkins, *Standing Fast*, 289.

247 *only to be insulted:* Wilkins, *Standing Fast*, 289.

248 *a mesmerizing speaker:* Wilkins, *Standing Fast*, 317.

249 *Let me show you how:* Malcolm X—Topic, "Message to the Grass Roots," from *All Time Greatest Speeches Vol. 3* (Master Classics Records, 2008). Malcolm X speech delivered November 10, 1963, in Detroit, MI. YouTube video. Posted by The Orchard Enterprises, November 8, 2014, accessed February 3, 2023, https://www.youtube.com/watch?v=XYzO1PCPKYI.

249 *They didn't integrate it:* Malcolm X, "Message to the Grass Roots."

249 *A million and a half dollars:* Malcolm X, "Message to the Grass Roots."

250 *For example, Dr. King was invited:* "Rev. King Speaks at UL Fundraising Fete," *Amsterdam News*, March 7, 1964, 38.

250 *much more than either mass acts:* Whitney Young, "Negroes: The New Power," n.d., 2. Speech. FH, B33, F22. Young delivered this speech at the ACTION Conference on race relations, likely between 1962 and 1964.

250 *have been accompanied:* Young, "Negroes: The New Power."

250 *express[es] its group:* Young, "Negroes: The New Power."

251 TIME *reported in 1967:* "Races: The Other 97%," *TIME*, August 11, 1967, accessed July 13, 2022, https://content.time.com/time/subscriber/article/0,33009,899687,00.html.

251 *There is no city in the US:* "Which Way for the Negro?," *Newsweek*, May 15, 1967, 27.

251 *In wretched Negro slums:* "Races: The Other 97%."

252 Newsweek *explained these dynamics:* "Which Way for the Negro?," 27.

252 *incurred political debts:* Tom Buckley, "Whitney Young: Black Leader or 'Oreo Cookie'?," *New York Times*, September 20, 1970, accessed July 13, 2022, https://www.nytimes.com/1970/09/20/archives/whitney-young-black-leader-or-oreo-cookie-whitney-young.html.

253 *Whitney sells out:* Nancy J. Weiss, *Whitney Young, Jr., and the Struggle for Civil Rights* (Princeton, NJ: Princeton Univ. Press, 1989), 173.

253 *Meanwhile, King:* Branch, *Parting the Waters*, 696.

253 *The* New York Times *estimated:* Buckley, "Whitney Young."

254 *Black Power, according to my definition: Independent Lens*, season 14, episode 8, "The Powerbroker: Whitney Young's Fight for Civil Rights," directed by Christine Khalafian and Taylor Hamilton, originally aired February 18, 2013, on Public Broadcasting Service; and Buckley, "Whitney Young."

254 *It means pride:* "The Powerbroker," directed by Khalafian and Hamilton.

CHAPTER 15: BETRAYED

255 *For example, it was rumored:* Lawrence P. Jackson, *Chester B. Himes: A Biography* (New York: W. W. Norton, 2017), 183–84.

256 *Others assumed Henry:* Chester B. Himes, *Pinktoes* (New York: Book-of-the-Month Club, 1994), 83. Himes alludes to this rumor in *Pinktoes*. He seems to suggest that Mollie, via the Mamie Mason character, would

sleep with any man, regardless of his sexual orientation, as long as he had money, prestige, and a functioning penis.

258 *strikingly attractive*: Himes, *Pinktoes* (1994 edition), 27.

259 *best friend*: Himes, *Pinktoes* (1994 edition), 27.

259 *the instincts*: Himes, *Pinktoes* (1994 edition), 26–28.

259 *serve the Negro*: Himes, *Pinktoes* (1994 edition), 28.

259 *There is nothing more*: Himes, *Pinktoes* (1994 edition), 24.

259 *I hear Mamie*: Himes, *Pinktoes* (1994 edition), 83.

259 *She's been named*: Himes, *Pinktoes* (1994 edition), 83.

261 *I just wish*: Henry Lee Moon to Mollie Lewis, May 20, 1938. Letter. HLMM, B1, F2.

261 *Some are good*: Henry Lee Moon to Mollie Lewis, May 20, 1938.

263 *bitch*: See Edward Margolies's afterword in the 1996 edition of *Pinktoes*. Chester B. Himes, *Pinktoes* (Jackson: Univ. Press of Mississippi, 1996), 258.

263 *cheat*: Himes, *Pinktoes* (1996 edition), 258.

263 *Here's a whore*: Himes, *Pinktoes* (1996 edition), 258.

263 *Himes also penned*: Jackson, *Chester B. Himes*, 184.

263 *It was rumored*: Himes, *Pinktoes* (1996 edition), 261.

264 *The real-life Maude*: Jackson, *Chester B. Himes*, 66.

264 *When Himes came up with*: Jackson, *Chester B. Himes*, 60.

265 *repugnant to those Negroes*: Chester B. Himes to Carl Van Vechten, September 13, 1956. Letter. CH, B6, F11.

265 *interracial togetherness*: "Literati: Chatter," *Variety*, February 24, 1965, 75.

265 *sex isn't lacking*: Lewis Nichols, "Collaboration," In and Out of Books, *New York Times*, April 4, 1965, BR8. This column also explains how G. P. Putnam's Sons and Stein and Day came to jointly acquire the rights of the book.

266 *a hilarious tour de force*: George S. Schuyler, Courier Bookshelf (column), *Pittsburgh Courier*, September 11, 1965, 9.

266 *a truly fascinating blend*: James Bannerman, Maclean's Reviews (column), *Maclean's*, September 18, 1965, 63.

266 *By the fall of 1966*: Paperback Best Sellers (column), *Chicago Tribune*, November 13, 1966, N11.

268 *Breathless coverage*: Thomasina Norford, On the Town (column), *Amsterdam News*, June 19, 1963, 12; Gladys Johnson, "Summer's Last Gasps," *Michigan Chronicle*, September 2, 1961, B3; and Society by Cynthia (column), *Pittsburgh Courier*, January 2, 1965, 5.

269 *Miss Kitt, of course*: Cathy Aldridge, "The Ladies and Eartha: Pro-Con," *Amsterdam News*, January 27, 1968, 1.

269 *one of those rare human beings*: Pauli Murray, *Song in a Weary Throat: Memoir of an American Pilgrimage* (New York: Liveright, 2018), 121.

269 *imagination and initiative*: Murray, *Song in a Weary Throat*, 121.

270 *Whitney had to concede*: Dennis C. Dickerson, *Militant Mediator: Whitney M. Young Jr.* (Lexington: Univ. of Kentucky Press, 1998), 292.

CHAPTER 16: A RECKONING

271 *Many socialites and civic activists:* "Mrs. Moon Sues for a Million," *Afro-American*, October 22, 1966, 3. See also "Mrs. Moon Alleges Slander," *New Journal and Guide*, October 22, 1966, A1.

272 *In fact, Sophia:* "Celebrity Sponsors Support Urban League Guild Beaux Arts Ball," *Amsterdam News*, February 5, 1966, 14.

273 *Mollie's main function:* Ray McCann, "Urban League Socialite Mollie Moon Settles Million-Dollar Suit Against New York Woman," *Philadelphia Tribune*, February 28, 1967, 20.

273 *tries to see how many:* "Mrs. Moon Sues," 3.

273 *were intended to mean:* "Mrs. Moon Sues," 3.

273 *false and defamatory:* "Mrs. Moon Sues," 3.

273 *By the time of the lawsuit:* Audrey Smaltz (former model and fashion commentator), interview by author, April 20, 2020.

275 *She would not have wanted:* Mollie Lee Moon Elliot, interview by author, March 7, 2021.

276 *On the one hand, Sophia:* For more on the bawd archetype, see Corinne T. Field, "Antifeminism, Anti-Blackness, and Anti-Oldness: The Intersectional Aesthetics of Aging in the Nineteenth-Century United States," *Signs: Journal of Women in Culture and Society* 47, no. 4 (Summer 2022): 843–83; Sophie Carter, *Purchasing Power: Representing Prostitution in Eighteenth-Century English Popular Culture* (Aldershot, England: Ashgate, 2004); and Marisa J. Fuentes, "Power and Historical Figuring: Rachel Pringle Polgreen's Troubled Archive," in *Connexions: Histories of Race and Sex in North America*, eds. Jennifer Brier, Jim Downs, and Jennifer L. Morgan (Urbana: Univ. of Illinois Press, 2016), 143–68. While scholars of Black women's history and Black feminist theory haven't fully explored the old bawd archetype, these works help us to move toward an analysis of the sexualization of Black women in middle and late age.

278 *Uncle Whitney:* Tom Buckley, "Whitney Young: Black Leader or 'Oreo Cookie'?," *New York Times*, September 20, 1970, accessed July 13, 2022, https://www.nytimes.com/1970/09/20/archives/whitney-young-black-leader-or-oreo-cookie-whitney-young.html.

279 *He loved to be lionized:* Nancy J. Weiss, *Whitney Young, Jr., and the Struggle for Civil Rights* (Princeton, NJ: Princeton Univ. Press, 1989), 171.

279 *like a puppy:* Weiss, *Whitney Young, Jr.*, 171.

279 *Whitney's emotional neediness:* Weiss, *Whitney Young, Jr.*, 174.

279 *The more she pressed:* Weiss, *Whitney Young, Jr.*, 170.

280 *This is black power!:* Weiss, *Whitney Young, Jr.*, 172.

281 *absolutely determined:* Richard P. Bourne-Vanneck, interview by author, August 7, 2020.

283 *misconstrued:* "Mollie Moon's $1 Million Suit Is Settled," *Call and Post*, March 11, 1967, 13.

283 *complimentary:* "Mollie Moon's $1 Million Suit," 13.

284 *Whatever feelings of joy:* "Beulah Lewis Buried in Detroit," *Chicago Defender,* August 23, 1967, 8.

284 *mental revolution: Still a Brother: Inside the Negro Middle Class,* directed by William Greaves, written by William B. Branch (New York: National Educational Television, 1968), documentary, 90 min.

285 *Young ended up dying: Independent Lens,* season 14, episode 8, "The Powerbroker: Whitney Young's Fight for Civil Rights," directed by Christine Khalafian and Taylor Hamilton, originally aired February 18, 2013, on Public Broadcasting Service, 2013.

CONCLUSION

287 *The Guild has given:* Cathy Connors, "Helen Harden Receives First Mollie Moon Award," *Amsterdam News,* October 28, 1989, 40.

288 *the doyen of sophisticated New York:* Cathy Connors, "Beaux Arts Ball to Salute Third World," *Amsterdam News,* January 31, 1980, 20; and Sara Slack, Sara Speaking (column), *Amsterdam News,* May 22, 1971, 7.

288 *Legions:* Sara Slack, Sara Speaking (column), *Amsterdam News,* March 4, 1972, B1.

289 *brainchild from away back:* Slack, Sara Speaking (column), March 4, 1972.

289 *marvelous Mollie:* Slack, Sara Speaking (column), March 4, 1972.

290 *In 1972, for example:* Betty Granger, Conversation Piece (column), *Amsterdam News,* August 19, 1972, B8; and Betty Granger, "Summer's Post Parties Finale," Conversation Piece, *Amsterdam News,* September 23, 1972, D11.

291 *Henry passed first:* Joseph Berger, "Henry Lee Moon Dead at 84," *New York Times,* June 8, 1985, 45; and "NAACP Library to Honor the Late Henry Lee Moon," *Amsterdam News,* January 23, 1988, 47.

291 *Throughout her life:* "Mollie Moon, Founder of NUL Guild, Dies," *Atlanta Daily World,* July 8, 1990, 2.

292 *dedicated and innovative volunteerism:* Peter B. Flint, "Mollie Moon, 82, Founding Head of the Urban League Guild, Dies," *New York Times,* June 26, 1990, B7.

292 *Taste, class, style:* Cathy Connors, "New York Bids Farewell to Mollie Moon," *Amsterdam News,* July 14, 1990, 39.

292 *It was as she wished:* Connors, "New York Bids Farewell," 39.

SELECTED BIBLIOGRAPHY

NEWSPAPERS AND PERIODICALS

Atlanta Daily World
Baltimore Afro-American
The Black Dispatch
California Eagle
Chicago Defender
Chicago Tribune
Cleveland Call and Post
The Crisis
Daily Oklahoman
Daily Worker
Ebony
Jet
Los Angeles Sentinel
Los Angeles Times
Maclean's
New Journal and Guide
New Pittsburgh Courier
Newsweek
New York Age
New York Amsterdam News
New York Journal American
New York Times
The North Star
Oklahoma City Advertiser
Opportunity
Our World
Philadelphia Tribune
Pittsburgh Courier

Pittsburgh Courier Magazine
Time
Variety
Welfarer

INTERVIEWS CONDUCTED BY AUTHOR

Adele Logan Alexander. Historian. Email interview. November 17, 2021.

Adele Logan Alexander. Historian. Telephone interview. December 2, 2021.

Tiffany Barber. Art historian. Telephone interview. November 30, 2021.

Richard P. Bourne-Vanneck. Son of Victoria and Richard Bourne-Vanneck. Telephone interview. August 7, 2020.

Sherry Brewer Bronfman. Philanthropist and fundraiser. Telephone interview. May 18, 2021.

Mollie Lee Moon Elliot. Daughter of Mollie and Henry Lee Moon. Telephone interview. March 7, 2021.

John Ellis. Art collector. Telephone interview. November 16, 2020.

Christina Greer. Political scientist and fundraiser. Zoom interview. December 29, 2021.

Ruth D. Hunt. Former model. Telephone interview. August 20, 2020.

Nakisha Lewis. Philanthropic strategist. Telephone interview. February 3, 2022.

Zakiya Lord. Chartered Advisor in Philanthropy. Telephone interview. February 1, 2022.

Terry Baker Mulligan. Author and Harlem resident. Telephone interview. April 17, 2020.

Victoria Rogers. Art collector. Telephone interview. November 30, 2021.

Audrey Smaltz. Former model and fashion entrepreneur. Telephone interview. April 20, 2020.

George Suttles. Philanthropic adviser. Telephone interview. May 2, 2020.

MANUSCRIPT AND OBJECT COLLECTIONS

Amistad Research Center, New Orleans, Louisiana
Chester B. Himes Papers
Clarie Collins Harvey Papers
Countee Cullen Papers
Frank Horne Papers & Addendum
Louise Jefferson Papers

Columbia University Rare Book and Manuscript Library, New York, New York
Whitney Young Jr. Papers

Houston Public Library, Houston, Texas
John Hay Whitney Foundation Collection

Huntington Library, San Marino, California
Loren Miller Papers

Library of Congress, Washington, DC
National Urban League Records, 1900–1988

Moorland-Spingarn Research Center, Washington, DC
Thomasina Johnson Norford Interview, Ralph J. Bunche Oral History Collection

New York Public Library, New York, New York
Waldorf-Astoria Hotel Records
Writers' Program, New York City: Negroes of New York Collection

Rockefeller Archive Center, Sleepy Hollow, New York
Ford Foundation Papers
Rockefeller Brothers Fund Papers
Rockefeller Foundation Papers
Taconic Foundation Papers
Winthrop Rockefeller Papers

Schlesinger Library, Cambridge, Massachusetts
Norma Boyd (interview), Black Women Oral History Project
Margaret Cardozo Holmes (interview), Black Women Oral History Project
Dorothy West Papers

Schomburg Center for Research in Black Culture, New York, New York
Bessye Bearden Papers
Henry Lee and Mollie Moon Papers
Hibernia Austin Papers
Voices From the Harlem Renaissance Collection, 1974–1977

Smithsonian Archives of American Art, Washington, DC
New Deal and the Arts Oral History Project

University of Arkansas Library, Fayetteville, Arkansas
Virgil T. Blossom Papers

Western Reserve Historical Society, Cleveland, Ohio
Henry Lee Moon Family Papers

SELECTED BOOKS AND ARTICLES

Alexander, Sadie T. M. *Democracy, Race, and Justice: The Speeches and Writings of Sadie T. M. Alexander.* Edited by Nina Banks. New Haven, CT: Yale University Press, 2021.

Allen, Nneka, Camila Vital Nunes Perira, and Nicole Salmon, eds. *Collecting Courage: Joy, Pain, Freedom, Love: Anti-Black Racism in the Charitable Sector.* Toronto: Civil Sector Press, 2020.

Anderson, Carol. *Bourgeois Radicals: The NAACP and the Struggle for Colonial Liberation, 1941–1960.* New York: Cambridge University Press, 2014.

Asch, Chris Myers, and George Derek Musgrove. *Chocolate City: A History of Race and Democracy in the Nation's Capital.* Chapel Hill: University of North Carolina Press, 2017.

Austin, Paula C. *Coming of Age in Jim Crow DC: Navigating the Politics of Everyday Life.* New York: NYU Press, 2019.

Banks, Patricia A. *Black Culture, Inc.: How Ethnic Community Support Pays for Corporate America.* Redwood City, CA: Stanford University Press, 2022.

———. *Represent: Art and Identity Among the Black Upper-Middle Class.* New York: Routledge, 2009.

Baradaran, Mehrsa. *The Color of Money: Black Banks and the Racial Wealth Gap.* Cambridge, MA: Harvard University Press, 2017.

———. *How the Other Half Banks: Exclusion, Exploitation, and the Threat to Democracy.* Cambridge, MA: Harvard University Press, 2018.

Bennett, Gwendolyn. *Heroine of the Harlem Renaissance and Beyond: Gwendolyn Bennett's Selected Writings.* Edited by Belinda Wheeler and Louis J. Parascandola. University Park, PA: Penn State University Press, 2018.

Birmingham, Stephen. *Certain People: America's Black Elite.* New York: Little, Brown, 1977.

Blain, Keisha N., and Tiffany M. Gill, eds. *To Turn the Whole World Over: Black Women and Internationalism.* Champaign: University of Illinois Press, 2019.

Bowley, Hazel. *Richard Wright: The Life and Times.* Chicago: University of Chicago Press, 2001.

Branch, Taylor. *Parting the Waters: America in the King Years, 1954–1963.* New York: Simon & Schuster, 1989.

Brown, Dorothy A. *The Whiteness of Wealth: How the Tax System Impoverishes Black Americans—And How We Can Fix It.* New York: Penguin Random House, 2022.

Brown, Nikki. *Private Politics and Public Voices: Black Women's Activism from World War I to the New Deal*. Bloomington: Indiana University Press, 2006.

Cabral, Amilcar. *Resistance and Decolonization*. Translated by Dan Wood. New York: Rowman & Littlefield, 2016.

Campbell, Mary Schmidt. *An American Odyssey: The Life and Work of Romare Bearden*. New York: Oxford University Press, 2018.

Clark-Lewis, Elizabeth. *Living In, Living Out: African American Domestics in Washington, D.C., 1910–1940*. Washington, DC: Smithsonian Books, 2010.

Clerge, Orly. *The New Noir: Race, Identity, and Diaspora in Black Suburbia*. Oakland: University of California Press, 2019.

Cook, Blanche Wiesen. *Eleanor Roosevelt, Volume 2: The Defining Years, 1933–1938*. New York: Penguin Random House, 2017.

———. *Eleanor Roosevelt, Volume 3: The War Years and After, 1939–1962*. New York: Penguin Random House, 2017.

Cooks, Bridget R. *Exhibiting Blackness: African Americans and the American Art Museum*. Amherst: University of Massachusetts Press, 2011.

Crocker, Ruth. *Mrs. Russell Sage: Women's Activism and Philanthropy in Gilded Age and Progressive Era America*. Bloomington: Indiana University Press, 2006.

Cromwell, Adelaide M. *The Other Brahmins: Boston's Black Upper Class 1750–1950*. Fayetteville: University of Arkansas Press, 1994.

Dawson, Michael C. *Blacks In and Out of the Left*. Cambridge, MA: Harvard University Press, 2013.

De Courcy, Anne. *The Husband Hunters: American Heiresses Who Married into the British Aristocracy*. New York: St. Martin's Press. 2018.

Dickerson, Dennis C. *Militant Mediator: Whitney M. Young Jr.* Lexington: University Press of Kentucky, 2004.

Dossett, Kate. *Radical Black Theatre in the New Deal*. Chapel Hill: University of North Carolina Press, 2020.

Drake, St. Clair, and Horace R. Cayton. *Black Metropolis: A Study of Negro Life in a Northern City*. New York: Harcourt Brace, 1945.

Flynn, Andrea, Dorian T. Warren, Felicia J. Wong, and Susan R. Holmberg. *The Hidden Rules of Race: Barriers to an Inclusive Economy*. New York: Cambridge University Press, 2017

Francis, Megan Ming. "The Price of Civil Rights: Black Lives, White Funding, and Movement Capture," *Law and Society Review* 53, no. 1 (March 2019): 275–309.

Frazier, E. Franklin. *Black Bourgeoisie: The Book That Brought the Shock of Self-Revelation to Middle-Class Blacks in America*. New York: Free Press, 1955.

Freedman, Paul. *Food: The History of Taste*. Berkeley: University of California Press, 2007.

Freeman, Tyrone. *Madam C. J. Walker's Gospel of Giving: Black Women's Philanthropy During Jim Crow*. Champaign: University of Illinois Press, 2020.

Friedman, Lawrence J., and Mark D. McGarvie, eds. *Charity, Philanthropy, and Civility in American History*. New York: Cambridge University Press, 2002.

Garrett-Scott, Shennette. *Banking on Freedom: Black Women in U.S. Finance Before the New Deal*. New York: Columbia University Press, 2019.

Gasman, Marybeth. *Envisioning Black Colleges: A History of the United Negro College Fund*. Baltimore, MD: Hopkins Press, 2018.

Gasman, Marybeth, and Katherine V. Sedgewick, eds. *Uplifting a People: African American Philanthropy and Education*. New York: Peter Lang Publishing, 2005.

Gilmore, Glenda Elizabeth. *Defying Dixie: The Radical Roots of Civil Rights, 1919–1950*. New York: W. W. Norton, 2009.

Gilyard, Keith. *Louise Thompson Patterson: A Life of Struggle for Justice*. Durham, NC: Duke University Press, 2017.

Graham, Lawrence Otis. *Our Kind of People: Inside America's Black Upper Class*. New York: Harper Perennial, 1999.

Harrington, Brooke. *Capital Without Borders: Wealth Managers and the One Percent*. Cambridge, MA: Harvard University Press, 2020.

hooks, bell. *Where We Stand: Class Matters*. New York: Routledge, 2000.

Horne, Gerald. *Race Woman: The Lives of Shirley Graham Du Bois*. New York: NYU Press, 2000.

Howes, David, and Carolyn Korsmeyer. *The Taste Culture Reader: Experiencing Food and Drink*. New York: Bloomsbury Publishing, 2016.

Hughes, Langston. *I Wonder as I Wander: An Autobiographical Journey*. New York: Hill and Wang, 1956.

———. *Letters from Langston: From the Harlem Renaissance to the Red Scare and Beyond*. Edited by Evelyn Louise Crawford and MaryLouise Patterson. Berkeley: University of California Press, 2016.

Jackson, Lawrence P. *Chester B. Himes: A Biography*. New York: W. W. Norton, 2017.

Jackson, Rodney. *A Philanthropic Covenant with Black America.* Hoboken, NJ: John Wiley & Sons, 2009.

Jenkins, Earnestine Lovelle. *Black Artists in America: From the Great Depression to Civil Rights.* New Haven, CT: Yale University Press, 2022.

Johnson, Joan Marie. *Funding Feminism: Monied Women, Philanthropy, and the Women's Movement, 1870–1967.* Chapel Hill: University of North Carolina Press, 2017.

Kennedy, Adrienne. *People Who Led to My Plays.* New York: Theatre Communications Group, 1987.

Kohl-Arenas, Erica. *The Self-Help Myth: How Philanthropy Fails to Alleviate Poverty.* Oakland: University of California Press, 2015.

Lewis, David Levering. *When Harlem Was in Vogue.* New York: Knopf, 1981.

Major, Gerri. *Black Society.* New York: Johnson Publishing, 1977.

Marable, Manning. *How Capitalism Underdeveloped Black America: Problems in Race, Political Economy, and Society.* Chicago: Haymarket, 2015.

McCarthy, Kathleen D. *Women's Culture: American Philanthropy and Art, 1830–1930.* Chicago: University of Chicago Press, 1991.

McGhee, Heather. *The Sum of Us: What Racism Costs Everyone and How We Can Prosper Together.* New York: Oneworld, 2021.

McGuire, Danielle L. *At the Dark End of the Street: Black Women, Rape, and Resistance—A New History of the Civil Rights Movement from Rosa Parks to Black Power.* New York: Penguin Random House, 2011.

McKay, Claude. *Home to Harlem.* New York: Harper & Brothers, 1928.

Michney, Todd M. *Surrogate Suburbs: Black Upward Mobility and Neighborhood Change in Cleveland, 1900–1980.* Chapel Hill: University of North Carolina Press, 2017.

Moore, Charles. *The Black Market: A Guide to Art Collecting.* New York: Petite Ivy Press, 2020.

Morey, Maribel. *White Philanthropy: Carnegie Corporation's An American Dilemma and the Making of a White World Order.* Chapel Hill: University of North Carolina Press, 2021.

Morris, Tiyi M. *Womanpower Unlimited and the Black Freedom Struggle in Mississippi.* Athens: University of Georgia Press, 2015.

Muhammad, Khalil Gibran. *The Condemnation of Blackness: Race, Crime, and the Making of Modern America.* Cambridge, MA: Harvard University Press, 2019.

Murphy, Mary-Elizabeth B. *Jim Crow Capital: Women and Black Freedom Struggles in Washington, DC, 1920–1945*. Chapel Hill: University of North Carolina Press, 2018.

Murray, Pauli. *Song in a Weary Throat: Memoir of an American Pilgrimage*. New York: Liveright Publishing, 1987.

Naylor, Gloria. *Linden Hills*. New York: Penguin Books, 1986.

O'Connor, Alice. *Poverty Knowledge: Social Science, Social Policy, and the Poor in Twentieth Century U.S. History*. Princeton, NJ: Princeton University Press, 2002.

Okrent, Daniel. *Great Fortune: The Epic of Rockefeller Center*. New York: Penguin Books, 2004.

Pattillo, Mary. *Black on the Block: The Politics of Race and Class in the City*. Chicago: University of Chicago Press, 2008.

Peterson, Carla L. *Black Gotham: A Family History of African Americans in Nineteenth-Century New York City*. New Haven, CT: Yale University Press, 2012.

Petry, Ann. *The Street*. Boston: Houghton Mifflin, 1946.

Raicovich, Laura. *Culture Strike: Art and Museums in an Age of Protest*. New York: Verso Books, 2021.

Ransby, Barbara. *Eslanda: The Large and Unconventional Life of Mrs. Paul Robeson*. Chicago: Haymarket, 2022.

Reed, Touré F. *Not Alms but Opportunity: The Urban League and the Politics of Racial Uplift, 1910–1950*. Chapel Hill: University of North Carolina Press, 2008.

Robinson, Cedric J. *Black Marxism: The Making of the Black Radical Tradition*. London: Zed Press, 1983.

Seebohm, Caroline. *No Regrets: The Life of Marietta Tree*. New York: Simon & Schuster, 1997.

Sherman, Rachel. *Uneasy Street: The Anxieties of Affluence*. Princeton, NJ: Princeton University Press, 2019.

Sherrard-Johnson, Cherene M. *Dorothy West's Paradise: A Biography of Class and Color*. New Brunswick, NJ: Rutgers University Press, 2012.

Taiwo, Olufemi. *Elite Capture: How the Powerful Took Over Identity Politics (And Everything Else)*. Chicago: Haymarket, 2022.

Taylor, Elizabeth Dowling. *The Original Black Elite: Daniel Murray and the Story of a Forgotten Era*. New York: Amistad Press, 2018.

Taylor, Yuval. *Zora and Langston: A Story of Friendship and Betrayal*. New York: W. W. Norton, 2019.

Todd, Tim. *A Great Moral and Social Force: A History of Black Banks.* Kansas City, MO: Federal Reserve Bank of Kansas City, 2022.

VanDiver, Rebecca. *Designing a New Tradition: Loïs Mailou Jones and the Aesthetics of Blackness.* University Park, PA: Penn State University Press, 2020.

Villanueva, Edgar. *Decolonizing Wealth: Indigenous Wisdom to Heal Divides and Restore Balance.* New York: Penguin Random House, 2021.

Watts, Jill. *The Black Cabinet: The Untold Story of African Americans and Politics During the Age of Roosevelt.* New York: Grove Press, 2020.

West, Dorothy. *The Living Is Easy.* Boston: Houghton Mifflin, 1948.

——. *The Richer, the Poorer: Stories, Sketches, and Reminiscences.* New York: Doubleday, 1996.

——. *The Wedding.* New York: Penguin Random House, 1995.

Weyl, Walter E. *The New Democracy.* New York: Macmillan Company, 1918.

Wilder, Gary. *Freedom Time: Negritude, Decolonization, and the Future of the World.* Durham, NC: Duke University Press, 2015.

Williams, Peter W. *Religion, Art, and Money: Episcopalians and American Culture from the Civil War to the Great Depression.* Chapel Hill: University of North Carolina Press, 2019.

Willoughby-Herard, Tiffany. *Waste of a White Skin: The Carnegie Corporation and the Racial Logic of White Vulnerability.* Oakland: University of California Press, 2015.

Wilson, Francille Rusan. *The Segregated Scholars: Black Social Scientists and the Creation of Black Labor Studies, 1890–1950.* Charlottesville: University of Virginia Press, 2006.

Winford, Brandon K. *John Hervey Wheeler, Black Banking, and the Economic Struggle for Civil Rights.* Lexington: University Press of Kentucky, 2019.

Zafar, Rafia. *Recipes for Respect: African American Meals and Meaning.* Athens: University of Georgia Press, 2019.

Zelizer, Viviana A. *Economic Lives: How Culture Shapes the Economy.* Princeton, NJ: Princeton University Press, 2010.

——. *The Social Meaning of Money: Pin Money, Paychecks, Poor Relief, and Other Currencies.* Princeton, NJ: Princeton University Press, 2017.

ABOUT THE AUTHOR

———

Tanisha C. Ford is a writer, researcher, and cultural critic working at the intersection of politics and culture. She has forged an international reputation for her groundbreaking research on the history of Black style/fashion and social movements. Tanisha was honored as one of *The Root*'s 100 Most Influential African Americans. She is currently a professor of history at The Graduate Center, CUNY, where she teaches courses on African American and African diaspora history, biography and memoir, and the geopolitics of fashion.

Her most recent book, *Dressed in Dreams: A Black Girl's Love Letter to the Power of Fashion*, was named to several must-read lists, including the *Philadelphia Inquirer*'s Big Summer Books of 2019, *Bitch Media*'s 15 Nonfiction Books Feminists Should Read, and *Essence*'s 10 Summer Reads, and it was the runner-up for the Popular Culture Association's Henry Shaw and Katrina Hazzard-Donald Award for Outstanding Work in African-American Popular Culture.

Tanisha is also the author of *Liberated Threads: Black Women, Style, and the Global Politics of Soul*, which won the 2016 Organization of American Historians' Liberty Legacy Foundation Award for best book on civil rights history. She is coauthor (with Kwame Brathwaite and Deborah Willis) of the visually stunning *Kwame Brathwaite: Black Is Beautiful*.

A native of a small Midwestern city, Tanisha enjoys researching the histories of often-overlooked people and places. Her work centers on social movement history, philanthropy and the cultural politics of money, Black feminism(s), material culture, the built environment, Black life in the Rust Belt, girlhood studies, and fashion and body politics. Tanisha makes connections between the past and the present in ways that shed refreshing new light on contemporary cultural and political issues. Her scholarship has been published in the *Journal of Southern History*, *NKA: Journal of Contemporary African Art*, *The Black Scholar*, and *QED: A Journal in GLBTQ Worldmaking*. Tanisha writes regularly for public audiences—with feature stories, cultural criticism, and profiles in the *New York Times*, the *Atlantic*, *ELLE*, *Harper's Bazaar*, *The Root*, *Aperture*, *TIME* magazine, and *Town & Country*.

Her research has been supported by prestigious institutions such as the Institute for Advanced Study (Princeton, NJ), Harvard Radcliffe Institute, Smithsonian Museum of American History, Andrew W. Mellon Foundation, Ford Foundation, Schomburg Center for Research in Black Culture, University of London's School of Advanced Study, and the Center for Black Music Research, among others.

In 2011, Tanisha earned a PhD in twentieth-century US history from Indiana University-Bloomington (*with distinction*). She spent the 2011–2012 academic year as the Du Bois-Mandela-Rodney postdoctoral fellow in the University of Michigan's Department of Afroamerican and African Studies before embarking on the tenure track in fall 2012. Before joining the Grad Center faculty, she held faculty positions in Women's, Gender, Sexuality Studies at the University of Massachusetts-Amherst and in the University of Delaware's departments of Africana Studies and History, where

she was hired as part of a material culture studies initiative. In 2016, Tanisha was promoted to associate professor, with tenure. And, in fall 2019, she was promoted to full professor—joining the woefully small cadre of Black women who have achieved this rank in her profession (a reality she's committed to changing). Tanisha lives in Harlem.